LONELY PLANET'S

Natural World

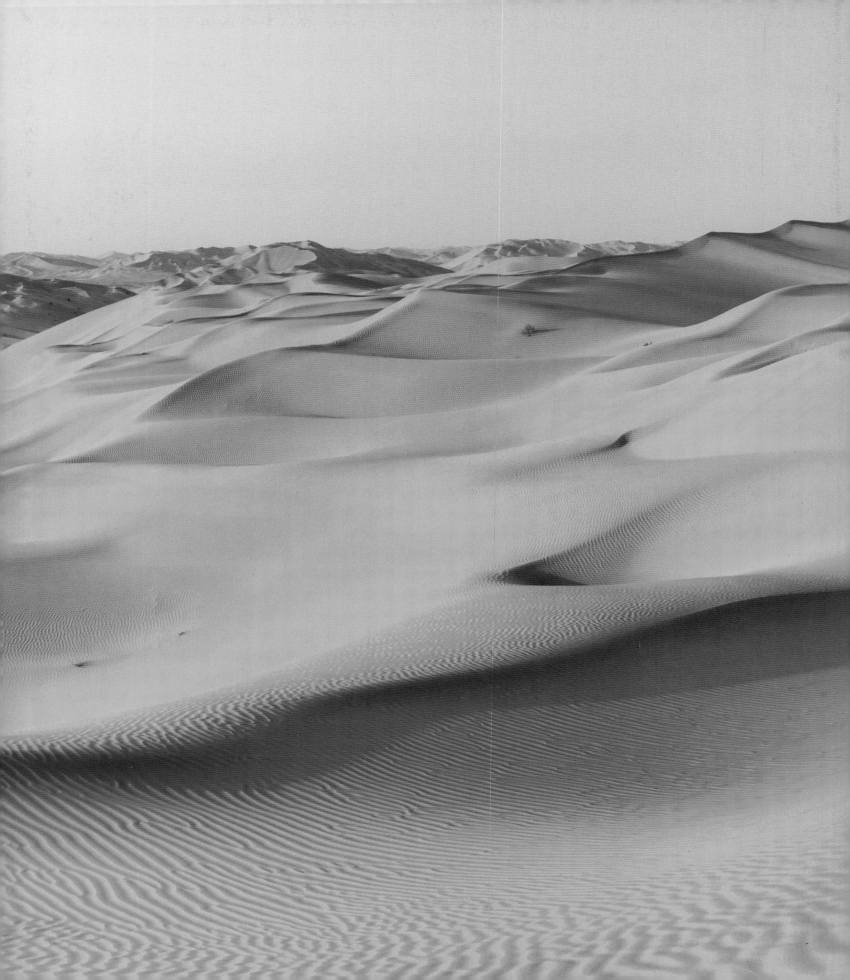

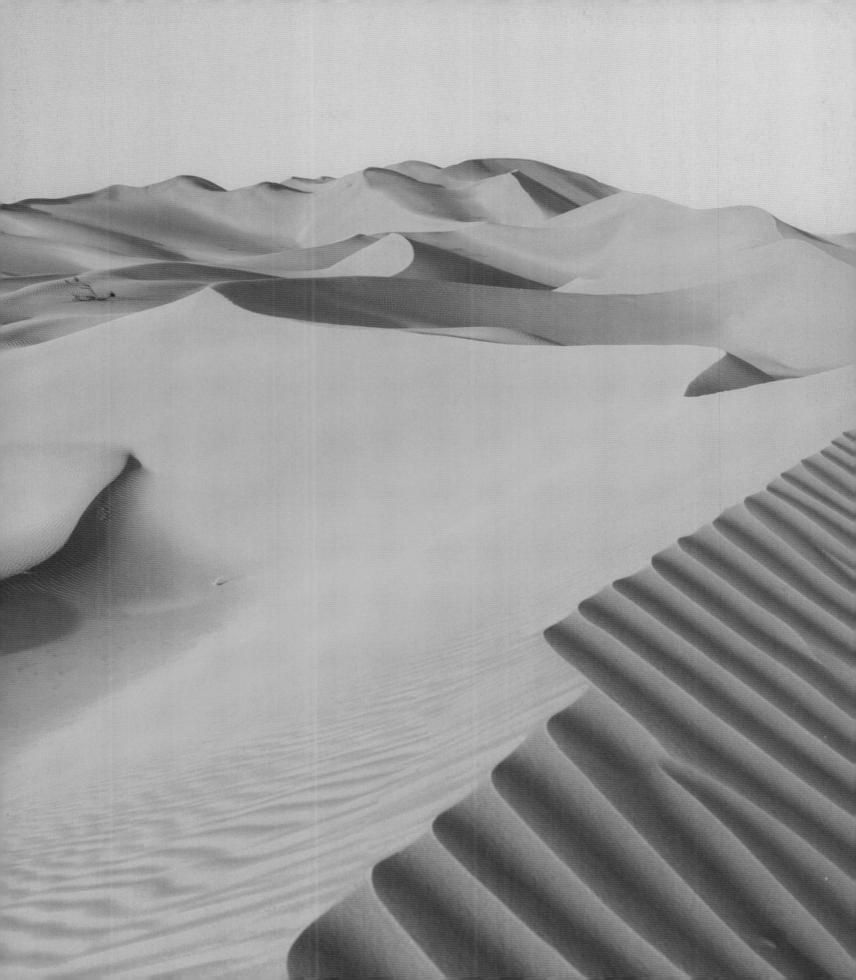

Contents

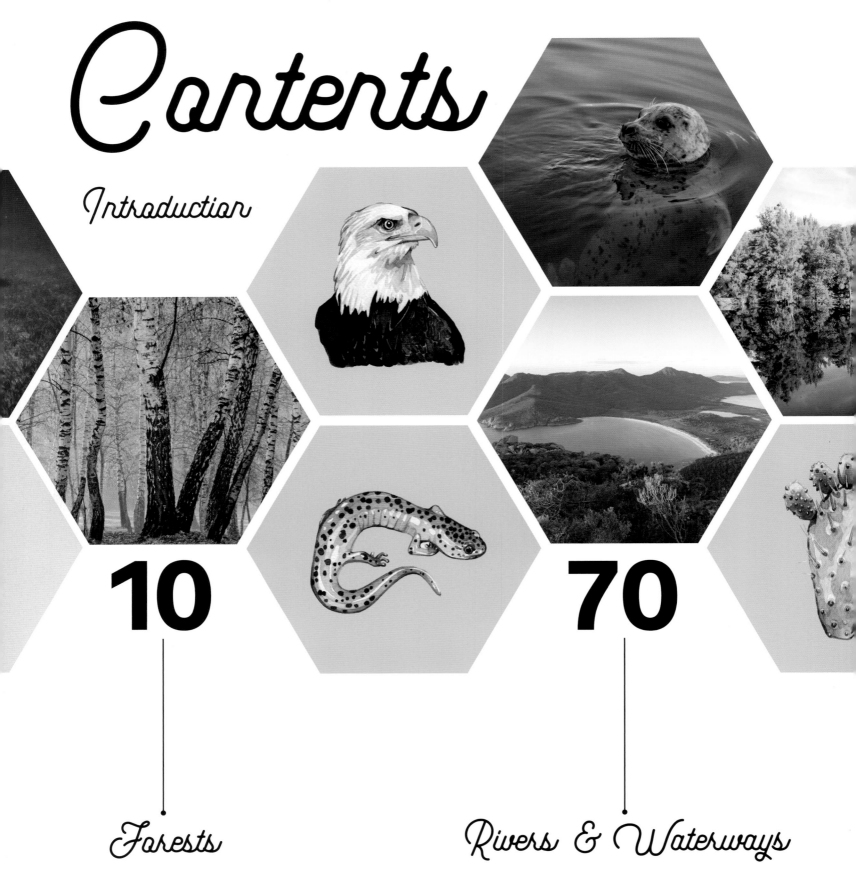

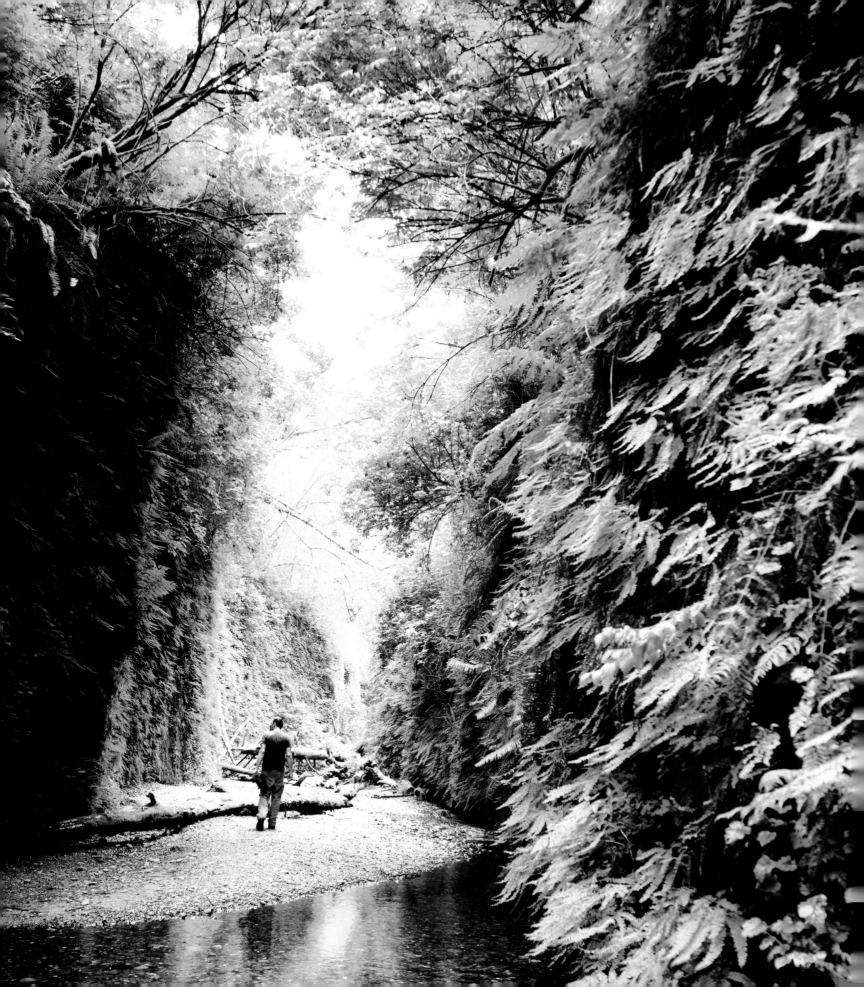

Introduction

After the next time that you go for a walk in the woods, write down three words about how you felt. There's a very good chance that the feelings you recall will be thoroughly positive: you might use words like calm, reflective, refreshed, relaxed, inspired, happy. Recent scientific research is establishing why it is that being in nature has such a beneficial effect on us but we don't need scientists to tell us that going for a walk, climbing a mountain or swimming in silky wild waters feels great. As animals we're hardwired to feel at home outdoors. Our senses and instincts are tuned into nature but – for some of us – living in and working in cities and offices has meant that the signal has become a little crackly. This book attempts to help us reconnect with nature.

We examine five different natural environments: coasts, mountains, forests, rivers and deserts. Each is very different but they have all inspired artists, explorers, mystics, seekers and adventurers. In their own ways they each offer us solace and joy. Expert writers, including Adam Weymouth, who canoed the Yukon River for his book *Kings of the Yukon*, and Adam Skolnick who wrote about his love of the ocean in his book *One Breath*, introduce each environment and consider some of its scientific, cultural and historical background. And then, for each environment, we suggest ten amazing places to explore further, places where you can reconnect with nature. In the chapter on forests, for example, we walk among the redwood trees of Northern California and venture into Australia's ancient Daintree rainforest. In the chapter about mountains we travel from Western Europe's highest mountain, Mont Blanc, to the mysterious Mountains of the Moon in central Africa. Adam Weymouth floats down the Danube River through Europe's cultural capitals and the Franklin River in Tasmania, Australia, scene of that nation's earliest environmental battles. Along the way we learn about the writers and artists whose work has been shaped by the natural world, such as poet William Wordsworth standing atop Mt Snowdon to watch the sun rise. The geography and history of each environment is also on the curriculum, from the first cultures to sail the oceans to the campaigns that protected these fragile regions.

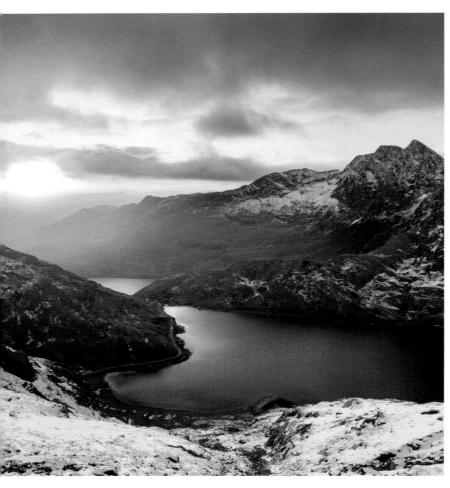

If you've ever wondered why it is that time seems to slow down when you watch a flock of swifts arc across the summer sky, why it is that some of your best ideas come to you during a quiet walk in a forest, or why we feel more alert yet serene in a natural space, we explain that too. Perhaps one of nature's most important lessons is how to be present in the moment.

You don't even have to travel far to enjoy nature – most of us have opportunities to try forest bathing, wild swimming or hill climbing near our homes, all of which may have a positive impact on our physical wellbeing, boosting our immune systems and lowering our blood pressure.

That's what nature does for us, for free. But in each chapter we also ask what can we do for the natural world? In our daily news are reports of polluted oceans and rivers, and forests being cleared for plantations around the world. The natural world is threatened like never before. But visiting and spending time and money in places like those featured in this book can help. Yes, there is a cost to the environment of travel but tourism also supports local communities and funds alternatives to poaching and deforestation. Some of the experts that we spoke to explained that people who enjoyed first-hand experience of being in nature were more likely to want to defend and preserve nature, especially young people. As Richard Louv, the author of the bestseller *Last Child in the Woods*, puts it: without reconnecting with nature, the destruction of nature is assured.

Thankfully, exemplary organisations are working to preserve wildernesses, such as the National Park Service in the US, which celebrated its centenary in 2016 and continues to encourage access to wild spaces for everybody. As this book reveals, we receive so much from nature, from our own personal wellbeing and sense of wonder to the natural balance of the planet's climate and ecosystems, that we must also do what we can to conserve and support the natural world around us.

Clockwise from top, sunrise over Snowdonia; Cape Tribulation and the Daintree forest in Queensland; the US National Park Service; previous page, Fern Canyon in Prairie Creek Redwoods State Park, California.

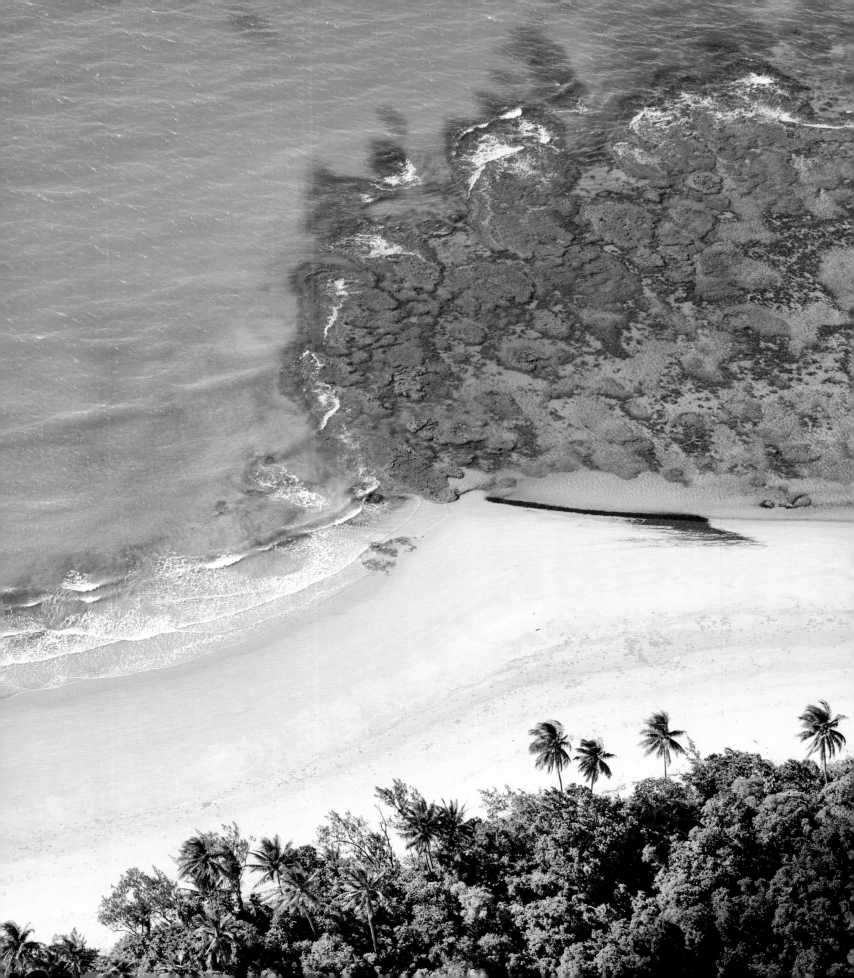

Forests

For centuries forests were a source of terror. They were dark and dangerous places where witches and monsters dwelled. Dante begins his Divine Comedy having lost his path in a 'savage forest', the very thought of which 'renews the fear'. How times change! Today, we know just how precious forests are, as the richest and most diverse habitats for living creatures and the planet's life-giving green lungs for converting carbon dioxide into oxygen. And we know now how precarious their existence is.

There's something else we've come to appreciate in recent years, though we've known it all along. Spending time in forests, quietly walking among the trees, allowing our brains to turn from dealing with the week's stresses to absorbing the forest's sights, sounds and smells, is actually really good for us. It's beneficial for our minds, our health and perhaps also our spirits. A new field of scientific research aims to establish exactly what it is about trees and forests that affects us so profoundly and how our attitude to forests has evolved. This chapter dives into that research and then explores some of the world's most extraordinary places to get closer to some amazing trees.

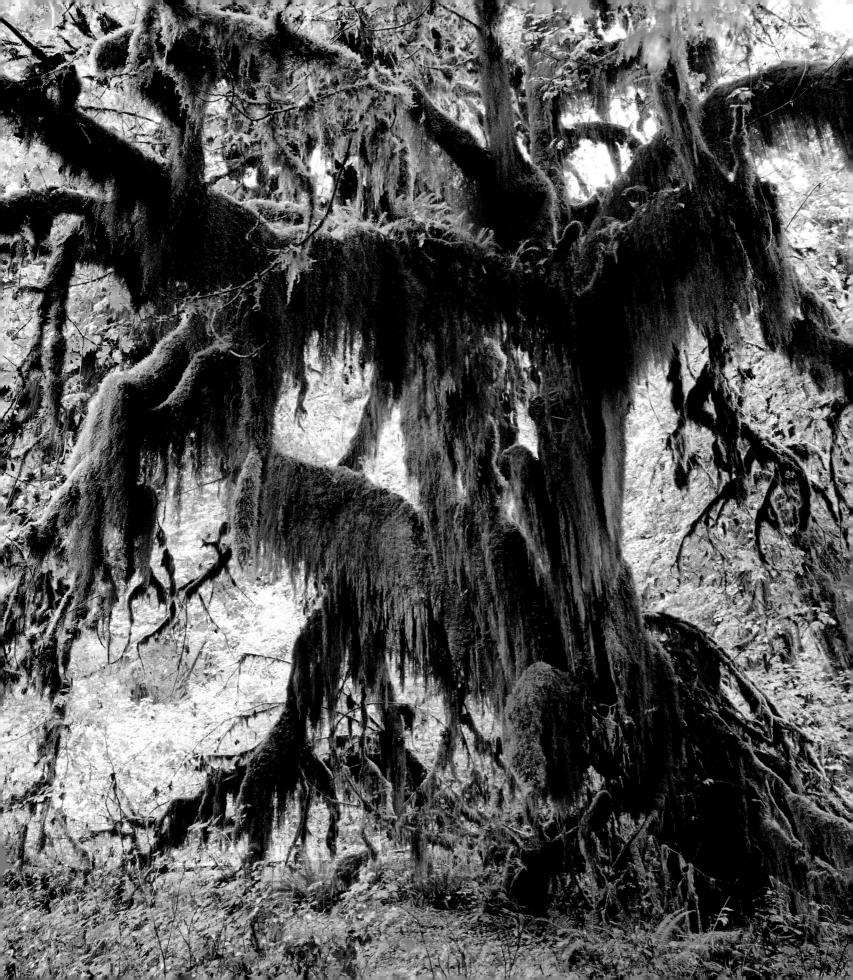

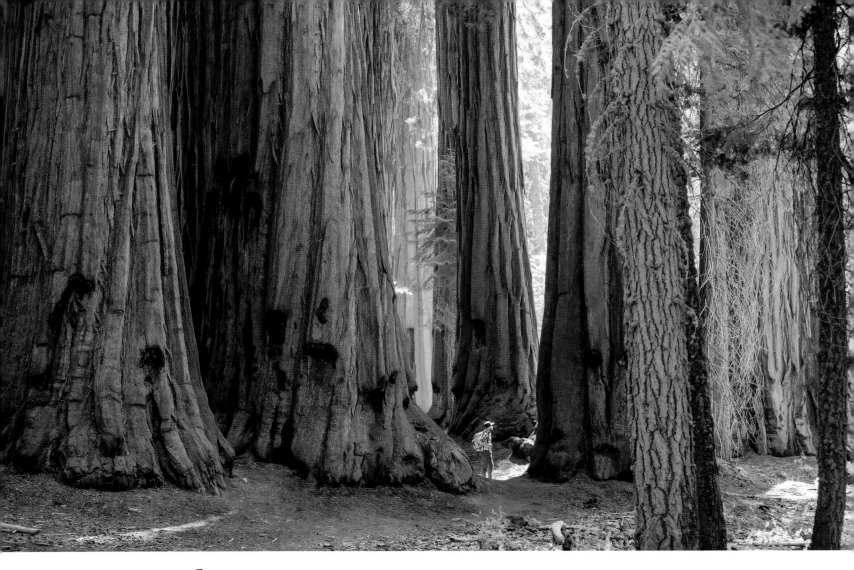

'Walk slowly, take pictures, smell the trees, and touch fallen redwood cones on the ground.' National Park Service Ranger Savannah Sanford at Muir Woods National Monument in Marin County, California, is explaining to me how best to appreciate this popular redwood forest.

'Often when we visit National Park sites we are on vacation, stressed about our itinerary or what time we need to get back for the next leg of the trip. Budget your time well, of course, but don't let it impact how you experience the forest. By allowing your body to relax and quieting your mind, you can observe nature with all your senses.'

Over the years, I've been fortunate enough to visit several of northern California's forests of redwoods, the home state (with Oregon and Washington) of these immense living organisms. Each time the experience has been nothing less than otherworldly, like passing through a portal to another planet where everything has doubled in size and you're not quite sure what's around the next corner.

According to Savannah Sanford, who grew up just a few miles from Muir Woods, this is an entirely normal response.

'The first memory I have of the redwoods was when I was five years old as a flower girl at a wedding,' she recalls. 'I got bored during the ceremony so sat down in the dirt and started playing with the redwood needles. I knew that I wanted to be a Ranger when I was about seven years old. In high school I joined my environmental science program, which I majored in at college. I then lived in Massachusetts for five years and it wasn't until I came back to California that I really understood how incredible redwoods were.'

Today, Savannah spends her days helping visitors to Muir Woods, who may never have set foot in a forest before, engage with the trees and get the most out of their trip. With redwoods all around, it's not hard to have a captivated audience.

'One of our programs is the Tree Talk, which is a 15-minute introduction to the history and ecology of Muir Woods and the redwood trees. During the summer each program could have up to 100 people but during winter attendance is much smaller. One winter I went out into the forest to give a Tree Talk in the middle of a rainstorm and was surprised to find 30 people waiting for me. They stayed

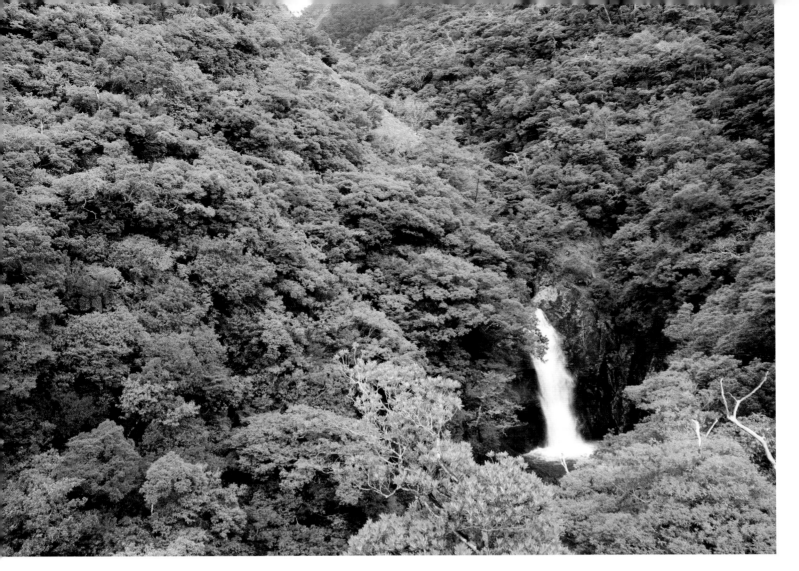

for the duration even though the pounding sound of water hitting the trees and boardwalk meant I had to yell so folks could hear me.'

Savannah Sanford has first-hand experience of the effect that being around trees can have on people. 'Being outside can help us to relax, de-stress, and is a great motivation for staying active,' she says. 'Natural spaces affect human health and I definitely notice a difference in my stress levels on days where I hike in the forest versus days where I spend most of my time in the office on a computer.'

Over the last decade a lot of scientific research has been devoted to discovering what it is about natural spaces – and forests in particular – that is so beneficial for our bodies, brains and perhaps our spirits. No longer need we rely on anecdotal evidence alone because there is plenty of data that makes a strong case for a walk in the woods.

One of the regions that made early progress in this field was Asia. Take Japan: here, 'forest bathing' (the Japanese term is *shinrin-yoku*) is more than a buzzword. Since the 1980s Japanese have been finding respite from their highly urbanised lives in the country's parks and forests. Dr Qing Li, author of the bestselling *Shinrin-Yoku: The Art and Science of Forest Bathing* and president of the Society for Forest Medicine, believes that such walks are not only relaxing but can help prevent conditions such as anxiety, depression (and even, he claims, cancers, ulcers and strokes) by boosting the immune system and lowering blood pressure and levels of cortisol (the fight-or-flight stress hormone that is released in response to much of our modern daily lives – such as driving, working or simply not having enough time in the day to do everything).

It is becoming increasingly accepted that being in nature does have positive physiological effects on people, to the extent that health services around the world are now offering 'green

Left: walking among the giants of Sequoia National Park; right, the rainforest of Yakushima island, Japan.

prescriptions' instead of medication for some complaints or ailments.

In the US, health insurance providers have started incentivising their customers to take a walk in park: insurer Kaiser Permanente has been investing in local parks since 2015, based on research from California State Parks that found people from all demographics gained better health and wellbeing when spending more time outdoors. More than 30 American states offer 'nature-prescription' programs.

At Oakland's Children's Hospital in California, the Center for Nature and Health researches how public health can use nature in healing. It advocates for nature as a public health priority by working with groups such as Parks Now! and was among the first in the US to refer patients to the outdoors. And in 2018 the American outdoor retailer REI announced a $1m investment in an initiative at the University of Washington's EarthLab to study the link between health and time spent outdoors.

On the Shetland Islands of Scotland, general practitioners (GPs or local doctors) have started suggesting patients go for a walk or take up an activity that encourages them to connect with nature, for example birdwatching.

'Getting out among nature is potentially part of a solution to why you're not feeling great,' says Dr Mark Maudsley, a GP in Scalloway, a Shetland village. 'It's not just to do with exercise and fresh air,' he explains. 'It's the idea of going out and connecting.'

Dr Ruth Booth, who works on the beautiful Shetland island of Fetlar, agrees: 'I personally have experienced the benefit of being out in nature – both the physical wellbeing it brings but also the mental improvement for myself. Encouraging people to slow down, be part of the

environment and enjoy the beauty and be mindful of what they are seeing has huge benefit.'

Of course, it's a lot easier to sell the idea of experiencing the great outdoors when the Shetlands' majestic shores are on your doorstep. Enabling city-dwellers to receive their dose of forest health was a problem that the Japanese solved by establishing a series of official 'healing forests' around the country, now numbering more than 60. There are healing forests close to most major cities and more than 1000 forest guides to help first-timers enjoy nature by suggesting mindful meditation techniques and offering plant leaves to smell and touch. This is not a wilderness experience. In Japan's official healing forests there will be other fellow patients around, many performing exercises to increase the potency of their dose: breathing in deeply, holding the breath, slowly exhaling.

South Korea has a similar form of forest bathing, called *salim yok*. For

Right, the Daimon-zaka staircase along the Kumano Kodo pilgrimage trail, Japan.

high-pressure societies like South Korea, where students have the highest graduation rates in the world and then go on to work the longest average annual hours of any OECD nation, being in nature offers a chance to decompress and reflect. Many go to such forests as Jangheong Cypress Woodland in the south of the country, the National Forest Healing Center to the east and Suncheon Bay National Garden and Wetland Reserve, and the Donghae Mureung Health Forest, where the antiseptic scent of hinoki cypress is all-pervading.

That fresh scent is a clue to one of the reasons that forests may be so good for us. One theory is that phytoncides, the aromatic airborne chemicals – turpenes, pinenes and limonenes – that plants emit to deter rot and insects, are just as beneficial for us, by boosting some types of our own white blood cells. Just take a stroll in the Australian bush to experience the punchy scent of a lemon tea tree.

HOW TO FOREST BATHE
Pick a place. Anywhere with some green space is good: a city or town park, a nature preserve, a local wood. The more trees the better.

Don't rush. Running is antithetical to forest bathing. 'It is important not to hurry on a forest walk,' writes Dr Qing Li. 'Walking slowly will help you to keep your senses open, to notice things and smell the forest air.' You will notice that time slows down.

Go alone or with a friend. A guide is not necessary. Being alone allows you to focus on yourself. If you take a companion, ensure that you're both on the same wavelength.

Breathe. Be mindful of your breathing. Relax. Stand still or sit. Inhale slowly but naturally. Feel your breath fill your lungs. Exhale slowly. After a few minutes you may notice your mind wandering. This is good.

Engage your senses. Listen to the forest sounds. Touch bark. Smell the forest fragrance. Notice how leaves and birds move.

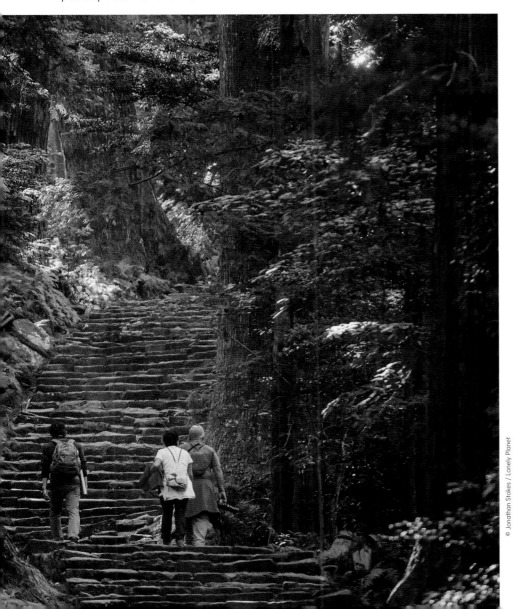

© Jonathan Stokes / Lonely Planet

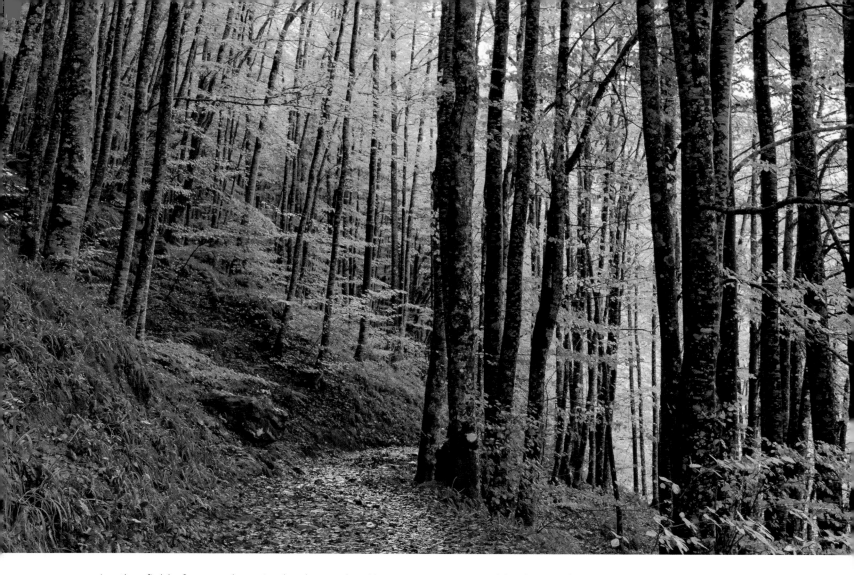

Another field of research posits the theory that it's soil compounds such as actinomycetes that are doing the good work. A 2007 study published in *Neuroscience* journal by University of Bristol neuroscientist Christopher Lowry found that mice inoculated with a soil bacteria coped with stress far better than other mice not inoculated. The brain neurotransmitter serotonin (also known as 'the happy chemical') was increased. And, intriguingly, neurons associated with immune response also lit up, suggesting a link between good mental health and immune systems.

We all know that scents trigger memories and associations especially quickly, as if there's a direct connection between our nose and our brain – think of your involuntary response to a bad smell (or a freshly baked croissant). The flip-side of a forest's clean and invigorating air to breathe is the polluted atmosphere of modern cities: minute particulates from pollution caused by vehicles also go straight into our brains and it's established that not only your respiratory health is compromised the closer you live to busy roads but you are also more likely to suffer from brain-centred problems such dementia and strokes.

It's the same with sound. Cities are fraught with loud, perpetual background noise – planes, trains, vehicles, sirens, construction and so on – that we try to tune out but which nevertheless has a hugely detrimental effect on city dwellers. Your brain cannot help but pay attention to it because, as animals, we are obliged to respond to stimuli. Studies have shown that children taking spelling tests do worse when there's distracting noise in the background, as you would expect.

Human activity adds about 30 unwanted decibels to the soundtrack of your daily life. The next time that you're outside, close your eyes and listen. There's a good chance that you'll notice first the rumble of traffic or a plane overhead before the sounds of the natural world. Not only does the noise that humans make drown out natural sounds, the effect can be awful for wildlife, which cannot hear to hunt or find a mate (although it should be noted that the stories of lyrebirds, nature's most accomplished mimics, copying the sounds of chainsaws and car alarms in Australia's forests are apocryphal).

Gordon Hempton, the 'Sound Tracker', aims to protect national parks and wild spaces by championing the world's remaining quiet places with his Quiet Parks International

project. For almost 40 years Hempton has been recording natural soundscapes around the world. According to him, the quietest place in the lower 48 states of the US is a spot in the Hoh Rainforest in Olympic National Park, Washington. For $9.95 you can purchase a 72-minute recording of the forest quietly going about its daily business, including chirrups from birds, froggy croaks, and the occasional drip of water.

Sound, like scent, is quickly processed by our brain. So it helps that our brains also respond instinctively to an absence of noise, or the new sounds of a forest. Birdsong is especially entrancing – out in a meadow you may eventually be able to spot a warbling skylark high above you but in a forest you often have only the sound of a bird to help identify it. In Australia's forests, whether the tropical rainforests of Queensland or the temperate woodlands of Victoria and Tasmania, the sounds can be particularly raucous – great see-sawing calls; sharp whip-like cracks; garrulous squawks of cockatoos. It's the avian equivalent of a heavy metal concert. Numerous studies have suggested that listening to birdsong, of any variety, improves mental alertness and mood. It's no accident that such airports as Amsterdam and Helsinki have played calming birdsong in their terminals.

What we do know is that outdoor spaces, whether near water or in forests, change our brains. According to a holistic theory, the combination of every sensation we enjoy outside – the sound of rushing water, the wind in trees, birdsong, the aroma of flowers and leaves, the mesmerising movement of trees and streams – activates a level of brain activity described as our 'rest and digest' setting. For most of the day our brains are revving hard on responses to prompts, whether that's a vexing work email or a family drama to resolve. But if we allow our parasympathetic nervous system to take over we find our heart rates slowing, our muscles, once clenched, now relaxing,

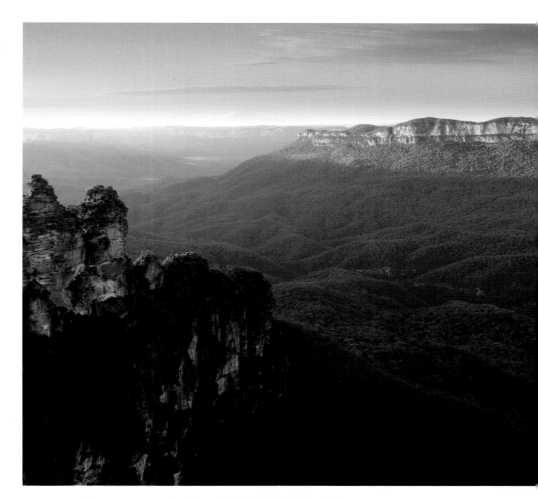

Clockwise from left: autumn in the Irati beech forest, Spain; the eucalptus trees of the Blue Mountains National Park, Australia; don't forget your sense of touch.

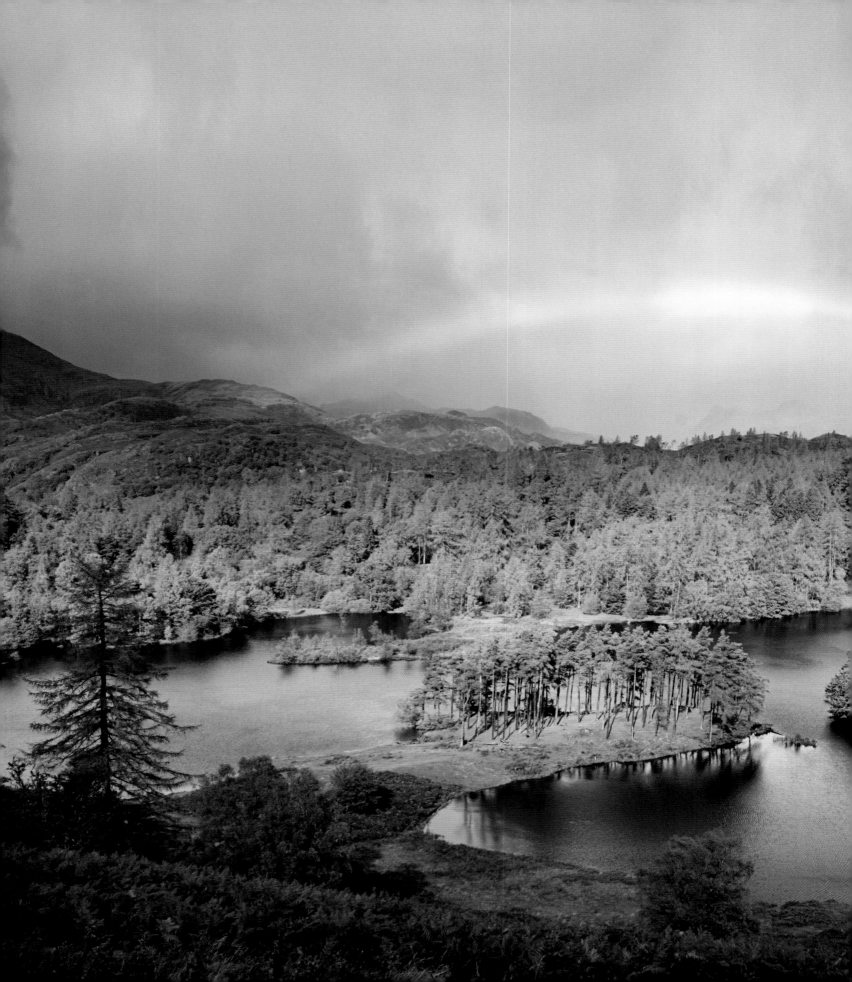

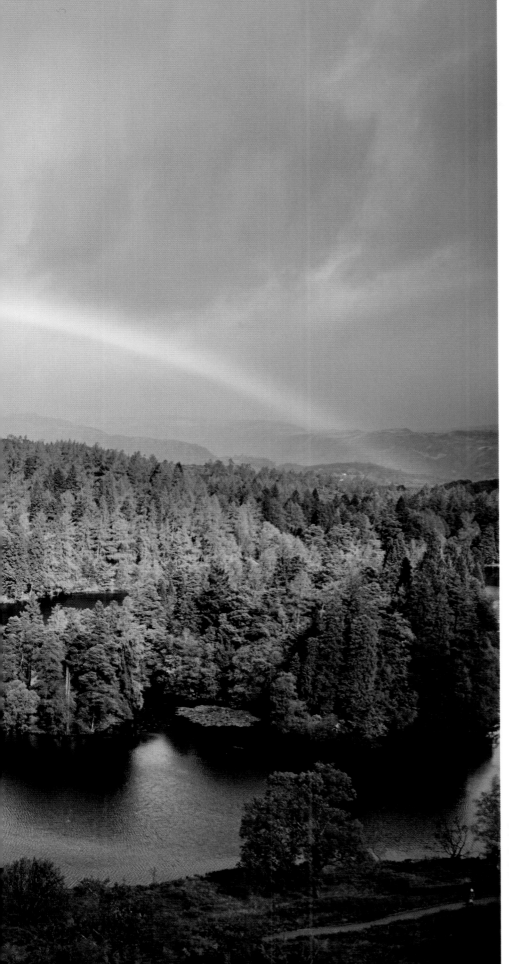

Left: Tarn Hows in England's Lake District, home to such Romantic poets as William Wordsworth.

and our minds wandering but with a curious intent. Scientists call this state 'soft fascination' or the 'attention restoration theory', proposed by Rachel and Stephen Kaplan in their 1989 book *The Experience of Nature: A Psychological Perspective*. This is why many of our best and most creative-ideas come to us during a walk in a green and natural environment.

'I think that I cannot preserve my health and spirits, unless I spend four hours a day at least – and it is commonly more than that – sauntering through the woods and over the hills and fields, absolutely free from all worldly engagements.' So wrote Henry David Thoreau in his essay *Walking*. In 1845 Thoreau moved into a cabin on the shore of Walden Pond just south of Concord, Massachusetts. 'I went to the woods because I wished to live deliberately,' he explained in *Walden*, the book he wrote during the two years he spent at the cabin. (Not so deliberately that he stopped his mother from doing his laundry.)

Around 40 years before Thoreau had retreated to the woods, another writer, William Wordsworth, was 'wandering lonely as a cloud' in England's Lake District. The poet, lynchpin of the English Romantic movement that revered nature and was a response to the Age of Reason, strongly associated nature with good mental health.

'In Nature there is nothing melancholy.' wrote his friend and fellow Romantic poet Samuel Taylor Coleridge in his poem *The Nightingale* (April 1798). Wordsworth especially sought solace in nature for understandable reasons. His mother died when he was eight and his father when he was 13. He was sent to live with frosty

relatives, separated from his beloved sister, Dorothy – it doesn't seem to have been a happy childhood. Years later he was reunited with Dorothy and they lived together in Dove Cottage in Grasmere, the heart of England's Lake District. Together with close friend Coleridge they would walk through the woods and beside the lakes in what Dorothy described as 'trance states'. She documented the trio's rambles around the fells and forests of the Lake District and was no slouch as a writer herself (see sidebar).

In Wordsworth's *The Prelude*, an epic poem published posthumously in 1850, though written decades earlier, Wordsworth traces his growth as a poet, his friendship with Coleridge and the impact of the natural world on his life. In book six of the poem he writes of his time as a student at St John's College, Cambridge. Through winter he would walk in the evenings through the college's grounds:

'... A single tree
With sinuous trunk, boughs exquisitely wreathed,
Grew there; an ash which winter for himself
Decked as in pride, and with outlandish grace:
Up from the ground, and almost to the top,
The trunk and every master branch were green
With clustering ivy, and the lightsome twigs
And outer spray profusely tipped with seeds
That hung in yellow tassels, while the air

Stirred them, not voiceless. Often have I stood
Foot-bound uplooking at this lovely tree
Beneath a frosty moon...'

What Wordsworth experiences is connection with nature, a relationship with the natural world. But in our modern world of screens that's a relationship on the rocks. For many people, deep happiness comes from restoring that relationship with the wild world. In Europe's most forested country, Finland, three quarters of the land is covered with trees and if not trees then lakes. Much of this land is publicly accessible thanks to the Finnish law of *jokamiehenoikeus* or 'everyman's right' (see also the 'right to roam' in Scotland or *allemannsretten* in Norway and similar laws throughout Scandinavia). Finns spend a lot of time being active outdoors – half the population cycles, one third cross-country skis and two thirds hike – and it's no coincidence that they also score highly on global happiness scales.

In 2014 Finnish researcher Liisa Tyrväinen studied the 'cardiovascular response' to forest walking across 48 young men (a co-author of the study was Qing Li of forest-bathing fame). The team concluded that heart rates and blood pressures were lower and moods better after a forest walk. In another study Tyrväinen published in the *Journal of Environmental Psychology*, the findings suggested that even short visits to nature areas had a positive effect on perceived stress (measured by cortisol levels in the subjects' saliva). Conversely, time spent in the city centre (bearing in mind this was tranquil Helsinki, not Hell's Kitchen) decreased positive feelings among the participants.

A few people, of course, are fortunate enough to work in forests. Biologist Dr Martha Robbins (see p50) spends much of her year deep in the rainforests of Loango National Park in Gabon, Africa, and the rest of the year in Leipzig, Germany. 'Switching between a city and a forest is an exercise in contrasts,' she explains. 'Cities are linear and predictable. You look both ways before crossing a road

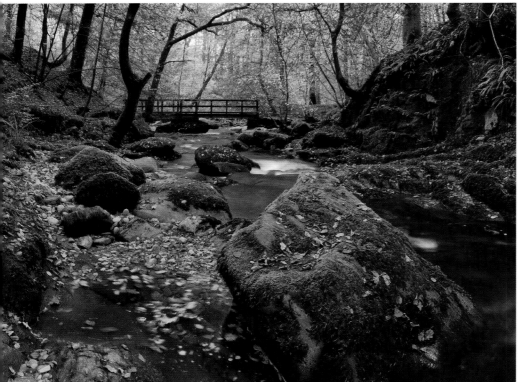

so you don't get hit by a driver. Noises are artificial. Forests are non-linear and unpredictable. You keep your eyes and ears open to make sure you don't bump into an elephant.'

For author Emma Mitchell, her connection with a local meadow was not a commodity, it was real (as was her distress when the meadow, home to thousands of lives, was mown in mid-summer). She writes in her book *The Wild Remedy*: 'This is not skincare I get from a beauty parlour. This is not a monthly subscription to sniff some dead-nettle flower. This is something that has changed my ability to live with my depression.'

The Finnish Forest Research Institute recommends spending five hours per month in nature. But what if you live somewhere with less readily accessed nature than Finland? As Ranger Savannah Sanford reports: 'We do have many visitors here at Muir Woods who either primarily live in urban areas or just have never seen trees quite as large as the redwoods. They are always amazed and awed.' Although Muir Woods National Monument is less than an hour's drive from downtown San Francisco, many people may not have access to a car or the opportunity to take public transport. However, urban planners have long understood the important of green spaces in cities. In ancient Rome, the Gardens of Sallust were established in the first century BC in the northwest of the city before becoming a public amenity under Tiberius and subsequent emperors for several centuries.

In the 18th century, urban gardens became popular in London and other

'It was very windy and we heard the wind everywhere about us as we went along the Lane but the walls sheltered us – John Greens house looked pretty under Silver How – as we were going along we were stopped at once, at the distance of perhaps 50 yards from our favourite birch tree. It was yielding to the gusty wind with all its tender twigs, the sun shone upon it and it glanced in the wind like a flying sunshiny shower – it was a tree in stem and shape and branches but it was like a spirit of Water – the sun went in and it resumed its purplish appearance the twigs still yielding to the wind but not so visibly to us. The other Birch trees that were near it looked bright & cheerful – But it was a Creature by its own self among them.'
Dorothy Wordsworth, *The Grasmere Journal*, 1801

Left, autumn at Stock Ghyll in England's Lake District; top, a cabin in a Finnish forest.

British cities, such as Bath, though more as a pastime for the upper middle classes than respite from the industrial revolution for workers. London's first public park, Victoria Park in the East End neighbourhood of Hackney, was opened in 1842. Compared to the private (and extensive) royal parks in the centre of the city, this was intended by the government to be used by all sections of society.

In the US, Frederick Law Olmsted, inspired by a visit to Birkenhead Park in Liverpool in 1850, where he noted 'the manner in which art had been employed to obtain from nature so much beauty', proposed a Central Park and a Prospect Park for New York. Deliberately, Olmsted landscaped Central Park to resemble the natural environment as much as possible, from its meadows and meandering paths to the rock outcrops and random clusters of trees – of which he ordered 300,000.

Urban parks are a start if we want to experience some greenery in our lunch breaks but they're no substitute for getting new generations to fall in love with real nature. Biophilia is 'the love of nature', a hypothesis proposed by American biologist and entomologist EO Wilson. In *The Biophilia Hypothesis*, he argues that we are all creatures of nature with an 'innately emotional affiliation ... to other living organisms,' and that our acceptance of that might lead to a new impetus for conservation. If we cut ourselves and our children off from nature, he asks, are we fully developed as humans? Wilson argued that introducing a love for nature was best started before adolescence.

In his book, *Last Child in the Woods*, Richard Louv makes the same argument. 'A lot of people think they need to give up nature to become adults but that's not true,' he writes. 'We have such a brief opportunity to pass on to our children our love for this Earth, and to tell our stories. These are the moments when the world is made whole. In my children's memories, the adventures we've had together in nature will always exist.'

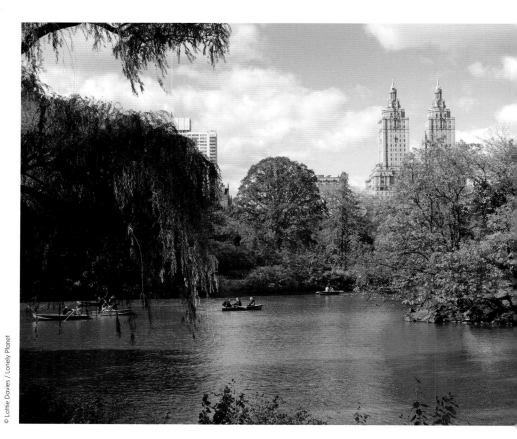

© Lottie Davies / Lonely Planet

His most important point is that nature – such as encountering other species – helps children develop empathy. He coined the phrase 'nature-deficit disorder', which hints at the rising rates of physical and mental maladies affecting children today. The benefits of experiences in the natural world, Louv explains in an interview with *Greater Good* magazine, published by the University of California, Berkeley, include self-confidence, calm and focus.

'If nature experiences continue to fade from the current generation of young people, and the next, and the ones to follow,' he asks, 'where will future stewards of the earth come from?'

For children, experiences in nature need not be complicated. 'Are kids getting their hands wet and their feet muddy,' asks Louv. Are they taking risks in outdoor play? Louv explains that this sort of play uses a cognitive skill called executive function, which is the ability to exert self-control, to control and direct emotion and behaviour. 'A child's executive function,' Louv says, 'is a better predictor of success in school than IQ.'

That connection between nature and personal development was made by Scandinavian educators in the 1950s. Educators in Denmark at that time discovered that young children educated in forest kindergartens had strong social skills, high self-esteem and self-confidence, and were able to work in groups effectively. In Sweden, Goesta Frohm developed his 'Skogsmulle' concept to help children learn about nature. Forest schools – also known as 'rain or shine schools' – became increasingly popular throughout Europe,

© My Good Images / Shutterstock

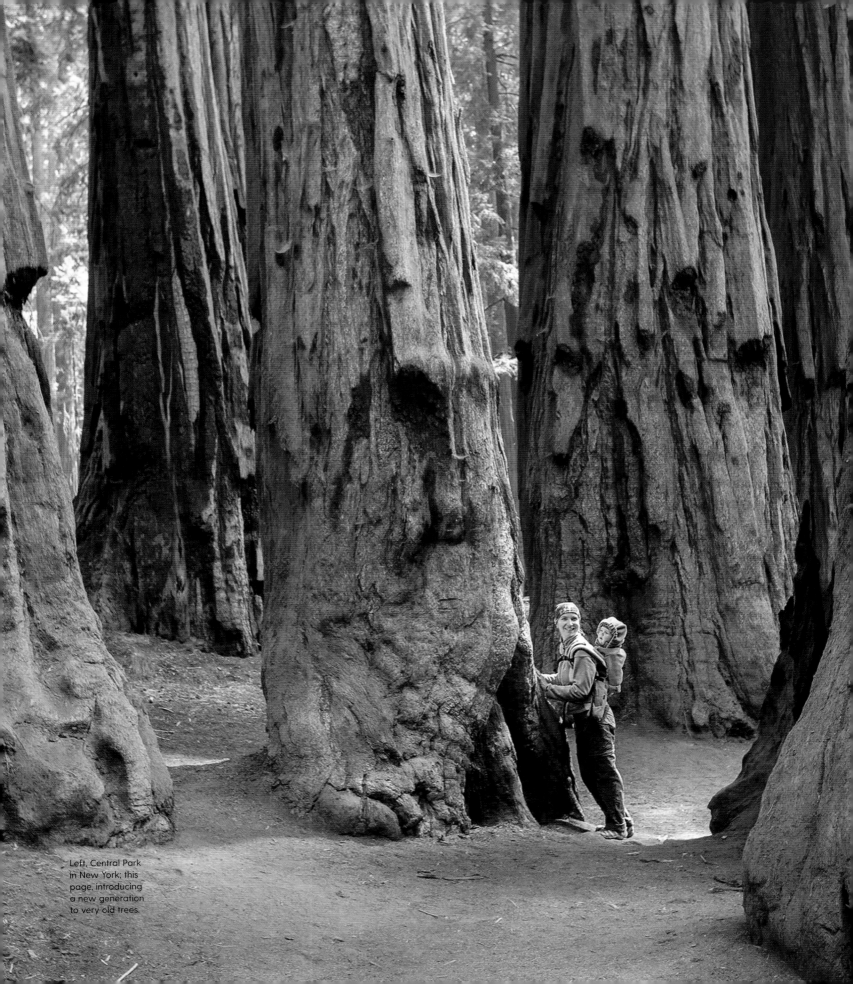

Left, Central Park in New York; this page, introducing a new generation to very old trees.

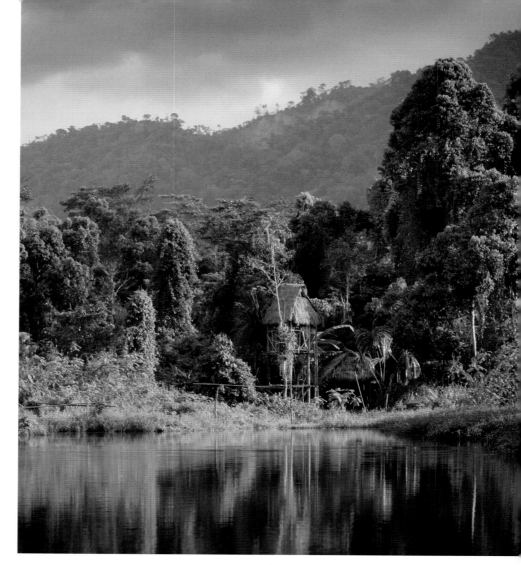

with several hundred in Germany alone.

Although some of Germany's *waldkindergrippe* (forest creches) are being forced to move out of the forests, perhaps for accident insurance reasons, there are many still operating – and sticks and fires are still part of some forest schools' daily routine. As Viola Zürcher, the leader of Reiselfeld forest creche in Freiburg, Germany, puts it: 'If children are never allowed to encounter risk, how can they learn to deal with it?'

At Viola Zürcher's nursery, the children play with what the forest offers, according to the season and what can be used safely. She believes that this stimulates active creative games, beneficial for strategy development and physical and mental growth. The children make forays through the forest, spotting beetles and moulding supple clay.

In London, Leanna and James Barrett were inspired by Europe's 'rain or shine schools' and opened first the Little Forest Folk group of outdoor nurseries for two-to-five year olds and then, in 2019, Liberty Woodland Primary School. Its classroom is Worcester Park in south London, where pupils aged four to 11 will spend 95% of their days.

So, there is hope for the next generation of conservationists but they face a great challenge in protecting the planet's fragile forests and woodlands.

One half of the world's trees live in forests, part of complex ecosystems. Forests cover less than one third of the planet's land area and they're disappearing. Between 1990 and 2016, the world lost 502,000 sq miles (1.3 million sq km) of forests. The Amazon has lost more than 17% of its rainforest in 50 years and the rate of deforestation is increasing. Aside from being home to thousands of unique species, forests also absorb carbon dioxide and greenhouse gases that we emit and they exhale oxygen. If we're to meet our goals to slow climate change, we need trees.

Several organisations are dedicated to that goal, one of which is Tompkins Conservation, founded by the entrepreneurs Kris and Doug Tompkins (see p62). The goals of Tompkins Conservation include restoring ecosystems by reviving habitats, monitoring wildlife species and even reintroducing keystone species. And one way to revive habitats is by creating national parks to conserve wild landscapes. In Chilean Patagonia, Tompkins Conservation bought and restored vast areas of wild land over a period of 25 years, such as Pumalín Park, which is home to some of the last stands of giant alerce trees.

'The alerce trees have been around for three million years,' says Ingrid Espinoza , Executive Director of Tompkins Conservation Chile. 'When you are able to witness them with your own eyes, you realise how impressive they are and gain a greater understanding of the necessity of protecting nature above all. I would love to see a consensus that these natural places aren't only important to Chile but to the planet.'

Experiencing first-hand any of the ten forests profiled in the following pages, perhaps as part of a trip of a lifetime, will only increase our appreciation of the natural world. Fortunately for Ingrid Espinoza, like Savannah Sanford and Martha Robbins, this can be a more frequent joy: 'For me, a national park is a sacred space, where the connection between living things is explicit and essential. These are places full of inspiration, concentration and calm.'

NEW ZEALAND

Waipoua Forest

Too big to hug, the giant kauri trees of the North Island inspire love and respect regardless.

© Imogen Warren / Shutterstock, © Shaun Jeffers / Shutterstock

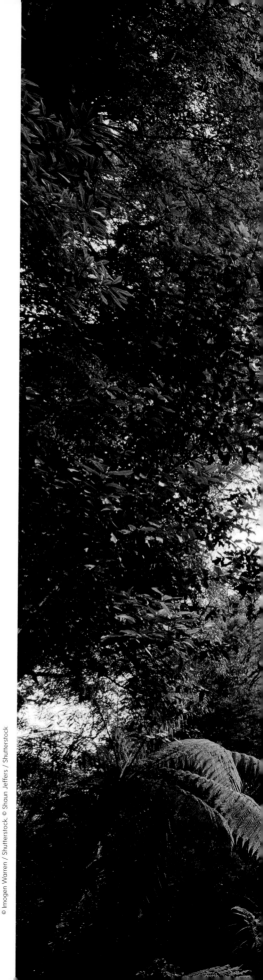

anginui, the Sky Father, and Papatūānuku, the Earth Mother, clasped each other tightly, such was their love. Not a shaft of sunlight could squeeze between them. But their children tired of existing in darkness and so their son, Tāne, used his broad shoulders and powerful legs to prise his parents apart. He pushed Ranginui upwards until the Sky Father arched above them and light and life flooded throughout, creating the world. The rain that falls from the sky is Ranginui's grief but Tāne, the god of the forests, is still braced against Ranginui and Papatūānuku.

So goes the Māori creation myth but you can see Tāne Mahuta today in Waipoua Forest at the top of New Zealand's North Island on the west coast. He is around 2000 years old and the largest of his kind: a kauri tree. Tāne Mahuta's grey-flaked trunk stands 167ft (51m) tall and a chunky 45ft (13.8m) in circumference. But he's not the broadest of the kauri trees in this forest: that would be Te Matua Ngahere, the 'Father of the Forest' in Māori, which has the broadest girth of any tree in New Zealand at 52ft (16m). That tree is estimated to be about 1500 years old and was discovered in 1937.

Kauri trees (*Agathis australis*), part of the conifer family, are among the largest and longest-lived trees in the world. In New Zealand, preferring sub-tropical climates, they grown only as far south as 38th parallel of latitude that bisects the North Island at around the city of Hamilton. Here, these giants thrived for millions of years, their

Right, Tāne Mahuta, the God of the Forest, in Waipoua.

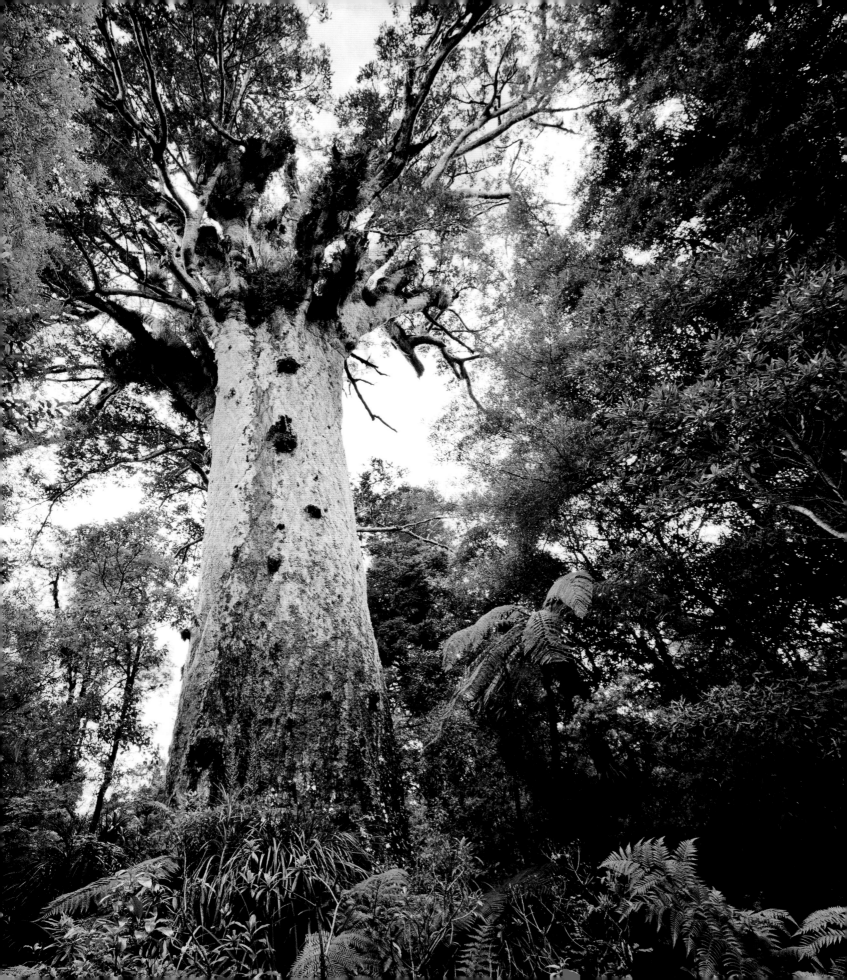

SAVE THE KAURIS

The local Māori are Te Roroa, historically supporting themselves with shellfish gathering, fishing, foraging in the forest and farming. The *iwi* has led the way in formulating a response to the Kauri dieback disease that is encroaching on the home of Tāne Mahuta. The disease is caused by a microscopic fungus that attacks the trees' roots. Measures to combat it include soil sampling, controlling feral pigs and educating visitors about keeping to the designated walking tracks.

Right, to protect the giant kauri trees, stick to the trail when walking in Waipoua.

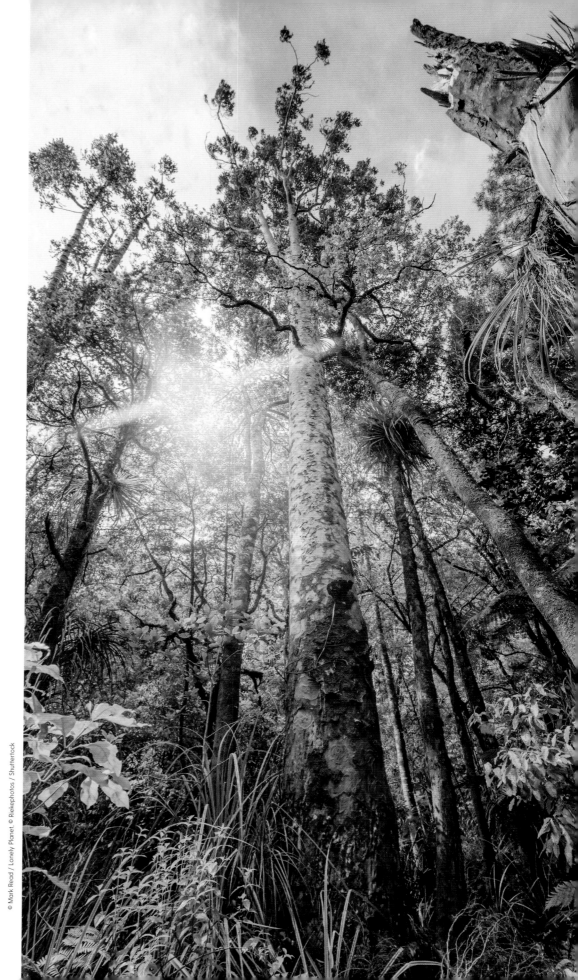

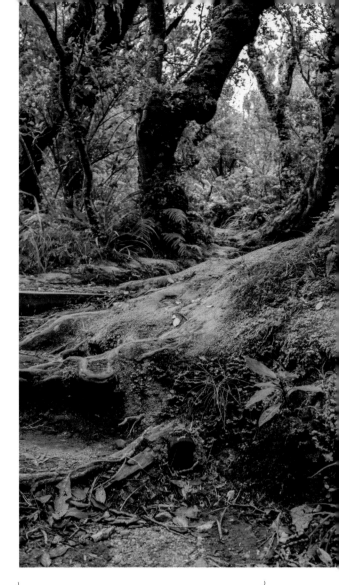

roots delving deep into the soil and spreading like a lattice across the forest floor. When mature, after 50 years, their crowns unfurl across the sky. By the age of 600 or 700 years their trunks are 1m wide, by their first thousand years they may be 2m in diameter. Some kauri are known to have had trunks 7m in diameter. Through all those days and nights, of rain from Ranginui and sun, human lifespans are but a flicker. But people have nevertheless left their mark on the kauri. There are now fewer than 8000ha of mature kauri forest in New Zealand. The Māori fashioned the resin-rich wood into torches with which to fish by night; smoke from the resin was used as an insect repellant and soot as pigment for Māori tattoos or *moko*. Trunks were used as canoes and when European settlers arrived in New Zealand the felling accelerated as young kauri were used as spars for masts, then kauri planks were required for roofs and walls for immigrant settlers. By the 1860s, 90% of the houses in Auckland were made from kauri.

Waipoua is the largest remaining expanse of native forest in the Northland region and home to the last giants of the kauri. To visit is to be humbled and awed by the natural world. Kauri, like arboreal skyscrapers, are part of complex ecosystem and support many plants, including epiphytes, orchids, moss and ferns. New Zealand is famous for its benign wildlife when compared to its neighbour Australia. While Australia is home to many of the world's most venomous varieties of snake, New Zealand has none. For many years it was thought that New Zealand's wildlife had evolved without any predatory mammals, though that is now thought to be not quite true.

What is sure, however, is that New Zealand has uniquely diverse birdlife, including many ground-dwelling species, as a result of the landmass separating from ancient Gondwana (see p36) 65 million years ago and evolution following a different path. And although its animals are not nearly as dangerous as Australia's, there are some relative giants to watch for in the kauri forest. The weta is a family of huge cricket-like insects that have lived on the island since its creation, sharing it with first dinosaurs and now us. Its Latin name, *deinacrida*, translates as 'demon grasshopper'. The Māori named wetas of the west coast '*taipo*' or devils of the night. As they can grow to fill a hand, they're certainly a memorable creature to encounter on a twilight walk in the forest. For worms, meeting a kauri snail is the beginning of a bad day: these giant carnivorous snails, unique to these forests, can grow to 3in (8cm) across and feast on smaller invertebrates. As New Zealand's Department of Conservation warns, these snails are 'highly mobile and have been known to move 33ft (10m) in two weeks.' Neither, however, fare well against such pests as rats that were introduced by colonists.

Kauri trees face new a threat today and the 200,000 people that visit the forest each year may exacerbate it: kauri dieback is caused by a microscopic spore that can be carried on people's shoes and is a death sentence for affected trees. Some tracks in Waipoua are being closed to hikers. Always follow instructions in this forest to protect the trees.

There's no public transport into Waipoua kauri forest but if you don't have your own transport and can get to Dargaville, 30 minutes' drive south, you can join guided walks with a couple of local operators (including overnight trips). But having a vehicle gives you much more freedom. Dargaville, on the northwest coast, is about three hours' drive north of Auckland and minibuses also ply this route along the kauri coast. In the forest, be sure to follow instructions to avoid the spread of kauri dieback – these may include scrubbing soil off your shoes and gear and using sprays at hygiene stations when you enter and leave. Always stay on the track and obey any track closures.

COSTA RICA

Corcovado National Park

Dodge the crocs and hike into a real rainforest jungle in this conservation-conscious country.

Famously, more than a quarter of Costa Rica's landmass is protected, in the form of 29 national parks, refuges and reserves. This is a higher proportion than any other country in the world. And about half the country is forested, including lots of rainforest, cloud forest and tropical dry forest.

Of those parks, some are more visited than others. Monteverde Cloud Forest Reserve, a three-hour drive from the capital San José, is top of tens of thousands of visitors' wishlists. And even 20 years ago Manuel Antonio's nightlife rivalled the wildlife of its national park, although the capuchin monkeys didn't seem to mind. No, for more immersive forest experiences you'll need to head further into the wild.

In Costa Rica's southwest corner the 700 sq-mile (1813 sq km) Osa Peninsula is Costa Rica's wildest corner. This is real jungle – without apology or amenities. But what discourages some visitors appeals to others. It's really tough to reach – great! There are crocodiles, snakes and biting bugs aplenty – I'm in!

Lowland rainforest dominates the peninsula and at its heart is Corcovado National Park. Many people stay at the handful of lodges of varying degrees of luxury on the Osa Peninsula at the edge of the national park, including La Luna, Lapa Rios and and Bosque del Cabo, or in eco-communities such as Dos Brazos de

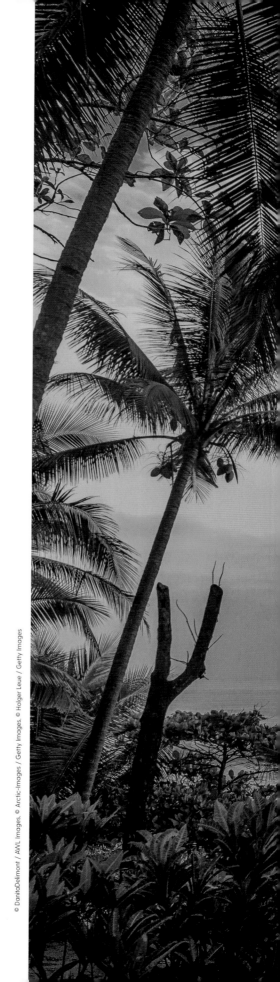

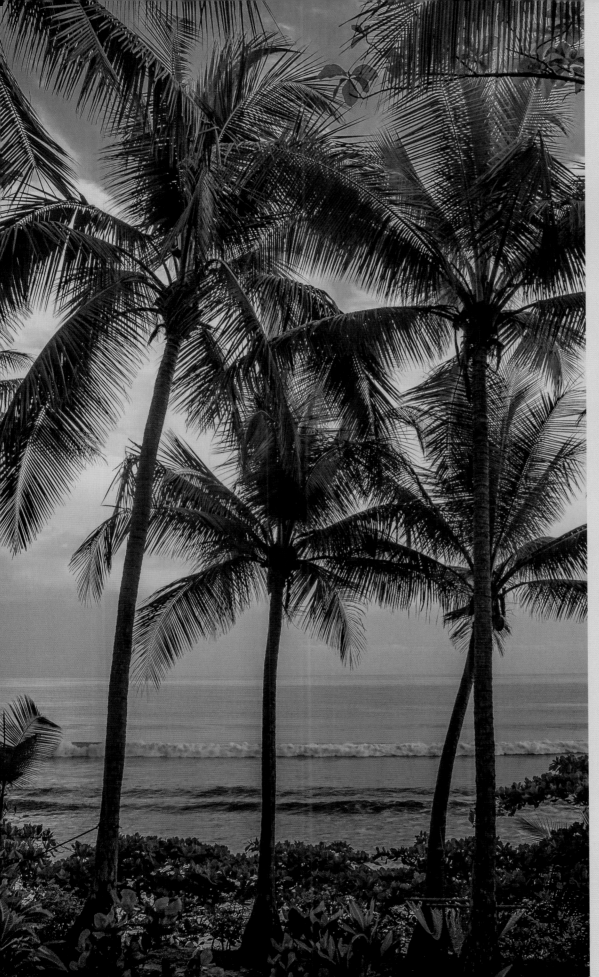

LOW-CARBON NATION

In February 2019, Costa Rica unveiled an audacious plan to be a carbon-neutral nation by 2050. This means that someone living in Costa Rica in 2035 would leave the same carbon footprint as a citizen from the 1940s. And by 2050 Costa Ricans will have a net carbon footprint of zero. Already, 98% of the country's electricity comes from renewable sources and the plan is to use this for public transportation (buses and trains) and to cut the number of cars in cities by half. Costa Rica also plans to expand its forests to counterbalance carbon emissions elsewhere. It's an ambitious aspiration but what's the problem with that?

Left, the Pacific-facing beaches make for perfect sunsets.

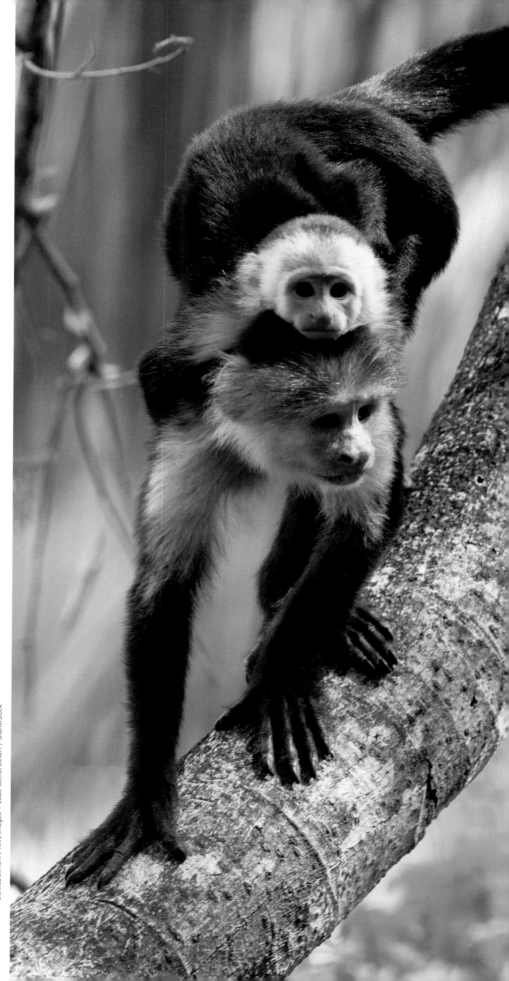

Right, white-headed capuchins are common in Corcovado; hikers in the National Park.

Rio Tigre. All roads stop at the edge of the park so to venture into the park you will need permits and a guide. The main trail leads along a beach from La Leona Ranger Station on the park's south side into the heart of the forest to Sirena Ranger Station. It may be a fever dream brought on by the heat and dehydration, but once you're trekking along the grey sand beach, scattered with drift wood and backed by impenetrable rainforest, it's ridiculously easy to believe that you're alone in a wilderness. You may spot the tracks of olive ridley turtles, which haul themselves up the sand to lay their eggs. Raucous flocks of scarlet macaws skim low over the trees. The adventure continues at the Río Claro, which you have to cross to reach Sirena (check your tide times).

Once at the basic Sirena Ranger Station you can begin to absorb your surroundings. Rainforests are the most biodiverse habitats on the planet and Corcovado alone contains some 2.5% of the world's species in its 160 sq miles (414 sq km).

Jaguar, puma and ocelot inhabit the park, alongside their less well-known feline relative, the small, dark-brown jaguarundi, the 'otter-cat'. Central America's largest mammal, Baird's tapir, may crash through the undergrowth surrounding you. On a smaller scale, the agouti and peccary forage on the forest floor. But watch where you tread: the fer-de-lance pit viper, which lives in trees as a juvenile, moves to ground level as a full-grown 6ft (2m) adult. Extremely skittish and very venomous, they're responsible for about 70% of the country's snakebites.

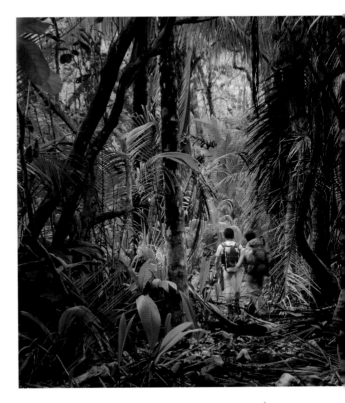

If bitten you have about two hours to reach medical help (or a veterinary clinic, which may be just as likely to have anti-venom) before haemorrhaging. The largest reptiles in Corcovado National Park are the American crocodiles that patrol the river mouths here.

The birdlife too is formidable: the giant, monkey-hunting harpy eagle is reputed to swoop through the most remote swathes of forest. And there are more than 460 other species of bird to spot, from the mangrove hummingbird to the fiery-billed aracaris, a toucan with a technicolour bill.

In the jungle your senses are suddenly sharpened; the further from civilisation you step, the more you regain your natural instincts. You begin to notice details as you become in tune with your surroundings. But even so, the fact is that in Corcovado National Park, you're much more likely to see leaf-cutter ants than a Jesus lizard, although it helps having a (compulsory) park guide for company. The reason is because most life in a rainforest occupies the tree canopy, far above you, never setting foot on the forest floor. Up there, plants (epiphytes) grow upon plants. Fig trees, supported by buttressed roots, provide fruit for squirrel monkeys.

Out in the Pacific ocean, the tropical fiord that lies between Puerto Jiménez on the peninsula and the town of Golfito is the Golfo Dulce and it's a birthing ground and nursery for humpback whales. Whether the creatures are large or small, Corcovado is a remarkable wildlife crossroads in a country that has determined its own profitable and conservation-friendly direction.

Corcovado National Park is an oblong shape with two points of access: Carate to the southwest and San Pedrillo to the northwest, both on the coast. The town of Puerto Jiménez, just outside the park to the southeast, is the regional hub. Carate can be reached via a rough 45km dirt road from Puerto Jiménez. A 4WD travels this route twice daily or share a taxi. From Carate, it's a one-hour walk along a beach to La Leona ranger station. At the northern end of the park, you walk from Bahía Drake to San Pedrillo in about seven hours. Or you can take boat trips to the San Pedrillo or Sirena ranger stations. You'll need to buy maps and a park pass from the Área de Conservación Osa in Puerto Jiménez.

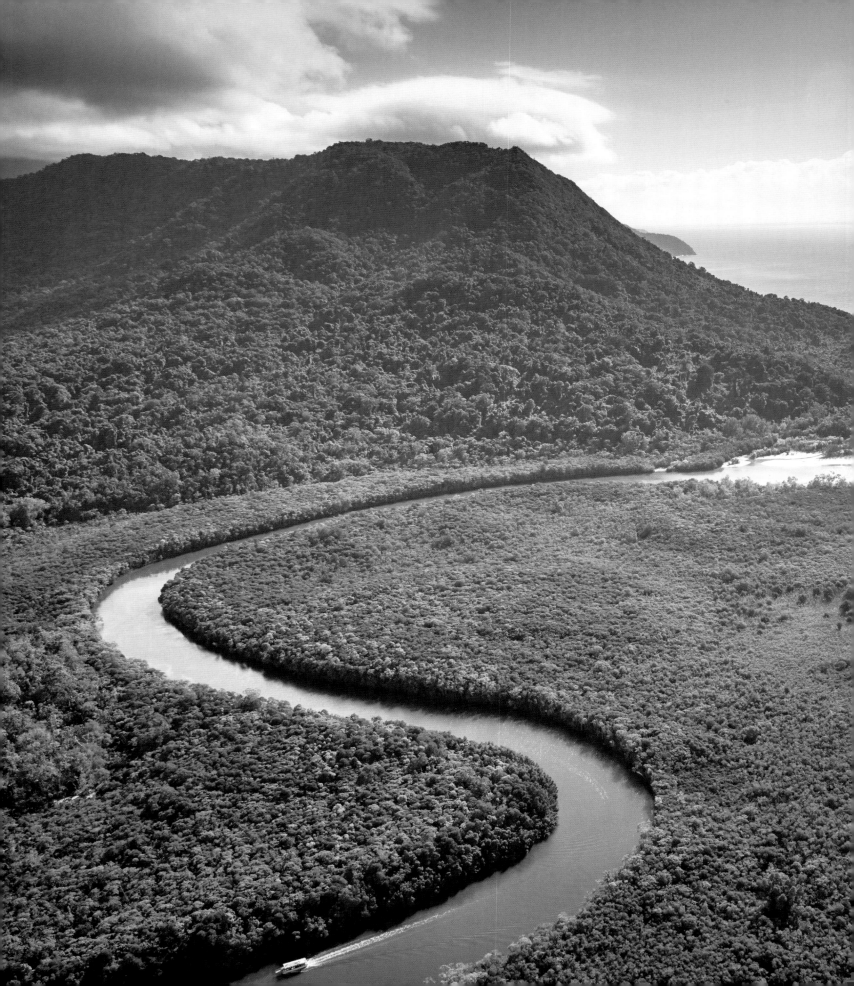

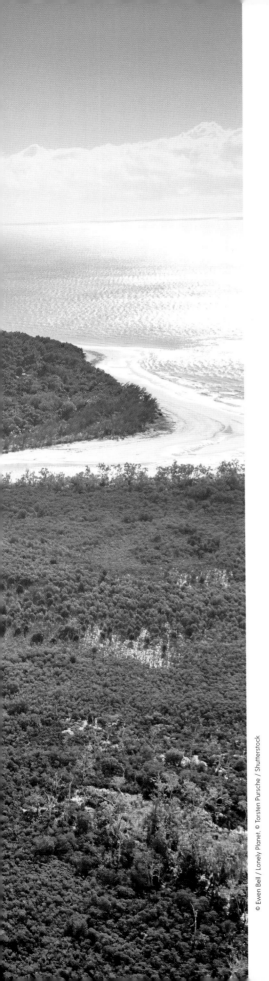

AUSTRALIA

Daintree National Park

Some forests are almost silent and the wildlife elusive. Not the Daintree. The volume is turned up to 11 in this northern Queensland national park. The cacophony contains rasping shrieks from parrots, calls from whipbirds, catbirds and the aptly named noisy pitta, with the coo-ing of technicoloured wompoo pigeons among the 300 or so bird species in the forest. The constant buzz of insects and the belching croaks of frogs add background to the soundtrack. But listen especially for a low booming, for that is the sound of a dinosaur.

The forest of the Daintree National Park stretches along the north Queensland coast from the Daintree river just north of the town of Mossman, past the beautiful tropical beach of Cow Bay in the south, where the forest meets white sand, past Cape Tribulation, to Mt Cowie. It covers about 463 sq miles (1200 sq km) and there are limited ways in and out of the Daintree so pay attention to the geography and any travel alerts. Bushwalkers are advised to be experienced and well equipped if venturing deeper into the park – getting lost, disorientated, dehydrated or injured is a very real danger.

But the threats that most visitors fixate on are the dinosaurs. The southern cassowary can stand 6ft (2m) tall, supported by two powerful legs that end in feet furnished with 4in (10cm) claws that can tear open a soft stomach. Their heads are crowned by a hard helmet that resemble a dinosaur's defences. Black, shaggy, hair-like

Seek adventure – and a really big bird – in Queensland's beach-fronted rainforests.

Left, the mouth of the Daintree River; above, a cassowary.

THE WHITE-LIPPED TREE FROG

The white-lipped tree frog is Australia's largest native tree frog at 5.5in (14cm) in length. Its direct ancestors existed before the Australian continent separated from Gondwana, the supercontinent that swirled about the South Pole of the planet for about 350 million years until the Jurassic period about 180 million years ago. Early humans, in contrast, existed about 300,000 years ago. The white-lipped tree frog can certainly claim to have been here first, but happily it's not a threatened species and relatively easy to spot in coastal areas, swamps, mangroves and urban parks and gardens. Just listen out for a large dog barking, which is the sound of its call.

From right; an aboriginal guide in Mossman Gorge; the jungle extends to the Coral Sea. Overleaf, the Daintree canopy.

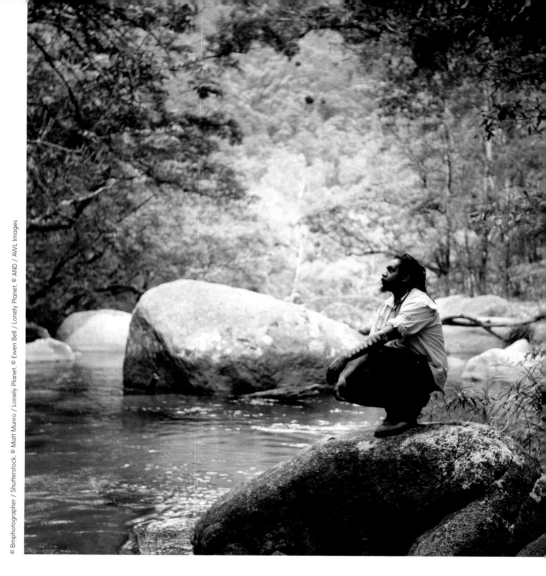

coats and a vivid blue neck complete the look for the world's second-heaviest bird. Recent scientific thinking suggests that many dinosaurs, rather than the scaled lizards of lore, were colourfully feathered. In the case of the cassowary, the apple hasn't fallen far from the tree.

Moving north through park brings you to beautiful beaches around Cape Tribulation, named by Captain Cook after his ship Endeavour first collided with the reef. 'Here began all our troubles', he wrote in his log. They are idyllic swimming spots but again, beware. From September to April deadly bluebottle jellyfish may swarm this coast. And avoid the mouths of the many saltwater creeks that empty into the ocean for these are where other dinosaurs lurk: estuarine crocodiles that can grow up to 16ft (5m) long. But apart

from those two threats – and the sea snakes – the Daintree coast could be mistaken for a paradise, albeit primeval.

That's because this is a truly ancient forest. It has been listed by Unesco as a World heritage site as 'an unparalleled record of the ecological and evolutionary processes that shaped the flora and fauna of Australia, containing the relics of of the great Gondwanan forest that covered Australia and part of Antarctica 50 to 100 million years ago.' Species of plants flourishing in this forest would have been growing tens of millions of years ago, without interruption. Scientists still don't know exactly what lies in its more unexplored tracts but so far there are more than 3000 plant species, 113 species of reptile and 51 species of amphibian.

The variation in elevation means that many rare Australian mammals

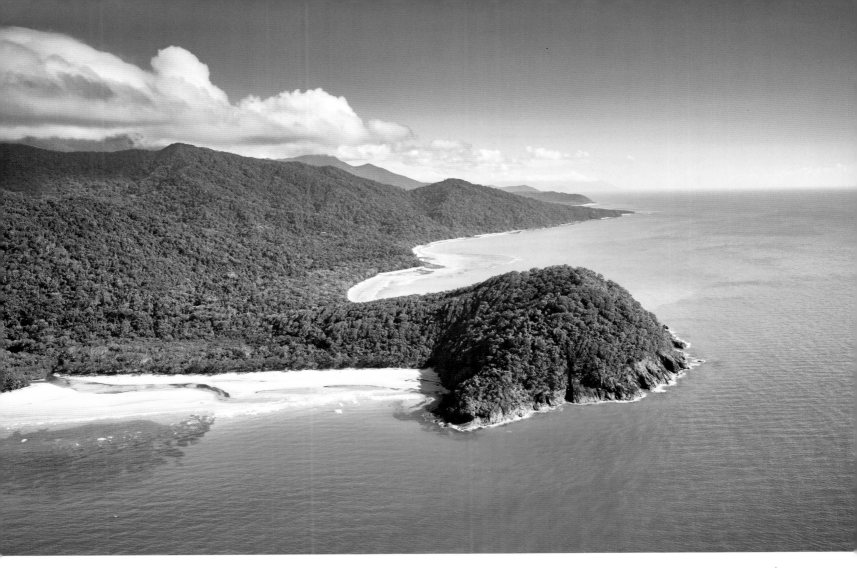

survive here. Bennett's tree kangaroos are among the most unusual, being macropods that have adapted to life in the tree canopy, climbing with their strong front legs and hopping along branches, using their heavy tails to balance. They live only in the forests around Cape Tribulation; listen out for them crashing through the foliage. Another local nocturnal marsupial is the beautiful black-and-white Herbert River ringtail possum, found only at altitudes of 985ft (300m) or more. Use a torch to spot eye-shine at night.

Far from being a restful experience, where you can wander freely (there are other forests for that), visiting the Daintree can be intense.

But there are ways to take stock. One is to take a tour of the Mossman Gorge, to the south of the park, with local indigenous people, organised by the Mossman Gorge Centre, a Queensland Tourism gold award-winning enterprise. The 1.5hr walk includes stories from the local Kuku Yalanji peoples' culture and a traditional smoke ceremony. Continue to Cooya beach, a 10-minute drive east, for a demonstration of traditional Aboriginal spear-hunting techniques with Juan Walker, owner of Walkabout Cultural Adventures, whose Kuku Yalanji ancestors taught him how to live in harmony with the land. 'They knew the old ways,' he says of his grandparents. 'They taught us how to hunt, how to make a boomerang and a spear. We're lucky that knowledge survived.' He takes groups of visitors out onto the seemingly barren beach only to point out tiny angelfish and half-hidden blue swimmer crabs. 'There's life everywhere,' he says. 'You just need to know where to look.'

This tropical wilderness does not enjoy the benefits of much public transport. A bus service runs from Cairns, the regional hub, north to Cape Tribulation and onward to Cooktown, depending on the road conditions. A sealed road to Cape Tribulation and Daintree Village means that a standard car will get you into the heart of the forest. But to go further will mean taking unsurfaced roads that could be more of a challenge depending on the weather. The Bloomfield Track north of Cape Tribulation is very much 4WD only. The region's wet season runs from December to April (the southern hemisphere summer) when the rivers are full and the crowds lighter.

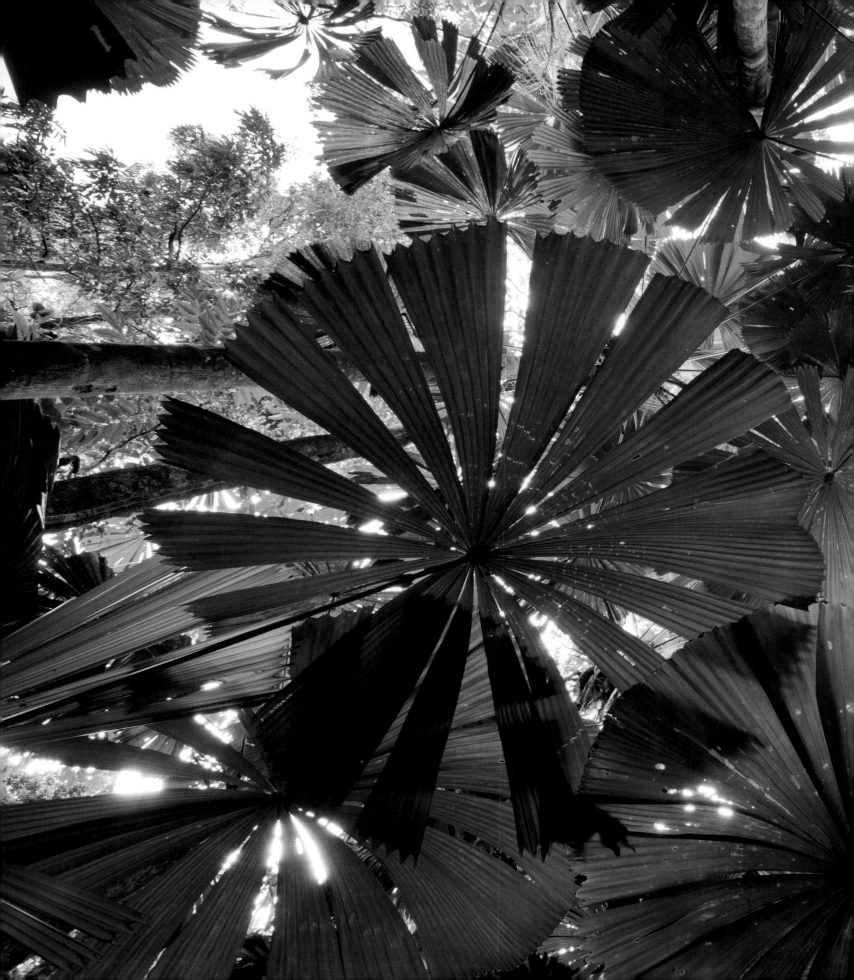

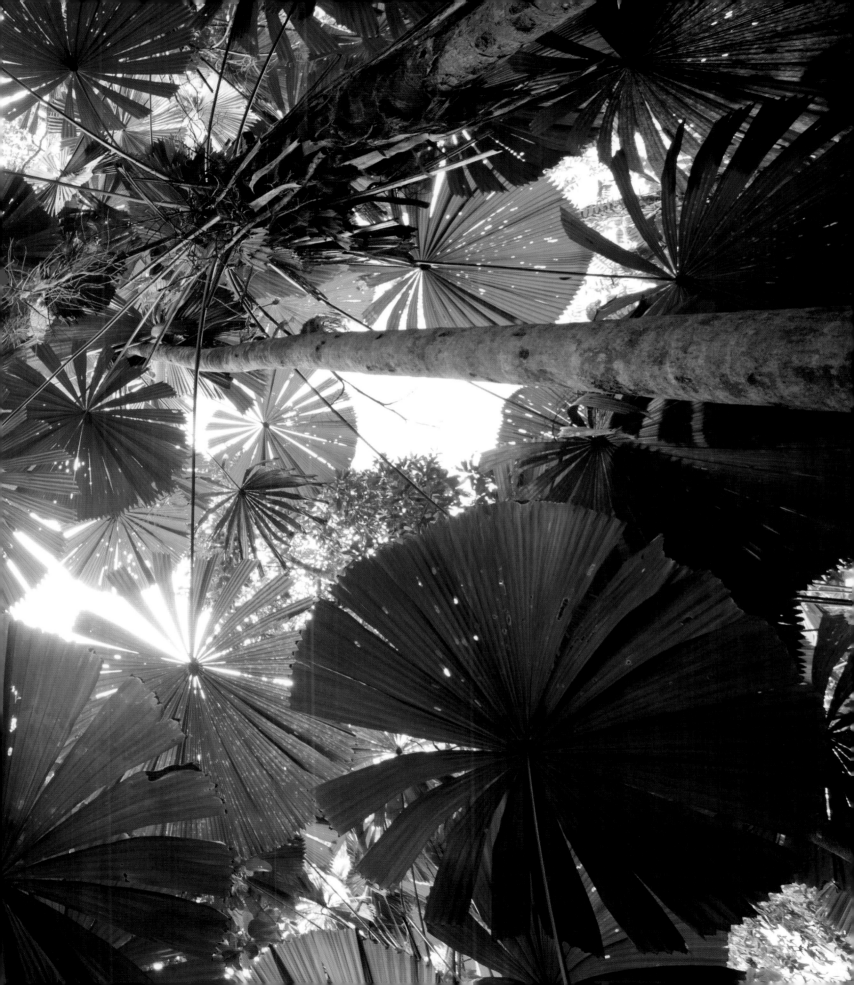

ENGLAND

The Royal Forest of Dean

Seasonal changes bring wonder and beauty to gentle English woodlands.

It's early May in one of England's largest forests and the blue sky above the verdant tree canopy seems reflected beneath in a sea of bluebells. Dormant for the winter months, the bulbs of this perennial have sent tall stalks upward, each drooping gracefully under the weight of seven or eight violet-blue flowers, each with petals that curl tightly back on themselves, ushering pollinating insects inside the bell-shaped flower. You can sit down on a mossy log and just take in the sight, aware that it is one of nature's fleeting majesties that is all the more special for coming around but once a year. When you next see these flowers you'll be a year older. Who knows what will happen in those intervening months? And how many times in your life you'll experience a forest of bluebells in an English wood in May?

Then, as you sit quietly, a bristling dark shape, moving with taut power, trots from behind a tree. Beauty and the beast: its muscular shoulders hunched behind a large head with a long snout and shiny, close-set eyes. This is a wild boar, now a regular sight in the Forest of Dean (see sidebar) without any threat from their natural predator, the wolf. Although they look, if you squint your eyes, like the ancestors of modern farmed pigs, they're not to be trifled with. Male boars can grow to 100kg in weight or elsewhere in Europe up to double that. And you separate a sow from her stripy boarlets at your peril. Destructive

BRITISH BOARS

Wild boars, once common in places like the Forest of Dean, were hunted to extinction in England 300 years ago. Then in the 1990s a group of boar escaped from a nearby farm and were joined by another group illegally released in 2004. Since then boar families, known as sounders and led by a matriarch, have thrived in the Forest of Dean. There are now thought to be more than 1000 of the feral pigs in the forest. They forage using their snouts to turn over the ground in the search of grubs, worms, nuts and fungi, which makes them slightly unpopular with some local people. You don't have to look hard to find them: some will congregate on verges.

Left, bluebells appear in the Forest of Dean during the month of May.

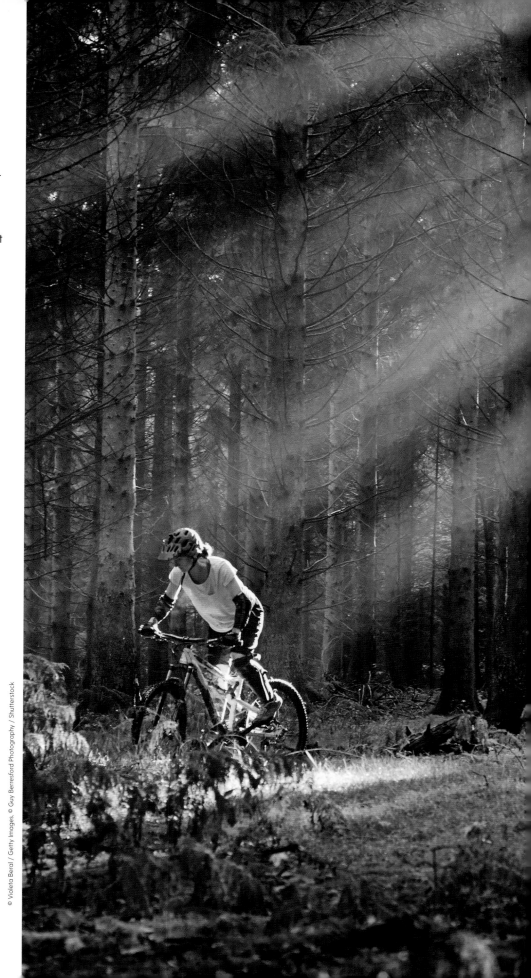

From right, the Forest of Dean has numerous trails for mountain bikers; the Puzzlewood part of the forest.

boars figured in the art and mythology of ancient Rome and Greece: Adonis, the lover of Aphrodite, was gored to death by a wild boar sent by Artemis, the goddess of hunting.

The animals are a reminder of the Forest of Dean's former status as royal hunting land. It was where Anglo-Saxon nobility hunted and after the Norman invasion of 1066 it was a favourite forest of kings. Today, the boars' presence is a connection with the wild woods of England's past – ensuring that your senses are more keenly tuned for movement and signs such as uprooted earth and pointed footprints.

'We are living through the earth's sixth great extinction,' wrote Helen Macdonald in *The New York Times* after encountering a boar in the Forest of Dean. 'Seeing this single boar gave me a sense that our damage to the natural world might not be irreversible, that creatures that are endangered or locally extinct might one day reappear.'

In 1838 the Forest of Dean was designated Britain's first national forest, covering 42 sq miles (109 sq km). But that was after having its oak trees logged over the previous two centuries for wood with which to build the English navy, ships that set sail for Asia, Africa and the New World, to trade or conquer. And all the while the forest has been quarried for stone and mined for coal and iron ore. Hopewell working colliery is open to the pubic and will shed light on the tradition of freemining in the forest. You'll be kitted out with a miner's lamp and helmet before venturing underground.

Pockets of the forest, however, seem as mystical and untouched as they were in Arthurian England. In Puzzlewood, near Coleford, the ravines and moss-covered rocks, grasped by snaking tree roots, have been the setting for such movies as *Harry Potter and the Deathly Hallows* and *Star Wars: The Force Awakens*. Forests have long been seen as resources to be exploited, whether that was for habitat

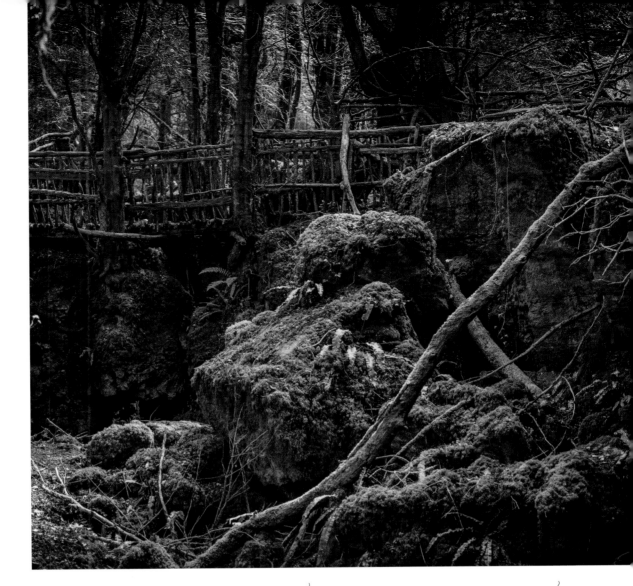

in which to hunt, for timber, or today for leisure and as a location for sci-fi films.

Not all the wonders of the Forest of Dean are natural. The forest's Sculpture Trail begins at Beechenhurst and takes in about a dozen artworks among the trees (some are blending back into the organic material). Perhaps the most enchanting piece is a stained glass window suspended in the trees, allowing natural light to be refracted by the coloured glass. It's called *Cathedral.*

Activities available include guided walks, mountain biking and forest-bathing experiences beneath the leaves, learning about meditation and mindfulness, led by a forest therapy guide. Or you can just wander by yourself, watching not only for the blaze of blue in spring but the white flowers of sweet woodruff and the yellow arcangel blooms.

The forest and Wye Valley lies along the north shore of the River Severn. It is accessible from Cardiff or Bristol by car in an hour's drive, or in three hours from London. The closest train stations are Abergavenny, Chepstow, Lydney and Gloucester, the last of which is on a direct line from London. Buses run throughout the forest (for example, Puzzlewood is near Milkwall, which is on bus routes from Chepstow and Gloucester), however, you'll have far greater independence with a car. Several local operators offer bicycles for hire, including e-bikes and mountain bikes for the forest's off-road trails.

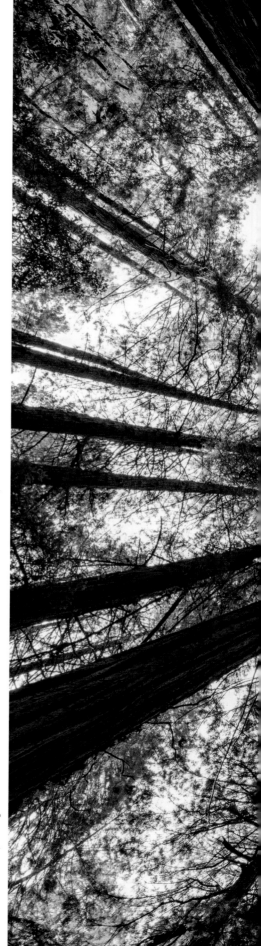

© Tom Mackie / AWL Images

UNITED STATES

The Redwoods

The redwood forests of the Pacific Northwest enchant all who enter them.

In this land of giants, it's not actually the size of these trees that makes the strongest first impression. After all, it's hard to get a sense of a single tree's scale when there's a forest of them before you. No, it's your sense of smell that first signals the otherworldly adventure you're embarking on. In a forest of giant redwoods, the air simply seems to be extra full of life. It has an unforgettable fecundity, a fresh headiness that you don't get downtown.

One reason for this extra zing might be that trees release oxygen when they convert carbon dioxide and water into glucose through photosynthesis. And redwood forests do more than any other to capture and convert carbon dioxide from the atmosphere, say scientists from Humboldt State University. That's a scientific explanation.

A geographic explanation might be that redwood trees grow only along a limited strip of northern California's coast and into southern Oregon, facing west and never far from the cool mists and fogs of the Pacific Ocean. They require rainwater to drink and can generate their own condensation by trapping fog in their crowns. With all this moisture, the trees can grow two or three feet per year. Perhaps it's this combination of invigorating ocean air and a powerful life force, as if these giants were inhaling and exhaling, that you can sense in a misty redwood grove.

After your sense of smell, don't neglect your sense of touch when encountering redwoods.

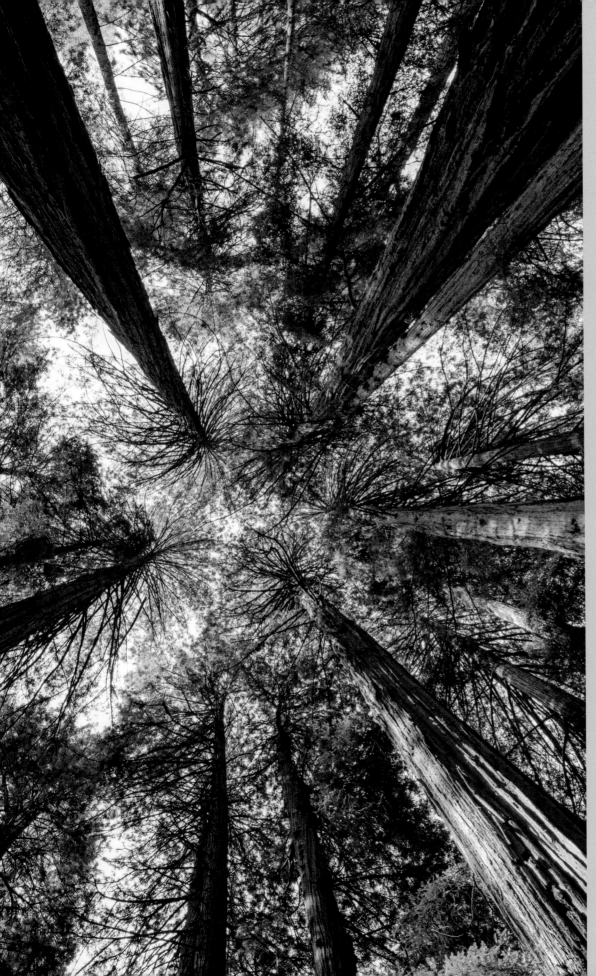

THE MARBLED MURRELET

This unassuming little seabird, a member of the auk family (see also puffins and guillemots), is responsible for the conservation of several redwood forests. As an endangered species, the marbled murrelet enjoys federal protection. But it wasn't until 1974 that the connection between the seabird and the redwood tree was revealed when a maintenance worker discovered a strange chick with webbed feet near the top of a redwood. Unlike their cliff-nesting relatives, marbled murrelets had adapted to nesting in the tall trees instead. Scientists set out along the north Pacific coast to watch for more marbled murrelets as they left for fishing trips early in the mornings, returning at dusk with a plaintive 'keer, keer' call.

Left, coastal redwoods are among the fastest-growing trees on Earth.

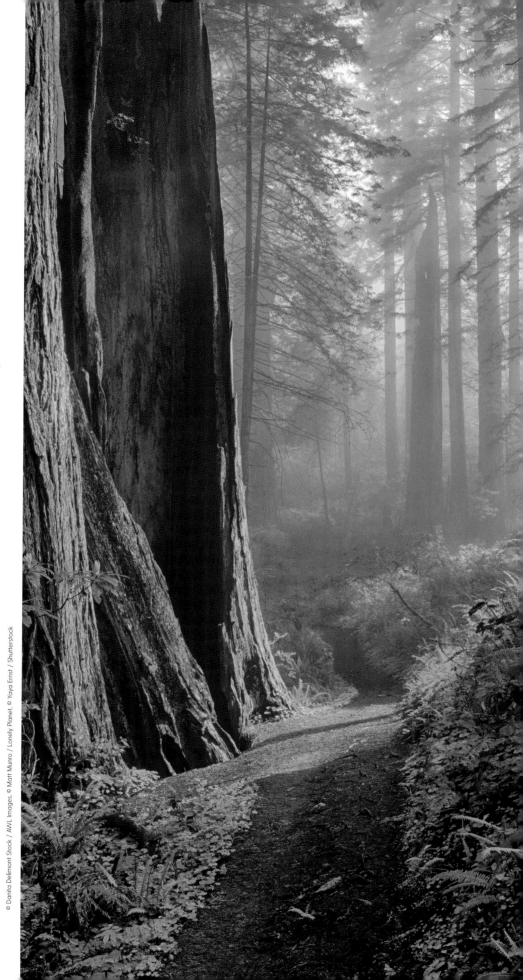

From right, trails in redwood forests are often springy, due to the organic material underfoot; Roosevelt elk live in the parks.

It's impossible to wrap your arms around an adult redwood – the very largest have a circumference of up to 100ft (30m) – but just resting your hands on them reveals a spongey and cork-like bark, riven with deep grooves and channels. Around each tree lie chunks of soft, red bark and the forest floor seems springy as you walk. Sounds, too, seem muffled in these peaceful places, the trees insulating noise from the world outside.

Finally, when you allow your sense of sight to engage, the overwhelming feeling is one of awe. Awe, according to Dr Dacher Keltner, a professor of psychology at the Greater Good Science Center at the University of California, is 'the experience we have when we encounter things that are vast and... transcend our current understanding of the world.' John Muir wrote of the redwoods near relative, the giant sequoias of the Sierra Nevada, that 'one naturally walked softly and awe-stricken among them ... subdued in the general calm, as if in some vast hall pervaded by the deepest sanctities and solemnities that sway human souls.' Redwoods grow to more than 300ft (90m) in height and can live for more than 2000 years; some doubtless pre-date Jesus. And they've been on the planet for around 250 million years. There's no better way to get a sense of perspective than to take a stroll among redwoods.

So how can you best appreciate this living infrastructure? There are a number of options along the Californian coast that cater to people who want to get out of their car and up close to a redwood. At the time of writing, perhaps the most unique experience is the annual opportunity to climb a redwood (located on private property near Santa Cruz)

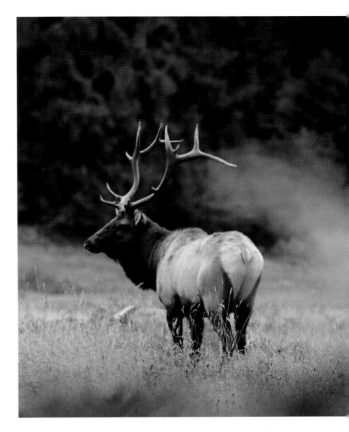

with Tree Climbing Planet's founder Tim Kovar, who is dedicated to connecting people with nature and inspiring them to take care of our forests. With very limited spaces available for the March ascent, sign up to be notified of when invites are sent out by emailing Tree Climbing Planet with 'redwoods' in the subject line. Also in Santa Cruz, Mount Hermon Adventures offers zip line rides through a redwood canopy.

Most of the state's redwoods grow north of San Francisco and some of the closest to that city are in the Muir Woods National Monument in Marin County. Here rangers host a huge variety of talks and tours through the year, such as a dawn walk through the old-growth redwood forest. Further north, Redwood National Park is a grouping of several state parks and forests, making up the largest protected redwood region. Parks to explore include Prairie Creek Redwoods State Park and the Humboldt Redwoods State Park. The latter lies off the famous Avenue of the Giants drive. Rather than use a car, you'll get more in touch with the forests on a bicycle: you can cycle the Avenue of the Giants south (use lights on your bicycle, it's dark under the trees) then turn right under Hwy 101 to enter the 20,000ha of Humboldt Redwoods State Park. The trees here have never been logged and consequently some of the tallest redwoods in existence are in groves that are short hikes from the bike-friendly road. The Giant Tree is more than 350ft (106m) tall and stands in the park's Rockefeller Forest. And the Dyerville Giant is a fallen titan that lies in the park's Founders Grove. Take a quiet moment of communion among some of the largest and oldest living organisms on our planet.

To properly explore the redwood coast of California and Oregon you will need your own transport (plus a pair of hiking boots and a good waterproof jacket). Sections of old-growth forest hug the coast from San Francisco, the region's international hub, north (there is a forest to the south at Santa Cruz). Amtrak's Coast Starlight train stops at Leggett and Garberville but buses thereafter are infrequent – it is much better to have your wheels (bicycles included). Redwood National Park extends along US Hwys 101 and 199 between Orick and Gasquet. The Avenue of the Giants runs parallel to Hwy 101 just south of Rio Dell, with the Humboldt Redwoods State Park leading onto the Lost Coast, which the builders of the road swerved.

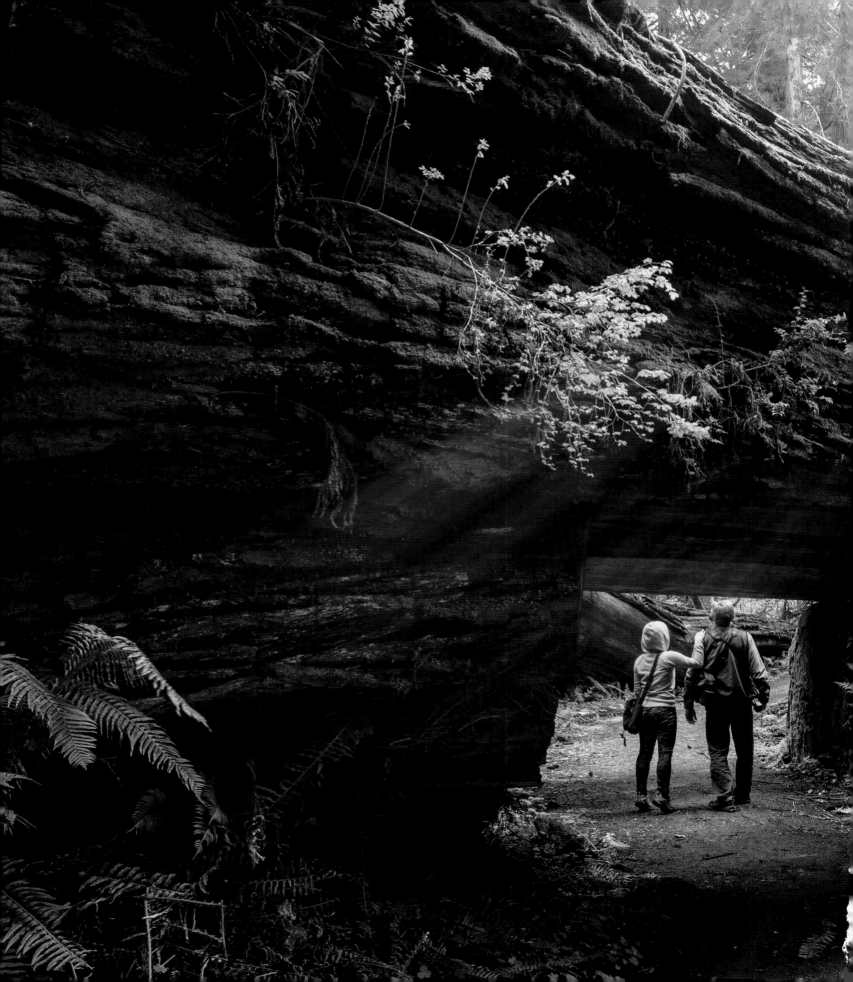

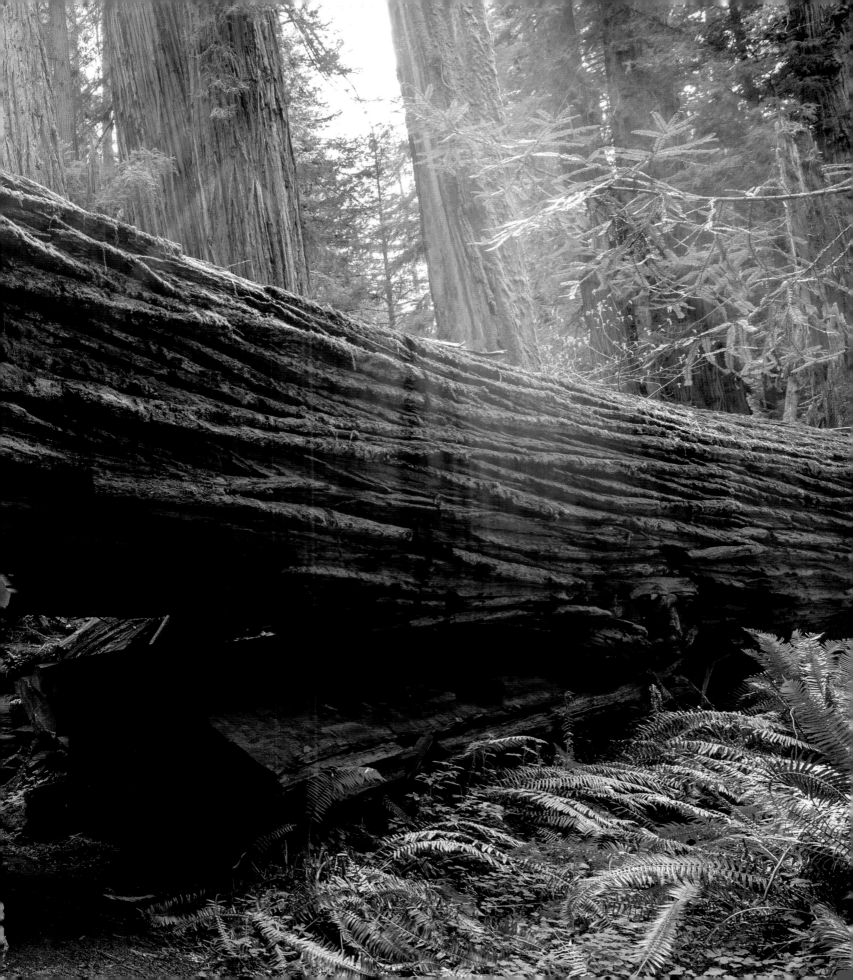

GABON

Loango National Park

Encounter gorillas in one of the world's greatest (and most challenging) natural environments.

Right, a Western lowland gorilla in Loango National Park.

S trange things happen where habitats meet. At Loango National Park in the small and beautiful West African country of Gabon, where the tropical rainforest extends all the way to beaches and the Atlantic ocean, that means you might witness beach-combing elephants and surfing hippos. But the most thrilling of wildlife encounters lies deep in the park: a couple of groups of Western lowland gorillas that have been habituated over several years to human visits. Since 2016 it has been possible to join trips into the jungle to observe the gorillas – if you follow a few house rules.

Dr Martha Robbins is a lead scientist at the Max Planck Institute for Evolutionary Anthropology's Department of Primatology in Leipzig. She has pioneered the project in association with Gabon's National Park Authority and spends much of the year in the rainforest of Loango National Park.

'Loango is special for many reasons, including the diversity of ecosystems and the abundance of wildlife. You don't need to spend much time in the forest before you hear or see animals.'

Dr Robbins' main area of interest is the populations of chimpanzees and Western lowland gorillas in this forest. Western lowland gorillas are the smallest variety; they're the gorillas that are kept by zoos. As a child, Dr Robbins always enjoyed science and liked animals: 'But I had no idea that I would end up working with wild gorillas in Africa,' she says.

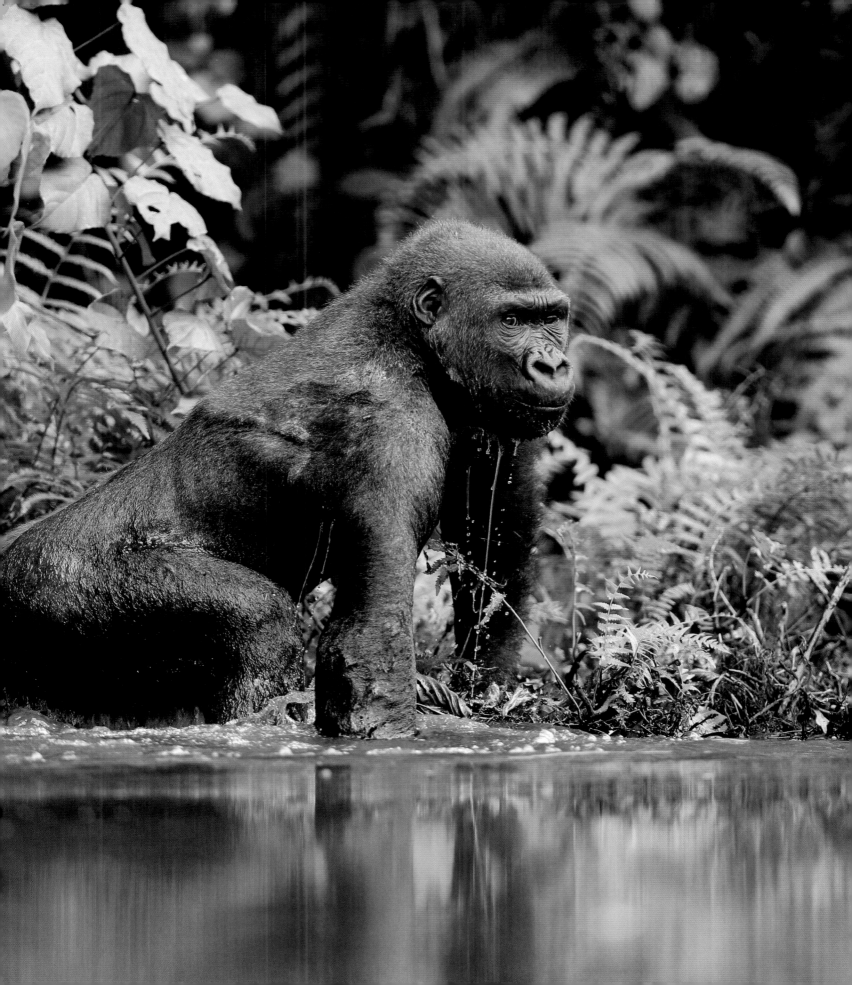

THE HOUSE RULES

As a guest of gorillas, there are some important house rules to observe:

· Don't go if you are ill. Gorillas are susceptible to human diseases. Wear a surgical mask when closer than ten metres.

· Maintain a distance of at least seven metres. If the gorillas move closer, move away.

· Don't make any sudden movements. If a gorilla charges, stay still and follow the guides' instructions.

· Wear neutral coloured clothing.

· The maximum time for a visit is about one hour with only four people visiting the group daily.

· Don't eat, drink or smoke near the gorillas and don't leave waste.

· Walk quietly.

· Don't use a camera flash.

· Finally, put your camera away for a few minutes and just watch the gorillas.

Right, forest elephants tend to have straighter tusks than their larger savannah-living relatives.

The process of habituating a group of gorillas in this park began in 2005, with the intention of replicating the experience of visiting mountain gorillas in central Africa. It wasn't easy.

'The first challenge of habituating gorillas is simply to find the gorillas,' explains Dr Robbins. 'Gorillas occur at a low density in the forest so there's a low probability of bumping into them if you are just walking. However, you can find footprints, faeces and remains of plants that they have eaten.'

The project used local pygmy tribes to track the gorillas. 'Pygmies are marginalised economically and socially across Africa but by working as trackers they are able to use their traditional knowledge and skills and provide invaluable assistance,' says Dr Robbins.

'During the initial stage of habituation, the gorillas are fearful of humans and will run away. In the next phase, gorillas stop fleeing but may respond to the presence of humans with aggressive charges that indicate feeling uncomfortable with human presence. Only at the final stage of habituation, when gorillas react calmly to humans in their midst and go about their activities normally, can they be considered habituated. The guidelines for visitors have been established to respect this special relationship: the gorillas are briefly letting us into their world so I view being with them in the same way as being a guest in someone's house. Even after studying gorillas for 30 years, I still enjoy the privilege of watching the day-to-day activities of a gorilla family.'

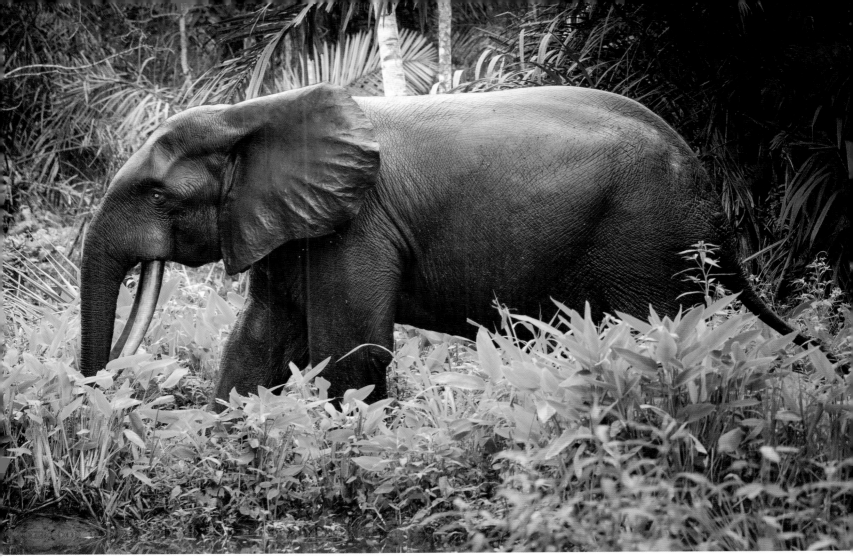

Loango's jungle, too, still intoxicates all who enter it: 'The lushness can be overpowering and the heat and humidity add to the intensity. You perceive the forest through all your senses. The huge trees and tangle of vegetation mean that there's no horizon; you hear insects, frogs, monkeys and unknown animals; you smell vegetation and damp earth; you feel that wiggly worm in the sole of your foot and are drenched after being in the rain so long. You may encounter a mother elephant and her calf or startle 100 bushpigs and cause them to scatter.'

To find the gorilla group you will undoubtedly need to wade through swamps in heavy rain. 'The gorillas feed in swamps so you end up spending a lot of time in them,' says Dr Robbins. 'All these things are physically and mentally challenging. Some people may not like all the insects but they are part of the forest, even that tick up your nose. The key is to focus on the good and remember that even if a day is tough, you've pushed yourself to get through it and seen amazing things. Gabon is off the beaten track and logistics can be complicated but it's worth it.'

It's worth the effort for the gorillas too: income raised from gorilla-watching permits in Loango and other sites aids gorilla conservation, reduces poaching and also raises awareness of the gorillas' plight.

Dr Robbins has a final piece of advice for visitors to this astounding forest: don't forget to bring a sense of adventure.

Gorilla watching with the Max Planck Institute of Evolutionary Anthropology is organised through Loango Lodge. Getting to Loango is part of the challenge: most international visitors will arrive by air at Libreville, Gabon's capital. A short flight with Afrijet can get you to Port Gentil, the closest city to the park. If you've booked accommodation with one of the upscale lodges 4WD transfers may be part of the package. It's also possible to take a cheaper and longer overland route using a bus from Libreville to Tchibanga then bush taxi to Gamba and a boat into the park. It is more cost-efficient to travel as a group so car and boat journeys can be shared.

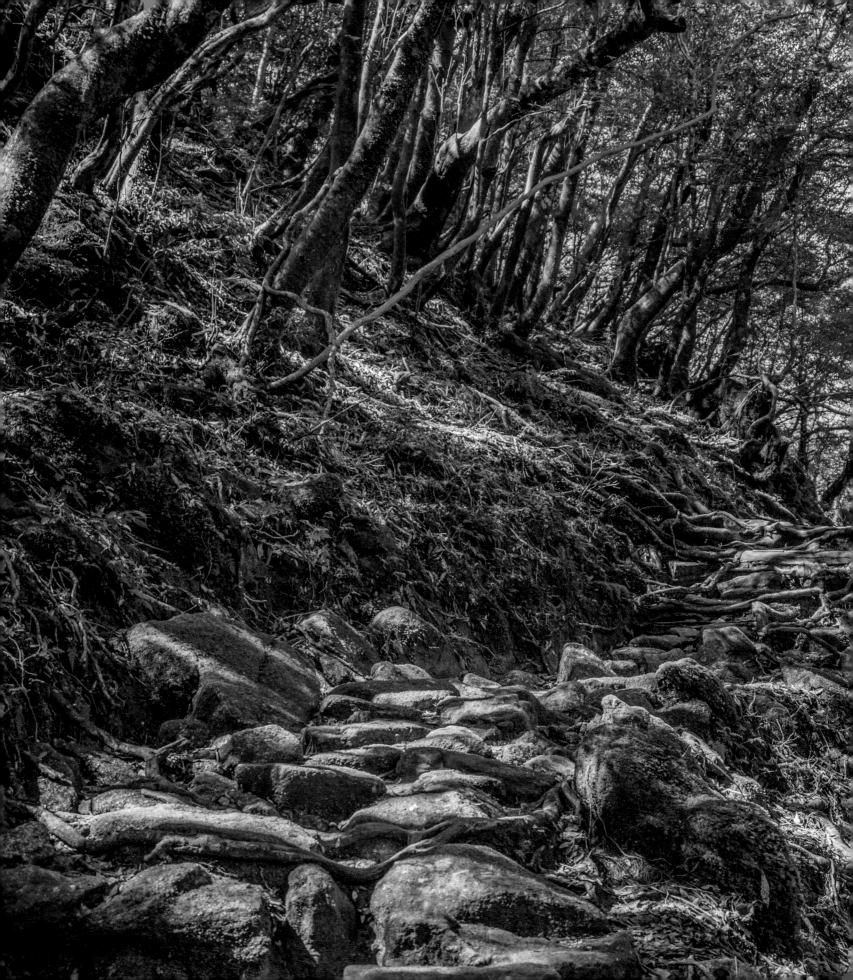

JAPAN

Yakushima Island

Japan, in the 14th century. A young, masked princess and her companion, Moro, an ageless white wolf goddess who raised her, are racing through a dark forest. They're battling a force of encroaching humans that threatens their forest home and the wild spirits within. This is the tale of *Princess Mononoke*, an animated film from the acclaimed Japanese director Hayao Miyazaki and Studio Ghibli. And if you wish to explore this fictitious forest – minus a raging boar god – there's an equally enchanting place that inspired it: Shiratani Unsuikyo Ravine in the northeast of the mountainous island of Yakushima.

Yakushima is a granite punctuation point between Japan's big four islands and the tropical southernmost archipelago of Okinawa. It's part of Kagoshima Prefecture, just south of the island of Kyushu. The climate is subtropical and the air seems all the thicker thanks to the abundant hot springs and volcanoes. Giant plants thrive in the warm climate, bromeliads and camellias, ferns and ancient banyan trees with roots descending from outstretched branches like so many legs.

At lower elevations, broad-leafed evergreen oaks give way to conifers such as spruce and fir before Yakushima rhododendrons appear in the cooler, higher air, their white flowers bursting from pink buds. The forested heart of 200 sq mile (500 sq km) Yakushima is protected by Unesco World Heritage status, with roads only circling the edge of the island (population 13,000). The forest's most notable denizens are the gnarled Japanese

Ancient, gnarled trees, mysterious pathways and – possibly – forest spirits, this enchanted island has it all.

Left, watch your footing on the paths through Yakushima's forests.

© The Asahi Shimbun / Getty Images, © Zmkstudio / Shutterstock, © AdamJPhotography / Getty Images

THE GENIUS OF GHIBLI

Hayao Miyazaki is the co-founder of Ghibli films (with Isao Takahata, who died in 2018) and one of Japan's greatest film directors and animators in any genre. Some of the best-known works from his studio include *My Neighbour Totoro*, *Kiki's Delivery Service*, *Princess Mononoke*, *Spirited Away* and *Ponyo*. While their charm could at times be mistaken for cute whimsy, such as the 'cat bus' that carries forest spirit Totoro, there's a harder, more horrific edge that isn't often found in children's movies, and an unmistakeable environmental message. And then there's *Grave of the Fireflies*, directed by Takahata, a harrowing story about the effects of WWII on a young brother and sister in Japan. It's described in *The New York Times* as 'one of the most startling and moving animated films ever.'

From right, moss-covered boulders; baby loggerhead turtles race to the Pacific.

cedars (*Cryptomeria japonica*) that grow above an altitude of 1650ft (500m) and can be aged 1000, 2000, even 3000 years or more. They're known as *yakusugi*, or at least the most ancient are. Those younger than 1000 years are merely *kosugi*, small cedars. Many were felled for timber – because it grows so slowly due to the poor soil here, the variety has a very high resin content, making for very long-lasting lumber. But the survivors are still found on this island, with dark-green leaves crowning twisted trunks and buttresses that, if you look long enough, can seem to writhe around the rough volcanic rocks. The most accessible of these cedars are in a nature park named Yakusugi Land; you can hike across boardwalks for between 30 minutes and three hours to reach these beautiful trees.

The Japanese relationship with forests is deep and multi-layered. Shinto, the local belief system, imbues natural things, including trees and rivers, with *kami*, a god-like sacred power. Shinto shrines are typically in natural spaces, with a red *torii* gate to mark the transition from the everyday to the otherworldly. Some shrines are surrounded by small wooded groves, known as *chinju-no-mori*. Shinto has enjoyed a resurgence in recent years, as a form of natural religion that honours ancient rituals and traditions, but is not without traces of nationalism too. (Some reading-up on Shinto before your visit to Japan will explain a lot, such as what the deal is with all the foxes.)

On a secular level, Japan has introduced the world to *shinrin-yoku*, or forest-bathing. A walk in the woods, while practising mindfulness (see

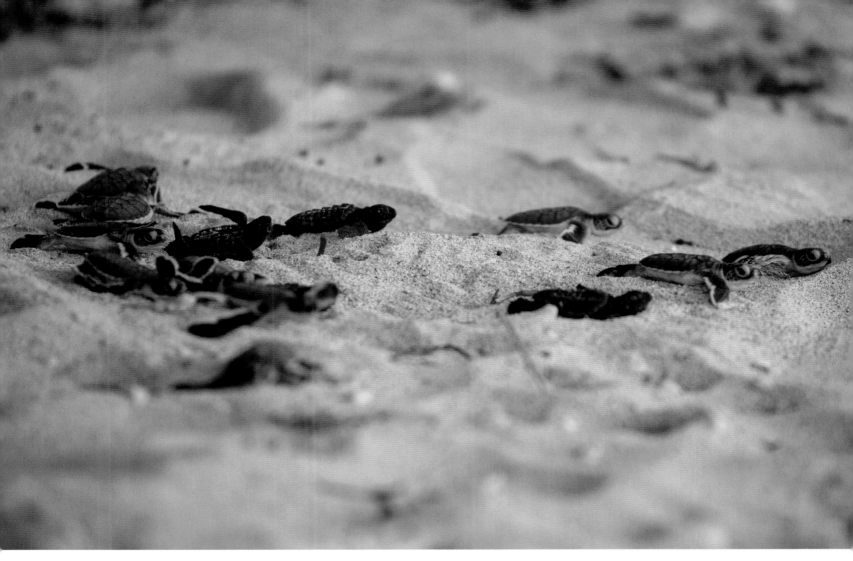

introduction), is now recognised as a panacea for stress and physical ailments. Visitors to Shiratani Unsuikyo can take a number of paths into it, ranging from one hour to a morning or more. The ravine is also the start of a challenging traverse of the island interior that can take three days. But be prepared to lose track of time once the canopy closes over your head. Sounds are muffled by the thick green moss that grows everywhere and the path can seem to disappear. Is it forest trickery? Afterwards, soak in one of the island's onsens.

Maybe it was the magic of this place that influenced Hayao Miyazaki. The natural (and supernatural) world plays an important part in many of Miyazaki's movies. In his breakthrough animation, *My Neighbour Totoro*, an altogether cuddlier story, a large but good-humoured spirit-creature is befriended by two girls, Mei and Satsuki, who have moved into an old house in the countryside. In a later film, *Ponyo*, the natural world is in tumult as a father searches for his daughter. *Princess Mononoke* is less equivocal. The forest spirits and their human friends, Princess Mononoke and Prince Ashitaka, battle Lady Eboshi, who runs a mining town on the edge of the forest.

Before you leave, go down to the ocean to witness one more miracle. As night falls between May and July, metre-long loggerhead sea turtles haul themselves across the soft sand of Nagata Inakahama beach on the island's northwest coast. About half of the world's critically endangered loggerheads use nesting grounds on Yakushima. They will lay their eggs here under the watchful gaze of wardens and visitors before returning to the ocean, having been protected since 1988.

There are domestic flights to the northeast coast of Yakushima but they are relatively expensive. A better option is to take the hydrofoil from Kagoshima on Kyushu to Yakushima, which takes about two hours. A ferry takes about four hours and there's also a ferry service that pauses overnight on the nearby island of Tanegashima. Once on the island, you can use local buses that follow the circuitous coastal road hourly, although renting a car from the port may give you more freedom. The Shiratani-unsuikyō hike's trailhead is served by 10 buses daily to and from Miyanoura. Allow three to four hours for the hike. There's a 300 yen entrance fee.

CANADA

Great Bear Rainforest

She pads cautiously down to the river's edge, her paws finding purchase on the slippery rocks. Memory guides her along the shore until she reaches a prime spot for catching the salmon that are making their way upstream. Standard bear behaviour, you might think, but she is no ordinary bear: with a creamy-white coat she's known as a spirit bear (or a Kermode bear) and she is found mainly in the Great Bear Rainforest of northern British Columbia. Spirit bears are a rare variation of the black bear, caused by a double-recessive gene found in only 10% of the black bears here – both parents must have the gene for their cub to be white too. There are about 400 spirit bears on Canada's west coast, with the highest concentrations found on two islands, Princess Royal and Gribbell, both within the vast Great Bear Rainforest that extends north for 250 miles (400km) to the Alaskan border, far larger than any national parks of the US and about the same size as Ireland.

This is a land of deep, forested valleys, of turbulent rivers that tumble into innumerable, glacier-carved fiords. Bears – and both black bears and the larger grizzlies are common here – are not the only apex species that call the Great Bear Rainforest home. Sea otters hunt, feed and relax anchored to the thick kelp forests of the fiords. Sea wolves patrol the hinterland between ocean and forest, frequently swimming from island to island and feeding often, like the bears, on the

Black bears, brown bears and rare white bears call this inaccessible and wondrous land home.

Left, boat tours depart Hartley Bay in the Great Bear Rainforest.

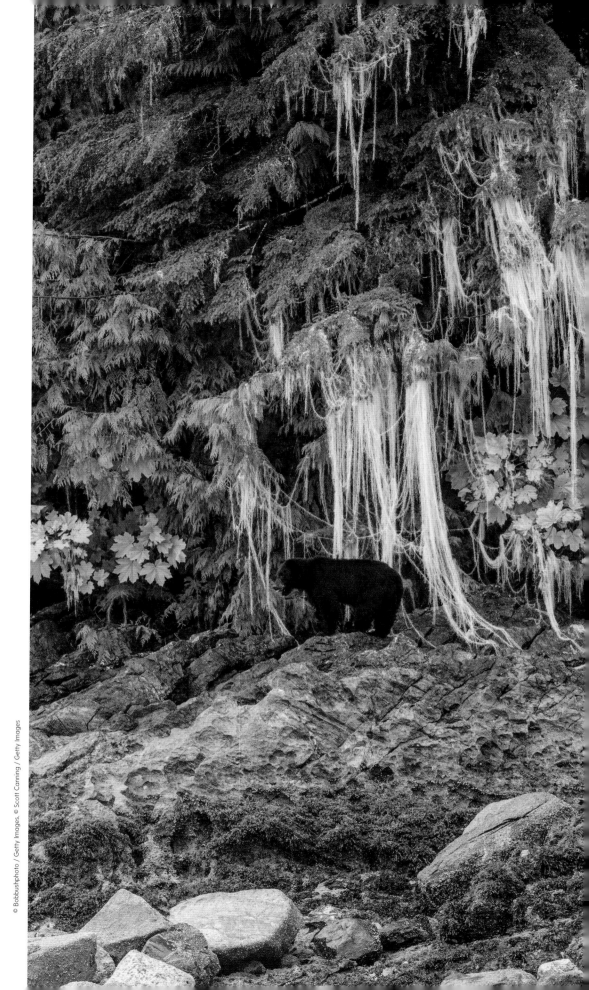

THE GRIZZLY BEAR

The spirit bears hog the attention but note that grizzly bears, *Ursus horribilis*, are far more widespread. Khutzeymateen Grizzly Sanctuary, in the north of the Great Bear Rainforest, has the largest population of grizzly bears in the world and lodges here can organise bear-spotting expeditions by boat. Floatplane is the only other way to access the reserve. The bears feast on spawning salmon and also protein-rich sedge grass in this wetland set around a large river estuary and backed by old-growth temperate rainforest. There are about 50 grizzly bears living in the sanctuary with only around 200 people visiting annually.

From right, a black bear forages along the shoreline; a spirit bear fishes for salmon.

salmon that are just one indication of the health of this ecosystem. In the deeper water of the fiords you may see orca and, from July to September, gray and humpback whales. In the skies soar bald eagles.

This is an incomprehensibly wild and biodiverse place, sometimes labelled the Amazon of the North, for want of a better reference point. It is the planet's greatest reserve of coastal temperate rainforest, which is an extremely rich habitat thanks to the fertile ocean. Each day mist and fog filters through the tall, slender Sitka spruce and 1000-year-old Western red cedars. Rain falls as the moist ocean air hits the cool mountains, and there's a lot of it, about 22ft annually.

Although this is now mostly protected land, in some way or another, it wasn't always thus. The region used to go by the depressingly prosaic name of the 'Mid-coast Timber Supply Area'. Environmental battles were fought throughout the 1990s to stop the clear-cut logging that was destroying swathes of this land. Eventually, in February 2016 the Premier of British Columbia and the First Nations of the region announced that 85% of the rainforest would be off-limits to logging, with strict harvesting regulations applying to the remainder. In September of that year, the Duke and Duchess of Cambridge endorsed the scheme and unveiled a plaque in the forest.

The First Nations have been the stewards of the Great Bear Rainforest since long before Britain's younger royals showed up. There are 27 First Nations that live along this coast. The Gitga'at and Kitasoo never spoke of the spirit bears – known as *mooksgm'ol* in the local language – to the colonist fur-trappers nor hunted the bear themselves.

In the heart of the Great Gear Rainforest, live the Heiltsuk people. Jess Housty is a community leader and Executive Director at QQS Projects, a Heiltsuk First Nations non-profit organisation that supports indigenous culture, the environment of the Great Bear Rainforest and prepares Heiltsuk youth for the responsibility of custodianship of this unique landscape.

'Our territory is unspoiled, untouched, unmarked,' she says. 'I don't exist separate from my homeland. I'm incredibly personally, spiritually, emotionally invested in this place.'

Climate change has an even greater urgency in regions like the Great Bear Rainforest, where people live off the land. If something affects, for example, the salmon spawning season, the First Nations people will not be able to feed their families. In recent years the local economy has diversified away from logging and now hosting visitors is an important source of income. You can stay in First Nations-owned lodges (one on Princess Royal Island offers tours to see the spirit bears) and be guided on trails into the forest to find prehistoric petroglyphs. But it's not an easy place to get around, with no roads. Access (see panel) is often by floatplane and a kayak is perhaps the best mode of transport, with some of the finest coastal paddling available in the world (often interrupted by orca in Johnstone Strait and the Broughton Archipelago). However you get around, it will be impossible not to feel awed.

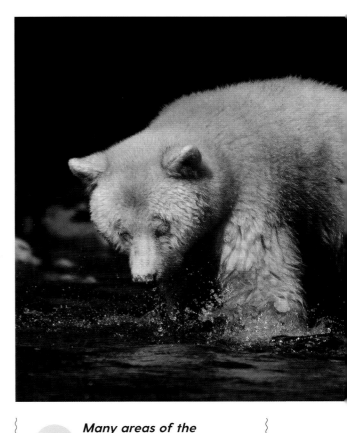

Many areas of the Great Bear Rainforest are accessible only by floatplane or boat – if you have your own, fine, if not then you'll need to book a tour package (typically including accommodation, transport and food). Independent options with just the plane or boat are also possible. This is true wilderness. Bella Coola, 950km (590 miles) via Hwy 20 from state capital Vancouver, is one of the few settlements to which it is possible to drive. You can also reach Bella Coola on an overnight BC Ferries seasonal service from Port Hardy on Vancouver Island. This is one of the world's most scenic ferry routes. There are also direct flights to Bella Coola from Vancouver airport.

CHILE

Pumalín National Park

Revitalise yourself in this newly created national park at the tip of the Americas.

Right, the trees of the Pumalín thrive in the ocean air.

Summer 1834-5 on the island of Chiloé. A man is walking in the shade of the tallest trees he's ever seen. And that's because he's a long way from home, which is the county of Kent, England. Every so often he stops to take a measurement or make notes in his journal, for this is Charles Darwin on his round-the-world trip – next stop the Galapagos islands, which cemented his theory of evolution. Darwin's time in Chile is thought to have been critical to his understanding not only of natural selection but also vast geological processes, such as earthquakes, eruptions and glacial erosion. He found seabed fossils on mountaintops and the bones of giant ground sloths, an elephantine gomphothere and an extinct wild horse.

But his initial impressions of the Chilean coast were not favourable: 'We anchored in the fine bay of Port Famine. It was now the beginning of winter, and I never saw a more cheerless prospect; the dusky woods, piebald with snow, could be only seen indistinctly through a drizzling hazy atmosphere.'

Darwin's expedition had rounded Tierra del Fuego in 1834 and sailed up the west coast of Chile. From July to November, he based himself in Valparaíso, close to Chile's current capital Santiago and from November to February his ship anchored off the island of Chiloé, adjacent to what is now Pumalín National Park, home to some of the world's oldest and tallest trees, *Fitzroya cupressoides*, or alerce trees. These

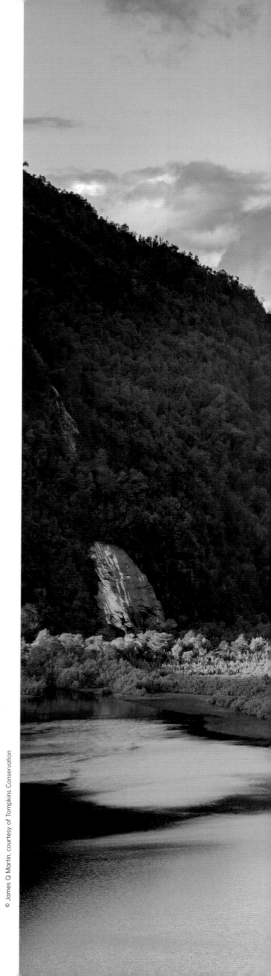

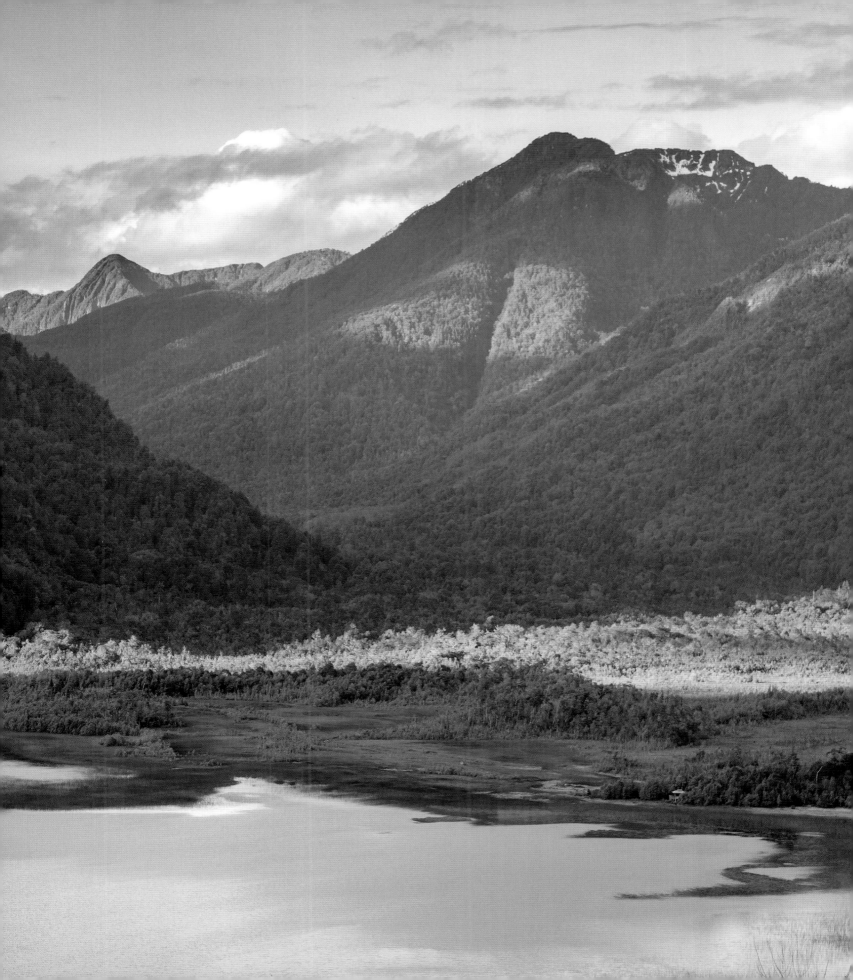

THE ALERCE TREE

Alerce trees (*Fitzroya cupressoides*) typically grow to 150ft (45m) in height and have a trunk diameter of more than 10ft (3m). Like *Sequoia sempervirens*, the coastal redwood found along the north coast of California, the alerce grows tall and straight and prefers cool, moist air. Interestingly, some fossilised foliage was found in Tasmania, Australia, suggested how the continents were connected many millennia ago. In Pumalín National Park the Sendero de Alerces starts around 7.5 miles (12km) south of Caleta Gonzalo and is a very short trail suitable for all ages and abilities.

From right, giant alerce trees; the Yelcho river flows through the Los Lagos region.

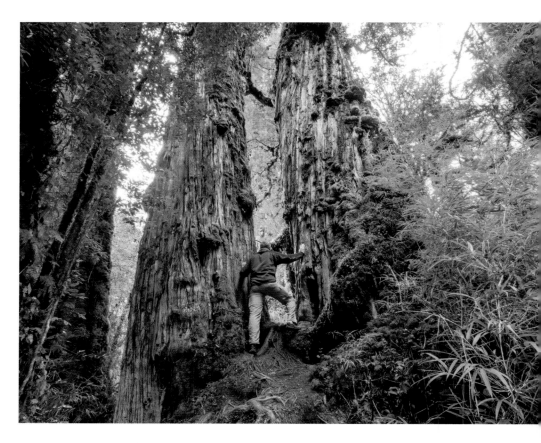

cypresses, native to the Andes, are the redwoods of the Southern Hemisphere. Not only do they rival coastal redwoods, a relative in the cypress family, in height but they exceed them in age. Redwoods can live up to 1800 years, alerce trees can grow for 3000 years, almost as long as bristlecone pines. They were named after Robert Fitzroy, the captain of *HMS Beagle*, the British ship that took Charles Darwin around the world in the 1830s.

To walk among these trees, as Darwin did, you can visit Pumalín National Park in the Los Lagos region of Chile, which extends from the Andean mountains to the fiords of the Pacific coast. Here, accessible and signposted walking trails wind through groves of massive alerce, many more than 1000 years old. The park was created from wilderness land purchased by the American conservationists Kris and Doug Tompkins (Kris is a former CEO of Patagonia, Inc. and Doug founded The North Face among other brands). After restoring hundreds of thousands of acres, Tompkins Conservation donated the protected lands to the Chilean government, which made Pumalín a national park in 2018.

One of the goals of the project was to raise awareness of the value of conservation among Chileans. 'About 20 years ago it was mainly foreign tourists who would visit these areas,' says Ingrid Espinoza, Executive Director of Tompkins Conservation Chile. 'Nowadays there are many Chileans who plan their vacations around these parts, from young adults to the elderly. It is always

better if people can visit: when you experience somewhere like Pumalín you understand the necessity of protecting nature. We create these parks because we believe that it is essential the planet recuperates these areas. If you are protecting the trees, you are also taking care of the wildlife that resides in these habitats. We've also reintroduced and rehabilitated species, such as the rhea in Chile.'

'There are about 200,000 alerce left in Chile and of those 50,000 are protected at Pumalín. Standing in front of such an ancient tree, my own life cycle feels so small. For me, the national park is a sacred space and full of inspiration and calm.'

To spend time in Pumalín is to encounter countless waterfalls cascading off cliffs and into fiords such as Reñihué and Comau, to spot dolphins from Caleta Gonzalo, climb the Chaitén volcano, hike to the Michinmahuida glacier, or just absorb the elemental majesty of this wild landscape from a vantage point above the forests and rivers. There are campgrounds and even cabins throughout the park.

Pumalín is just one national park among 17 that form the Ruta de las Parques de la Patagonia, an initiative of Tompkins Conservation that extends for 1700 miles (2735km) from Puerto Montt to Cape Horn, covering 11 million hectares. Not all of these parks are open to the public and some are only accessible seasonally or are accessed only by sea. But a trip to visit several of them could be as enlightening as it was for Charles Darwin.

Pumalín National Park is open year-round and can be reached by car, boat, bicycle or bus. If you wish to take public transport, there's a bus service from Puerto Montt, a port city and the transport hub of Los Lagos, to Caleta Gonzalo in the southern side of the park. Caleta Gonzalo can also be reached via ferry from Fiordo Largo or by car from Chaitén. This is the region with the most infrastructure; there's less infrastructure in the north of the park but you can reach it via private vehicle with a couple of ferry crossings. There are direct flights from Santiago, Chile's capital, to Puerto Montt. There are no fees to enter the park. Visit www.parquepumalin.cl for bookings and more details.

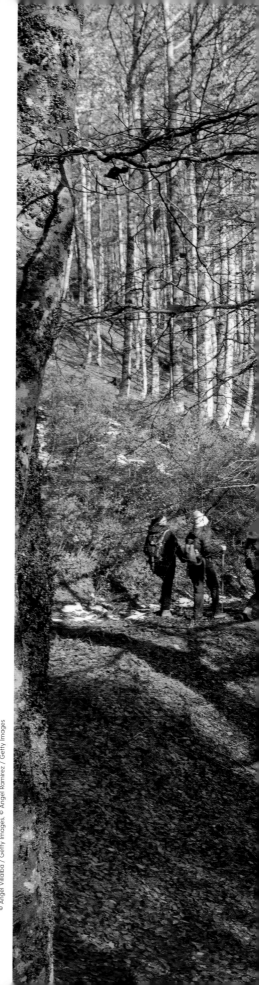

SPAIN

Irati Forest

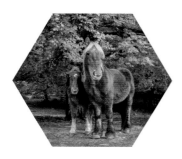

Delight in the colours of this classic European woodland near the northwest border of Spain and France.

Ask a forest fan to list their favourite tree and you can expect a long pause. It's a tough question but for many people *Fagus sylvatica*, the European beech, would be close to the top. In spring, its simple, oval leaves unfurl, bright green and soft in the sunshine. They darken and harden during the summer until the changing seasons cause a vivid display of colour as the foliage turns a rich, rust-golden shade before they fall to the forest floor. Here, inches deep, the dried, delicate leaves create russet drifts that move where the wind blows them and rustle as you kick your way through them. The beech leaves serve another purpose than just providing fun for us: they decompose and, unusually, release compounds that hinder the growth of competing plants. Couple this with the fast-growing beech trees' propensity to crowd out slower growing species such as oaks, and you can see why beech forests are more of a monoculture than many other more mixed deciduous woodlands.

Europe's second-largest beech forest sprawls on the border of France and Spain in the western Pyrenees (the continent's largest is Germany's Black Forest). The Basque country straddles many worlds. From Spain's wine country of Rioja and the food- and art-focused cities of Bilbao and San Sebastian, the land gains height into the foothills of the western Pyrenees, punctuated by villages and

One of Europe's strangest and most elusive creatures lives in the waterways of the Irati Forest. The Pyrenean desman is just about the last of its line of aquatic mammals, once widespread throughout Europe (there's now just a larger Russian relation). The desman is a small, voracious creature, most resembling a shrew but with a rat-like tail, huge webbed back feet, and a very long, inquisitive nose for seeking out the invertebrates it feeds on. The desman hunts at night so has little need for sharp eyesight. Its nocturnal lifestyle also makes it extremely hard to spot but if you can find a clear, fast-flowing mountain stream there's a chance a desman may be holed up nearby, awaiting darkness to fall.

Left, hikers (and horses) enjoying the beautiful beech foliage of Irati forest.

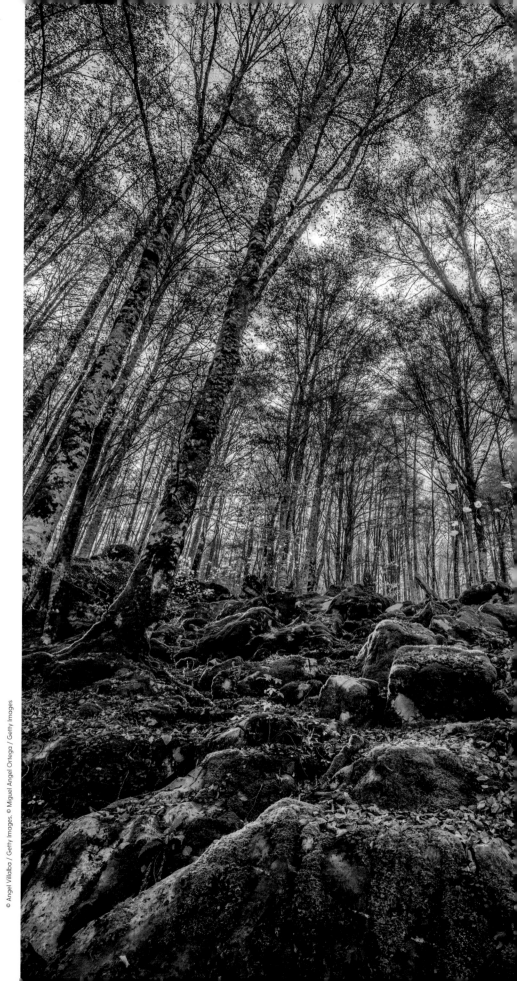

Right, beech forest around the Irabia reservoir; rivers plunge off the Pyrenean foothills.

megalithic sites. This is one of the greenest corners of Spain and frequently cloaked in fog; 64% of the Navarra region is forested. Water has eroded gullies through Irati, rushing downhill over rocks. The beeches thrive on this poor soil and higher altitude. 'Never reach land with beech', goes a Spanish farmers' proverb due to the lack of pasture in the rugged high country. But there is life, fertility and food aplenty here. Beechnuts fall from the trees, food for squirrels. In autumn fungi – some delicious, if you know what you are seeking – sprout from the forest floor. Red deer roar during their annual rut. Around the waterways lives the quirky desman, a shrew-like creature with poor eyesight, webbed feet and a snorkel for a nose.

Above, the forest is on the route of migrating birds as they escape the European winter for Africa. From mid-July to mid-November, the Orgambidexka pass is an ideal vantage point from which to view the passing traffic: cranes, storks and numerous passerines all instinctively tracing timeless routes south and across the Straits of Gibraltar.

Circling the skies, their massive 10ft (3m) wingspan catching thermals rising off the hills, are griffon vultures, populations of which have bounced back in the Pyrenees. Rarer still is the *ossifrage*, the bone-breaker, better known perhaps as the lammergeier or bearded vulture. They too are returning to southwestern Europe's skies but remain one of the continent's most endangered birds.

In late spring another migration occurs as the region's shepherds, numbering more

than 300, accompany their flocks up to the summer pastures where the sheep and cows feed on grasses and flowers. Distinctive cheeses, such as fruity and nutty Ossau-Iraty, are made in mountain villages like Isaba (on the French side of the forest, look for signs for 'fromage à vendre').

There's something enchanting about a beech forest. Perhaps it's the airy spacing between the trees or the carpet of delicate copper and russet leaves, or the sense of abundant life thriving beneath the canopy of trees. Throughout Iraty forest are hiking trails, some of which use woodcutters' or shepherds' paths. The Errekaidorra interpretative trail is a good introduction but if you pack a rucksack you can hike to spots like the Cubo waterfall.

And as you walk deeper into the woods, where the sounds of civilisation fade and your senses become attuned to nature you may recall the characters of Basque mythology. There's Basajuan, the lord of the woods, who protects the forest and also the flocks, roaring to alert shepherds and their sheep of approaching storms so that they can seek shelter. The hairy giant is believed to have built the dolmens around the southern fringe of Irati, along the Abodi ridge. At night, Gizotso emerges, half-man, half-wolf. The Basque Queen of Nature is Mari, who lives underground and keeps natural forces in balance. Everything in the Basque Country is about the land, or Ama Lurra, Mother Earth.

The gateways to Irati Forest are the villages of Ochagavía and Orbaitzeta. The former has a visitor centre that can help suggest hiking routes (find opening hours at www.turismo.navarra.es). From Ochagavía, the Salazar valley is the route into the forest; from Orbaitzeta take the valley of Aezkoa (check that roads are open in winter). The closest city is Pamplona, just over an hour's drive southwest. Airports in the vicinity include Bilbao, San Sebastián and Pau across the border in France. With the limited public transport options in these remote foothills, a rental car can be the best way of getting around. Or the best option: a bicycle.

Rivers & Waterways

Rivers shape our planet. Carving valleys through the earth, hefting rocks, forming estuaries, they are some of the greatest geological forces in our world. They shape our civilisations, too. Managing water may have been our first attempt at collective engineering. Many of the original sites of our greatest cities were chosen for their rivers, and they remain synonymous with them. London's Thames; Paris' Seine; New York's Hudson: each is impossible to imagine without its river.

And yet ever since people have made their lives by rivers, they have disagreed about how best to use them. The word 'rival' comes from the Latin *rivalis*, 'a person using the same stream as another'. In previous centuries, where industry boomed, they became toxic-waste disposal channels, so polluted they were flammable. Now, in a warming world, they are changing once again. But in recent years we have begun to value our rivers and lakes again. For their beauty and calm, for their life-giving properties. As the future of our planet looks uncertain, we are going down to our rivers again.

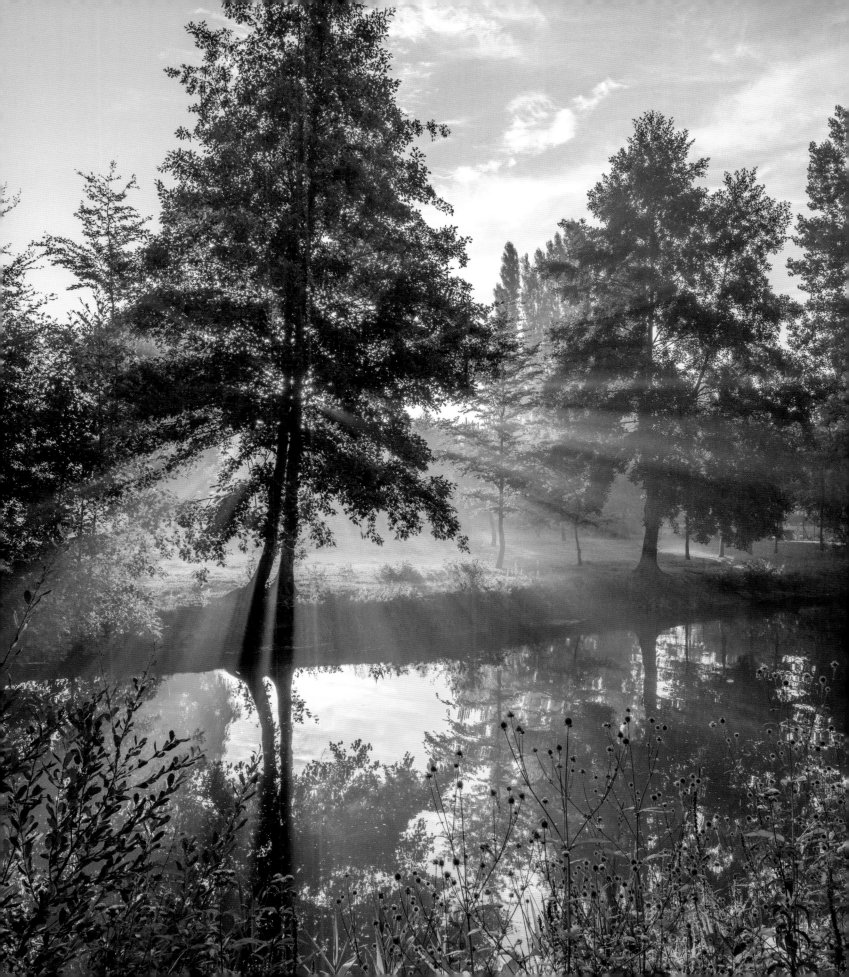

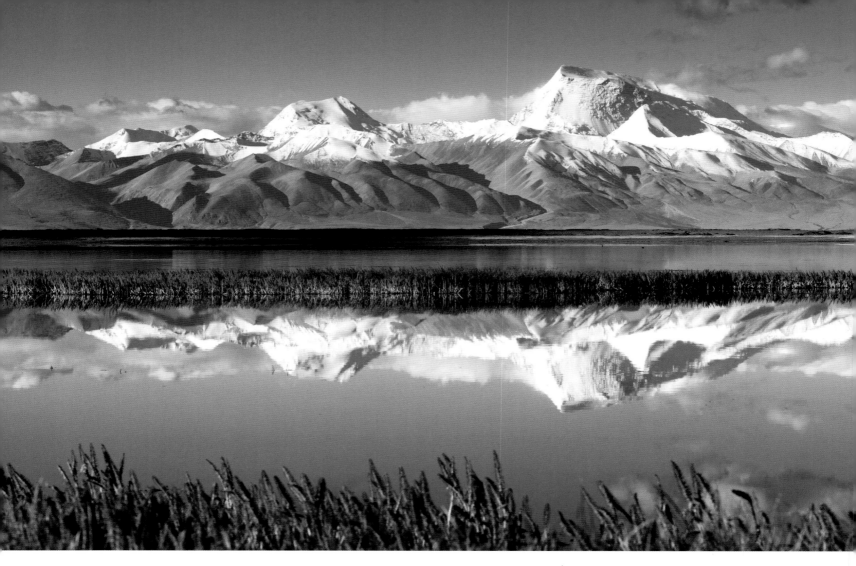

'W hen it hurts, we return to the banks of certain rivers.' So wrote the Polish poet Czelaw Milosz, in a sentiment that may be as old as the very first people.

Because for as long as there have been people to worship at them, there have been waters that are sacred. Manasarovar, the holiest of all the holy lakes in Tibet, sits at 14,764ft (4500m) on the Tibetan Plateau, its waters said to wash away the sadness and evil that lies at the base of the human heart. Across Britain there are ancient holy wells, sites of Christian pilgrimage and older, at Glastonbury, Walsingham, Fernyhalgh, Whitestaunton: cool pools of water bubbling up from mossy rocks, the trees around them hung with offerings – bathing in them was said to cure the incurable. In Peru, the Urubamba flows past Machu Picchu, and in its course the Incas saw the mirror of the Milky Way, channeling the earth's waters up into the sky. In the Middle East there is the River Jordan, the frontier of the Promised Land, in which Jesus was baptised.

If these beliefs feel as if they belong to another time, they do not. We have not wandered so far from the source. At Al-Maghtas, on the River Jordan, where John the Baptist had his ministry, masses of the faithful, both Christian and Jew, submerge themselves each year. During the Banyu Pinaruh ceremony, the Balinese gather by rivers and lakes, believing that by bathing in their waters they can rejuvenate body and soul. Many millions come to the Ganges during the Ardh Kumbh Mela festival to absolve their sins and seek liberation from *samsara*,

'By the rivers of Babylon
Where we sat down
And there we wept
When we remembered Zion'
Rivers of Babylon
The Melodians (1970)

From left, the holy
Lake Manasarovar in
Tibet; birdlife on the
Urubamba river in
Peru; the Urubamba
from Machu Picchu.

the painful cycle of reincarnation, despite the waters being riddled with *E. coli* these days. Water flows through religion, in East and West, symbolising purity, fertility, serenity and connection. We still toss coins into wishing wells, douse babies' heads with holy water.

As much as rivers have shaped our minds, they have also shaped the land we live on. They are found everywhere, except for the very hottest, coldest and driest places, and they are the most powerful erosive forces on earth. The world that we inhabit, a world of hills and valleys, is a world that has been made by rivers. Gushing down steep mountainsides, roaming across plains, fanning out into estuaries. Nowhere is it more apparent that geological processes are ongoing, ever changing. The rivers of the planet carry 20 billion tonnes of land down to the sea each year. A river in spate can change its banks overnight. Meanders alter, lakes form, deltas grow. They are the lifeblood of the land, flexing, breathing, shifting. 'In the same river we both step and do not step,' wrote Heraclitus, a reflection on their constant yet ever-changing nature. Is any other part of the earth so animate? Perhaps this is why they draw us so.

Whilst rivers are ancient, the majority of the planet's lakes are young. Those formed by rifting (shifts in the tectonic plates), such those of Southern Africa, can be many millions of years old, and extremely deep and large. Lake Baikal, the deepest, oldest lake in the world, holds nearly as much water as the five Great Lakes combined, 22% of the earth's

fresh surface water, and was formed 30 million years ago. But most were carved out during the last Ice Age, 14,000 years ago, as retreating glaciers exposed the basins they had gouged into the land, which then filled up with meltwater. This is why most lakes are found in the northern hemisphere, within the extent of the last glacial maximum. Geologically speaking, all lakes are temporary, gradually filling up with sediment and becoming marsh, or reaching a point where they overspill their basin. In the Arctic, as the permafrost melts, lakes are seeping away into the newly porous ground. Lake Beloye in central Russia made headlines in 2005 when it disappeared literally overnight. It is presumed to have been sucked into an underground cave following subsidence on the bed, but to this day no one is really sure where it went.

'Usually, fall is the good time to go to the Brazos [northern Texas, USA], and when you can choose, October is the best month – if, for that matter, you choose to go there at all, and most people don't. Snakes and mosquitoes and ticks are torpid then, maybe gone if frosts have come early, nights are cool and days blue and yellow and soft of air...Most autumns, the water is low from the long dry summer, and you have to get out from time to time and wade, leading or dragging your boat through trickling shallows from one pool to the long channel-twisted pool below, hanging up occasionally on shuddering bars of quicksand, making six or eight miles in a day's lazy work, but if you go to the river at all, you tend not to mind. You are not in a hurry there; you learned long since not to be.'
John Graves, *Goodbye to a River: A Narrative* (1959)

Right, the braided
channels of the
Dezadeash river
flowing through the
Yukon, Canada.

When much of the land was still
wild, rivers would often have provided
the simplest way of travelling through a
landscape, a thoroughfare through the
endless forests, drifting down in rafts,
poling up in dugouts. (It is said in the Native
American stories of the northwest Pacific
coast that once all rivers flowed both ways,
downstream on one side and upstream
on the other, but the human-animal figure
Raven decided that this made everyone's
life too easy, and fixed it so that they
only flowed in the direction of the sea.)
In places that endure as wildernesses,
river travel remains the easiest way to go:
the Yukon is used by remote indigenous
communities as their highway, by boat in
summer, and in winter by dog sled or, these
days, by snowmobile.

As people spread and settlements
grew, lives would have been shaped
around water. Cities such as Glasgow and
Vancouver are thought to have been sited
for the great salmon runs that would have
swum past every year, an annual glut of
protein that would have fed their early
residents. It is impossible to overstate just
how much a river would have provided, in a
way that we fail to appreciate today when
our water is incarcerated in pipes. Drinking
water, transport, bathing, irrigation, waste
disposal, powering watermills, essential in
making everything from metal to cloth.

Yet for as long as we have been
using rivers, we have been abusing them.
Redrawing their boundaries to suit our
needs, canalising, channeling, constricting.
As cities grew, rivers began to be seen

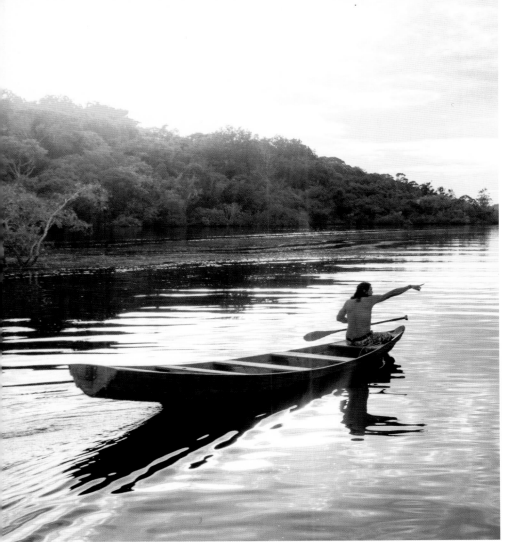

Left, life on the
Amazon river, which
flows from Peru
through Brazil.

less as the givers of life, more as workhorses that could endure limitless toil and abuse. For centuries, pollution and effluent were discharged into what appeared to be a convenient channel for waste disposal. In the Peruvian city of Iquitos, I watched residents throwing their waste into the Amazon, sending it downriver to Brazil: someone else's problem. By some estimations, rivers contribute as much as 2.4 million tonnes of plastic waste to the oceans every year. In Alaska, I was told: 'The Canadians shit in our water, so we're going to take their fish.'

But the water doesn't simply carry the waste away, for some distant ocean to deal with: such treatment has local repercussions. In 1957, London's Natural History Museum declared the Thames biologically dead, with no oxygen and no fish to be found in it. The Cuyahoga River in Cleveland has caught fire at least 13 times, the legacy of the manufacturing plants that line its banks. And here is Jonathan Swift, in 1710, writing about the River Fleet, which was once one of the Thames' major tributaries, large enough to drive watermills and transport cargo ships across the city:

'Sweepings from butchers' stalls, dung, guts and blood
Drown'd puppies, stinking sprats, all drench'd in mud
Dead cats and turnip tops, come tumbling down the flood.'

If you look at a map of London today, you will not see the Fleet. Fleet Street bears its epitaph. Through a grille in the pavement outside the Coach pub on Ray Street in Clerkenwell you can hear a gurgle of waters in the darkness below, one of the last clues to its existence. As the waters became ever more foul, and in the search for ever more land to build on, the Victorians covered it over. The 19th century saw many urban rivers culverted, entombed beneath the cities' pavements. In Bradford, northern England, there are those who swear that they can hear the Beck behind their basement walls.

But things are changing. There is a growing movement among town planners across the world to bring buried rivers back to the surface. It is known as daylighting. In Zürich it is enshrined in law, and has been going on for 30 years, but elsewhere it is a more recent phenomenon. Sheffield is a city of seven rivers, stretches of which are gradually being uncovered. In Seoul, the Cheonggyecheon Stream is a 3.6-mile (5.8km) artificial stretch of waterway fed by the city's underground river, and has transformed a rundown area once synonymous with crime to a place visited by many thousands of residents each day.

A 2011 paper by Thomas Wild *et al* found that removing the concrete over rivers had concrete effects: 'ecological benefits, reduced flood risks, recreation for local communities and a stimulus for regeneration'. In a warming world, city planners are increasingly preoccupied by flooding, 'deculverting' rivers is one way to

manage this. Rivers also help to cool cities down. With these tangible improvements comes another, broader benefit, perhaps best articulated by Tom Mansell, stormwater project engineer at Auckland city council, in New Zealand, which exposed one of its streams in 2014. 'You then find that people actually care about and want to look after the river a lot more,' he said. If people are not insulated from nature but instead experience it, they care. And what better way to expose an urban population to nature than to uncover what already lies beneath their very feet.

Culverting is one thing, but there is nothing that can so dramatically change a river as the addition of a dam. Dams are some of the largest artificial structures on earth, and cause some of the greatest ecological changes. Earth dams are as old as Egypt, but it was in the 20th century that their construction boomed; 45,000 large dams now provide almost one sixth of the world's electricity, and many more are planned. In a world that urgently needs to reduce carbon emissions, hydroelectric is often seen as an answer, but the environmental impacts can be devastating.

Dams exacerbate floods and droughts, destroy habitat for birds and other wildlife, and erase human settlements from the map. They alter ecosystems and halt the migration of anadromous fish – those that swim upstream to spawn. The Grand Coulee dam, on the Columbia River in the US state of Washington, has been called 'the single most destructive human act towards salmon of all time'.

Yet, as with daylighting, there is now a growing movement for dam removal. From the Kuma in Japan to the Loire in France, rivers are being allowed to breathe again. The largest project to date was on the Elwha River in Washington, USA. Two dams were removed in 2012 and 2014, and by 2016 there were almost 40,000 salmon fry heading out to sea. A century ago, before the dam went in, salmon numbers were ten times greater, but perhaps one day the river

can make a full recovery. On the Danube's delta in the Ukraine, the removal of dams saw fish and otters return in the very first weeks of liberation. 'It's amazing how quickly Mother Nature can recover,' Maxim Yakovlev, one of the team involved with the project, told the Guardian newspaper in 2019. 'She just needs a helping hand sometimes.'

We are coming to understand just how entangled rivers are with the land they flow through. There is perhaps no better example of this than the journey made by salmon. Salmon spend their adult lives at sea, growing fat on the ocean's bounty – the king salmon can reach 100lb and more – fuelling up for their final journey. Then, in the last months of their lives, they return to the river in which they were born and make their way upriver, heading for the exact same places where they hatched, to spawn and then to die.

A handful make it. But many more end up sacrificing themselves for a

greater good than their own next generation. Grizzly bears must add 50% to their body fat before they den for the winter, and how well fed they are directly influences the number of cubs they will have next spring. Bear density can be 80 times higher in places where there are salmon. They can polish off 40 salmon in eight hours, although faced with such a glut, they will generally select only the choicest, most calorific parts: the brain, the belly, the eggs. The rest of the fish they sling away, and left back in the scrub these remains descend the pecking order. Bald eagles, ravens and gulls feast on them. The smaller mammals chew the carcasses, then the birds and beetles. The insects that clean up the remaining scraps of meat pollinate the flowers that grow along the river beds. Maggots hatch inside the rancid flesh, breaking the salmon down into the soil.

It's at this point that the most remarkable consequence of a healthy, abundant salmon population can be measured. For where the salmon runs

HOW TO SWIM IN RIVERS AND LAKES
Rivers and lakes can be extremely cold. If you're new to the practice, plunging straight in midwinter is not the best idea. Ease yourself in gradually, and stay within your depth. Best is to start swimming in the summer months and keep it up as the temperature drops – your body soon adapts.

Whatever you might look like, a swim hat (or two) and neoprene gloves and socks can help greatly as the body pulls your heat towards its core. Should it be warm enough to swim naked, remember that attitudes to (and laws about) nude bathing vary around the world; if you do feel able to go for a 'skinny dip', have a bit of respect for what those around you may not want to see.

Books and swimming clubs provide some inspiration. Learn the signs of hypothermia, and how to look out for them. Don't push yourself and if you're swimming alone inform others of your plans.

© ClickAlps / AWL images. © Przemysław Kłos / EyeEm / Getty images

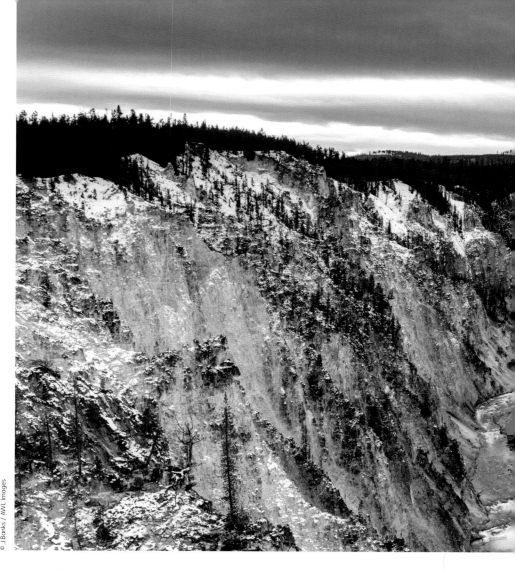

© J.Banks / AWL Images

OTTERS' TALES
'Twilight over meadow and water, the eve-star shining above the hill, and Old Nog the heron crying kra-a-ark! as his slow wings carried him down to the estuary.' So begins *Tarka the Otter*, Henry Williamson's fictional account of the life of Tarka, a wild otter who lives in the 'country of the two rivers', the Taw and Torridge in North Devon. With *Ring of Bright Water* by Gavin Maxwell, it's one of two classics of nature writing to feature otters, both relating dark and tragic tales in seductive prose.

Williamson's story was first published in 1927 (and published in the US in 1928). *Ring of Bright Water*, set in Scotland, came later, in 1960, and was a true story. Both books inspired new generations of nature writers and if you wish to get even closer to the creatures, you can follow the 180-mile (290km) Tarka Trail cycle route along the rivers and shores of beautiful North Devon, perhaps to spot an otter,

are thickest, the levels of carbon, nitrogen and phosphorus found in the surrounding soils, carried from the ocean to the land in the salmon bodies, can be higher than commercial-grade fertilisers. The trees draw up these nutrients and rely on them so completely that I met biologists who told me they could gauge the state of a salmon run by observing the surrounding forest. Spruce and willow grow up to three times faster around salmon streams; the years when the runs have been bad are echoed in the tree rings. And a study by Katsuhiko Matsunaga at Hokkaido University has shown how fallen leaves leach acids into streams and rivers, and ultimately fuel the growth of plankton in the oceans. More plankton, more salmon – and so the cycle turns again.

Such interdependence is not unique to the boreal forests of the north. One of the more unlikely videos to go viral in recent times is a short YouTube segment entitled 'How Wolves Change Rivers', which has now had more than 40-million views. It tells the story of the wolves that were reintroduced into Yellowstone Park, USA, in 1995, and the subsequent changes. The park had become badly deforested from the constant browsing of the elk whose populations were exploding without any predator to keep them in check. The wolves not only reduced elk numbers, but kept them skittish and on the move, away from the river valleys where they had no clear line of sight. And as the trees grew back along the river banks, the birds returned, and the beavers. The beavers built dams that

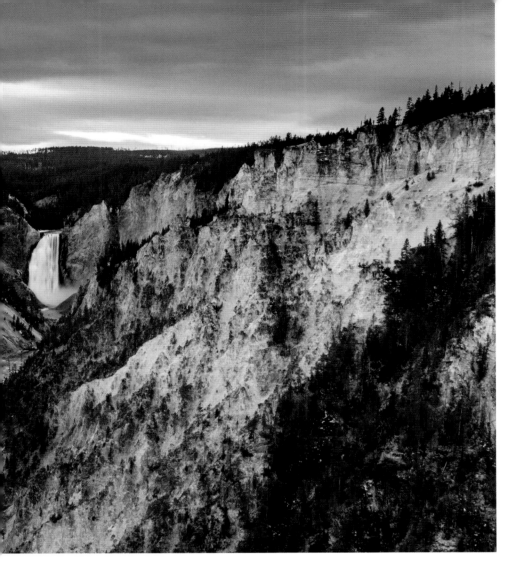

created the pools favoured by other sorts of creatures: otter, duck, fish, the reptiles and amphibians, all of which began to repopulate the waters. As the roots of the trees shored up the banks, the rivers became more sinuous, forming in slower-flowing pools that in turn attracted more wildlife. 'The wolves,' says the narrator, British environmental writer George Monbiot, 'changed the behaviour of the rivers.'

The abuse of rivers continues. One need only look at the Yangtze's eutrophication (the dense growth of plant life often caused by excessive agricultural run off), or the rise in liver cancers amongst those who take their water from the Sarno in Italy. But, across the world, there are those who are trying to turn it around. And despite their centuries-long mistreatment, rivers are often able to bounce back surprisingly quickly. Thirty years ago, the poor condition of many of Britain's waterways contributed to its reputation as the 'Dirty Man of Europe'. But in recent years, salmon have been seen in city centres and seals in the Thames. Otters were almost extinct in Britain by the 1970s. Hunted by fisheries managers and poisoned by DDT insecticide running off the fields, they vanished from many rivers entirely. But a ban on both DDT and hunting otters has led to a gradual comeback. In 2011 the Environment Agency announced that otters have now returned to every county in England.

As we learn to be better stewards of our rivers, we are also realising that they bring benefits beyond the merely utilitarian. Kenwood Ladies'

Pond officially opened in 1925, although women have been swimming there for far longer than that. One of three ponds set aside for swimming on Hampstead Heath in North London, it is a tree-fringed, murky pool across which ducks and swans carve gentle arcs at dawn. In the summer months it can be heaving with women bathers and sunbathers; but come winter the numbers dwindle to a hundred or two hardy swimmers who make their morning pilgrimage to immerse themselves in the shocking cold. Some of them are well into their 80s, pattering across the concrete in neoprene socks as the morning mist rises off the water. Undoubtably it is a salve, a sanctuary of nature in London's urban sprawl, a moment to connect with the more-than-human world. But there is more going on than that. Julia Dick, 63, co-chair of the Ladies' Pond Association, told the *New Yorker* magazine recently: 'It's a welcoming space. The pond can support you through crises. It helped me with the death of my parents. And with menopause, all the mood changes.'

Swimmers have always known that cold water is good for you. In his seminal treatise *Waterlog*, Roger Deakin documented his journey swimming in the rivers, ponds, canals and lakes of the British Isles. 'Natural water has always held the magical power to cure,' he wrote. 'I can dive in with a long face, and what feels like a terminal case of depression, and come out a whistling idiot.' Now there is increasing scientific evidence to corroborate the apocryphal. In 2018, the *British Medical Journal* published

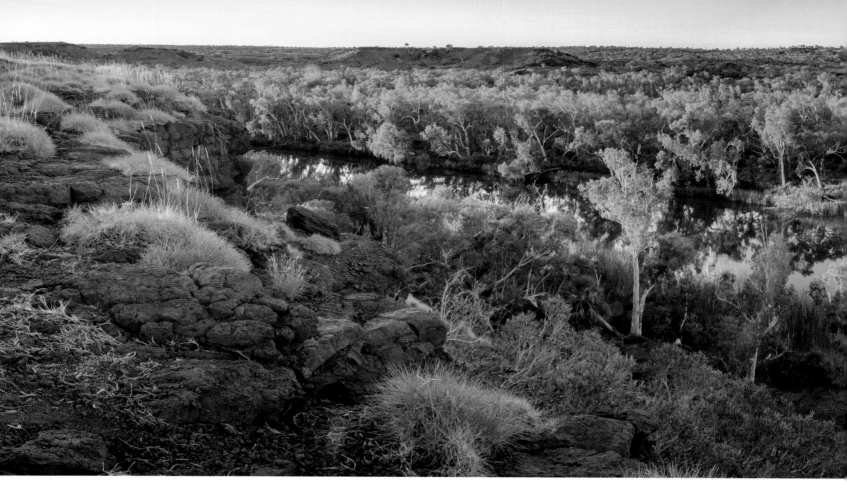

a study entitled 'Open water swimming as a treatment for major depressive disorder,' a case study of a 24-year-old woman who had found antidepressants ineffective for several years, before embarking on a weekly programme of cold open-water swimming. 'This led to an immediate improvement in mood following each swim and a sustained and gradual reduction in symptoms of depression, and consequently a reduction in, and then cessation of, medication,' the authors reported. 'On follow-up a year later, she remains medication-free.'

Cold water reduces stress hormones such as cortisol and boosts the hormones that make us feel happy: a Czech study in 2000 found that immersion in cold water raised dopamine levels by 250%. It reduces inflammation in the body, which has been linked to certain depressive disorders. Couple that with the growing understanding of the broad health benefits derived from being immersed in the outdoor world, and what better way is there to immerse yourself in nature than by jumping into it? Perhaps it is this that has led in recent years to the sudden boom in 'wild swimming' (what was once called 'swimming') and a proliferation of books on hidden swimming holes, swimming clubs, white

bums and anarchic shrieks from the forest. It is, to me, the swiftest, most complete way of connecting with a landscape – I often don't feel I have arrived somewhere until I have plunged in to its waters and washed the city off. The possibility of being naked beyond the confines of one's own house is another part of the charm, as is the wild childishness of splashing about in silky, icy water. It is not about endurance, nor athletic prowess. It is about a total immersion in the present.

There are ways to experience a river that allow you to keep your clothes on. Rivers suggest journeys, alternative lines on maps, ones that have worn the truest route across the landscape for millennia, much as a pair of boots will eventually erode a path. Since I began to travel rivers, it is as though maps I look at have grown another layer, their blue lines calling out. To stand at a river's source is to feel a journey's tug, the water already urgent for the sea.

When I canoed the Yukon River in 2016, there was a swimmer a few days ahead of me. I never met him, but I heard stories from bewildered locals who had seen him passing through. Several people took their boats out to try to stop him drowning; he waved them away with a smile.

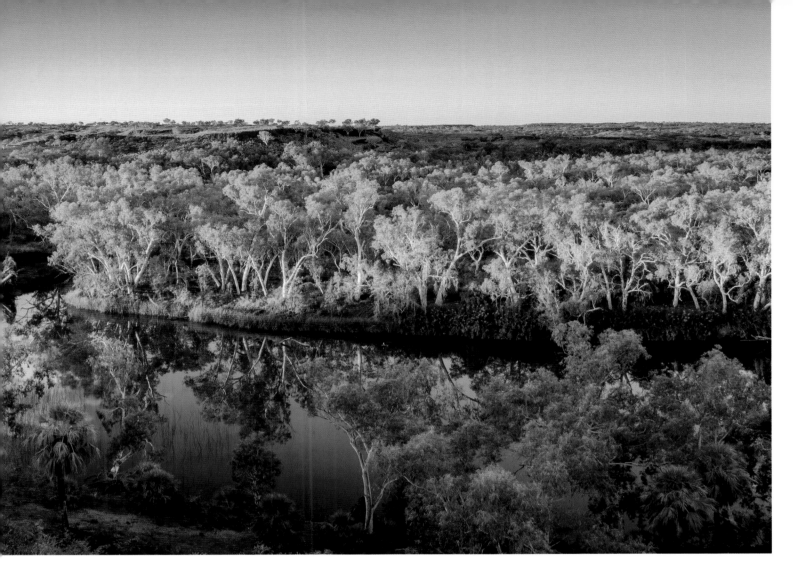

One man nearly shot him because he thought he was a moose. Denis Morin, the swimmer, retired in his fifties from his high-pressure tech job in Quebec City, sold everything he had and caught a plane to Whitehorse to begin his 75-day, 1990-mile (3200km) swim. 'I think it was more about changing my rhythm of life,' he said.

I live on a hundred-year-old Dutch barge moored on the River Lea in London. In one of the world's largest, busiest cities, life on the canals is at an utterly different pace. There is time to watch the ducks, to stop a neighbour for a chat. And, whether in the boat, canoeing or kayaking, swimming or lounging, time I have spent on other rivers leads to an inevitable slowing down. You stare at the water for long enough, when you raise your eyes it is the land itself that seems to move. A canoe is a wonderful way to travel. Between rapids, you need do nothing more than sit back and float, and let the river take you. Make a coffee in the boat, look out at the scenery. I find myself readjusting, recognising bird song, being able to distinguish between different trees simply by how their leaves move in the wind. It is a pace that forces us to notice.

Part of a river's healing power, I think, lies in its possibility for metaphor. In *The Fish Ladder*, Katharine Norbury sets out, with her daughter, to follow a number of rivers from the sea up to their source. Her initial purpose is as a diversion from the sorrow of a miscarriage the previous year, but as she walks through her grief she finds herself on a journey to the very source of life, and to 'places in the heart that [she] simply hadn't imagined could exist'. There is something in a river, in its meandering course to an unshakeable destination, that allows it to map on to life's journey.

Taking such journeys can have true transformative effects. Pilgrim Bandits and Higher Ground

Above, plants and birds thrive around the Fortescue river in the Pilbara desert of Western Australia.

Left, the Gokyo lakes, fed by some of the largest glaciers in the Himalaya.

are groups that work with traumatised military veterans. One way they do this is by embarking on multi-day paddling trips down wild and challenging rivers. In *The Nature Fix*, writer Florence Williams joins an all-female group of former veterans, all suffering from PTSD, many of whom are scarcely able to leave the house or to look after themselves in the most basic of ways, and yet who, after a week in a raft, are able to reconnect to parts of themselves they believed were lost forever.

We are at last remembering to appreciate our rivers and lakes, but today they are facing a new era of threats in a warming world. Lake Poopó in Bolivia was the country's second largest, but now the boats that were moored in its shallows lie keeled over on an Andean plain many miles from any water. Seventy five species of bird have forsaken the area, and so have many thousands of people. The threats to it are severe: the glaciers that once fed it have shrunk, there are the droughts caused by El Niño, and its remaining waters continue to be diverted for agriculture and mining. Lake Poopó may never return.

At the other end of the spectrum, melting glaciers in the Himalayas are leading to lakes becoming dangerously full. Imja Tsho is a lake which did not exist until 70 years ago, when meltwater began collecting at the foot of Imja Glacier, held in place by a terminal moraine. In 2009 it was described as one of the fastest-growing lakes in the Himalayas, and fears grew about the integrity of its dam and the threat posed to downstream communities. In 2016, the Nepalese army spent six months, and $3 million, draining it to a safe level. Yet many other surrounding lakes present similar problems, and they will only worsen as the glaciers continue to melt.

Who knows what the future holds? What is clear is that our rivers and our lakes are as dynamic as they ever were. And how they will change will impact not only on the planet, but also on our communities and how we think about ourselves.

I don't know who God is exactly.
But I'll tell you this.
I was sitting in the river named Clarion, on a water splashed stone
and all afternoon I listened to the voices of the river talking.
Whenever the water struck a stone it had something to say,
and the water itself, and even the mosses trailing under the water.
And slowly, very slowly, it became clear to me what they were saying.
Said the river I am part of holiness.
And I too, said the stone. And I too, whispered the moss beneath the water.
I'd been to the river before, a few times.
Don't blame the river that nothing happened quickly.
You don't hear such voices in an hour or a day.
You don't hear them at all if selfhood has stuffed your ears.
And it's difficult to hear anything anyway, through all the traffic, the ambition.
Mary Oliver, from *At the River Clarion*

ALASKA, USA

Yukon River

North America's longest free-flowing river is home to the greatest salmon run in the world.

Right, the Yukon's headwaters rise in British Columbia before flowing through the Yukon and into Alaska.

There was a scheme to dam the Yukon in the 1950s. It would have created the largest artificial lake on the planet, a record it would still have held today. It was one of Alaska's formative environment battles, the first time in American history that campaigners successfully defended a river on the basis of its wildlife. The Yukon remains the longest free-flowing river in North America. There is one small dam near the headwaters, a single hiccough at Whitehorse, and from there it runs unimpeded 2000 miles (3200km) to the sea.

The Yukon traverses some of the remotest country on the planet, rising high in the mountains of Canada, flowing across the border into Alaska and bisecting the state west to east, before emptying into the Bering Sea. It is vast, two to three miles (3-5km) across in places; where it meets the ocean, it is seven miles (11km) from bank to bank. Its name derives from the indigenous Gwich'in phrase *chųų gąįį han*, 'river of white water'. The headwaters are a swimming-pool blue, but as tributaries meet it it becomes a milky, soupy brown, laden with silt rubbed from mountainsides, so murky that you can see scarcely a knuckle deep when you place a finger it in. Many people have been drowned as their boots and pockets fill with silt.

Its remoteness makes it home to what remains a fully functioning ecosystem. Thousands of miles of unbroken spruce forest

© Robert Postma / Design Pics / Getty Images

There are five species of Pacific salmon breeding in the Yukon, but it is the king salmon which travel furthest, swimming 2000 miles (3218km) upriver to the exact pools where they were born, to spawn and then to die. They navigate by smell, searching out the particular chemical composition of the waters of their birth.

For millennia they have been a vital food source to the many indigenous groups that live here, as well as integral to the ecosystem. There are over 50 different mammals that feed on kings, and as their nutrient-rich carcasses break down their minerals are drawn up into the trees. But for various reasons they are now in serious decline, calling into question not only their own future, but the lives of all those who depend on them.

Right, the Yukon squeezes through Miles Canyon near Whitehorse; overleaf, the Yukon's source are glacial lakes.

full of wolverine, wolf, lynx, grizzly bear, golden eagle, bald eagle, black bear. And yet there are also many people who live along its banks. Some are isolated individuals, eking out tough lives in log cabins, but for the most part it is villages of indigenous groups: Tlingit, Tr'ondëk Hwëch'in, Athabaskan, Yupik. Many are hundreds of kilometres from the nearest road system and the Yukon is their highway, travelling by boat in summer, and in winter when the river freezes and temperatures hit 40 below, by dog sled, or more typically now, by snowmobile. These people have made their lives along the Yukon not just for ease of travel through the bush, but for the great runs of salmon that flow up it every year. Summer is a busy time, with whole families coming together at ancestral fishing spots to set their nets for the coming runs. They catch, prepare and smoke the fish in readiness for the brutal winters, as they have done for generations.

Yet the ice is not as dependable as it used to be. Since the end of the 19th century, gamblers in Dawson City have bet on the moment that the ice breaks up as a good way to see in spring: a tripod erected on the ice, attached by a wire to a clock, falls and trips a switch when the ice beneath it shifts. Each year the moment has been recorded in a ledger, and it shows that spring is coming earlier and earlier. With the increasingly violent break-ups that result from hotter weather, there are more severe floods. There are frequent stories of hunters who know the land intimately disappearing through the ice in recent years, their many years of acquired knowledge no

longer dependable in a climate that is warming twice as fast as the rest of the planet. Their bodies are rarely found.

The section between Whitehorse and Dawson City is one of the most travelled, and most beautiful. The river races along, its currents eddying and swirling. It is a couple weeks' float (or a mere two days for competitors in the Yukon River Quest, surely one of the most gruelling paddle races in the world) and there are various outfitters in Whitehorse who can rent you a canoe and pick you up at the far end. It is down this stretch of river that 100,000 prospectors travelled in 1896, when news of gold nuggets the size of walnuts in the Klondike lured in men from across the world. Remnants of that invasion still litter the river banks, rusting hydraulic machinery, old cabins, ancient paddle steamers: coming across one of these vast boats rotting on a wooded island is like stumbling across the remains of some ancient Inca temple, a memory of another time when the river thronged with life. Most of the men left, empty-handed, a few short years after they arrived, but the legacy of the Gold Rush is still celebrated in Dawson, where you can try your hand at panning before visiting the nightly cancan shows or sampling the infamous Sourtoe cocktail in the Downtown Hotel (a shot of liquor with a severed human toe as garnish).

 There are direct flights to Whitehorse from Germany during the summer months. As an alternative to flying, it is a long, but incredible, drive from Vancouver through the Rockies. The Yukon is frozen solid between October and April, so if you're intending to paddle you'll want to plan a summer trip. Summer months also mean almost endless daylight, good weather and a necessity for mosquito spray. Kanoe People and Up North, both based in Whitehorse, will rent you a canoe and all the necessary gear for a float down the Yukon to Dawson City. You can camp anywhere along the river where you can sensibly put a tent. You'll need to carry all the food for the trip with you. Educate yourself about bears before you go.

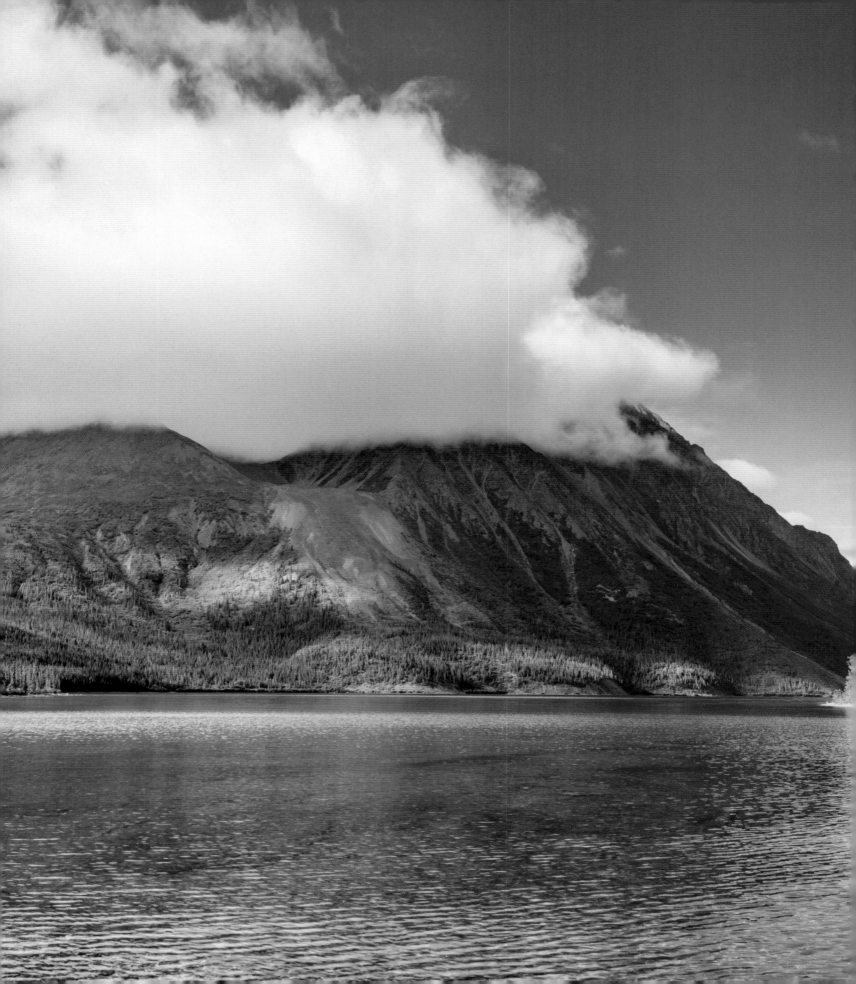

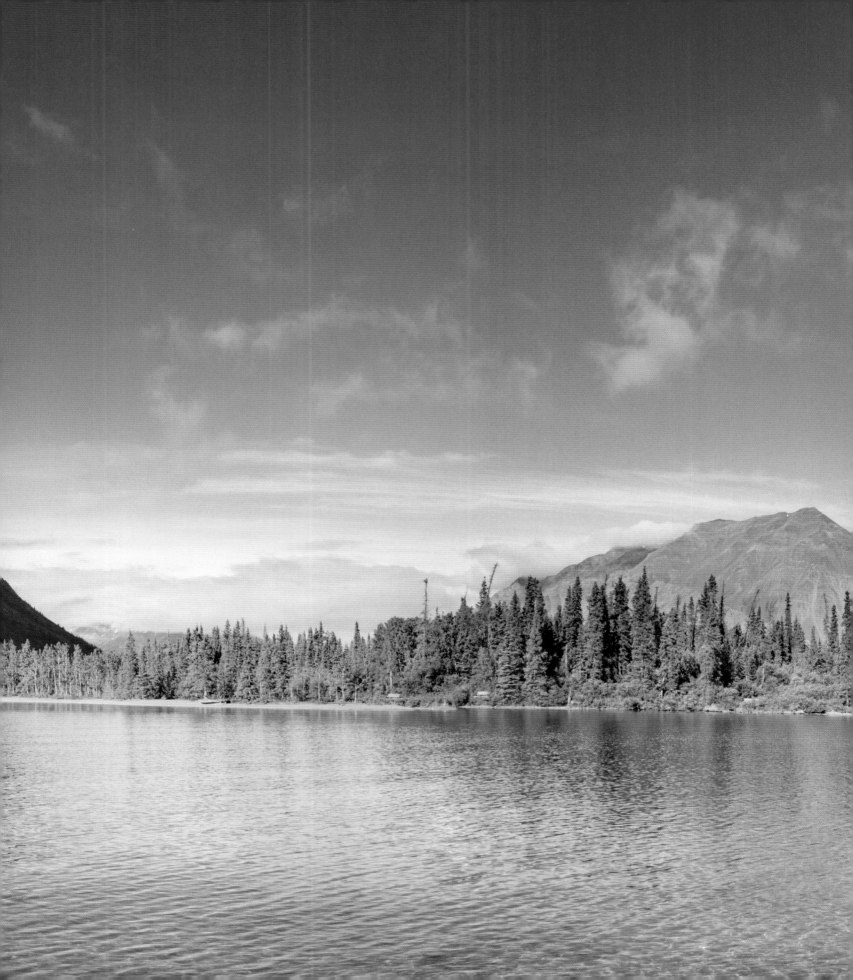

SCOTLAND

Spey River

Speyside waters flow through two-thirds of Scotland's malt whiskies and provide one of the best paddling experiences in Britain.

Bill Mason, the legendary Canadian canoeist, made it a rule not to paddle on water that he wouldn't also drink. It is uncertain whether or not he had the Spey in mind. The river rises high in the Monadhliath Mountains before carving a northeast diagonal towards Spey Bay and the North Sea. For centuries its water has been the raw ingredient of the majority of Scotland's whisky.

Over two-thirds of the malt whisky produced in Scotland, made in more than 50 different distilleries, comes from Speyside, that region of the Highlands comprising the River Spey and its tributaries. It is as though nature has conspired here to produce the perfect conditions for an excellent single malt: the purest water in the country, flowing over peat terrain; the most fertile land for growing barley; the perfect climate for both the condensing of the spirit and for whisky maturation. Plenty of the distilleries offer tours and samples. Until the railroads came in the mid-19th century, the Spey Valley's remoteness had the additional benefit of being far off the radar of the 'gaugers' – the excise men – and that allowed the many illegal stills in operation to remain unnoticed.

It feels as remote today. Despite main roads running much of the valley's length, on the river it is a different, quieter world. Once the Spey supported much local industry, from logging to boatbuilding, salmon fishing to droving, but most of that has gone now. Yet it remains one

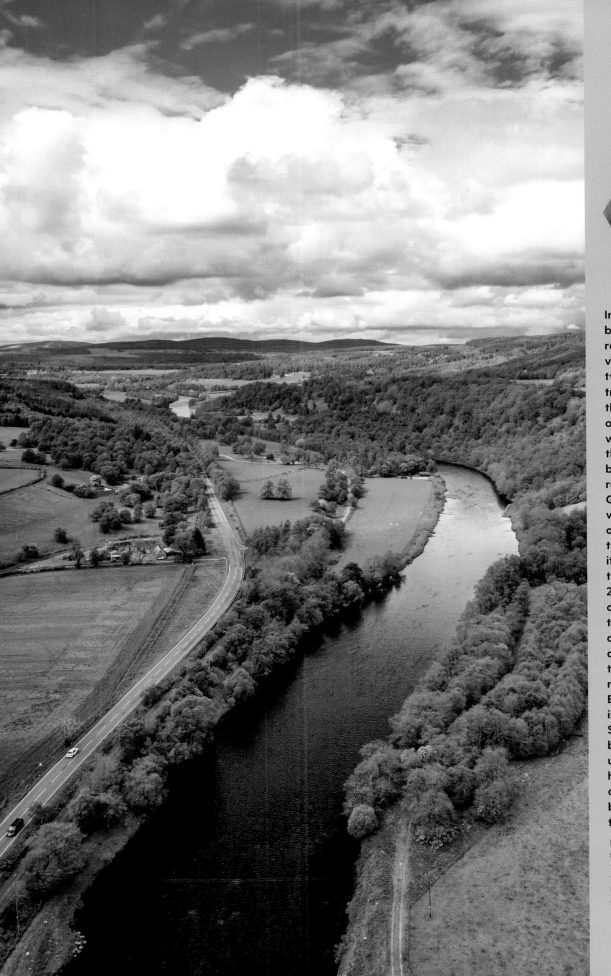

In 1822, George IV became the first reigning monarch to visit Scotland in almost two centuries. The royal trip did much to create the romanticised image of the Highlands that would persist through the Victorian era and beyond, including the reputation of its whisky. George tasted an illicit whisky being distilled on the River Livet, a tributary of the Avon, itself a tributary of the Spey, and where 200 illegal stills were operating. Taken by the spirit, unavailable outside the Highlands, he asked his Chamberlain to secure a supply, and next year he passed the Excise Act. Farmer and illegal distiller George Smith was the first to be granted a licence under the new act for his Glenlivet distillery, and today it is one of the best known whiskies in the world.

Left, the A95 road follows the course of the River Spey, making access easy for visitors.

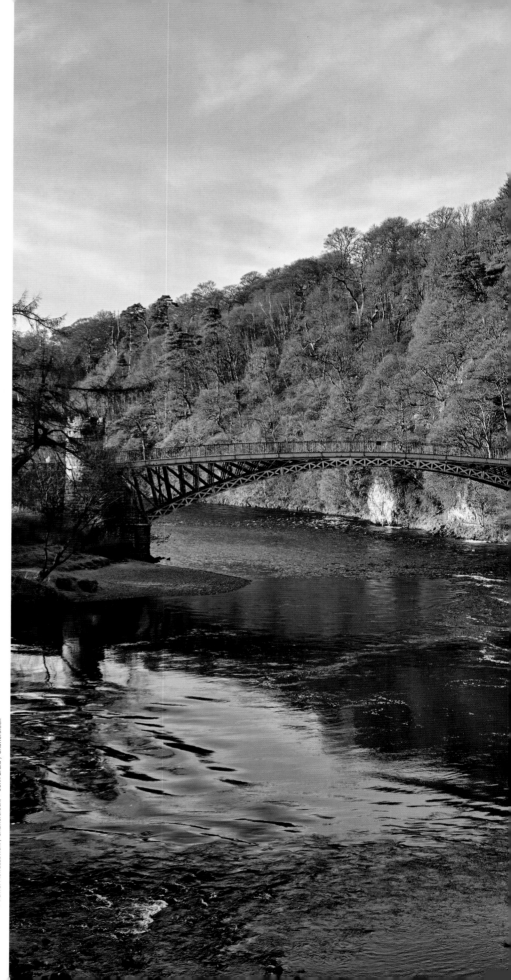

Right, Craigellachie Bridge over the Spey was designed by Thomas Telford and built from 1812.

of the most important salmon and sea trout rivers in Western Europe, and you can expect to see herons and fly fishers in waders, submerged up to their waists, as you travel down its length. Sport fishing brings in £8 million a year, and patrols of bailiffs keep a sharp eye out for any piscine poachers.

The Spey is Scotland's third-longest river, and it is one of the best canoe trips in Britain. It is also Britain's fastest-flowing river, and unusual for speeding up as it gets closer to the sea. It is swift enough to not meander, but instead shoulders a straight line across the landscape, its banks constantly shifting in its urgency for the sea.

Paddling from Lochain Uvie to Spey Bay is 84 miles (135km), a comfortable trip in four or five days. Some of the rapids sound intimidating, the Knockando and the Washing Machine, but they never exceed a grade 2, which means that the whole journey should be possible for any paddler with a bit of experience: bumpy enough to keep things exciting, yet never too much of a challenge. But if canoeing doesn't take your fancy, the Speyside Way, a 66-mile (106km) hike, follows the river from Aviemore to the sea, in many places using the now defunct railway lines. And every summer there is the bracing River Spey 10k Whisky Swim from Kingussie to Loch Insh.

The Spey makes its way through a succession of Highland towns – Newtonmore, Kingussie, Aviemore, Grantown-on-Spey – as it traces the western edge of the Cairngorms National Park, its dark mountains a backdrop to the river for much of the Spey's length. Away

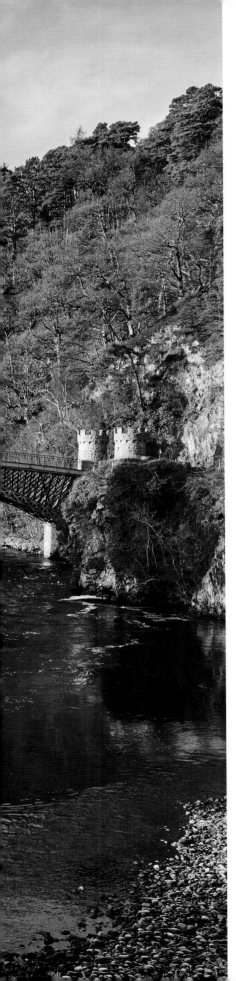

Right, Macallan was one of the original Speyside distilleries, its new visitor experience opened in 2018 and cost £140m.

from the towns is some of the best country that Scotland has to offer. Ospreys nest on islands in the lochs; buzzards wheel against a grey sky. Red squirrels, otters and pine martens flit through the undergrowth. Whooper swans and greylag geese, redshanks, snipe and lapwings are all to be found at Insh Marshes Nature Reserve. Bottlenose dolphins and seals come to feed in Spey Bay. The Scottish Right to Roam means that wild camping is permissible more or less anywhere, so long as it is out of sight of a road and you move on after one night. With a campfire on a sand bar, the canoe pulled up to lean against, and the seemingly endless half-light of a summer dusk, it is as much a wilderness as anyone could want.

It is the Spey's sheer abundance of water that is one more reason for the presence of the distilleries. It takes 50L of water to make a litre of whisky, three-quarters of which is used in the condensers, and is ultimately returned to the river. Yet even in a country as notoriously wet as Scotland, the climate is changing. At points during the heatwave of 2018, the Spey ran at 97% lower than its usual minimum, and some of the springs which feed it ran completely dry. Distilleries were forced to halt production. Output at Glenfarclas was down 300,000L. If carbon emissions continue unchecked, the whisky boom of the past two centuries could one day return to a trickle.

Most trips on the Spey begin at Lochain Uvie, three miles (5km) upriver from Newtonmore. The headwaters of the Spey can be paddled, but putting in closer to the source at Loch Spey means a long walk with your boat and some pretty serious rapids arounds Garva Bridge (up to grade 4). There are campsites and other places to stay in the towns along the river, but wild camping is also possible, and highly recommended. Midges are notorious small flying biting insects and their season runs May to September, with a peak in June, but is often not so bad in the east of the country. You have been warned! Various tour operators, many in Newtonmore and Aviemore, will rent boats and gear, and provide shuttles to put-in and take-out points.

PHILIPPINES

Cabayugan River

Paddle up one of the world's longest underground rivers, a cavernous wonder in the depths of one of the world's most beautiful islands.

To reach the Cabayugan River, you must travel to one of the most beautiful islands in the world. Palawan Island is the Philippines' fifth largest, but unlike some of the country's more developed spots, Palawan, a narrow sweep across the western side of the archipelago, a continuous ridge of mountains reaching up to 6560ft (2000m), is the kind of tropical paradise you might picture when you close your eyes. It regularly wins awards for the 'Most Beautiful Island in the World'. White sand beaches, lush jungle tumbling down sheer mountainsides to meet a stunningly turquoise sea, fishermen casting nets from outriggers above reefs of verdant coral.

The island has had biosphere status since the 1990s, and is home to the Puerto Princesa Subterranean River National Park. Its karst limestone cliffs are sculpted into peaks and pinnacles and precipitous shapes that meet the water in mangroves and beds of sea grass. The Cabayugan River rises in these mountains, and runs for a little over 20 miles (32km) before meeting the South China Sea. In all other respects it would be fairly inconsequential, except that, where it meets St Paul Mountain, it disappears inside the earth. For the next five miles it runs underground, and that made it the longest subterranean river in the world until 2007, when the Sistema Sac Actun was discovered in Mexico, smashing the record by around 90 miles (145km).

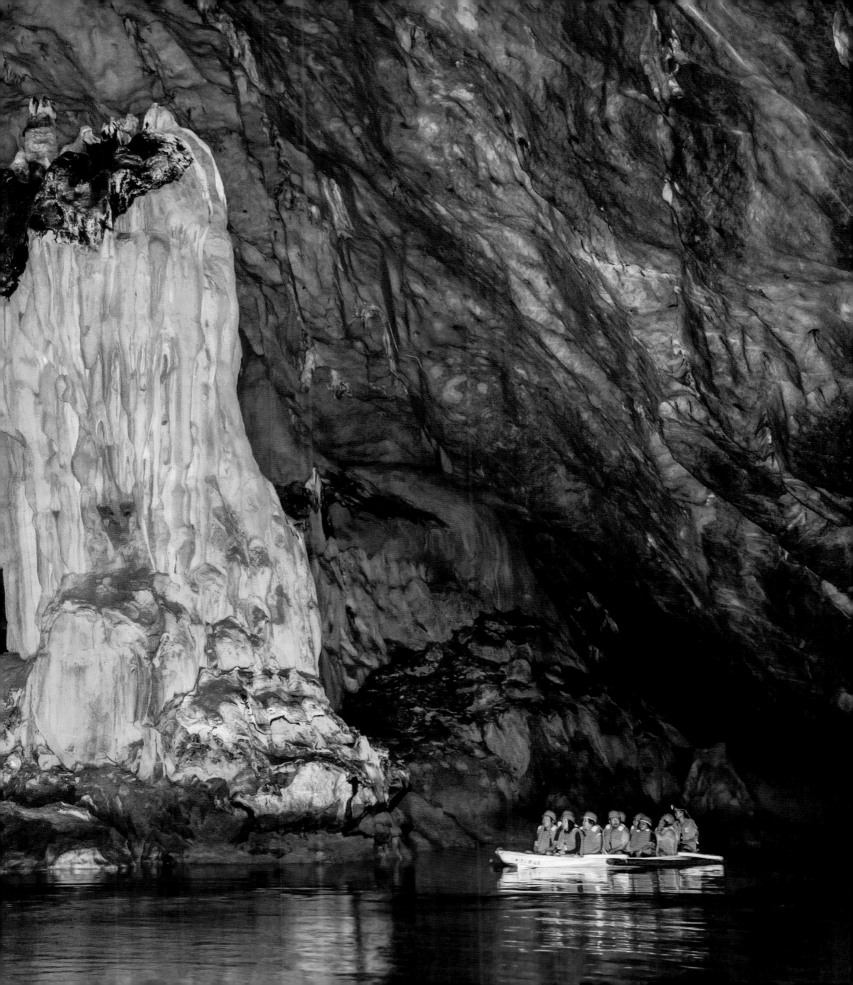

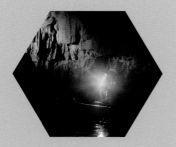

Throughout human history underground rivers have conjured a sense of the otherworldly, an antithesis of everything that we think of as a river. There is Coleridge's River Alph, in his poem 'Kubla Khan', which runs 'through caverns measureless to man / Down to a sunless sea'. Jules Verne's characters stumble upon an underground 'torrent' in their journey to the centre of the earth. They are perhaps most resonant in Greek mythology: the underworld had five rivers flowing through it, including the River Styx, at the boundary to the underworld, across which Charon ferried the souls of the newly dead. Those who could not pay the crossing were condemned to wander its banks for all eternity.

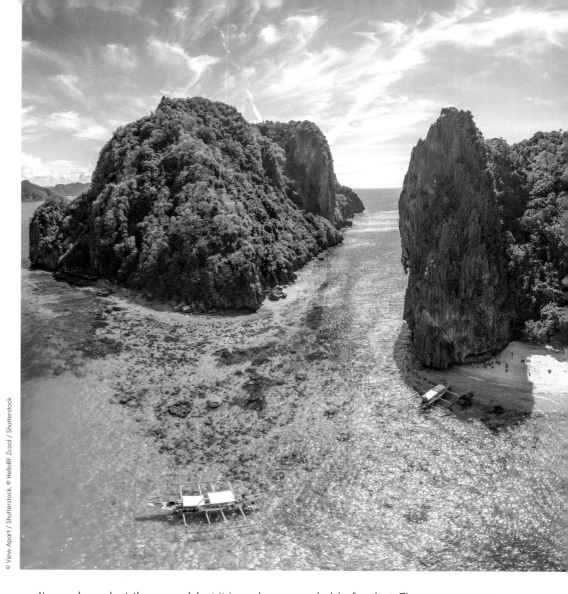

It may have lost the record, but it is no less remarkable for that. The cave system was formed 20 million years ago, and it houses one of the most varied, diverse underground ecosystems in the world. It became a Unesco World Heritage Site in 1999, and in 2011 the river was named one of the New7Wonders of Nature, a heady list that includes the Amazon, Iguazú Falls in Argentina and Table Mountain in South Africa. It is one of the very few underground rivers that directly meets the sea, and that makes it the longest subterranean estuary on the planet. The river is subject to the tides for up to four miles inside the caves, and the entrance is regularly half-submerged by rising seas – which is one reason why the river went undocumented for so long. The American zoologist Dean C. Worcester seems to be the first to have written of the river, in 1898, the first year of American rule in the Philippines. In a document of his travels, he wrote that he had become aware 'if accounts are to be believed, of a lake opening to the sea by a subterranean river'. But the accounts were not confirmed until decades later.

From Sabang, a beach town fringed by rainforest, outriggers festooned with bunting make the short crossing to Sabang beach. From there, in life jacket and hard hat, it's another short boat ride across the lagoon, and into the river itself. Hawksbill and green sea turtles paddle through the depths; cockatoos shriek overhead. Stalactites cover the entrance, some reaching as far down as the water, reflecting them back at themselves – but once inside the caves open up into vast expanses. It may be only 5 miles (8km) long, but down here that feels far longer. Some of the chambers reach as high as 197ft (60m). The Italian's Chamber, 1180ft (360m) long and

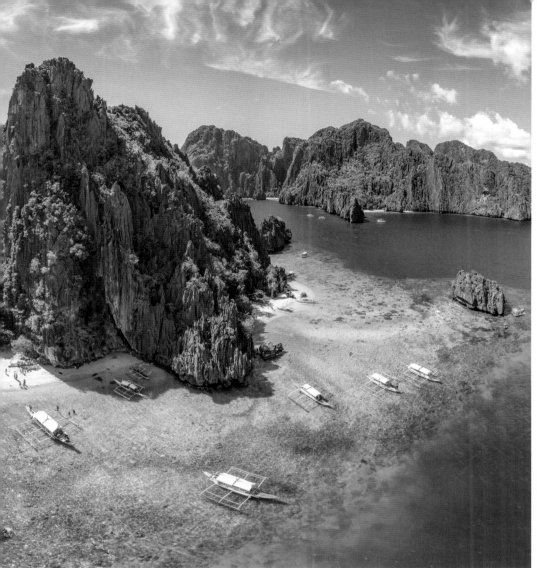

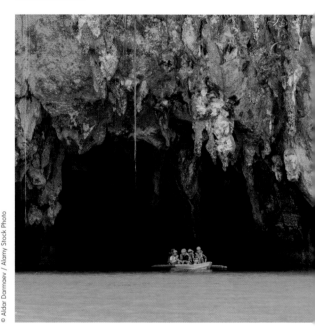

Left, karst rock formations at El Nido, Palawan; below, the entrance to Puerto Princesa river; previous page, boat tours take in the rock formations of Puerto Princesa's caves.

© Aldar Darmaev / Alamy Stock Photo

Most trips begin in Puerto Princesa, with a two-hour drive through pristine rainforest to Sabang, where either a boat will take you to the cave or you can hike the two miles (3.2km) through the jungle. You can book with a tour company, who will sort everything out for you, but if you choose to organise things yourself then you will need to buy a permit before leaving the town of Puerto Princesa.

In Sabang, permit in hand, go down to the pier to get it stamped and find a boat. There are plenty of places to stay in town, and boats from here also tour the mangroves, which is highly recommended.

262ft (80m) high, is one of the largest known in the world. In the torch beams shone by the guides, glinting off crystals, picking out enormous, otherworldly shapes, tracing fissures where river channels snake off into the gloom, you can start to get some sense of the grandeur and uniqueness of this place.

As you travel further back all becomes pitch dark and silent, except for the sound of the paddles echoing off the cave walls, and the rattle of leather wings overhead. This subterranean brackish water makes for a unique environment. There are plant species found nowhere else on the planet. The Palawan swiftlet uses echolocation, like bats, to hunt in the pitch dark and makes its nest from a mix of moss and its own saliva, gummed to the cave walls. There are nine species of bat down here, with colonies numbering in the millions. Cave crickets, whip spiders, snakes and crabs lurk in the cracks. And there are the 20-million-year-old fossilised remains of a *sirenia*, a sort of sea cow like a dugong, but one completely unknown within Asia except for this lone specimen. With a special permit you can go in to see it for yourself. Boats will paddle you up to a mile inside – from there you can only imagine. Much of the cave system still remains to be explored – who knows what else is living down here?

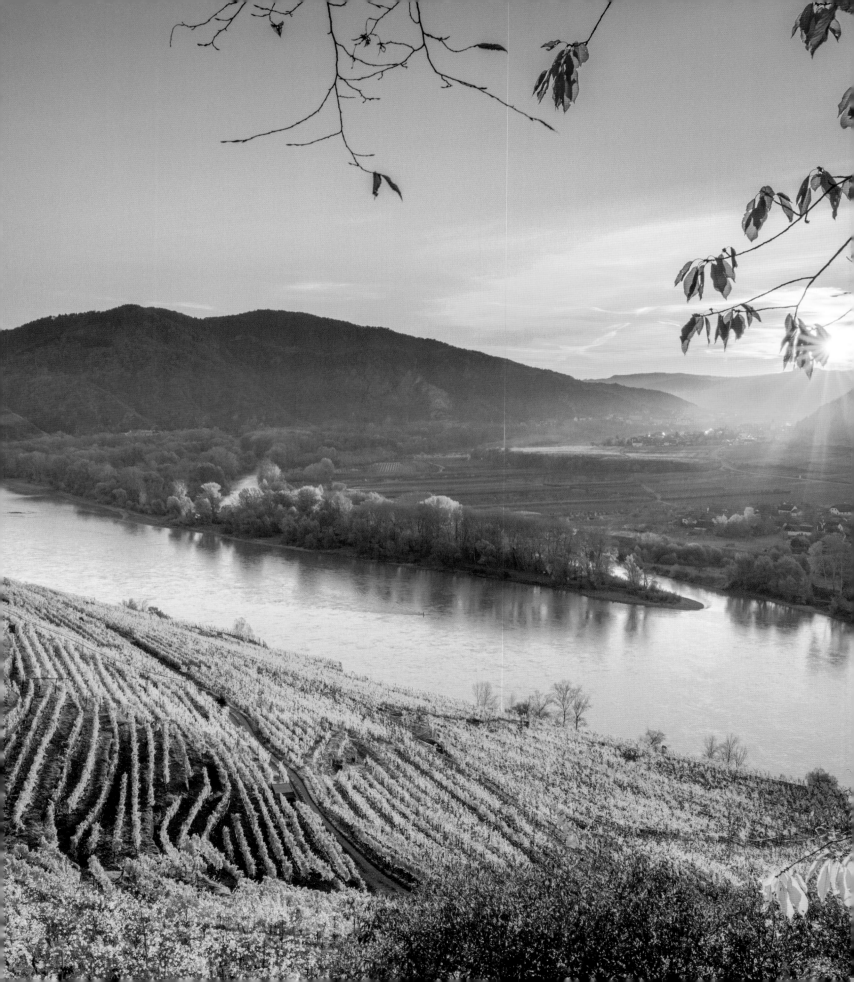

EASTERN EUROPE

Danube River

The Danube is the true itinerant of rivers, flowing through 10 countries, more than any other river in the world. Germany, Austria, Slovakia, Hungary, Croatia, Serbia, Bulgaria, Romania, Moldova, Ukraine. A trip down it is not only one of Europe's epic journeys, but a trajectory shot through thousands of years of the continent's history and people.

There are as many ways to travel it as countries that it flows through. If it's luxury you're after, on a trip themed around classical music, perhaps, or Christmas markets, then there are various river cruises lasting from a few days to the full three weeks to cover its entire 1775-mile (2850km) length. Docking in the grand and gorgeous ports of Central and Eastern Europe, Munich, Vienna, Bratislava, Esztergom, listening to opera and the obligatory Blue Danube Waltz, eating sumptuous pastries, it would be easy to imagine yourself on some grand tour of the Victorian age.

But for more of an adventure you can't beat self-propulsion. It is possible to cycle the whole of the Danube. For the first half of its length there is a dedicated cycle path that runs along the bank. Separated from traffic, almost pancake flat, and with the wind at your back, it is ideal for family trips. After Budapest the route becomes rather more conceptual. You'll need a map and your wits about you, but the deeper

Europe's second-longest river embodies the continent's rich if bloody history yet retains its wildness along its eastern reaches.

Left, the vineyards of Weißenkirchen in der Wachau beside the Danube river.

However you get there, the baths in Budapest are a must for soaking away the stresses of the journey, the waters rich in calcium, magnesium and hydrogen carbonate. The capital sits on a fault line, and there are 120 hot springs throughout the city. Alongside the pools, most offer saunas, steam rooms and massage treatments. The largest complex, Széchenyi, opened in 1913, and has 18 pools, 15 indoor and 3 outside, with floating chessboards if you fancy a game while you soak. The less-frequented Király Baths opened in the 16th century, when Budapest was under Ottoman rule, whilst the Rudas Baths, also dating from Ottoman times, includes a modern rooftop pool that looks out over the Danube.

From right, the ruins of Aggstein Castle, Austria; fishing at Saint George, Romania; overleaf, dawn at Weißenkirchen in der Wachau.

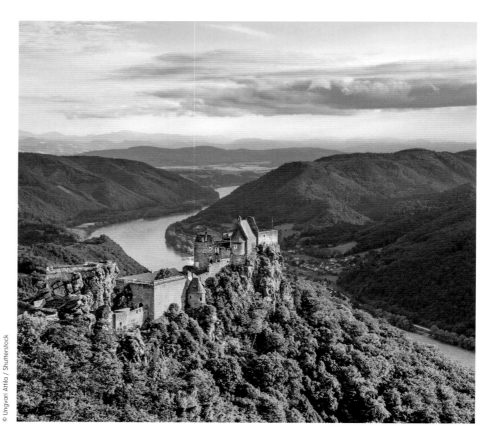

© Ungvari Attila / Shutterstock

you get into Eastern Europe the more fascinating it becomes, a world away from the refined cafes and elaborate architecture of its upper reaches.

Or there is the kayak or canoe. Plenty of people have paddled it from its source in the Black Forest as far as the Black Sea, in a trip that would take you several months. There are plenty of dams and locks to contend with, and the huge wakes of river traffic that can flip a small craft like a penny. But unlike other epic river journeys in wilder environments, when you might be lucky to come across some village every hundred miles or so, a journey down the Danube is almost overwhelming in its variety. Ancient monasteries, crumbling castles, vineyards, soaring mountains and untouched forests, some of Europe's greatest cities, an accumulation of

history that builds and builds as you drift closer to the sea.

Every year, the Tour International Danubien paddles the river as a regatta during the summer months, often with many dozens of participants. Its admirable aim is to bring together people from diverse cultures in all their myriad political, ideological and religious views, and to form friendships between them. On a waterway nearly choked with its past, such a display of solidarity is heartening.

Bisecting the continent, the river has long marked a frontier between worlds. It was the northern border of the Roman Empire, holding back the barbarians on the other side for centuries before the Empire was at last overrun. During the Medieval period, the Ottomans fought for

control of the river against a variety of European enemies upriver. In the 20th century alone, it flowed through two World Wars and countries suffocated by dictatorships; it delineated stretches of the Iron Curtain, and concentration camps stood near its banks. Jews were shot on its banks in Budapest during WWII, so that the water would carry off their bodies. Its waters also closed over those those shot or drowned swimming it in an attempt to escape Ceausescu's Romania. In the final years of the last millennium, it witnessed the collapse of Yugoslavia. Has any river been more turbulent?

Downstream from Belgrade, the river passes into the Carpathian Mountains, through towering cliffs known as the Iron Gates of the Danube. There are no major cities from here on the wide floodplains of Romania and Moldova. This is the wildest reach of the river, with towns only relatively recently emerged from communist rule, and traditional ways of life still very much intact – fishermen working the estuary, women harvesting paprika, Roma smelting copper. Whilst centuries of pollution have taken their toll, the river is still home to a wide array of wildlife, including beavers, turtles and the sturgeon. The delta is Europe's second largest after the Volga, and continues to expand year on year. It spans the border between Romania and Ukraine, and is perhaps the least inhabited region of temperate Europe, making it a haven for birdlife, including egret, pelican and ibis.

There are as many ways to explore the Danube as there are countries that it passes through. Its source is contested, as all rivers' are, but it becomes navigable in Ulm, and if you intend to paddle the whole way this would be a place to start.

There are plenty of paddling clubs along the river who will generally be amenable to letting you store your craft and gear. It's worth taking along a bike lock and chain for additional security. Wild camping is illegal in Germany and Austria, but becomes more possible after that. A canoe trolley is helpful for portaging around locks.

From Hungary onwards you will need to register your arrival with port customs upon entry into each country.

ENGLAND

The Kennet & Avon Canal

Once an artery for England's Industrial Revolution, it is now a haven for wildlife and off-gridders.

Since the earliest civilisations, people have sought to control their rivers. The Romans built the first canal in Britain in AD 50, connecting Lincoln to the River Trent. But it wasn't until the second half of the 18th century that construction of canals began in earnest, providing the network to support a booming Industrial Revolution, and turning huge profits for the businessmen who built them.

The Kennet and Avon Canal opened in 1811. It connected the port city of Bristol to Reading, from where barges could join the Thames all the way to London, and it enabled a much quicker, safer trade route between the two major cities of the south. The Kennet and Avon consists of two canalised rivers, linked by a 57-mile (92km-long) stretch of man-made canal (it's 87 miles/140km long in total). The canal was a huge undertaking, requiring two aqueducts, a 1506ft (459m) tunnel, and 105 locks, including the flight of 29 locks at Caen Hill, which takes a half day to navigate the two miles (3.2km) that they cover. Bath stone, coal and other goods were traded all along its length. Seventy barges, carrying up to 60 tonnes each, worked the canals daily.

Yet their heyday was short-lived. By 1840, one of the Kennet and Avon's main functions was transporting the materials for the construction of the Great Western Railway. It was the same story across the country, as rail quickly replaced trade on the canals as a

Right, numerous pretty towns and villages straddle the canal, including the city of Bath.

© Les Watson / Getty Images

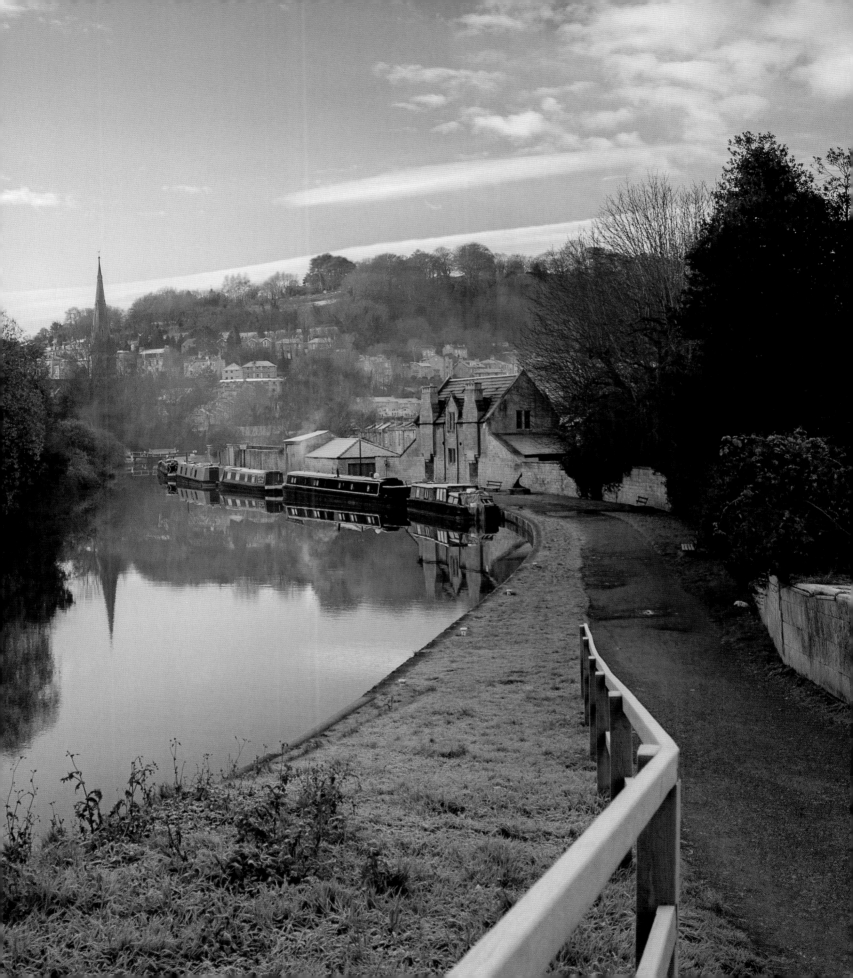

John Betjeman, the late poet laureate, went to school in Marlborough in the 1920s, an experience which he had little good to say of. He spent as much time as he could away from school, tramping through the countryside, and it was here that he fell in love with the Kennet. It is not hard to see why. 'The smell of trodden leaves beside the Kennet, On Sunday walks, with Swinburne in my brain," he wrote in his autobiography *Summoned by Bells*. 'When trout waved lazy in the clear chalk streams, Glory was in me.' When the Crofton Pumping Station was restored in 1970, it was Betjeman who was invited to open it. (It is open to visitors daily through the summer.)

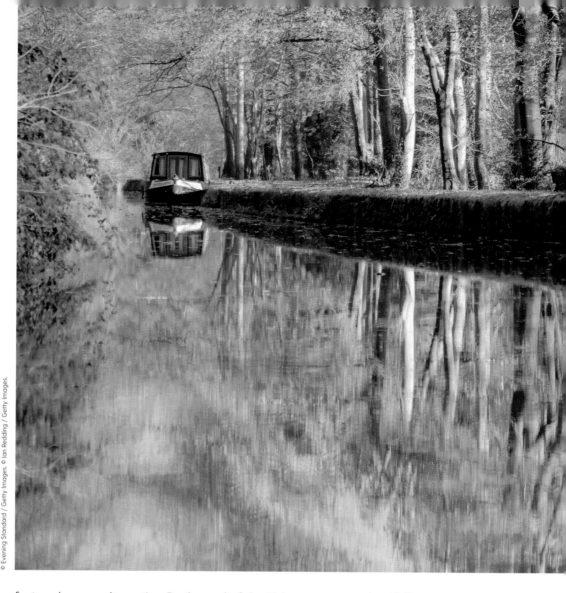

faster, cheaper alternative. By the end of the 19th century, most had fallen into disrepair.

In the 1960s, the Kennet and Avon Canal Trust brought together hundreds of volunteers to restore the canal. Thanks to the work of groups like theirs, today there are roughly 3000 miles (4830km) of navigable canals and rivers in the UK. With close to a hundred other projects on the go, the eventual aim is to add another 2500 miles (4000km) to the network. They are crucial habitat for wildlife, commuting routes for cyclists, a place for an evening stroll, and they are also offering an alternative lifestyle to those priced out of, or fed up with, bricks and mortar.

There are 38,000 narrowboats on the canals, even more than at their 19th-century peak, and a quarter of them are homes. Most boats have a mooring, but over 5000 are continuous cruisers, required by their licence to move their boat every two weeks. It is one of the few nomadic lifestyles still permitted in the UK. Cabins are warmed with wood, solar panels provide the electrics, and a water tank of several hundred litres can last for a few weeks if you're careful how often you shower. It is off-grid, low-impact, and in a world where people feel increasingly separated from their neighbours, an enticingly communal way to live. Mooring up alongside each other, lending a spanner, a cup of sugar, sharing barbecues on boat roofs late into the night.

The very affordability of boat life allows for a mix of those unable to afford the escalating house prices, a ragtag bunch of writers, musicians, apprentices and artisans. Yet there are those who now believe that the lifestyle is under threat, as the Canal and River Trust increase the distances that continuous cruisers are expected

Left and below, slow down to enjoy autumn colours and spot grey herons and other birdlife on the Kennet and Avon.

© Ben Birchall / PA Images / Getty Images

Companies along the canal will rent you a narrowboat for a day, a week, or longer. In the UK there is no need to own a licence to operate one, and after an hour or two of instruction you're good to go. Pay attention when going through the locks and you shouldn't have any problems. It is impossible to hurry. A lock can take up to an hour. The speed limit is 4mph (6.5kmh), but it's unlikely you'll reach it. There are great restaurants, good fishing, and plenty of pubs where you can spend the night moored up . Boaters are a friendly bunch, and always happy to offer advice. Bristol, the start, is easily reach by road, rail and air from London.

to move, meaning that those with work or children in school find it hard to stay within the range of where they need to be.

If a full move aboard and the long winters don't appeal, it is still possible to experience the lifestyle. A very flat cycle route runs the entire length of the canal, or you can rent a narrowboat for a week or two.

The Kennet and Avon ambles through the countryside of southern England. Many of those making their homes here have opted for a way of life far from the freneticism of the cities. Swallows dip to the water. Ducks shepherd their young. The banks are a lush green mix of nettle and comfrey. You feel far from the motorways and cities, entering a market town by the most picturesque of routes before returning to the countryside. Every so often there is a pub or a cafe with a mooring at the bottom of its garden. You will pass through the pretty market towns of Bradford-on-Avon and Newbury, and the city of Bath where you can soak in England's only hot springs and wander through its blend of Roman, Medieval and Georgian architecture. Moor up wherever you can find a spot on the bank to bang your mooring pins in, and listen to the sounds of the river as the boat rocks you to sleep.

MALAWI, MOZAMBIQUE, TANZANIA

Lake Malawi

Wonderful beaches, spectacular (and delicious) fish and a world-beating festival: welcome to the Lake of Stars in the heart of Africa.

Africa is splitting in two, tearing itself asunder along the lines of the East African Rift. As tectonic plates, the vast slabs of the earth's lithosphere, jostle for position, the geological changes that occur are some of the most dramatic on our planet. Mountains rise, cracks form. In places where three plates meet – in East Africa it is the Arabian plate, the Nubian plate and the Somali plate – then rift valleys can form. And it is one fork of this rift, known as the Western Rift, that forms the Rift Valley Lakes. Lake Malawi is the most southerly of a chain that includes Lake Tanganyika, the second oldest, second deepest in the world, and reaches as far north as Ethiopia.

Lake Malawi is huge, the ninth largest lake in the world. It is often called the Calendar Lake, because it is 365 miles (587km) from top to bottom and 52 miles (84km) at its widest point, with 12 major rivers flowing into it. So although Malawi is a land-locked country, the majority of its eastern border with Tanzania and Mozambique, and one fifth of the entire country, is taken up by water.

Its well-worn nickname, the Lake of Stars, was first bestowed on it by David Livingstone, who camped on its shore and watched the hurricane lights of fishing boats twinkling on its surface. The year was 1859, and he wrote to the Earl of Malmesbury that 'we have traced the river Shire up to its point of departure from the hitherto undiscovered Lake Nyinyesi or Nyassa,'

Right, Lake Malawi is a source of food or income for many people.

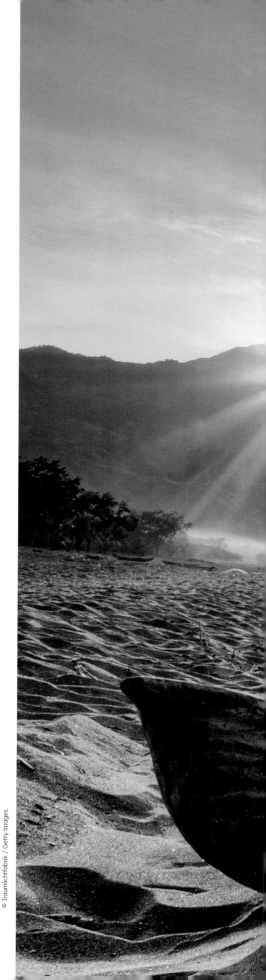

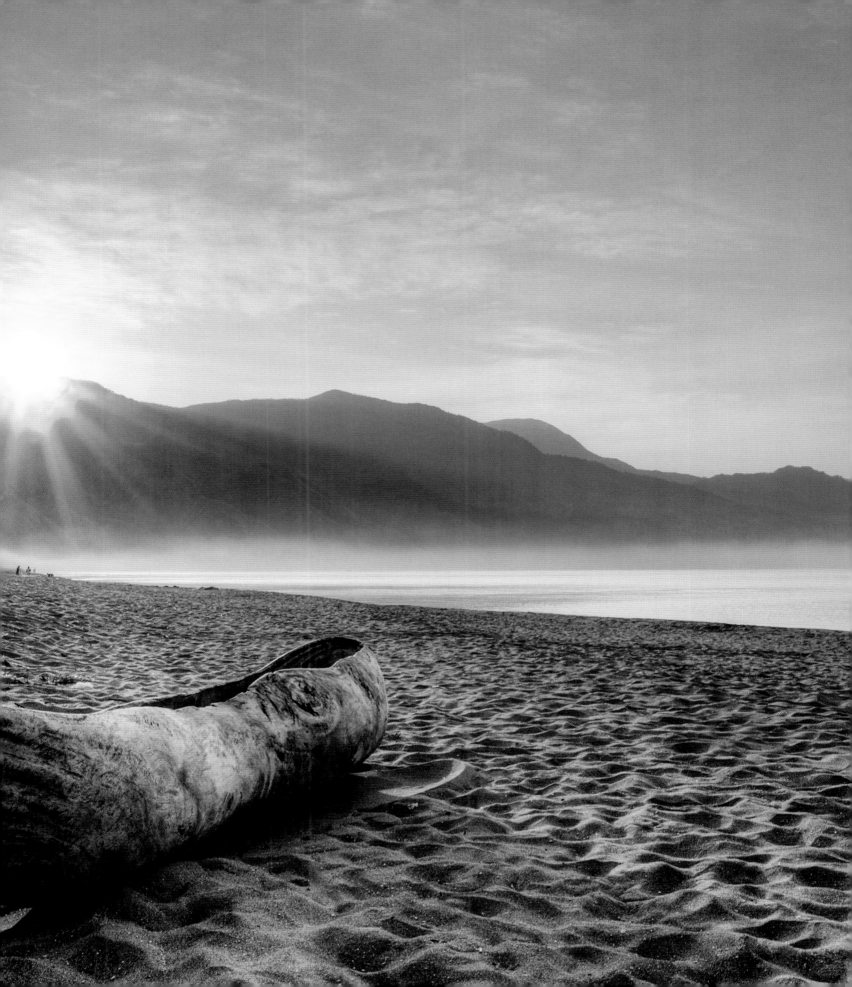

Lake of Stars is a three-day festival that has been held every year since 2004 on the shores of Lake Malawi. In 2015, *Time Out* declared it the most beautiful festival location in the world, and it's certainly hard to beat watching the sun come up over the lake before you make your way to bed. The line-up has featured a wide mix of international artists such as Nick Mulvey, DJ Yoda and the Young Fathers, playing alongside local musicians. From small beginnings, it has grown to become one of Africa's major festivals. It is estimated to generate $1.3 million for the Malawian economy each year, but there are only a few thousand tickets on sale, so you'll need to be quick.

Right, dawn on the Shire River, which flows out of Lake Malawi's southern end.

although the Portuguese had in fact been there 13 years before, and local people had of course been living on its shores for millennia. The lake drains by Malawi's longest river, the Shire, which runs for 250 miles (402km) before joining the mighty Zambezi. The Shire has two hydro-electric dams now, providing much of the power for the south of the country.

When Livingstone called it the Lake of Stars he could equally well have been speaking of the glinting light on the surface on a typically beautiful day, or the millions of stars visible at night in what is still a pitch-dark sky. One of the best ways to see the lake is to hop aboard the MV *Ilala*, which carries people and goods its entire length from Monkey Bay to Chilumba. You can get a cabin, or for a cheaper ticket, put your sleeping bag up on deck. It's worth making a stop at Likoma, the lake's largest inhabited island, to spend some time on the beautiful beaches and to see the hundreds of baobab trees. Climb the clocktower of St Peter's Cathedral, one of the largest cathedrals in Central Africa, for a magnificent view across the island and all the way to Mozambique.

Like many deep tropical lakes, there is no vertical circulation, and so at its lower depths it is full of toxic chemicals such as methane and hydrogen sulphide, where sunken vegetation is decomposing on the bed.

But higher up it is teeming with life. It is home to more species of fish than any other lake on the planet. That includes 700 species of cichlid, many of them stunning oranges, yellows and blues and found nowhere else in the world. The Lake Malawi National Park encompasses much of the waters around Cape Maclear, and is one of the most important sanctuaries for freshwater fish in the world. Go snorkeling around West Thumbi Island or off Otter Point, where some of the most spectacular collections of cichlids are found. The water is warm, generally calm, and the visibility excellent. And if you want to get even closer, then you can learn to scuba dive here, too. For something really different, local fishermen will take you out to feed the fish eagles. Seeing these majestic raptors up close is an unforgettable experience. Each one has its own name and, it's said, its own personality.

This diversity of fish means that there are still plenty of fishermen making their living here, many paddling the traditional dugout canoes, the hollowed out trunks of trees. Chambo, a sort of tilapia, is found nowhere else. It is the local delicacy, and is best eaten barbecued on the beach, as fresh as it comes, pulled from the water a few moments before. Washed down with a cold Carlsberg in front of a crimson sunset, the waves breaking on the shore, it's a meal that you'll never forget.

You can nip to the lake in an hour and a half from Lilongwe, Malawi's capital, but to really explore it will take longer. Many travellers choose to make for Cape Maclear, which has been a hub for travellers for years. You'll find a wide variety of restaurants, beds and activities, from yachting to kayaking to scuba. It's easy to find one of the children in town to organise a beach barbecue for you, which will cost only a few dollars per head and is bound to leave you full and happy. (Malaria is present all along the lake, so you'll need to take the usual precautions, from avoiding getting bitten to taking medication.)

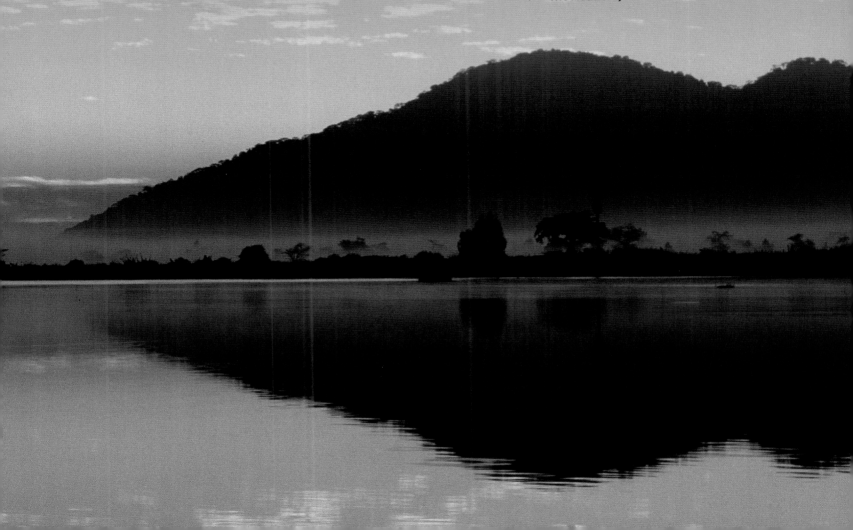

AUSTRALIA

Franklin River

Four decades ago the people of Tasmania saved its wildest river. It's since become one of the world's best rafting trips.

In Booker prize-winning Richard Flanagan's first novel, *Death of a River Guide*, Aljaz Cosini lies beneath a waterfall on the Franklin, drowning. Visions of his own past and the histories of his ancestors run through his mind as his body sinks beneath the water, Tasmania's story unravelling as the rapids hold him down. The event is based on Flanagan's own experience, who was only saved from death after several hours by a friend. 'I learnt what I had never learnt from the modern novel,' he has said. 'That even in our darkest hour, we are not alone.' Not just because of those that love us and who save us, but because of the presence of that which is not man-made that surrounds us, the very Franklin itself.

The Franklin-Gordon Wild Rivers National Park is in the southwest of Tasmania, less than 100 miles (160km) west of the state capital Hobart, and it is named for the two rivers that run through it. The Franklin crashes through glacier-hewn ravines for 80 miles (129km) before meeting the far more placid Gordon, which empties into the sea on the island's west coast. The park comprises one of the last three remaining temperate rainforests in the southern hemisphere, with stands of Huon pine and myrtle beech, the rank smells of fecund decay, the calls of a yellow-tailed black cockatoos bouncing around the gorges. It is a river lost in time, unchanging, as wild today as it has ever been.

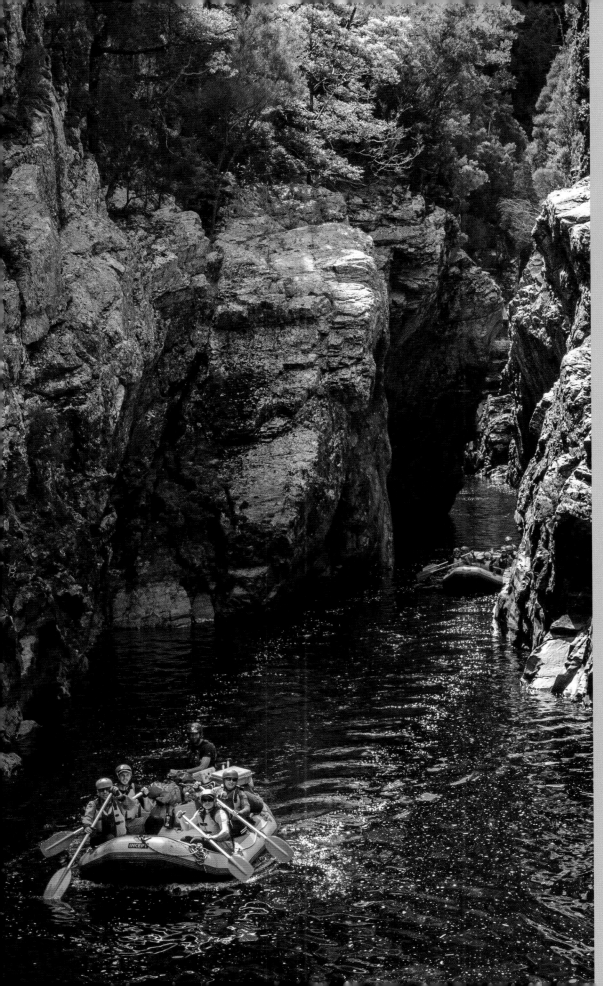

The Huon Pine (*Lagarostrobos franklinii*) is found only in southwest Tasmania. They are some of the world's oldest living organisms, with one stand of trees on Mount Read dated at 10,500 years old, and individuals in the stand as old as 3000 years. With their girth growing at a just 1 millimetre per year, and not reproducing until hitting puberty at 600 years old, they are highly vulnerable to exploitation, and yet were heavily logged in the early days of British rule: its extremely high oil content renders it waterproof and impervious to insects, and made it one of the best woods for boatbuilding in the world. Today it is carefully managed, and salvaged dead timber is the only wood still worked with.

Left, paddling the Irenabyss or Chasm of Peace on the Franklin River.

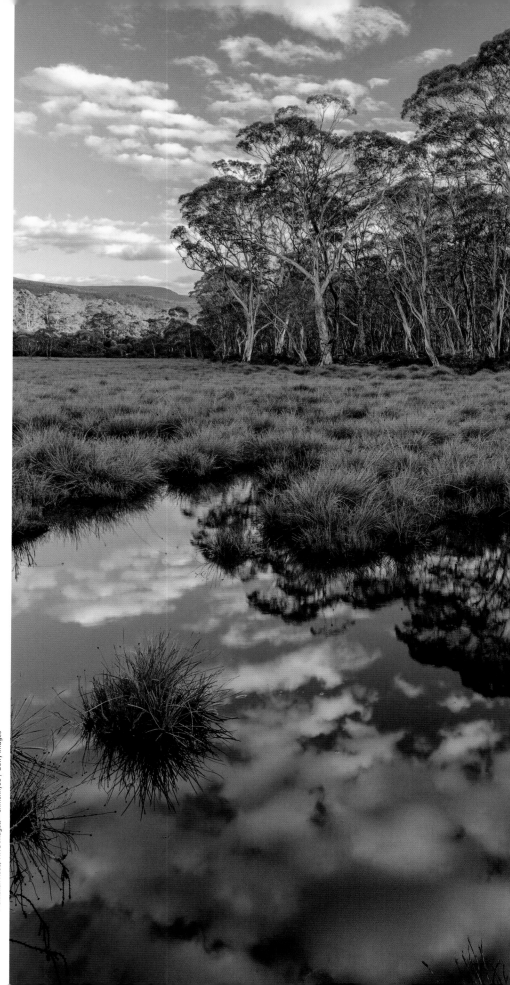

From right, a blue gum forest in Franklin-Gordon Wild Rivers National Park; crossing the river on a suspension bridge.

There are mossy caves along the river hollowed into limestone cliffs, which were the most southerly habitable place on earth during the last ice age. Thousands of fragments of stone tools have been found here, and masses of wallaby bones, which Aboriginal hunters would have butchered 20,000 years ago when this landscape was not rainforest but tundra. Yet the river was not seen by Europeans until 1822, when a group of escaped convicts from a nearby penal colony stumbled across it (before one of them, Alexander Pearce, ate the others to survive). The river was only officially discovered in 1841, by which time only a few hundred of Tasmania's original population of Aboriginal people had survived the ravages of colonialism. And yet despite sustaining the indigenous for millennia, the river was named after Tasmania's then lieutenant-governor, the British Royal Navy officer Sir John Franklin.

It is not just Flanagan whose life has been carved out by the Franklin. The first raft descent of the river was made in 1976, by Paul Smith and Bob Brown. Brown described the river as 'a wild and wondrous thing,' and soon after became the first director of the Tasmanian Wilderness Society, which was founded at his house. When the state-owned Hydro-Electric Commission mooted a plan in 1978 to dam the Franklin, the society galvanised against it. Robin Gray, Tasmania's premier, gave the project the go-ahead, dismissing the river as 'a brown ditch, leech-ridden and unattractive to the majority of people,' but the majority of people disagreed. Six thousand people

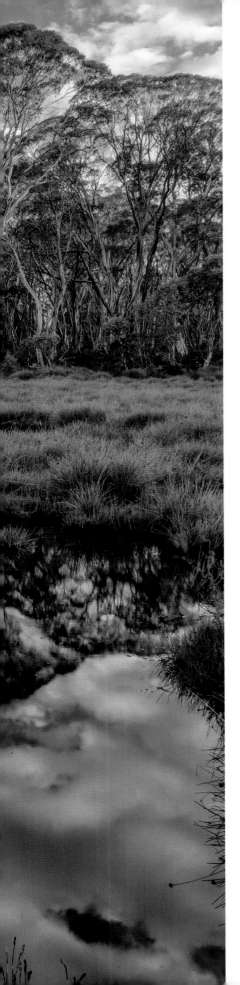

joined the protest, 1500 were arrested. The dam became a defining issue of the 1983 national elections, images of the Franklin plastered across newspapers and billboards alongside the slogan: 'Could you vote for a party that will destroy this?' It was a defining moment for nascent Australian environmentalism, a whole country rallying behind the health of one of its rivers. Bob Hawke, the new prime minister, repealed the project, and on the day of his release from imprisonment for the protests, Bob Brown became the first Green representative in Tasmania. He would ultimately go on to lead the Australian Greens.

Today there are various rafting outfits that will take you the Franklin's length. It is a 10-day journey of true remoteness, bivouacking on beaches and cooking under stars. Once you launch the raft you are truly committed, with little by way of an escape route until you pop into the Gordon. Some of its rapids are truly jaw-dropping, with standing waves reaching the height of two-storey houses when the river is running high. Yet travelling with guides at the right time of year, in the summer, means that no prior rafting experience is necessary, just a basic level of fitness and a willingness to get soaked. Between the rapids, drift through tranquil canyons and watching the sea eagles turning overhead. Most tours include a day's hike up Frenchman's Cap for a panoramic view of the park, and there's even the possibility of a glimpse of a foraging duck-billed platypus as you shoot over a wave.

The put-in for the full trip is on the Collingwood River Bridge on the Lyell Highway. The best time for avoiding floods and impassable rapids is between November and April. Even in summer the river can rise a metre in an hour after rains, so be prepared to sit out days on the banks as the flood recedes. Commercial outfitters operate out of Hobart and the surroundings, running with small groups of up to 10. If you want to go it alone, you'll need a permit from Tasmanian Parks and Wildlife and you'll need to be highly experienced, both in paddling and in remote wilderness travel. Once on the Gordon River, you can charter a boat for pick-up, or it's a paddle to Heritage Landing, 13 miles (20km) downstream and a ride out in a cruise ship.

PERU-BRAZIL

Amazon River

The planet's mightiest river, stretching the distance from New York to Rome.

No list of rivers could be complete without the Amazon. Whether it can claim the title for the world's longest river is a debate that will never be resolved, with both the Nile and the Amazon occasionally recalibrating their lengths as expeditions discover new sources, new meanders. And the Amazon is so vast at its mouth that it is hard to say exactly where it ends and the ocean begins. But it is able to retain its other records much more comfortably. It has the largest drainage basin on the planet. It is the world's most biodiverse river system. It discharges more water than any other – a fifth of all the freshwater entering the seas. Just the word conjures uncharted enormity, fecundity, the shrieks of exotic birds and the tantalising presence of uncontacted tribes. And the word also symbolises the struggle of an imperilled natural world, clinging on as its resources are plundered in the face of a rapidly warming climate.

In 1542, Francisco de Orellana, the Spanish conquistador, became the first European to navigate the entire length of the river, and he named it following one of the many battles that his crew fought along the way. As he massacred the Tapuyas people, their women brought to Orellana's mind the Amazons, a tribe of warrior women from Asia Minor. Orellana returned to Spain at the end of his voyage to tell his tales, but his stories of a sophisticated civilisation on the Amazon's banks were considered preposterous,

Right, 3000 fish species live in the Amazon (some of which are food for the pink Amazon river dolphin).

© Coulanges / Shutterstock, © Worldclassphoto / Shutterstock

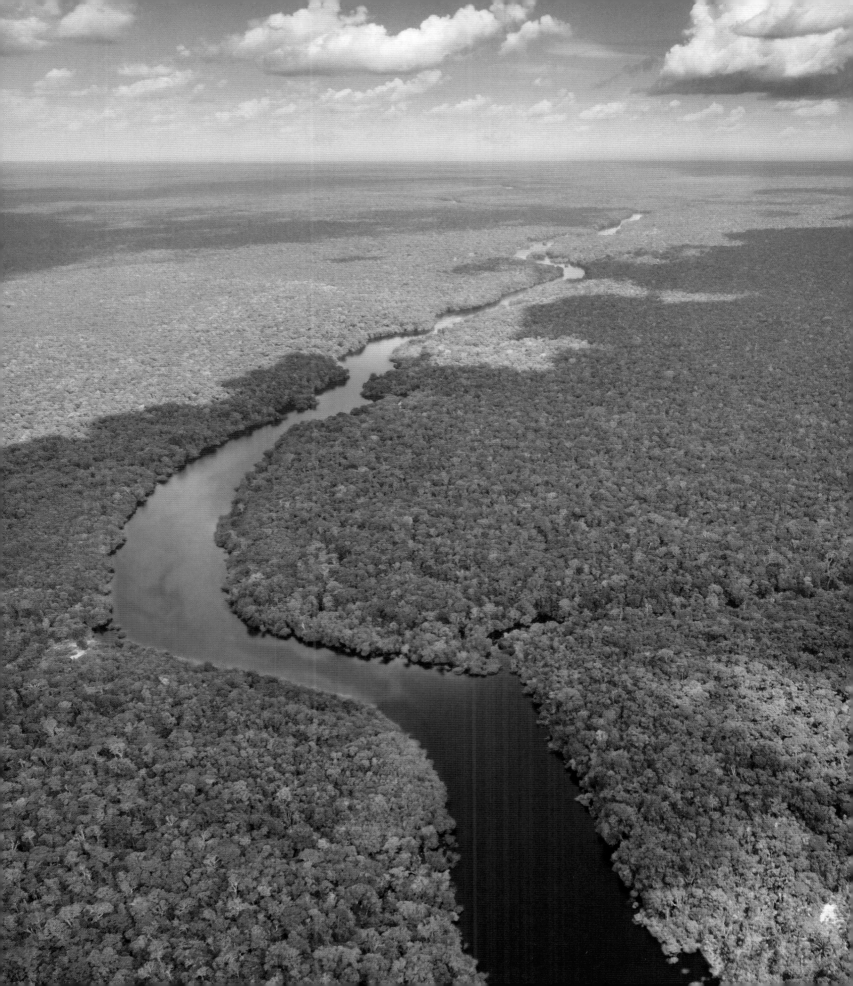

Several years ago, the scientific community was stunned by news that a new river, as long as the Amazon, had been discovered in South America. The Hamza River mirrors the Amazon's route, but is 2.5 miles (4km) beneath it, and hundreds of times wider. It was a remarkable discovery, deduced by examining temperature data taken from boreholes across the Amazon Basin that had been dug for oil exploration. Yet the Hamza pushes the definition of a river to its limit, with the water moving through porous rock towards the sea at speeds that can be measured in centimetres per year, and with a much higher salinity than the Amazon itself.

Right, paddling through the Amazonas region of Brazil; overleaf, fishing from a canoe on the Nanay River, a tributary of the Amazon in Peru.

until quite recently. But in the 1970s, newly deforested regions revealed signs that once cities had indeed thrived along the Amazon's banks, long before its people were decimated by the arrival of European diseases. As the most obvious way to explore, and ultimately conquer, a country, rivers have frequently been the sites of many of the initial genocides of imperial nations. Five million people are believed to have lived along the river before the Europeans arrived. By 1900, it was one million.

Little has changed: both the people and other creatures of the Amazon River remain under severe threat. Brazil's government often sees in the Amazon Basin an almost infinite untapped resource, and the failure to maximise it an impediment to the country's growth. Such a casual attitude to one of the planet's most vital wildernesses is alarming, and there is so much at stake. One in ten of the world's species are found in the Amazon, and many are found nowhere else. Species such as the arapaima, the largest freshwater scaled fish in the world, which can grow up to 10ft (3m) long. It has not evolved for over 20 million years, and has no predators but for humans. Or two species of river dolphin, including the pink dolphin, which is now feared to be extinct. Or the giant river otter, a highly sociable animal, as big as an adult human, whose numbers are now as few as 2000 individuals in the wild. Halting the decline set in motion 500 years ago is crucial not just for these unique creatures and the many indigenous groups

that live along the river, but for the health of the whole planet.

Being such an enormous river, there are myriad ways to explore it. Jungle lodges are scattered throughout the forest, ranging from the rustic to the sumptuous, and allow you to experience the absolute darkness and the endless chatter of a night deep in the rainforest. From these lodges you can set out on hikes, or canoe trips through flooded forests, keeping an eye out for jaguar and caiman, the shrieks of howler monkeys and the rattle of toucans echoing through the canopy. Climb trees and spend a night in a hammock, or go fishing for piranhas. To get more of a sense of the Amazon's grandeur, take a riverboat trip that lasts for anything from a couple of nights to 10 days. Opt for one of the 'survival' tours, camping and learning to forage, or go upmarket and snuggle down in a luxury berth.

Since Orellana, there have been various projects to descend the Amazon from its source. Teams have kayaked and canoed it. The English explorer Ed Stafford walked it between 2008 and 2010, and his trip remains a Guinness World Record as the longest jungle trek. Martin Strel, a Slovenian long-distance swimmer, swam it in 2007. He came close to losing his mind during the three-month journey, a combination of the relentless sun, a parasite infection and his incessant drinking. The resulting documentary, *Big River Man*, makes for compelling viewing, with more than a nod to Joseph Conrad's *Heart of Darkness*.

Travelling in May or June will avoid the worst of the rain and heat. If you're not intending to invest several years travelling from one end to the other, it can be hard to know where to begin. Fortunately, there are a myriad of tours to suit all time frames and budgets. Manaus, in Brazil, is a hub for many tour companies, although making for places off the beaten track, such as Tefé and Alter do Chão, will mean less-crowded trips.

You can fly to Manaus and the other towns, but taking the boat is a far more interesting experience. Hang your hammock on deck, chat to the locals, and gaze out for hours at the passing forest.

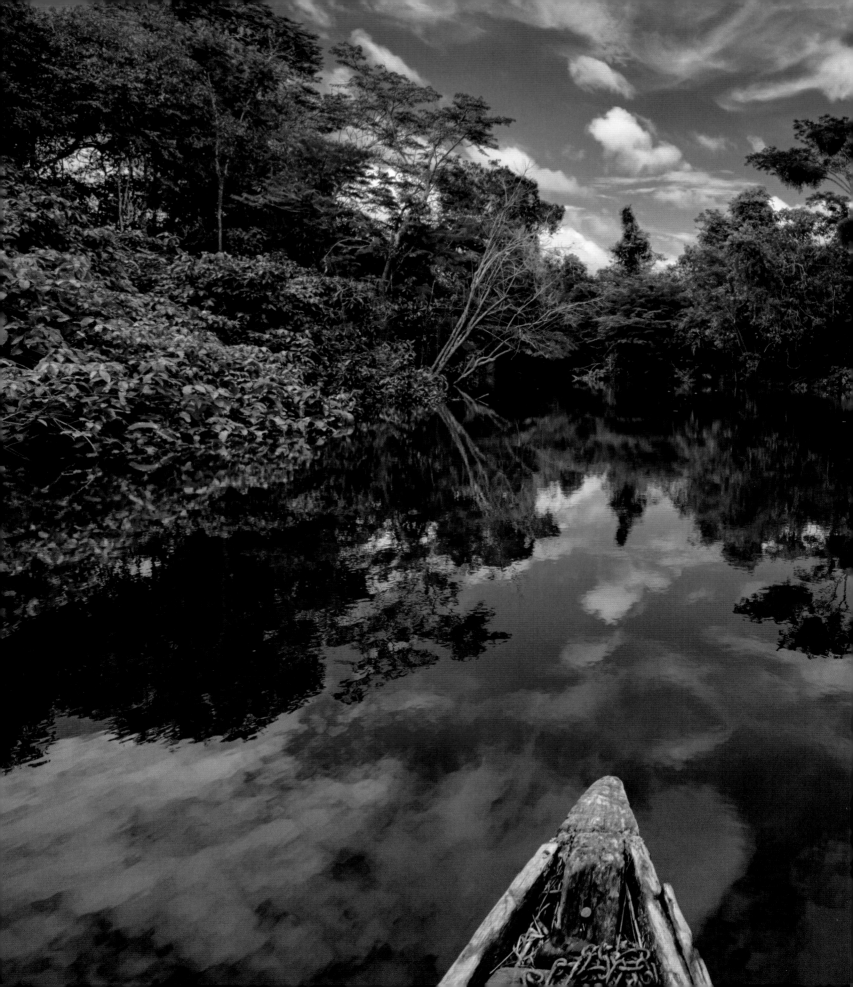

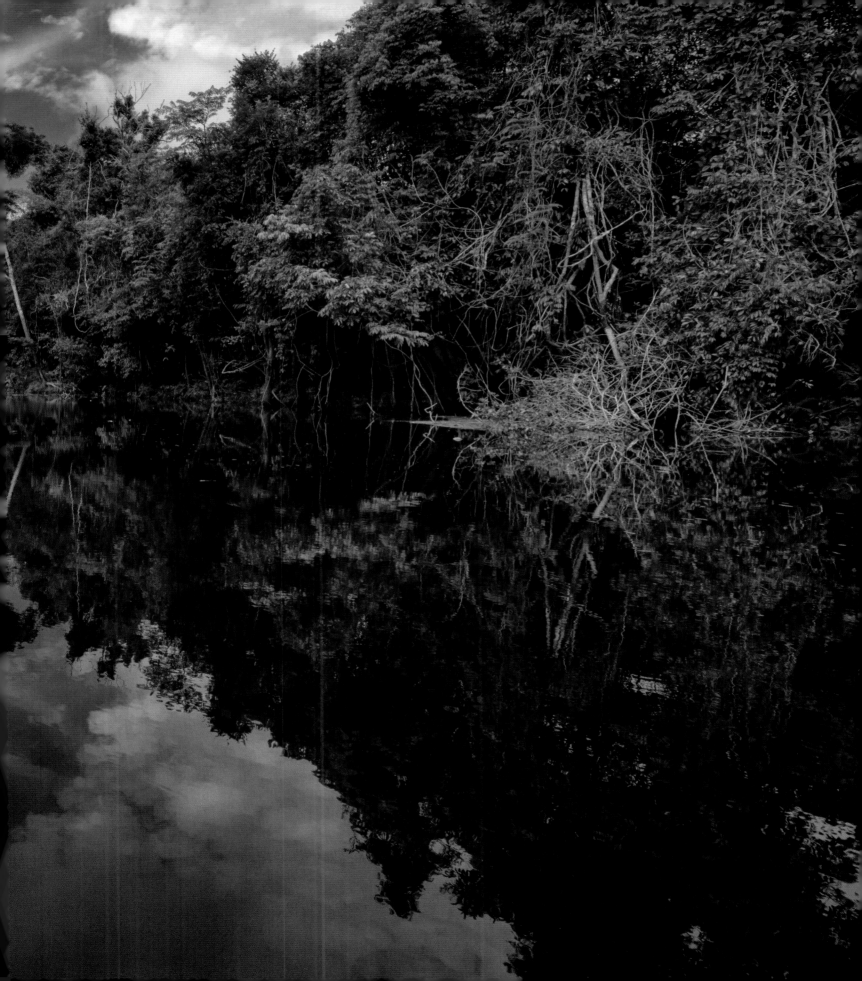

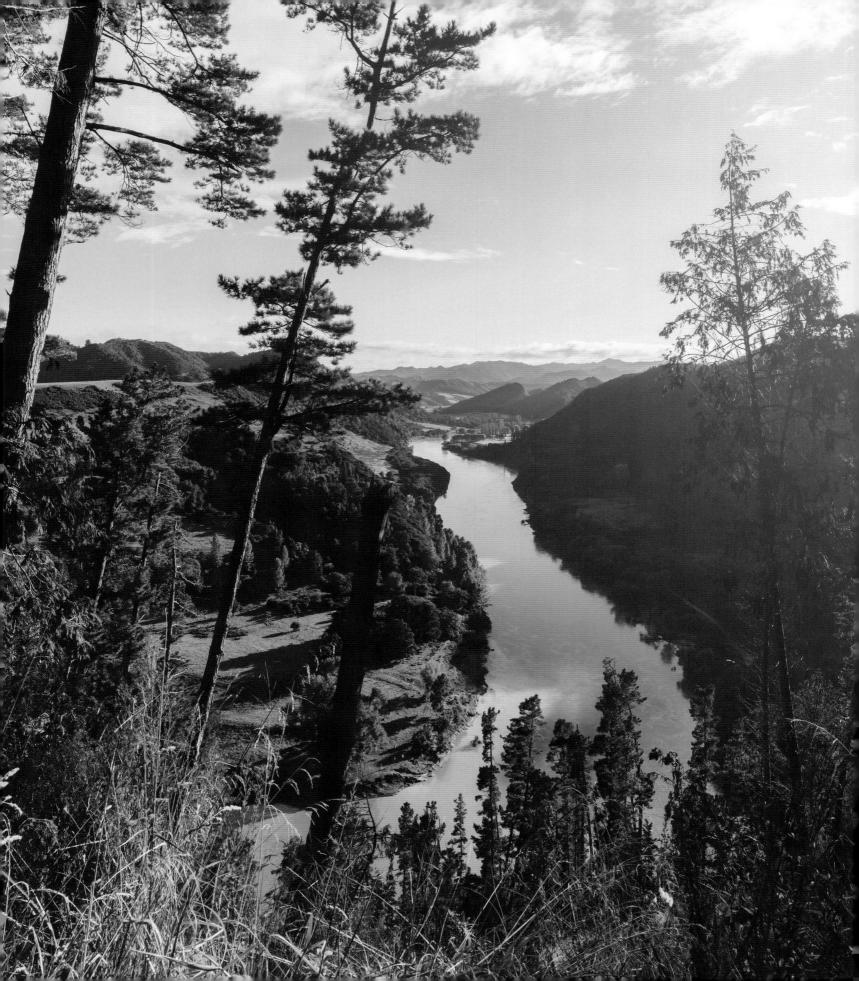

NEW ZEALAND

Whanganui River

*I*n 2017, the Whanganui River became the first river in the world to be recognised as an indivisible and living being. The decision gave it 'all the rights, powers, duties and liabilities of a legal person'. It is indivisible not only in the sense that everything from its source to where it meets the sea, its waters and its riverbed, is considered as a whole, but that it is intrinsic to the landscapes and the lives of the people that surround it, including their spiritual lives. For the first time in history, a river has a chance to stick up for itself.

The Whanganui, on New Zealand's North Island, is the country's third-longest river. It rises in the snowfields of Tongariro National Park, its streams gushing down the sides of the great volcanoes of Ruapehu, Tongariro and Ngauruhoe. It cuts through deep gorges in Whanganui National Park, before flowing across the plains and farmland and through bush covered hills to meet the sea at the town of Wanganui (without an h).

The Whanganui has been crucial as a path across the landscape since it was first explored by Tamatea, the captain of the *Tākitimu* canoe, which brought some of the first Polynesian migrants to the island around 1350. The Whanganui *iwi* (the Māori people of the river) have lived by, travelled on and drawn sustenance from the river ever since. They caught eels in latticework weirs. They descended vine ladders from their villages high

As the Māori people say of this river, *Ko au te awa. Ko te awa ko au* (I am the river. The river is me).

Left, a view from the Whanganui River Rd in the national park.

I speak for the trees, for the trees have no tongues

The Whanganui is not the only water source to be granted legal personhood. India recognised the Ganges and Yamuna rivers as legal entities in 2017, although their status was removed by the Supreme Court three months later, deeming such a declaration to be legally unsustainable. In 2019 Bangladesh bestowed legal rights on all of its rivers, as did the Yurok Tribe on the Klamath River in northern California , and the citizens of Toledo, Ohio, on Lake Erie. A river has yet to defend itself in a court of law, but when this new status does come to be tested the results could be far-reaching, for the rights of nature and for our future.

From right, riverside pasture; giant tree ferns; the rare whio, or blue duck.

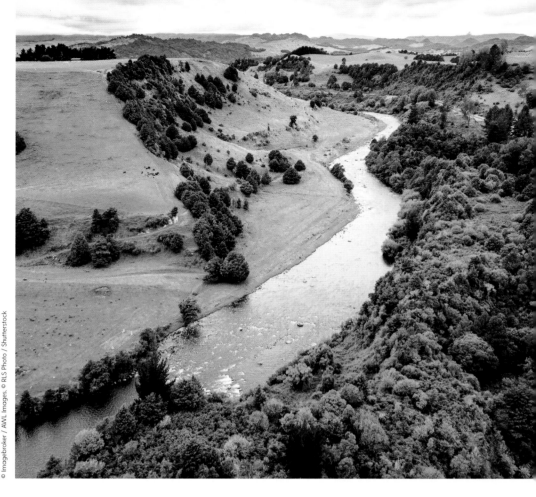

© Imagebroker / AWL Images. © RLS Photo / Shutterstock

above to reach its waters. They had a name for each of its 239 rapids.

In 1840 the British settler Edward Wakefield bought 40,000 acres of land around the river off the local Māori chiefs, and Europeans began arriving soon after. The town of Wanganui began as a garrison defending the settlers' interests, before growing into one of the major cities on North Island. The river was promoted as the 'Rhine of New Zealand,' its rapids dynamited to allow easier passage for paddle steamers that hauled well-dressed Victorians through the gorges, gawping at the hundreds of Māori villages that lined the banks. The gravel of its beds was extracted for the construction of railways and roads. The city drained its waste into its waters. Gradually, it became a

shadow of its former self.

Recognising the river as a legal entity is just the most recent step in an ancient battle for the spirit of their land. Since 1883, the *Iwi* have attempted to resist the colonial development of their river, claiming the Crown's violation of their treaty rights, resulting in the longest-running legal case in New Zealand's history. In 1975 the Waitangi Tribunal declared the river to be 'central to the lives and identity of the river people,' and it was their work that ultimately led to the Whanganui's legal personhood.

It is a landmark ruling, a validation of what the Māori have always known, as well as a harbinger of a shift in how we think about the natural world. And yet the river continues to suffer. The water in its lower stretches is frequently

contaminated by the extensive sheep farming that surrounds it. And the hydropower scheme at the headwaters of the river has been accused of diverting the river's flow, as well as warming the river's waters and causing build-up of sediment. Yet the pre-existing contract for the hydropower scheme cannot be overturned by this new legislation.

Yet for all that, this is still a trip through some of the best country New Zealand has to offer, and there is no better way to see it than by canoe. Most people choose the three-day trip, but it is worth starting at Taumarunui for the full five-day journey, when there's a good chance you'll have the river entirely to yourself.

There are some good rapids on the first section, as the river wends through a blend of cultivated land and native bush, but it is at Whakahoro that the Whanganui becomes truly beautiful. Verdant banks of moss and great tree ferns form dank banks, speckled with bright flowers and birdlife. Keep an eye out for the whio, tūī and brown kiwi, and for long-tailed bats overhead in the dusk. Look also for the old landing stages left from when the steamers ran, and holes in the banks where the Māori poled their canoes upriver in times past.

Waterfalls crash down the cliff walls. The river snakes around the Kirikiriroa Peninsula and under the vast overhang of Tamatea's cave. At Mangapurua Landing haul up your canoe and walk into the forest to find the Bridge to Nowhere, a lonesome concrete bridge built in WWI and now being swallowed by the bush. From Pipiriki it is possible to paddle another two or three days downriver, to eventually meet the sea at Wanganui.

The Whanganui is 3.5 hours' drive from Wellington, or there is the bus. The 190-mile (45km) float from Taumarunui to Pipiriki takes five days. Outfitters organise guided tours, or can rent you a boat of your own, organising shuttles to the put-in and take-out. The rapids should be manageable for beginners, if you don't mind getting wet.

The river is generally paddled between October and April, known as the Great Walks season. There are huts and campsites along the route, for which booking is essential. Outside of the season the weather is cold, the daylight limited and the river often in spate. Avoid unless you know what you're doing.

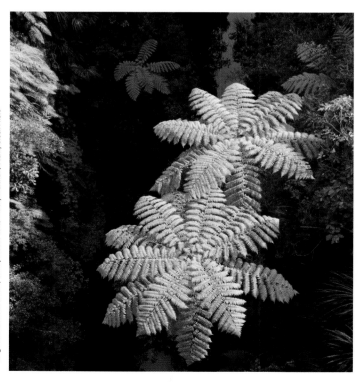

PERU AND BOLIVIA

Lake Titicaca

One of the world's highest lakes is a place of stunning ancient ruins, Incan myth – and a beguiling community afloat.

Lake Titicaca straddles the border of Bolivia and Peru. At 12,507ft (3812m) elevation, it is often referred to as the world's highest navigable lake, certainly high enough to induce altitude sickness, best rectified by regular sipping of the local coca leaf tea. Whilst many smaller lakes are higher, nothing at this altitude comes close to Titicaca's size: 118 miles (190km) long and 50 miles (80km) across at its widest point, with a narrow channel cinching its waist. It is the second-largest lake in South America, and one of the most remarkable bodies of water on the planet.

In Andean belief, it is the birthplace of the sun, the moon and stars, brought into being by the god Viracocha. It is also the birthplace of some of the oldest cultures known to have existed in the Americas, testified by the ruins that have been found around its shores, the burial towers at Sillustani and Cutimbo, and by a temple discovered in 2000 on the lake's bed. Tiwanaku, just a few miles from the Bolivian end of the lake, is often described as the Stonehenge of the Americas, a stunning ancient site of vast stone blocks, temples, pyramids and carvings of human and puma heads. And Incan mythology has it that the first Inca king, Manco Cápac, was born on an island on the lake.

It is easy to believe it all, for it is an outstanding place. The deep blues of one of the world's deepest lakes echo the blues of a high-altitude sky. There is something about

Right, Lake Titicaca lies at the northern end of the Andes.

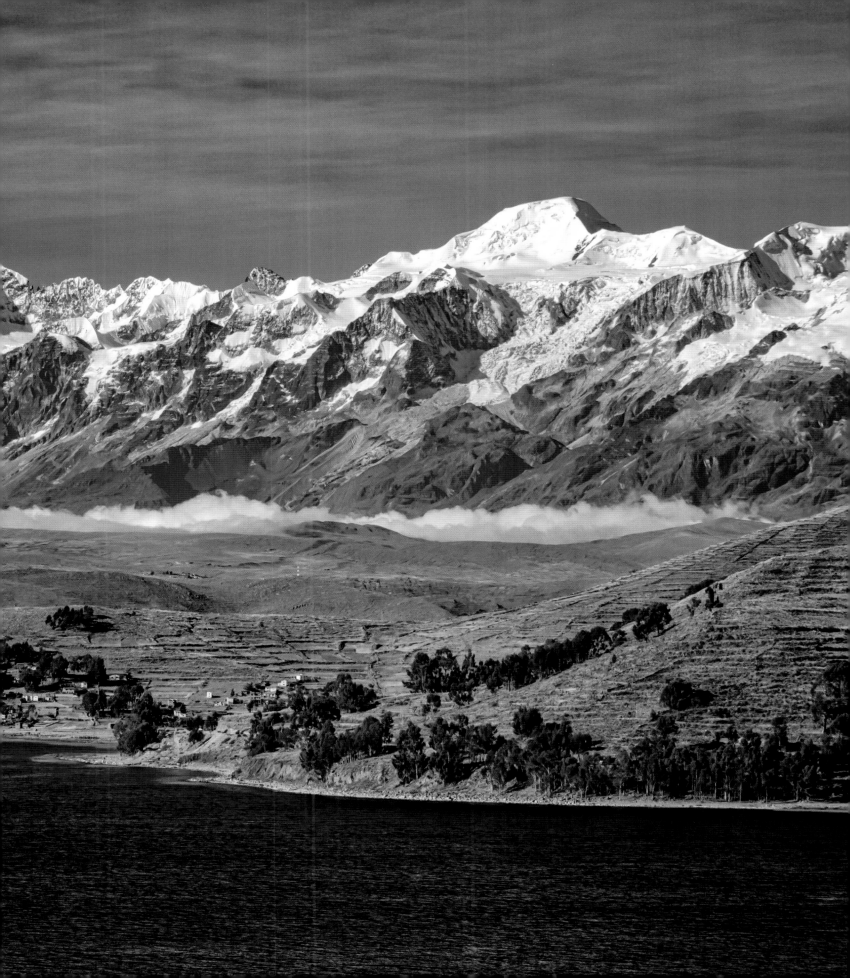

The islands of the Uros are built by sawing large chunks of totora reed roots, enmeshed with mud, from the shallow bed. These they bind together, and then more reeds are laid on top, piled several metres thick. They are buoyed up by the gasses released by the rotting layers underneath, and are in need of almost daily repair. The islands are roped together to prevent them drifting apart, and anchored to the bed with tree trunks. The inhabitants must be careful: most don't know how to swim. The islands were once several miles from shore, but in 1986 a terrible storm destroyed many of them, and most islanders ended up relocating closer to the city of Puno.

© Saiko3p / Shutterstock, © HMS / AWL, © Olga Gavrilova / Shutterstock

the quality of the light up here that brings a clarity to everything. In the distance, the mountains of the Cordillera Real, jagged and snow capped, soar to heights of more than 21,000ft (6400m). There is a sense of space, of the earth stretching on forever. Whilst it is fed by 27 different tributaries, there is only one that drains it, the humble Desaguadero. The remainder of the lake's excess water evaporates beneath the baking sun and constant wind. The water level is in constant flux, over the course of each year as well as in cycles of several years.

There are 41 islands in the lake, many of them distinct in culture and character. There are plenty of possibilities to organise homestays on local tours to better appreciate these ways of life. On Amantaní, there are around 4000 Quechua who still farm quinoa, potatoes and other produce by hand on the terraces, and there are no machines allowed on the island. Isla Taquile was once used as a prison, but since 1970 has belonged to the Taquile people, renowned for making some of the best handicrafts in Peru. This is the place to visit to purchase some of the bright woven fabrics that everyone wears here. There are regular boats to the islands, and it's also possible to rent a kayak to go and see them under your own steam.

Alongside the many natural islands, there are more than 120 man-made ones. These are the homes of the Uros people, an indigenous group from Peru and Bolivia. It is said that the Incas forced them from the Amazon, and finding themselves with nowhere to go, moved on wherever they tried to settle, they came at last to the shore of Titicaca and took matters into their own hands. Their islands are woven

From left, llamas have been reintroduced to the region; wild cactus on the Isla del Sol.

There are plenty of ways to visit the islands, spanning the range of budgets and timeframes. For the cheapest and simplest, go to the dock at Puno and pay for a place on one of the boats to the Uros islands, which will take a couple of hours to get a glimpse of this unique way of life. For more of a traditional experience, various tours offer the chance to spend a night on one of the floating islands in a family's home, your sleep softened by the reeds. In the morning, you'll head out at sunrise with the fishermen. For those seeking a bit of luxury, Isla Suasi is privately owned and has a swish eco-lodge, with great food, a sauna and kayaks.

together from totora reed, a plant which grows in the shallows. Not only do they live on totora reed, but they eat it as well, use it for medicine, and weave their houses and their boats from it. The boats are stunning, crescent-shaped craft known as *balsas*, many with figureheads of mythic beasts, that they use for their fishing and for transport.

Some aspects of life are changing. There are fewer people living in the traditional ways now, and more are moving to the cities. Fishing is now longer such a reliable way to make a living, and the lake is under threat from pollution from the surrounding towns, as well as from climate change. Local governments have taken steps to try to clean things up, but there is still much that needs to be done. Species have gone extinct, and others are under threat, including the Titicaca water frog, which can grow as large as 1kg. There is concern that, in a warmer world, toxic algal blooms will spread across the lake, or that parts of it could even dry up. It can only be hoped that a lake that has played a crucial role in human history since the very beginnings of civilisation can continue to thrive well into the future.

Mountains

We think of mountains as immutable. But the fact is that they're in constant flux, shifting up, down, sideways, changing from season to season, century to century, always offering something new. Our relationship with mountains is similarly fluid. In the past, people would have sought revelation in mountains, now we seek recreation, and in so doing we perhaps reveal a bit more of our own character and aspirations.

Mountains have always represented challenge and risk to humans through the ages, from Hannibal crossing the Alps with his elephants to modern-day mountain bikers riding the length of a range under their steam or climbers conquering soaring summits. 'Adversity is the first path to truth,' said the poet Byron. Whether artist or adventurer, the places in this chapter will inspire: we journey to lost cities, mythical mountains, natural wonderlands, and famous peaks high above the clouds.

Every peak in Scotland over 3000ft (915m) in height is classed as a 'Munro'. That's not the name of each individual mountain but the name of Sir Hugh Munro, who catalogued and then published his 'Tables' of Scotland's highest mountains in 1891. After years of exploration and much hillwalking, Munro, an original member of the Scottish Mountaineering Club, arrived at the total of 282 for the number of Scottish summits above 3000ft (the 1997 edition of Munro's Tables puts the actual tally at 284). As soon as there was a list of peaks, there were people clambering to conquer them all. One of the first was the Reverend AE Robertson, who claimed his final Munro, Meall Dearg above Glen Coe, in 1901. Today about 150 Munroists complete the challenge each year.

My own first Munro was Ben Lawers, on the north side of Loch Tay. It's far from an obscure example. In fact, the tenth highest Munro (at a whopping 3983ft, 1214m) is one of the most popular, being set south of the Cairngorms and easily reached from the Scottish cities of Perth, Stirling, Dundee, Edinburgh and Glasgow (there's even a convenient car park at its base).

However, on a wintry day in late November, the route frosted with snow and ice, it definitely felt like an adventure with my more experienced winter-climbing friends, Jenny and Simo from Sweden and Finland. We were the only people on the hill that day and edging along the ridge, our hoods pulled tight against our faces as snow swirled around a dark sky, it felt like an expedition up Mt Everest. Exhilarating though the day was, it was only later that I realised

The ptarmigan, camouflaged in seasonal snow-white plumage, lives and breeds in Scotland's highlands.

Left, descending Ben Lawers in winter; right, the Salisbury Crags above Edinburgh, Scotland; previous page, the Dolomites viewed from the Alpe di Siusi mountain plateau.

the journey had been more than an invigorating walk up a big hill.

First of all, it was a trip back in time. Scotland's stubby mountains are among the world's oldest. And the planet's highest range, the Himalaya, home to such giants as Mt Everest, K2 and Annapurna, is its youngest. Around 60 million years ago Scotland broke away from Greenland and North America; 170 million years ago Scotland would have sat in the planet's northern tropics, a land of arid deserts. And 400 million years ago mountains the size of the Himalaya dominated the land – it is their weathered and eroded nubs that hillwalkers enjoy today.

Mountains are created when continental plates collide; where they buckle over and under each other ranges rise. In the 1960s the planet's plates were named: the North American Plate, the Australian Plate, the African Plate and more. The Alps rose when the Adriatic Plate smashed into the Eurasian Plate. The Himalayan range was conceived when the Indian Plate butted up against the Eurasian Plate just 65 million years ago. The plates are still moving and Mt Everest, the world's tallest mountain, is still growing.

Had I realised this on Ben Lawers, I may have paid more attention to the sparkly sheen of mica, a stone that is common on the mountain. Each 3mm layer of this rock represents a hundred centuries of sediment, a colossal amount of history – think of 3.65 million sunrises – compressed by the forces of time and gravity. In *The Lie of the Land*, Ian Vince's engaging introduction to the geology of the British Isles, he explains that the rocks

of the northwest Highlands of Scotland are more than three billion years old and how evidence of dramatic events is plain to see if you know how to look: the now-tranquil Great Glen in Scotland was a fractious fault line 400 million years ago, causing earthquakes and volcanoes over millions of years. One such volcano erupted beneath what are now the Salisbury Crags in Edinburgh's Holyrood Park. In the 18th century, the Edinburgh geologist James Hutton argued that the Crags were formed by molten rock. Back then geology was a young and much mistrusted science. After all, it's not easy to overturn established wisdom. Rather than read bibles, geologists read landscapes and by the 18th century they were able to illustrate how the Earth was millions of years old and was still changing. To travel to mountains was now to engage on a quest for answers. Scientists like Charles Darwin couldn't help

MARILYN OR MUNRO?
There's a lot more
to British mountain
terminology than Munros.
A Marilyn is 'a hill of any
height with a drop of
150m (490ft) or more
on all sides. So, they're
really just quite high
hills but that's enough
inspire walkers to tick
off all 600 in the British
Isles, including the
famous peaks of Scafell
Pike in England's Lake
District, Mt Snowdon in
Wales and Ben Nevis in
Scotland. And then come
the Corbetts, Donalds,
Simms, Hewitts, Tumps,
Humps and more. Only a
little, densely populated
island with no high
mountains could come
up with so many ways of
cataloguing landscapes.

Above, Glen Coe and
the Munro Buachaille
Etive Mòr, close to
Fort William and the
southern tip of the
Great Glen fault line.

but join the hunt: 'Who can avoid admiring the wonderful force which has upheaved these mountains and even more so the countless ages which it must have required, to have broken through, removed, and levelled whole masses of them?' he asked in his *Diary of the Voyage of HMS Beagle*.

One such evangelical geologist was the art critic and essayist John Ruskin, who published his volume *Of Mountain Beauty* in 1856. Ostensibly a discussion of art, particularly the paintings of JMW Turner, Ruskin's essays were also on-target scientifically. He recognised that mountain ranges were waves in perpetual motion and that the Matterhorn's toothy, triangular profile, as distinctive as any peak's, was an exquisite example of geological sculpture, carved by ice and time. And he was very clear on his main thesis: 'Mountains are the beginning and end of all natural scenery'.

This remained a novel point of view even by the 19th century. Before the 18th century, risking your life to climb a mountain would have been considered absurd. In those days, ordered landscapes, like gardens, were preferred to wildernesses. Mountains were the most aesthetically abhorrent of all. And they were believed, rightly, to be dangerous places, home to gods or monsters.

But then, in 1757, Edmund Burke published his *Philosophical Enquiry into the Origin of Our Ideas of the Sublime and Beautiful*, which changed everything. In Burke's theory of the sublime (defined as elevated or heightened) he argued that: 'Whatever is fitted in any sort to excite the

ideas of pain and danger, that is to say, whatever is in any sort terrible, or is conversant about terrible objects, or operates in a manner analogous to terror, is a source of the sublime; that is, it is productive of the strongest emotion which the mind is capable of feeling.'

So, terrifying mountains could also induce heightened emotions. He went on:

'The passion caused by the great and sublime in nature, when those causes operate most powerfully, is astonishment: and astonishment is that state of the soul in which all its motions are suspended, with some degree of horror. In this case the mind is so entirely filled with its object, that it cannot entertain any other, nor by consequence reason on that object which employs it. Hence arises the great power of the sublime, that, far from being produced by them, it anticipates our reasonings, and hurries us on by an irresistible force. Astonishment, as I have said, is the effect of the sublime in its highest degree; the inferior effects are admiration, reverence, and respect.'

Humans are susceptible to feeling awe and astonishment at phenomena beyond our control and comprehension: the infinite stars of the deep night sky, an irresistible storm, and the world's most imposing mountains. The study of awe is a growing field of psychology and experiencing awe, says Professor Dacher Keltner of the Greater Good Science Center at the University of California, Berkeley, can help us feel more satisfied with life, more humble, grateful, generous and connected with each other and the wider world. And some studies have suggested that it may reduce materialism and increase the ability to think more critically. We seek out wild places, whether we realise it or not, because we need that emotional connection with nature, and we venture into the mountains because of how they make us feel.

Certainly, after Burke's theory of the sublime gained currency, there was a rush to alpine settings by people. Where once Grand Tourists would have made straight for the ruins of Italy and Greece during their months-long European trips, now they tarried in the Alps or travelled to Scotland's Highlands and the fells of England's Lake District. The very first travel guides were compiled about the Alps by writers such as Mariana Stark and John Murray.

In the chapter on Chamonix (Chamouni), from *Travels on the Continent* (1820) Mariana Stark writes: 'The Traveller is

presented with a sight of the Mer de Glace; to reach which, occupies a full quarter of an hour; and persons who venture to walk upon its surface should be especially careful to avoid the cracks and chasms with which it abounds: the colour these chasms assume is a beautiful sea-green; and the waves of this frozen ocean, which from the top of Montanvert appear like furrows in a corn field, are now discovered to be hillocks from twenty to forty feet high. The Mer de Glace is eight leagues in length, and one in breadth: and on its margin rise pyramidical rocks, called Needles, whose summits are lost in the clouds; they likewise are denominated the Court of their august Sovereign, Mont Blanc; who glitters on the opposite side, in stately repose; and being far more exalted than her attendants, veils in the heavens, which she seems to prop, a part of her sublime and majestic beauties.'

Note that she offers practical advice on surviving a walk on France's largest glacier because fear had now become something to be conquered. This was the age not only of the first travel guidebooks but also the first self-improvement manuals: what doesn't kill you makes you stronger was the new creed.

Fear was an entirely rational reaction to the great Alps of France, Switzerland and Italy. Unlike a walk in the woods, climbing mountains is a passion for which people may die. In 1865, the first successful summiting of the Matterhorn swiftly turned to tragedy. Edward Whymper had led his team, including an 18-year-old lord, Francis Douglas, and the Reverend Charles Hudson, to the top on 14 July. But on the descent four of the eight-strong group, including Lord Douglas and the reverend, fell to their deaths. The macabre details were pored over in the press of the day: nothing was found of Lord Douglas bar a boot, a belt, and a pair of gloves. Whymper, however, lived into his seventies and is buried in the English Cemetery of Chamonix, among many other climbers. 'The effect of this strange Matterhorn upon the imagination is

indeed so great that even the gravest philosophers cannot resist it,' wrote Ruskin in 1862 of his favourite mountain.

As the 19th century came to a close, most of the major Alpine peaks had been conquered by mostly British climbers. In 1830 the Royal Geographical Society had been founded in order to support scientific research expeditions. Now its members turned their attention to ranges of the Andes, the Caucasus and, most of all, the Himalaya. Here, deadly peaks like Kanchenjunga and K2 bewitched Western climbers. And Mt Everest, highest of all, known as Chomolungma, Mother Goddess of the Universe, to Tibetans and as Sagarmatha, Goddess of the Sky, to Nepalis, cast the strongest spell of all. 'My darling ... I can't tell you how it possesses me,' wrote climber George Mallory to his wife Ruth. The RGS made reconnaissance trips to Mt Everest in 1921: photographs show pipe-smoking, tweed-wearing British adventurers fixing a determined gaze on the massif. Mallory, of course, perished a short distance below the summit of Everest in 1924. Even as recently as 2019, 11 people died on Everest, with climbers stepping around dead bodies.

There's a romanticism to the high mountains that isn't borne out by

© Royal Geographical Society / Getty Images. © Mountainpix / Shutterstock

the reality, which is one of cold, fear and unforgiving rock. Unlike some of the other natural environments in this book, high on a mountain many of your senses desert you. You can't touch your surroundings with bare hands, your senses of smell and taste no longer work, and there's nothing to hear above the sound of the wind. Your sight is all that remains and it's what keeps you alive. Plenty of climbers have died after losing their sight through damaged eyes and wandered off cliffs.

After you reach a certain altitude your body starts to shut down at an ever-quickening rate. At sea level the percentage of oxygen in the air we breathe is about 21%. At 3000ft, the height of Britain's highest mountains, oxygen levels are 18.6%. At 5000ft, the altitude of some

Left, members of the 1921 RGS Mt Everest expedition camping at 17,300ft with Mallory lower left; right, the Mer de Glace on Mont Blanc.

Rousseau on the Alps: 'Imagine to yourself all these united impressions; the amazing variety, grandeur and beauty, of a thousand astonishing sights; the pleasure of seeing only totally new things, strange birds, odd and unknown plants, to observe what is in some sense another nature, and finding yourself in a new world...'
Jean-Jacques Rousseau, *Julie, ou la nouvelle Héloïse* (1761)

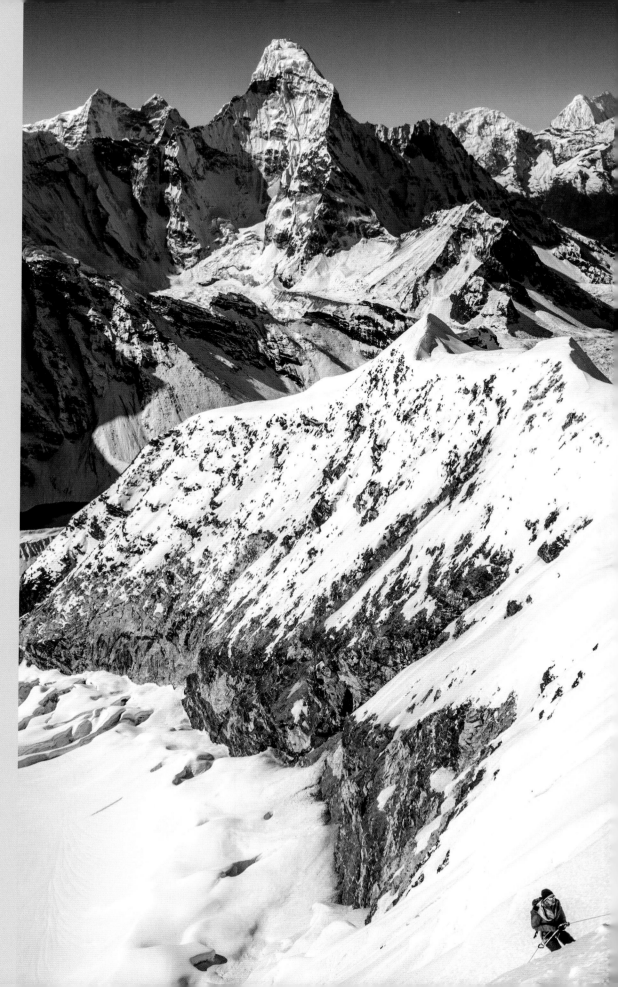

MALLORY ON EVEREST

Did he or didn't he? That's the question everybody asked of George Mallory's attempt to be the first person to summit Mt Everest on the British expedition of 1924. The climbing party had arrived at Base Camp on 28 April and on 25 May they were all blessed by the Lama at Rongbuk Monastery. On the morning of 6 June, after a breakfast of sardines, biscuits and tea, George Mallory and Andrew Irvine set out from Camp IV for the summit. Fellow climber Noel Odell recalled seeing the pair just 800 vertical feet from the summit, but five or six hours too late in the day. Mallory and Irvine never made it down. Mallory's body was found by climber Conrad Anker in 1999 at around 26,770ft, still clad in hob-nailed boots and shreds of clothing.

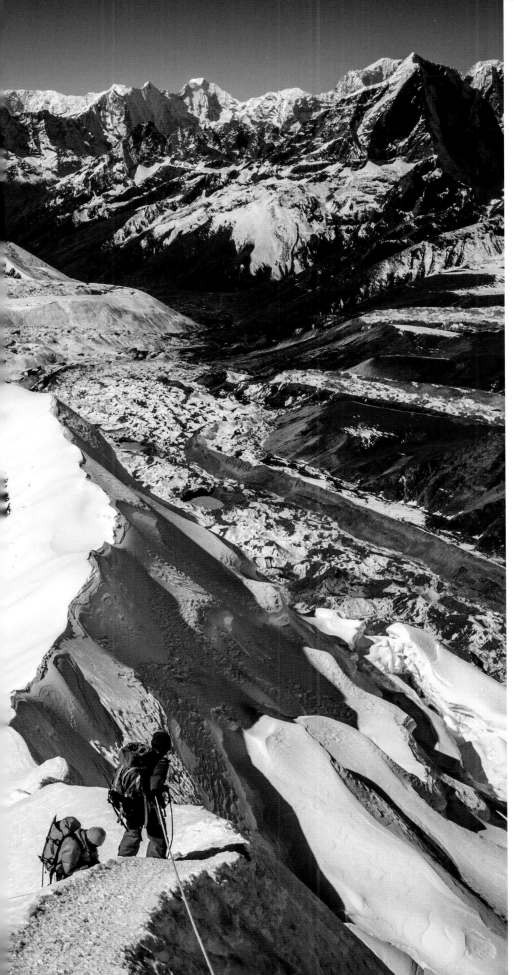

Left, descending from
Island Peak, or Imja
Tse, in the Himalayas
of eastern Nepal.

popular mountain towns in the US, such as
Boulder, the percentage of oxygen in the
air is about 17.3%. At the top of Mont Blanc,
only 15,750ft, it's about 11.5%. At 18,000ft,
the height at which Everest Base Camp
lies and also the peak of Mt Elbrus, the
highest mountain in Europe, you'll enjoy
less than 10.5% oxygen, about half of what
is available at sea level. And at 29,000ft,
deep in the death zone, the thin air is just
6.9% oxygen, which is why most people on
Everest carry supplemental oxygen tanks.

The body does adapt to altitude,
producing extra haemoglobin to carry
more oxygen around the body, but as
your blood thickens the risk of a stroke
or thrombosis increases. The symptoms
of high-altitude cerebral oedema
include a severe headache, irrationality,
hallucinations and retinal haemorrhages.
Oxygen deprivation – hypoxia – has a
marked effect on brain function with many
accidents on Mt Everest and other high
peaks attributed to poor judgement.

But this is a book about the benefits of
being in nature! And there are profound
effects on our bodies and minds to
exploring high lands. Visiting mountains has
long been one of the most popular leisure
activities of recent decades: in 2018 there
were thought to be 47 million Americans
identifying as hikers. In the same year
there were 318 million visits to National
Park Service sites in the US. To get into the
mountains, some physical exertion and a
spirit of adventure is required.

It was the Romantic poets of 18th-
century England who first popularised
walking as a recreation. William

Wordsworth, who we last met wandering the woods of the Lake District (see p19), clearly found walking essential for his mental wellbeing. His friend Thomas de Quincey observes in *Recollections of the Lakes and the Lake Poets*: 'Wordsworth was, upon the whole, not a well-made man. His legs were pointedly condemned by all the female connoisseurs in legs that ever I heard lecture upon that topic.' But Wordsworth's legs were perfectly serviceable as de Quincey explained: 'I calculate, upon good data, that with these identical legs Wordsworth must have traversed a distance of 175 to 180,000 English miles – a mode of exertion which, to him, stood in stead of wine, spirits, and all other stimulants whatsoever to the animal spirits; to which he has been indebted for a life of unclouded happiness, and we for much of what is most excellent in his writings.'

From an early age, Wordsworth sought to escape and explore. He went to school in Hawkshead in the Lake District but was more interested in ice-skating, climbing cliffs for birds' eggs, boating, and walking ceaselessly at night and before classes started each morning. There are striking parallels with another nature-loving writer, John Muir, who would sneak out at night and scale the dangerous

sea cliffs near his childhood home in Dunbar, Scotland. Climbing, perhaps, teaches problem solving and the power of concentration to restless minds. Indeed, Wordsworth's friend and fellow Romantic poet Samuel Taylor Coleridge is credited with being an early recreational rock climber when he became the first person recorded to summit Scafell Pike, followed by a hair-raising improvised descent.

One of Wordsworth's formative adventures was his walk through the Alps with his friend Robert Jones. Both were Cambridge University students who should have been studying for their exams but Switzerland exerted a greater pull. It was an act of rebellion and it also had political resonances: Switzerland was a republic, which appealed to Wordsworth, and it also had connections with Jean-Jacques Rousseau, the German philosopher. Wordsworth embraced exploring places, in his words, 'in 'an humble evangelical way ... like a peasant'. Nature and simplicity and modesty were woven together. As Rebecca Solnit explains in her book *Wanderlust*, 'Rousseau and romanticism equated nature, feeling, and democracy, portraying the social order as highly artificial and making revolt against class privilege "only natural."'

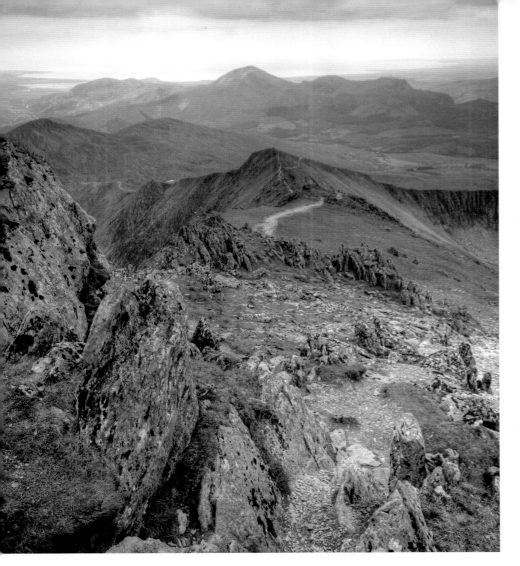

Wordsworth's poetry was composed in language plainer than that of more flowery writers. It was deliberately conversational. So when his great poem *The Prelude* concludes with a visionary experience on top of Mt Snowdon in Wales (a shepherd guides Wordsworth and a friend to the top so they can see the sun rise) it is something that we feel we can share in and emulate ourselves. Climbing a mountain can become a journey of self-discovery. Note the number of hermitages and monasteries up high, such as those of Meteora in Greece or the ancient churches carved into the sides of mountains in Ethiopia. In all three monotheistic world religions, founders received revelations on mountain tops.

As well as looking within, from the tops of mountains you can also see further: panorama is Greek for 'all-embracing view'. To work out how far you can see from a given elevation before the Earth curves away, you will need to do some maths using the radius of the Earth (3963 miles or 6378km). It could well be more than 100 miles (160km), with one of the limiting factors being the air quality of the atmosphere. From a Munro on the west coast of Scotland you can see the curvature of the Earth out at sea. Standing above the clouds, as if on an island, is a mind-bending mental shift: there's no better way of gaining a sense of perspective in life than being reminded of your physical insignificance. Robert Macfarlane observes in his book *Mountains of the Mind* that 'Those who travel to mountain tops are half in love with themselves, and half in love with oblivion.'

Others travel to the tops of mountains mostly to enjoy the trip back down them, in search of what some scientists call a 'flow' state. Skiers and mountain bikers, much like surfers on waves, seek the sensation of being utterly focused on the moment. Psychologist Mihaly Csikszentmihalyi, author of *Flow: The Psychology of Optimal Experience*, explains: 'The best

moments in our lives are not the passive, receptive, relaxing times... The best moments usually occur if a person's body or mind is stretched to its limits in a voluntary effort to accomplish something difficult and worthwhile.' Carving down a mountain side at speed, 'in the zone', on skis or a bicycle, mind and body working as one, is to be truly present in the moment, finding balance and momentum thanks to gravity. The resulting release of endorphins, dopamine, serotonin and adrenaline is a form of natural high. Interestingly, another of Csikszentmihalyi's conclusions is that money alone doesn't make us happy. But perhaps being out in nature, concentrating completely on something we love, may.

Another aspect of positive mental attitude may come from transcendental experience. While recent studies at London's Imperial College found that people who had psychedelic experiences (for example with LSD or psilocybin) tended to form a stronger bond with nature, which contributed to a broader sense of psychological well-being, sometimes nature, and especially mountains, can provide the psychedelics. While mountain ranges may seem to be the opposite of the forests and waters explored elsewhere in this book, bleak and hostile rather than teeming with life, they may be even more mood-altering. 'How could we expect anyone else to understand the peculiar exhilaration that we drew from this barrenness, when man's natural tendency is to turn towards everything in nature that is rich and generous?' wonders Maurice Herzog in his book *Annapurna*. As he climbed the mountain Annapurna in June 1950, Herzog had a transcendent experience on the final ascent from Camp V, even as his body was breaking down in the thin, icy air: 'But all sense of exertion was gone, as though there were no longer any gravity ... they were the mountains of my dreams.' Unfortunately, a short while later, almost all of Herzog's fingers and toes would need to be amputated.

Frostbitten fingers aside, taking part in adventure leaves a memory that we can tap into at any time, as if a switch has been thrown permanently. Adventure lends a child's attitude to life, where everything can be new and exciting. You don't need to go to Everest; there will be hills near your home that you've never set foot on, or you can experience them in a new way at night or out of season. Being in the hills boils life down to essentials: food, shelter, water and warmth. And it's a lot of fun.

For those dwelling in Europe's fast-growing cities, the closest hills and mountains became an escape, much as they are today. They provided space for that favourite pastime of Romantics, contemplation, and inspired poetry, painting and music.

From being places of fear, mountains gradually became centres of health and wellness, with sanatoriums opening in the clear air of the European Alps. Originally these facilities were built to help patients with tuberculosis, bronchitis and other diseases to recover. In just one Swiss town, Davos, there were 30 sanatoria in the 1920s and 1930s. 'Sickness is the vacation of the poor,' said French poet Guillaume Apollinaire. Workers from Europe's dirty, crowded cities would be sent to the mountains to recover from illnesses (or die – the cure of fresh air and sunshine was not guaranteed).

After wars, soldiers with what we would know as Post-Traumatic Stress Disorder would also find respite in these beautiful havens. However, after

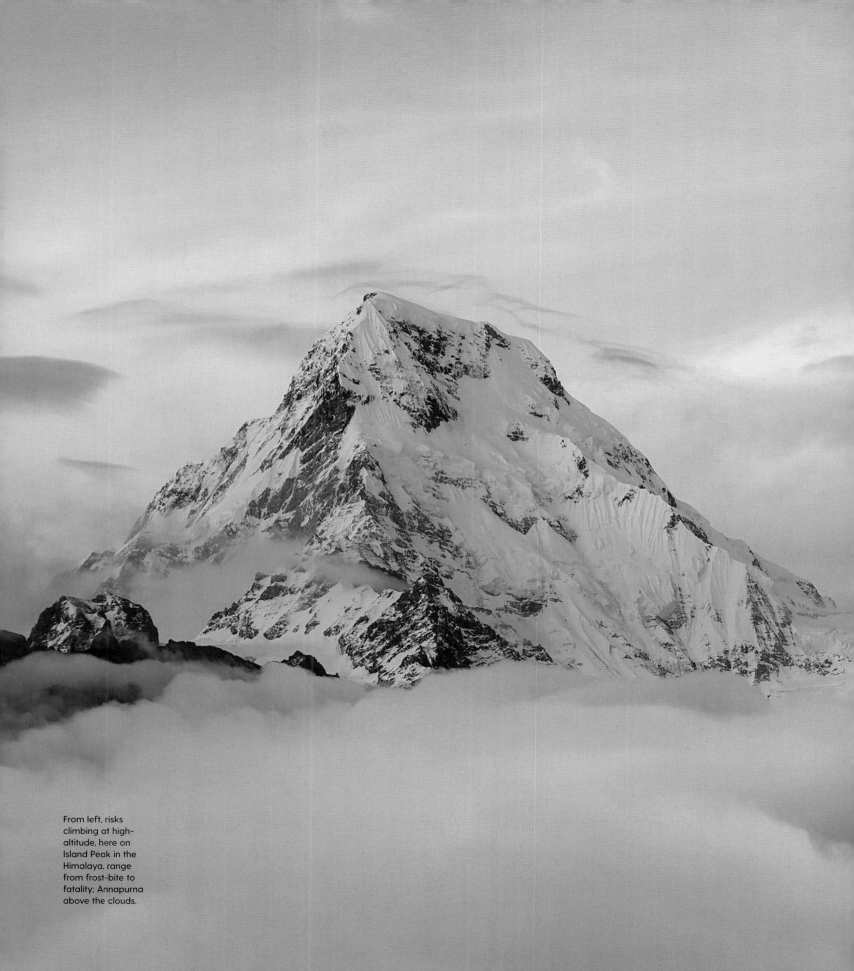

From left, risks
climbing at high-
altitude, here on
Island Peak in the
Himalaya, range
from frost-bite to
fatality; Annapurna
above the clouds.

'Pinnacles of snow, intolerably bright, part of the chain connected with Mont Blanc shone through the clouds at intervals on high. I never knew – I never imagined – what mountains were before. The immensity of these aerial summits excited, when they suddenly burst upon the sight, a sentiment of ecstatic wonder, not unallied to madness...' Shelley in a letter to his friend Thomas Love Peacock in 1816

penicillin was discovered by Sir Alexander Fleming in 1928 there was decreasing demand for such health retreats. It still seems rational to believe that clean air is healthier than air filled with noxious fumes and that natural food, exercise and sunlight can help us stay healthy.

Mountains are good for us but we're not so beneficial for mountains, which are thermometers warning of a warming planet. According to the National Oceanic and Atmospheric Administration in the US, glaciers worldwide have lost mass every year for the last 30 years (from 2018). They've been shrinking, off and on, since the last ice age about 10,000 years ago. Those wide U-shaped valleys that lead up into the mountains were once filled with slow-moving ice rivers. Now those glaciers have retreated to the very highest ranges and polar regions to the north and south and the rate of their disappearance is accelerating. Aside from rising sea levels, there's another chilling consequence of the great melt: in many regions, including China, India, South America and the western United States, glaciers are great frozen reservoirs of water for hundreds of millions of people. In central Asia and the Subcontinent, glaciers feed vast river basins where millions of farmers produce food for some of the world's most populous nations. What will be the geo-political consequences when the water supplies in these regions dwindle in another 30 years? Inevitably, we will find out.

Right, Loch Lomond viewed from Ben Lomond in Scotland.

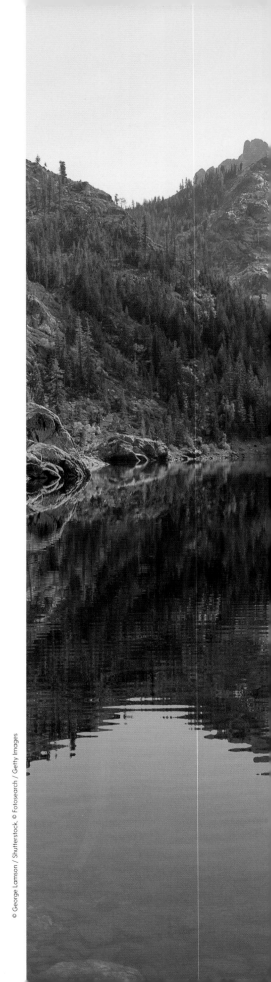

USA

The Last Sierra

Release your inner adventurer with a hiking, biking, fishing and chilling trip into this secluded northern corner of the Sierra Nevada.

California's storied Sierra Nevada mountain range runs for 400 miles (645km) down the east side of the state, sometimes crossing into Nevada. It is roughly book-ended by two national parks, Lassen Volcanic to the north and Sequoia to the south and includes perhaps America's most famous national park, Yosemite, just about three hours' drive east of San Francisco. Yosemite National Park was inaugurated in 1890, eight years after America's first national park, Yellowstone. Both established the US as a world leader in the preservation of natural landscapes (by comparison, Britain didn't create its first national park until 1951). The Sierra Nevada also features the tallest peak in the continental US, Mt Whitney, and numerous National Forests – Lassen, Plumas, Tahoe, Stanislaus, Sierra, Inyo – add to the recreation space.

The national parks of the Sierra Nevada also include Kings Canyon. Both Yosemite and Kings Canyon had the most influential and ardent advocate of the outdoors in the figure of John Muir, a Scottish naturalist and writer whose family had emigrated to the US in 1849. At the age of 29 Muir moved to San Francisco from where he made his early forays into the mountains. The following year he started a job as a shepherd in the hills around Yosemite, described in the profoundly inspiring *My First Summer in the Sierra*. Not long after, Muir co-founded the Sierra Club, which held its first meeting on 28 May, 1892

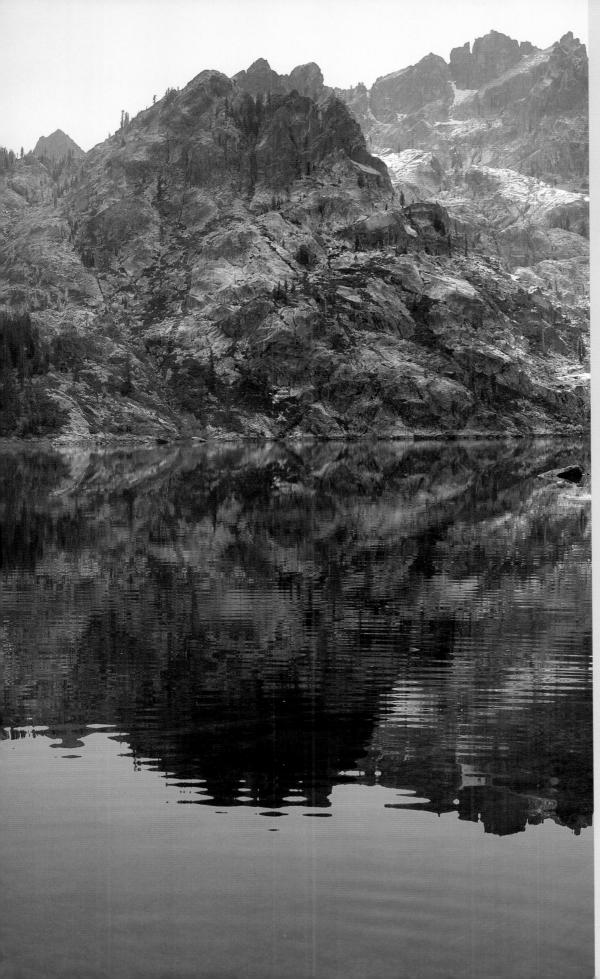

'After luncheon I made haste to high ground, and from the top of the ridge on the west side of Indian Canyon gained the noblest view of the summit peaks I have ever yet enjoyed. Nearly all the upper basin of the Merced was displayed, with its sublime domes and canyons, dark upsweeping forests, and glorious array of white peaks deep in the sky, every feature glowing, radiating beauty that pours into our flesh and bones like heat rays from fire. Sunshine over all; no breath of wind to stir the brooding calm. Never before had I seen so glorious a landscape, so boundless an affluence of sublime mountain beauty.'
John Muir, *My First Summer in the Sierra* (1911)

Left, the Sierra Buttes and Upper Sardine Lake in the Lost Sierra near Downieville.

From right, descending the North Yuba trail in the Lost Sierra; Downieville is almost unchanged in 100 years, apart from all the mountain bikers.

and is still active in the region's conservation today. In 1903 President Theodore Roosevelt visited Yosemite National Park and camped out at Glacier Point with John Muir (presumably in the days before presidential security details). 'Lying out at night under those giant sequoias was like lying in a temple built by no hand of man, a temple grander than any human architect could by any possibility build,' Roosevelt later said. This was also a president who declared: 'The lack of power to take joy in outdoor nature is as real a misfortune as the lack of power to take joy in books.'

With such serious evangelists, it's no wonder that Yosemite National Park now receives about four million visitors each year. And places like Mammoth Mountain and Lake Tahoe are similarly crowded whatever the season. But there is a corner of the Sierra Nevada where you can find quieter trails, more authentic mountain towns and equally uplifting views: it's called the Lost Sierra.

The Lost Sierra lies in the north of the Sierra Nevada, roughly spanning the triangle of glacial lakes, granite mountains and irrepressible rivers between Downieville, Graeagle and Quincy. Much of it lies within Sierra County, which has a total population of 3000, making it California's second most sparsely populated county. This is where to escape the crowds and find solace among the lofty Douglas firs and cerulean lakes.

Of course, the 19th-century gold prospectors got here first, travelling up from San Francisco, now a three-hour drive northeast, then a long trek by foot or horseback. Towns were founded and trails forged into the wilderness by miners and

their packhorses. Then the gold rush slowed to a trickle and almost everybody moved on, bar a few hold-out families hoping to score big, someday.

Many years later, in the 1980s and 1990s, a group of locals started riding their bikes on these trails and soon the Sierra Buttes Trail Stewardship (SBTS) was formed to represent all trail users and help support a local economy and healthy outdoor lifestyles. With such stand-out sights as the highest peak in the north of the range, Sierra Buttes, and forest-fringed Gold Lake, all linked by rugged and rocky trails, the Lost Sierra is a high-altitude heaven for people who love the outdoors. Hiking in the Sierra mountains granted Muir, in his words, 'admission into a new realm of wonders as if Nature had wooingly whispered, 'Come higher.'' And because there are no national parks in the region, only national forests, access for horse riders, mountain bikers and off-road motorcyclists is more easily negotiated and permits are typically not required for camping.

The Pacific Crest Trail, a through-hiking route from Canada to Mexico, passes through the Lost Sierra but the region is better appreciated by mountain bikers who can tackle many of the more remote trails. Some of the favourites crafted by the SBTS include Mt Hough, Mills Peak and the 15-mile (24km) descent from Packer Saddle all the way to Downieville. But SBTS has a greater vision, to connect 15 mountain communities across four economically disadvantaged counties with multi-use trails. So, unlike, say Yosemite's surrounding area, you can be sure that you're doing some good by exploring and playing in the Lost Sierra.

San Francisco has the nearest international airport. From San Francisco, drive northeast via Sacramento to Downieville, the gateway to the Lost Sierra. The town has several accommodation options, including cabins at The Lure on the river, rooms at the Carriage House Inn, and campsites. Towns deeper in the Lost Sierra, including Graeagle, offer more options. The trails open to mountain bikers when the snow melts at the higher elevations, usually in June. Trails at lower levels are often open year round. For shuttles to the top of mountains, contact Yuba Expeditions in Downieville and Quincy.

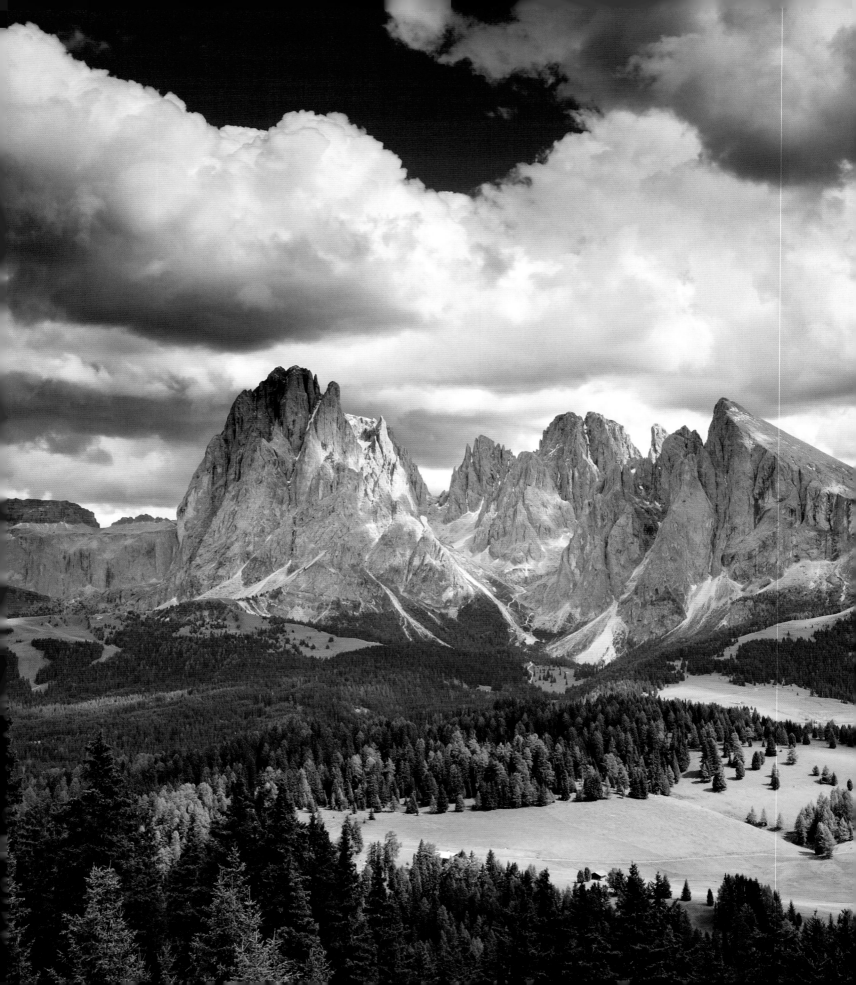

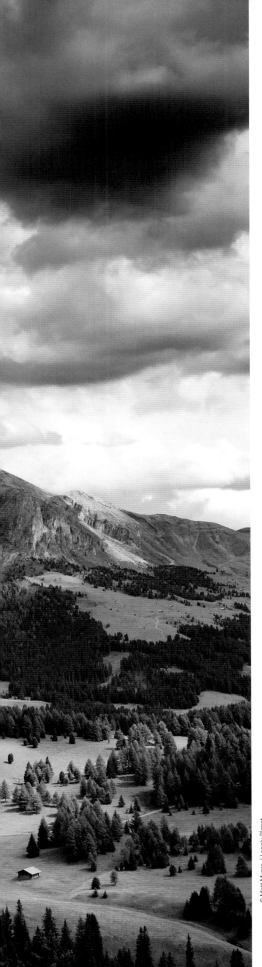

© Matt Munro / Lonely Planet

ITALY

The Dolomites

Jaw-dropping landscapes and horrific history combine in Italy's Dolomite mountains.

t's 18 October in 1915, five months after Italy had declared war on the Austro-Hungarian Empire in WWI. Night has fallen and a party of Italian soldiers have climbed the east side of Mt Lagazuoi in the heart of the Dolomites range of northern Italy. The mountain is 9301ft (2835m) and the soldiers are halfway up, sheltering beneath a ledge. They're bombarding the Austrian trenches beneath them with gunfire. And from above, Austrian soldiers are dangling each other off the mountainside to lob grenades at the Italians' position. Such is war in the high mountains.

The Dolomites are not the only range where high-altitude warfare has taken place. In the Karakoram, India and Pakistan have long skirmished on the Siachen Glacier at over 16,000ft (5000m), surrounded by dozens of unclimbed peaks over 19,000ft (5,800m). But only in the Dolomites has war changed the mountains so drastically.

The Dolomites border Italy and what is now Austria. Part of the range lies in the South Tyrol, a semi-autonomous region that was part of the Austro-Hungarian Empire until WWI. The Treaty of Versailles of 1918 gave the South Tyrol to Italy but it remains strongly German-speaking and everywhere has both an Italian name and an Austrian name. The local food, culture and style have a similar duality.

During WWI, soldiers from both sides fought fierce battles in the Dolomites and, in order to

Left, the Sassolungo range in the Dolomites.

HOW TO USE A VIA FERRATA

You'll need a helmet and a climbing harness with a lanyard attached that splits into two ends, each tied to a large carabiner. Modern lanyards typically have an energy absorber to minimise the jolt if you fall. Via ferrata typically consist of a cable looped through anchor points attached to the rock every 10ft (3m) or so. As you move forward, both the carabiners are clipped around the cable, until you reach an anchor point, whereupon you undo and reattach each carabiner, one at a time. Therefore you should always have one carabiner clipped to the cable. The same principle applies to climbing the metal rungs pounded into the rock faces of the Dolomites. It's climbing with all of the thrills but less of the risk.

Right, edging along the Brenta Dolomites using via ferrata.

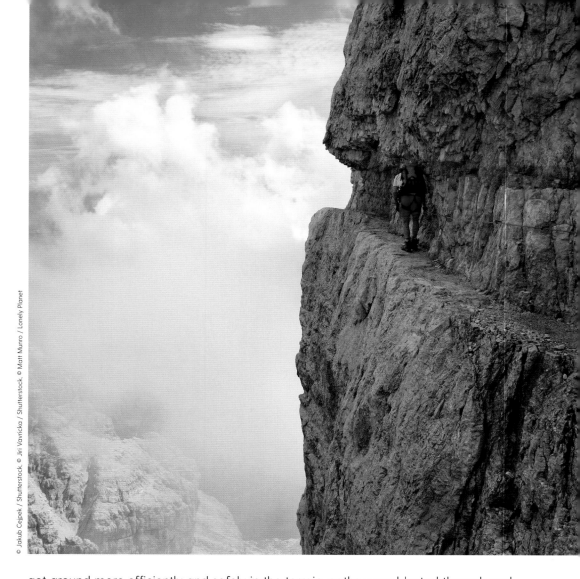

get around more efficiently and safely in the terrain, paths were blasted through and around mountains, and cables and metal rungs were hammered into rock faces. The new routes were known as via ferrate, iron ways, and today they enable access to the higher and more rugged corners of the Dolomites that would have been out-of-bounds to those without mountaineering skills. If you can use a carabiner and have a head for heights, the Dolomites can be explored, a playground that has been tilted 90 degrees.

The original name for the range, Monte Pallidi, the pale mountains, gives more of a clue to its character. These limestone pinnacles are exceptionally craggy and consist of rock spires and pinnacles, set around cascading meadows and woodlands. The morning and evening light catches the snows and pale stone of the mountains, making this range perhaps the most beautiful, photographically, in the world.

It's straightforward to explore too, thanks in part to war-time trail building but also historic tracks made by locals, such as shepherds, both now carefully maintained and signposted. Add the large number of *rifugios* where you can find a comfortable bed for the night and a plate of home-cooked food with local Italian wine, and the Dolomites make for a perfect walking and easy-going climbing trip.

The range spans numerous national parks and the Italian provinces of South Tyrol, Belluno and Trentino, from the Brenta Dolomites in the west where the highest peaks are Cima Brenta, Cima Tosa and Campanil Basso, to the Friulian Dolomites to the east, which descend to the River Piave to mark the range's eastern border. There are almost 200 via ferrate routes in the Dolomites, of varying degrees of difficulty and popularity.

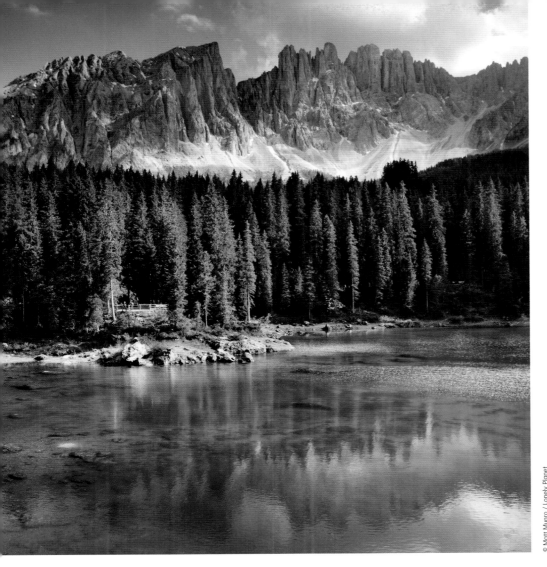

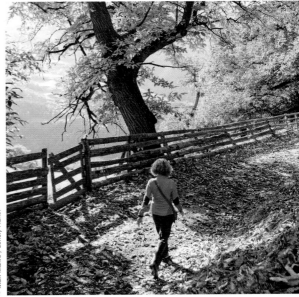

Left, Lago di Carezza (Rainbow Lake); below, it's not all high-altitude thrills in the South Tyrol.

The western side of the range is closer to such cities as Bergamo, Verona and Milan, which have international airports. The transport hubs in this part of the Dolomites include the town of Trento. To the east, the best access point may be Venice, which offers train services north into the mountains.

But it's the long-distance trails through this landscape that perhaps have the most appeal for those seeking to connect with nature. These are trails where you have to be a bit more self-sufficient, such as Alta Via 1 and 2, each of which extends for more than 100 miles (160-70km) across the mountains and meadows. Accommodation is in *rifugios* and towns such as Cortina d'Ampezzo, 11 miles (18km) north of Lagazuoi, host skiers in the winter and climbers and hikers in the summer.

Near to Cortina stands the Col di Lana, where one of the most famous battles was waged in the Dolomites. As happened on Lagazuoi, the Austrians held the high ground. So the Italians spent three months chiselling a tunnel up beneath them inside the mountain. In March 1916 the Austrians could hear the hammering beneath them but were ordered to stay at their stations. On 14 April there was silence from the shaft, which now ended 12ft (3.5m) beneath the Austrians. More than five tonnes of nitroglycerin was packed into the tunnel. When it was detonated at night on 17 April, 100 men died and the mountain was suddenly 90ft (27m) lower. All told, it is thought that 18,000 soldiers died fighting for the Col di Lana alone, and hundreds of thousands more across the Dolomites, many from avalanches. Reminders of the war and the violence, such as shreds of barbed wire, still remain strewn across this astonishingly beautiful and terrible battleground.

© Westend61 / Fotofeeling / Getty Images, © Sharon Davis / Alamy Stock Photo

NEW ZEALAND

Fiordland

ew places match the natural majesty of New Zealand's South Island with, from top to bottom, beaches, whales, glaciers and waterfalls. New Zealand's highest mountains are here: Aoraki/Mt Cook in the middle of the island, Mt Aspiring, and Mitre Peak, the triangular talisman marking the mouth of Milford Sound. Keep going, past the adventure towns of Wanaka and Queenstown and you'll reach Fiordland at the very southern tip of the island. This craggy corner of New Zealand is a vast national park and Unesco World Heritage area, covering 4633 square miles (120,000 sq km).

From the west, Antarctic weather fronts batter the park. But it was glaciers that carved the namesake fiords, bulldozers of ice grinding their way downhill. The rock detritus now largely blocks the entrances to the Fiordland's 14 fiords, resulting in a layer of seawater beneath a layer of fresh water.

To immerse yourself in nature, away from the crowds, you may have to go a bit further. One third of New Zealand's nine Great Walks are in Fiordland. With numbers limited during the tramping (hiking) season, the Milford Track, the Routeburn Track, and the Kepler Track, in order of popularity, are typically fully booked months in advance. And even if you do bag a space, you'll be sharing the track and the huts with up to 100 other hikers each day, no matter how early you set off each morning.

There are less well-known multi-day tracks

The South Island's fractured southwest coast offers up watery adventures in the mountains.

Left, Mitre Peak in Milford Sound is a very challenging climb.

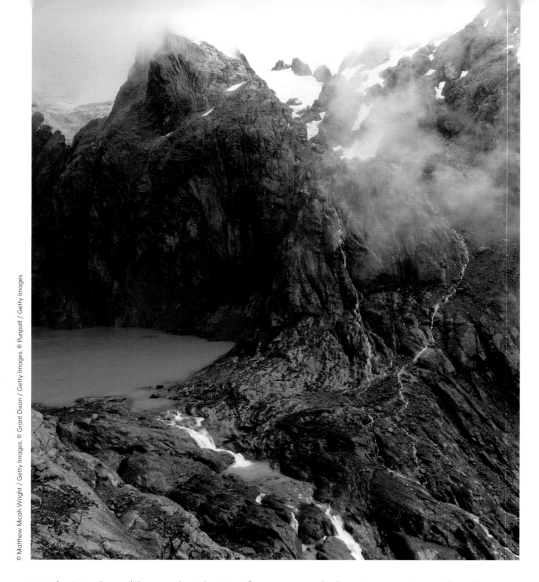

THE BLUE DUCK

True to New Zealanders' thrill-seeking reputation, the whio, or blue duck, could also be known as the white-water duck. Unlike most of its duck relatives, the whio lives year-round on churning, fast-flowing rivers, which is a challenging lifestyle, especially in winter. The ducks are making a return to Fiordland, with 64 breeding pairs found in the region in 2019. Introduced mammals, such as cats and stoats, are a big reason there are fewer whio today but pest eradication program has clearly helped the ducks. The birds are also a sign of clean, healthy (and quiet) rivers. Female whio incubate their eggs for more than a month. From October to December keep an eye open for whio chicks riding the tumultuous white water of Fiordland's rivers and streams.

Right, a glacial lake, green with sediment, in the Darran Mountains of Fiordland.

to take into the wilderness but they're often a more challenging experience than the Great Walks, with less cosseting and lot more mud, sweat and possibly tears. The Dusky Track, for example, takes eight to ten days to traverse three valleys and two mountain ranges between Lake Hauroko and Lake Manapouri (in either direction). Expect fallen trees, knee-deep mud and potentially dangerous river crossings after heavy rain. The rewards are views of Dusky Sound and Gair Loch. A little less off-the-beaten-track is the Hollyford Track, a fantastic alternative to the Routeburn. It meanders from the Darran mountains along the Hollyford River to St Martins Bay on the wild west coast, where you may spy fur seals and crested penguins. There are still unbridged river crossings but because it follows a river there are no alpine passes to cross.

One man who did get off the beaten track was Richard Henry, known as the 'father of New Zealand conservation,' in a country where conservation is taken extremely seriously. Henry was born in 1845 in Ireland but by the time he was six years old his family had settled in Australia. He later moved to Lake Te Anau in Fiordland, which he described as 'a fine place for a waterproof explorer'. Here he became enchanted by the region's flightless birds, in particular the kakapo, a large ground-dwelling parrot He wasn't the only person to be charmed by the parrot with big personalities. A lighthouse keeper in Fiordland kept a pet kakapo called Major, which would use his dog, Hector, as a cushion on which to sleep. 'As soon as Major had had sufficient sleep, he began to pull the dog's ears, nose, tail, toes, and hair... apparently to Hector's thorough enjoyment,' recalled the lighthouse keeper. The parrots later found wider fame in an episode of the TV series *Last Chance to See*, with Stephen Fry.

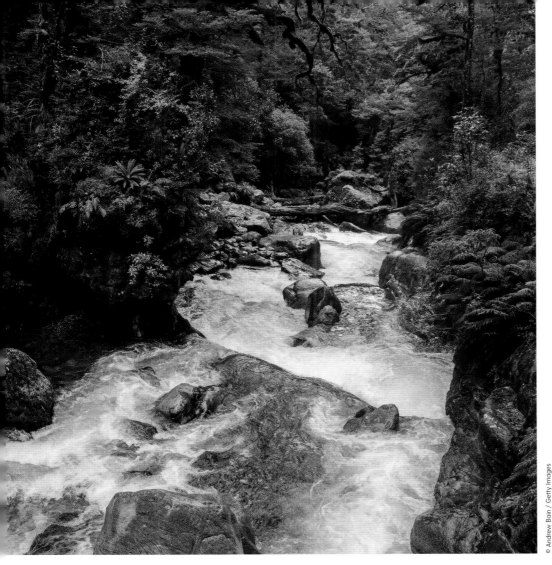

Left, Lake Marian Falls, near the Hollyford Track; below, crossing Hidden Falls creek on the Hollyford Track.

© Andrew Bain / Getty Images

Henry had noticed that the parrots were being predated by such introduced mammals as weasels and stoats. The parrots were even easy for people to catch by simply shaking a bush. With the foresight to see that the kakapo's days were numbered wherever they were exposed to predators and people, Henry set about collecting as many as possible and ferrying them to an island sanctuary. With the help of his dog, Lassie, who tracked the birds by their scent, he would gather a clutch of them and then row the kakapo to safety across Dusky Sound, alighting on Resolution Island in the centre of the fiord. He did this over several years until 500 kakapo resided on Resolution Island.

It wasn't only the kakapo's lives he was saving as the curator of Resolution Island. He had suffered from depression all his life and made a suicide attempt shortly before take the job. It was his conservation work and being in nature that perhaps gave him reason to live.

Sadly, the kakapo's sanctuary in Dusky Sound didn't remain undiscovered for long. By 1900, predators had started to swim to the island and soon there were just 50 of the parrots surviving. From the 1950s onwards, New Zealand made considerable efforts to protect its native creatures and a tiny population of kakapo was established on Codfish Island and other offshore islands, where, at the end of 2019, they numbered more than 200.

AUSTRALIA

Victoria's High Country

Follow the footsteps of pioneers into Victoria's beautiful, restful high country.

Right, the summit of Mt Buffalo at sunset, with dead snow gum trunks.

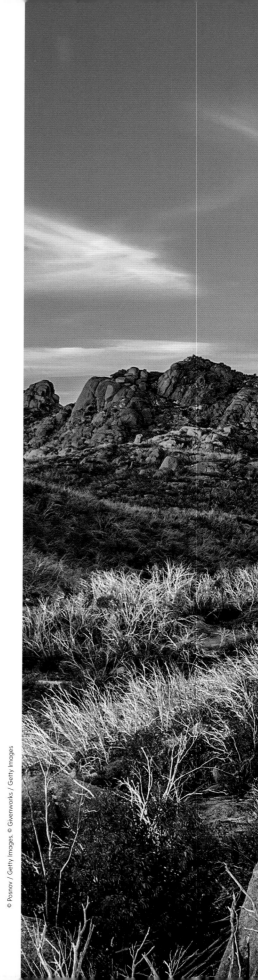

*A*fter the cattleman had unrolled his swag and lit a fire for his billycan, he would have sat outside the hut and watched the sun set over the vast expanse of high country bushland, the scrubby snow gums turning lilac in the low light. A new dawn would mean another long day in the saddle, pushing his cattle on, with another night in one of the many cattlemen's huts scattered across the distant hills.

Victoria's High Country occupies the northeast of the state, steadily gaining elevation from the country towns of Mansfield and Euroa up to the mountain towns of Bright and Mount Beauty. Beyond Bright and Mount Beauty lie Victoria's two highest peaks, Mt Bogong, at 6516ft (1986m), and Mt Feathertop (6306ft, 1922m). That's not especially high but in the 1830s, as pioneers such as the cattle graziers moved into the region, they would have been crossing true wilderness, reliant on their own wits. Today, hiking, biking and 4WD tracks allow access deep into the High Country, much of which is now the Alpine National Park.

Around 200 of the original huts survive, some more ramshackle than others, all in need of maintenance. The Victorian High Country Huts Association (VHCHA) has restored about 20 huts since its founding in 2003. They're available to bushwalkers, if the VHCHA's code of conduct is followed, which includes sleeping outside (in a tent or bivvy), putting out any campfire carefully, and respecting the hut's heritage.

For hikers, the High Country is filled with

© Posnov / Getty Images. © Givenworks / Getty Images

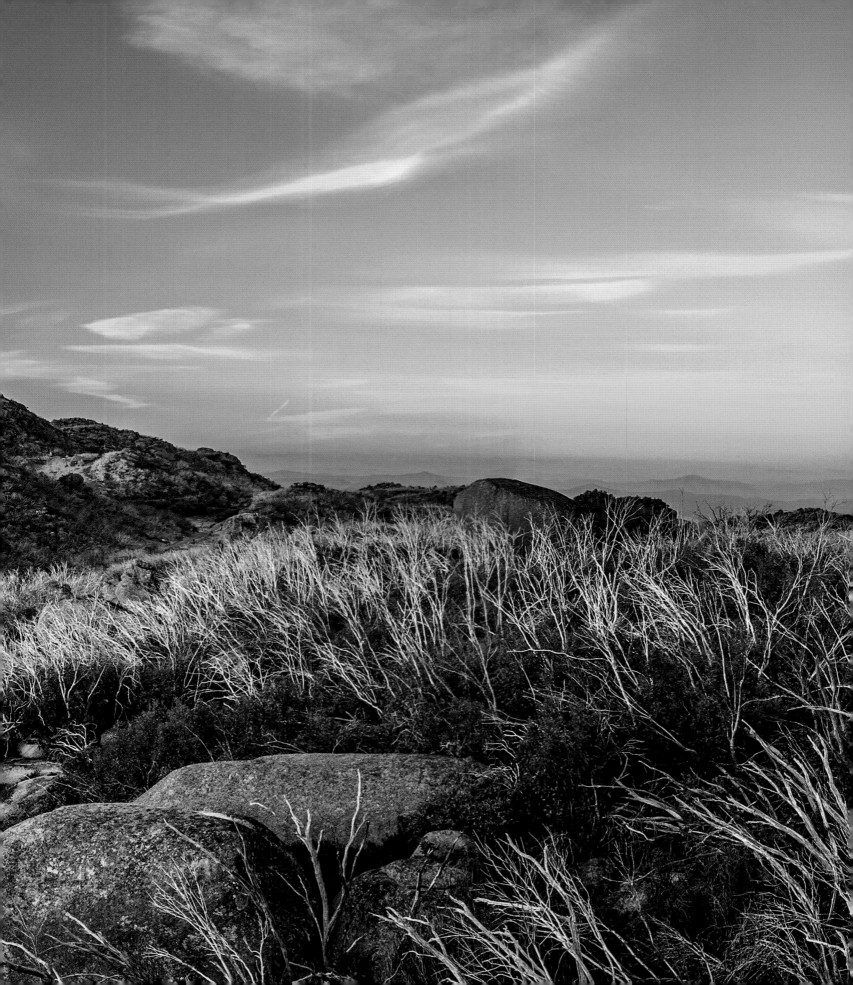

MOUNTAIN BIKING
Bring a bicycle if you visit the High Country. You can even reach it on the Murray to the Mountains rail trail that ends in Bright. Road cyclists will have most of Australia's toughest climbs (and descents) on their doorstep: Mt Buffalo, Mt Hotham, Falls Creek and beyond. It's possible to put together some stunning loops. Mountain bikers can try the trails at Bright's Mystic Mountain Bike Park or the trails at Falls Creek or Beechworth. Bike rental is available in Bright and Falls Creek. And cyclists who prefer unsurfaced gravel roads are spoiled for choice in King Valley, Kiewa Valley and around Beechworth. See www.ridehighcountry.com.au for ideas.

From right, Lady Falls on Mt Buffalo; watching the sun rise from the 'Hump' of Mt Buffalo.

© Robin Barton. © Alpine Gundog Photography / Shutterstock

enticing trails. Geologically, these highlands are ancient, with the rocks dating back 4-500 million years, so there are no huge edifices to scale, only undulating hills. A classic day-hike is along Razorback Ridge from Mt Hotham to Mt Feathertop. From this peak you will have 360-degree views over the High Country. Take the time absorb the natural wonders of the Australian bush: long scrolls of eucalyptus bark cascading to the ground, the rustle of an echidna burrowing beneath a log, the flashes of colourful, fast-flying rosellas. More than 1100 plant species live here, supporting mammals like wombats, wallabies and the ultra-rare mountain pygmy possum. Spring and autumn are especially beautiful times of year in the High Country; winter sees snowfalls across higher elevations.

Victoria's first ski resort, at the top of Mt Buffalo, just outside Bright, was constructed by the state government in 1910. Generations of families played in the snow and use Australia's first ski tow. The Mt Buffalo chalet closed in 2007 (and is still awaiting restoration) but this mountain remains a fantastic place in which to reconnect with nature, whether you're into walks, wildlife or activities such as kayaking on Lake Catani, climbing or cycling.

It was named by the explorers Hamilton Hume and William Hovell in 1824, during their expedition to find more grazing land in eastern Australia. They'd noticed that the outline of the mountain resembled (loosely, it has to be said) a sleeping buffalo. The ascent from the Ovens valley, which can be furnace-hot in summer, sees you pass through different habitats: tropical forests and waterfalls low down, with the trees becoming short and gnarlier as you climb, past an alpine lake and then into a more spartan landscape of

© Josh Tagi / Getty Images

Melbourne Tullamarine is the closest international airport. You'll need your own transport and the High Country is only a four-hour drive up the Hume Fwy to Bright (although a V-Line train can get you to Wangaratta or Wodonga, bus services east are infrequent). Accommodation is plentiful in tourist towns like Bright and Beechworth. The VHCHA's website lists the country huts: www. hutsvictoria.org.au

giant granite tors and snowgrass plains at the top. Here wildflowers, butterflies and birds, including the feisty scarlet-breasted flame robin, catch the eye. The first sightseers arrived atop Mt Buffalo in the 1850s with the Bright Alpine Club being formed in 1883 and the first guidebook to the region's walks published in 1887. The mountain was made a national park in 1898, making it one of Australia's earliest national parks. While Mt Buffalo has hosted artists, explorers and botanists, the very first visitors were Aboriginal Australians foraging for large bogong moths to eat.

The region's cuisine has moved on and now Bright and Beechworth offer excellent places to eat and drink after a day in the hills. Both towns have breweries and everything from gourmet burger bars (Tomahawks in Bright) and pizzas (Bridge Road Brewery in Beechworth) to high-end restaurants such as The Provenance in Beechworth. But if you prefer the simple pleasures of a starlit night and a camp stove, that's just as easy to enjoy in the High Country.

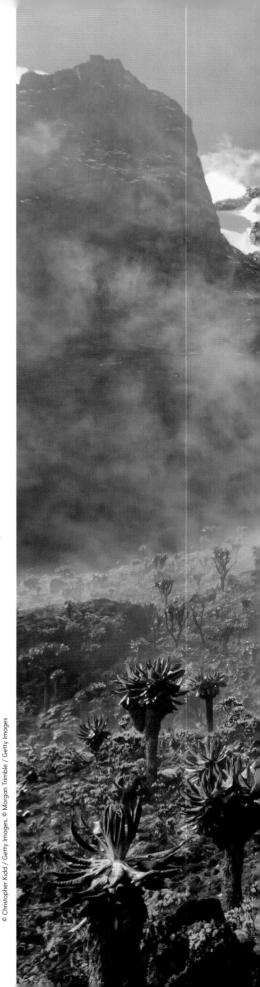

UGANDA

The Rwenzoris

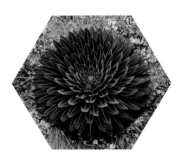

The Mountains of the Moon are as otherworldly and enthralling as their nickname suggests.

Right, you'll pass giant groundsel in the mysterious terrain of the Kilembe trek to Mt Stanley.

After hiking up through the bamboo forest, where the bamboo grows so fast that you can almost see it move, you cross over into montane moorland, an eerie, fog-shrouded world of peat bogs and grasslands where you are dwarfed by familiar yet freakishly large plants, such as giant heather and giant lobelias that tower 20ft (7m) above you. These are the Rwenzoris, which means 'rain maker' in the local language, and are also known as the mythical Mountains of the Moon.

The Mountains of the Moon first appeared on one of the earliest atlases of the world, annotated by Claudius Ptolemy as Lunae Montes. He had heard of the source of the Nile from a Greek travelling merchant known as Diogenes. Diogenes, it seems, was lacking in cartographical exactitude and his mountains were neither where he said they were nor the source of the Nile. However, the name stuck and is now commonly applied to this range straddling the border between Uganda and the Democratic Republic of the Congo (DRC) in Central Africa, very close to the equator.

Perhaps it was the mystique of the name or the fact that some of Africa's highest mountains, many with permanent snowcaps, and most unique landscapes are found in this range, but many of the 19th century's most famous explorers set out for the Rwenzoris. John Speke, the first European to see Lake Victoria (now thought of as the actual source of the River Nile) and Henry Stanley, the American who found a misplaced David

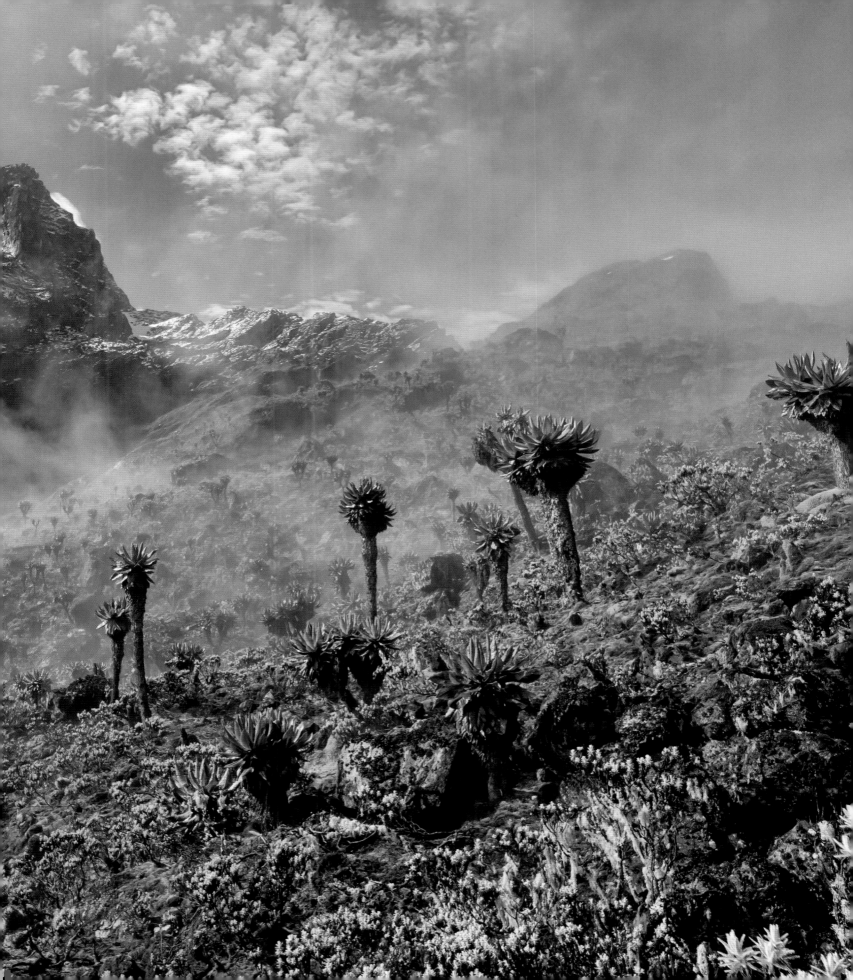

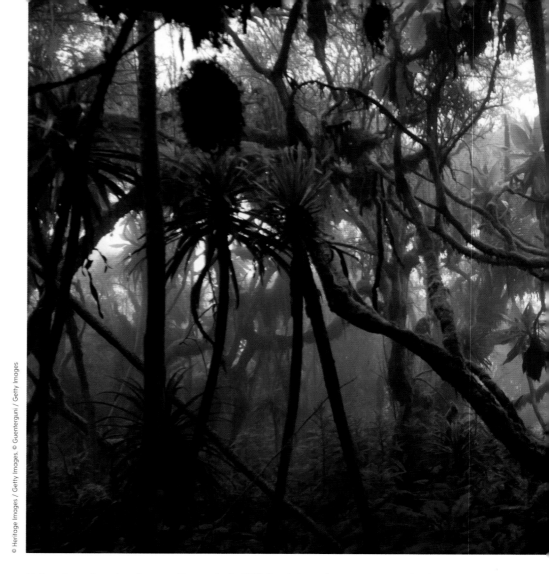

MOVING MOUNTAINS

Since debuting in Ptolemy's first-century cartography, showing the Nile flowing from a pair of alpine lakes, the Mountains of the Moon moved around on maps. Ptolemy's Greek manuscripts reappeared in the 13th century. They supported the notion that the mountains lay south of the equator. Later Christian speculation had them as the site of the biblical Paradise (with a similar lack of precision). As detail was added to the map of Africa from the coast inwards, after Portuguese circumnavigations, the mythic mountains shifted into the uncharted interior, which is where 16th-century cartographer Martin Waldseemüller placed them in his influential wall map of 1507. At the end of the 16th century Filippo Pigafetta noted that: 'midway between that Cape and the Tropic [of Capricorn] rise the Mountains of the Moon so praised by the ancients, who consider them the source of the Nile, which is false.'

Livingstone in what is now Tanzania in 1871, both lent their names to the highest mountains of the Rwenzoris. Margherita Peak of Mt Stanley stands 16,762ft (5,109m), not far behind Mt Kenya and Mt Kilimanjaro, but attracting less traffic.

One of the Rwenzori's most ardent advocates was HW 'Bill' Tilman, explorer, sailor, climber, colonialist and big-game hunter. His book *Snow on the Equator* was first published in 1937 and contains entertaining accounts of Tilman's ascents in the Rwenzoris and his 3000-mile (4800km) bike ride across the continent, among other excellent adventures.

'To those who went to War straight from school and survived it, the problem of what to do afterwards was peculiarly difficult,' he admitted in the opening chapter, because making plans 'seemed rather a waste of time.' Tilman had returned from the Rhine in April 1919 and by August he was on a boat to Africa. Reaching the Mountains of the Moon, he set about forging trekking routes up its highest peaks with Eric Shipton, though they frequently lost their way in the fog and snowstorms. (Despite his numerous mountaineering expeditions in Africa and Asia, including two to Mt Everest in the 1930s, Tilman was actually lost at sea in 1977, presumed dead when the boat he was crewing sank somewhere between Rio de Janeiro and the Falkland Islands.)

The glaciers have retreated somewhat since Tilman and Shipton's time but the land of the Rwenzoris remains as otherworldly now as then. At their lower elevations trekkers pass through savannah grasslands, where elephant and zebras roam. But above about 5500ft (1675m), the jungle takes over; lianas try to trip you and moss-draped trees block your way. Higher still, you pass through forests of bamboo.

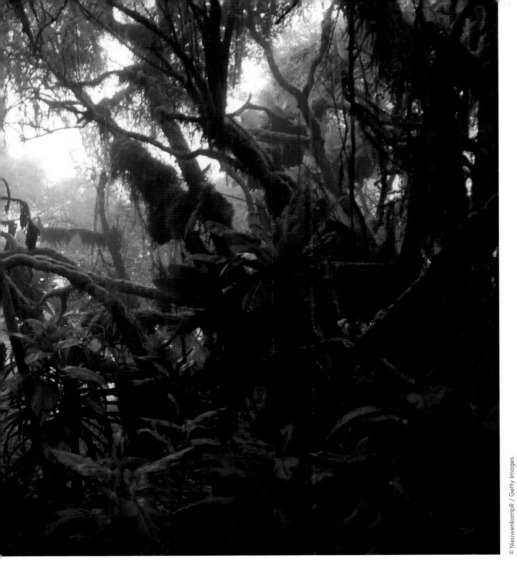

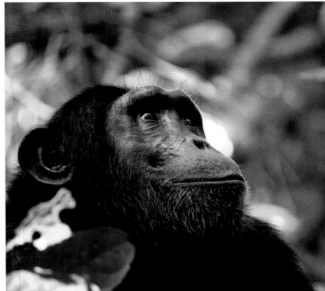

Left, thick cloud forest at lower elevations in the Rwenzoris; below, a chimpanzee in Kibale Forest National Park, near the Rwenzoris.

And then, up to about 12,000ft (3650m), in the misty heath and moorland, the plants just keep getting larger and stranger: giant flowering lobelias like alien visitors, huge heather plants festooned with lichen, impossibly springy moss around dangerously deep bogs. Bird calls, from the 219 species here (19 unique to the mountains), fade into the fog. It rains for about 350 days a year here, which accounts for the incredibly rich flora. Once you reach 14,500ft (4400m), you're in real mountaineering terrain, with snow and ice. When the skies clear, which is infrequently, you can see pristine valleys, rivers and waterfalls.

The highest elevations are protected by Uganda's Rwenzori Mountain National Park and the region has also been a UNESCO World Heritage Site since 1994. Most access today is via the Ugandan side for reasons of safety — on the DRC side the incredible Parc National des Virunga, home to rare mountain gorillas, has recently been closed to tourism. Popular trekking routes include Kilembe Trail, which opened in 2009, and the Central Circuit Trail, which heads up Bujuku valley and into the high country. It takes about 10 days for experienced climbers to summit Margherita Peak on Mt Stanley. Lying on the equator, there's not a lot of seasonal variation but the weeks between December and March and June to August tend to have less rain.

The Rwenzoris lie west of the Ugandan capital, Kampala, where most international visitors will arrive. With the gateway to the mountains being Kasese, around 250 miles (400km) by road from Kampala, one option is to take a direct bus (with Link, for example). Groups may prefer to hire a taxi. Or there are daily flights from Entebbe airport to Kasese. Once in the region, a couple of tour operators offer guides for the two principal routes into the Rwenzoris, the Kilembe Trail and the Central Circuit. Try Rwenzori Trekking Services for the former and Rwenzori Mountaineering Service for the latter.

ITALY AND FRANCE

Mont Blanc

Tour the Mont Blanc massif on foot or bicycle to appreciate this classic peak and its history.

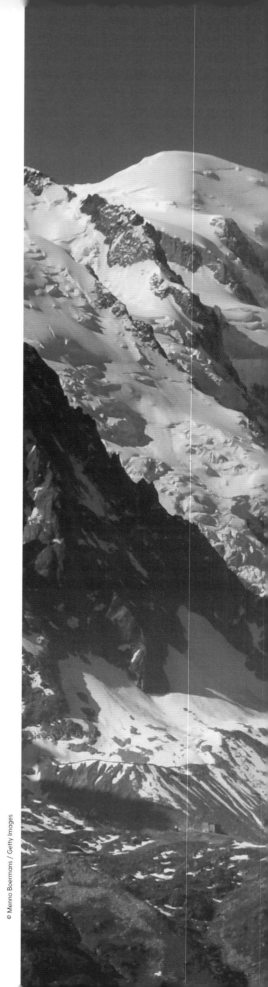

Western Europe's highest mountain is also its deadliest. Around 20,000 people attempt the climb each year and up to 15 may die, with around 100 perishing in the entire Mont Blanc massif of another ten separate summits over 13,000ft (4000m). One reason for the death toll may be that Mont Blanc, standing 15,774ft (4808m) above sea level, attracts many inexperienced climbers, much as Mt Everest does. Even so, to be qualified and permitted to guide clients onto the peaks around Chamonix, mountain guides working in France must pass Le Probatoire, one of the toughest tests in the outdoors, set by France's École Nationale de Ski et d'Alpinisme (ENSA). The tests, such as to scale then traverse and descend an ice wall, using ice axes, against the clock, are designed to sort the Reinhold Messners from the merely messy. So you'd think that anybody on the mountain would be in safe hands.

For more than 200 years, Mont Blanc has been sold as a bucket-list box to tick, even if you're not a committed climber. The very first people to summit the peak were Jacques Balmat, a 26-year old hunter and collector of crystals, and Michel Paccard, a doctor and amateur scientist, both from Chamonix. They succeeded on 8 August 1786, 26 years after Horace-Bénédict de Saussure, the scientist

© Menno Boermans / Getty Images

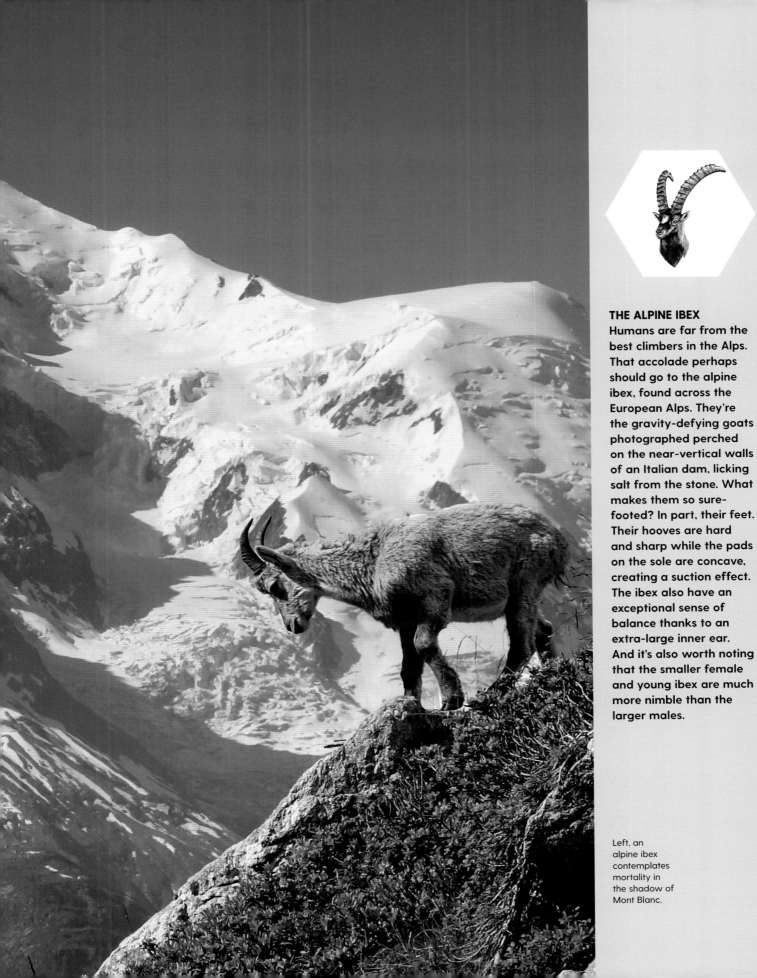

THE ALPINE IBEX

Humans are far from the best climbers in the Alps. That accolade perhaps should go to the alpine ibex, found across the European Alps. They're the gravity-defying goats photographed perched on the near-vertical walls of an Italian dam, licking salt from the stone. What makes them so sure-footed? In part, their feet. Their hooves are hard and sharp while the pads on the sole are concave, creating a suction effect. The ibex also have an exceptional sense of balance thanks to an extra-large inner ear. And it's also worth noting that the smaller female and young ibex are much more nimble than the larger males.

Left, an alpine ibex contemplates mortality in the shadow of Mont Blanc.

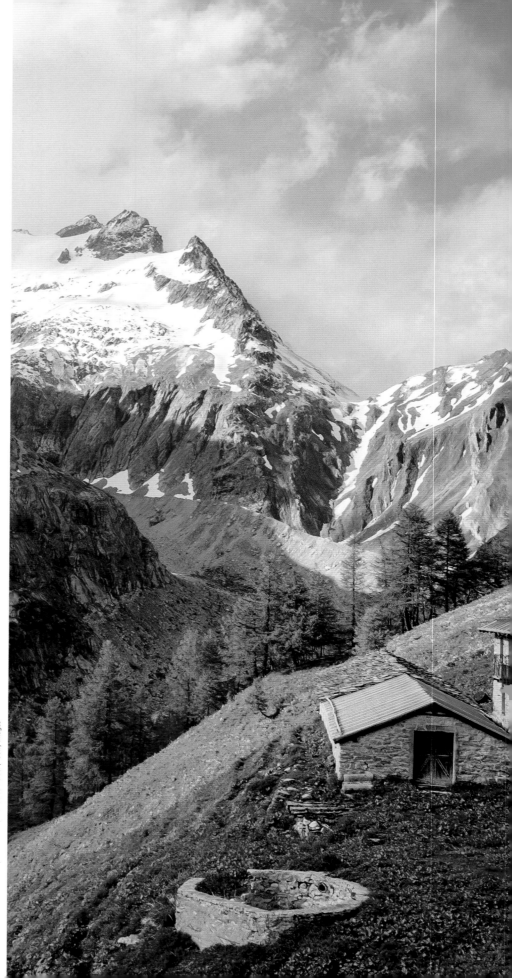

From right, the Bonatti mountain refuge on the Tour du Mont Blanc; the route is popular with mountain bikers.

and author of *Les Voyages dans les Alpes*, had offered a reward to whoever climbed Mont Blanc first. Both made it to the top, 'where no one had as yet been, not even the eagle or the chamois,' Balmat later recounted melodramatically. Balmat was not above a bit of boastful embellishment and Paccard, probably the more competent climber, was airbrushed from contemporary accounts. (Ever the fortune seeker, Balmat later died after falling into a chasm in the Sixt Valley while searching for gold.) Although Paccard and Balmat were first, it was arguably de Saussure's subsequent ascent in 1787 that had a greater impact across Europe, thanks to the wealth of sketches, notes and measurements that he made. He calculated the summit to be 15,666ft (4775m), which isn't far out. By the fourth and fifth ascents, with the use of mountain guides, ladders, ropes, tents and huts, the conventions of alpine expeditions had been established. Today, as aspiring summiteers check their GPS units as they set off from the Goûter Refuge, which resembles a retro space-pod attached to the cliffs at 12,516ft (3815m), for the last leg of their ascent, it appears that the only uncertainty comes from the weather.

Yet, gradually, each year the mountain becomes more dangerous for one key reason: climate change is causing ice to melt on the mountainside, making the cliffs unstable and slippery, and rock falls more likely. Such are the hazards today that from 2019 France requires all Mont Blanc climbers to apply for a limited number of licenses. The Mer de Glace (see p138) has lost more

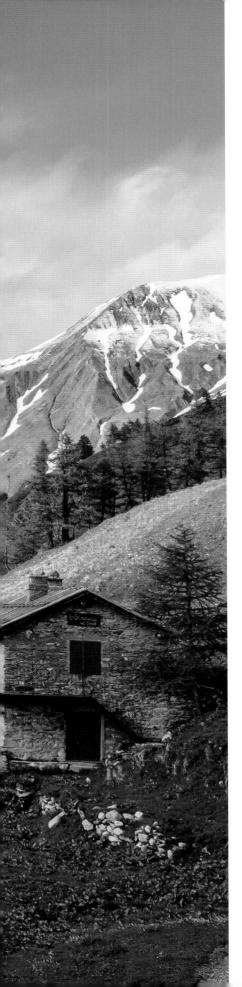

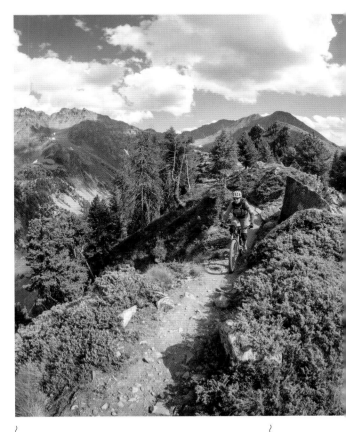

than 213ft (65m) in depth since 1996. 'What we see with this glacier melting is irrefutable evidence of global warming,' said French president Emmanuel Macron. 'It's the battle of the century.'

So why visit such a risky and vulnerable place? Well, you don't have to climb Mont Blanc in order to appreciate it. The Tour du Mont Blanc is a trail for hikers and mountain bikers that circles the Mont Blanc massif from Chamonix via the Italian mountain resort of Courmayeur. The trail is 105 miles (170km) long so there's the choice of going fast-and-light over four or five days or taking your time over ten days and exploring some of the mountain culture and scenery. With 32,800ft (10,000m) of ascent – more than you gain climbing Mt Everest – it's not a journey to be underestimated. But the mountain huts that open from June to September make the walk a little more comfortable. Early in the season you'll be surrounded by alpine flowers in the meadows and marmots will be emerging from their burrows. They spend three quarters of the year hibernating so for the time that they are above ground they're extremely busy. You may also see ibex and eagles and, if you're very lucky, a lammergeier (bearded vulture) soaring on thermals rising from the valleys.

Out here, hiking in the high spaces of Europe's greatest mountain range, accompanied only by the clanging bells about the cows' necks and surrounded by the beautiful, snow-crested alpine ridges, you can't help thinking a bit more about your personal priorities and goals. It's a life-affirming experience.

Most people visit Mont Blanc via Chamonix, which has good road links to surrounding towns and cities, including Geneva, Annecy, Grenoble and Lyon. Public transport options include buses from Geneva (around two hours) and Courmayeur in Italy (itself with connections to Turin and Milan), via the Tunnel de Mont Blanc. Train travellers from Paris will need to change at St-Gervais-Le-Fayet but it's a fast and frequent service. The scenic train route is the Mont Blanc Express from the Swiss town of Martigny. The closest international airport is Geneva. In Chamonix, many operators offer support services for hikers, bikers, skiers and climbers all year round.

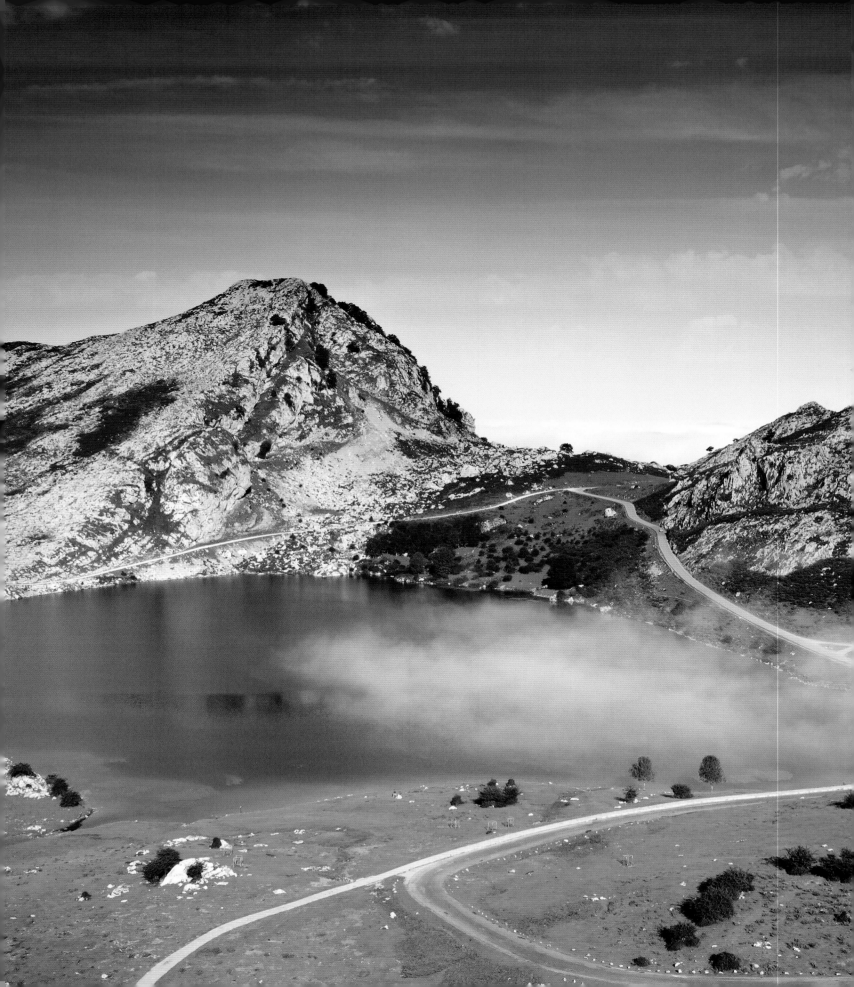

SPAIN

Picos de Europa

The Parque Nacional de los Picos de Europa in northwest Spain doesn't receive quite the same degree of attention as the most popular areas of the Alps or the Pyrenees, which is perhaps why you'll be sharing the mountains with more of the mammals at the top of Europe's food chain.

The Picos are part of the Cordillera Cantábrica, the Cantabrian mountains that rise up between Oviedo and León and span the regions of Asturias, southwest Cantabria and northern Castilla y León. Just over the horizon is the Atlantic ocean and the storm-tossed Bay of Biscay. If everything looks green and fertile here, there's a good reason for that.

Three massifs dominate the park: the western Macizo El Cornión at 8517ft (2569m); the eastern Macizo Ándara, with a peak of 8018ft (2444m); and the especially craggy Macizo Central, reaching 8687ft (2648m). In total more than 200 peaks remain snow-capped all year round. Surrounding these mountains is a wild and beautiful landscape of alpine lakes, meadows filled with grazing cattle, and jagged limestone peaks.

Threading their way through the Picos are some of the best hiking trails in Europe, age-old connections between mountain villages that are now comprehensively signposted so you don't need to be local to avoid getting lost. The most popular day hikes are the six-mile (10km)

Discover the food, drink, wildlife and astounding scenery of northern Spain's little-known mountain range.

Left, Lake Enol, one of the Lagos de Covadonga.

THE IBERIAN WOLF

The best season in which to go wolf-watching is summer when the wolves stay close to their dens and their cubs (August and September, say trackers). During winter they hunt and forage more widely so the closest you may get to them is a trail of large paw prints. Several tour operators offer wolf-watching tours. Head for Riaño, a lupine stronghold. What are you looking for? The Iberian wolf is smaller than the grey wolves of North America and slightly more dark brown in colouring. Listen for their howls. Their diet mainly consists of small mammals but as the wolves return to their former haunts in Western Europe, including Portugal and the Pyrenees they're inevitable causing consternation among farmers.

Right, the monolithic peak of Naranjo de Bulnes in the distant Picos de Europa.

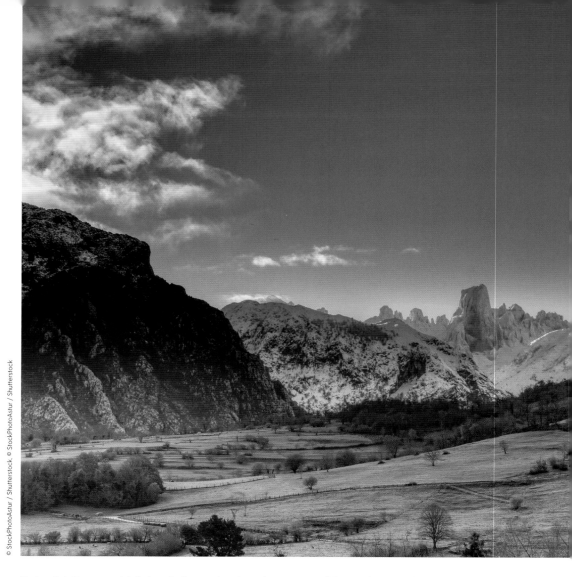

© StockPhotoAstur / Shutterstock. © StockPhotoAstur / Shutterstock

Ruta del Cares, which leads from the Asturian town of Poncebos to Caín in Castilla y León via a path chiselled into the wall of a steep gorge, and the hike up to Los Lagos de Covadonga, Lake Enol and Lake Ercina.

On longer routes like GR-202, the Ruta de la Reconquista from Covadonga to Cosgaya covering 36 miles (58km), hikers can shelter in *refugios* (mountain refuges) that can be booked from April to September.

Wherever you wander in the Picos, you will likely be surrounded by grazing cows and sheep and wild horses. Highland pastures surround clear lakes and in spring and summer the wild flowers and herbs on which the cattle, sheep and goats graze lend extra flavour to the local cheeses. Four Asturian cheeses have gained Protected Designation of Origin: Cabrales, a punchy, cave-aged blue cheese made from a blend of cow, sheep and goat milk, Gamonéu, Casín and Afuega'l Pitu, a spicy, crumbly cows-milk cheese that was once used as a currency by farmers to pay their taxes.

And that is one of the best things about exploring the Picos: after a day in the mountains, hikers can recover their energy with the robust local cuisine. In addition to the unique cheeses, there's the bean-and-sausage stew *fabada* and tart local *sidra* (cider) poured theatrically in *sidrerías*. In autumn, the Asturian forests offer a rich harvest of walnuts, chestnuts, acorns and hazelnuts, which often appear in cakes and desserts. Try the classic *requesón* (soft cheese and honey).

The Picos de Europa is very much a working landscape (visit the Ecomuseo de Someido at Pola de Somiedo to the west of the park for more insights into the

Below, a Pyrenean chamois; right, a mountain retreat near Los Lagos de Covadonga.

© Marques / Shutterstock

mountain life) and local people have always lived off the land. From spring to autumn grazing livestock are shepherded by wandering *vaqueiros de alzada* and their large dogs. At night, the *vaqueiros* shelter in stone cabins called *teitos*. There's good reason for the *vaqueiros* and their guard dogs: dozens of wolf packs roam the Cantabrian mountains, making the Picos one of the best places to see wild wolves in Europe. The species, protected in Asturias, is slowly recovering, despite farmers still shooting several each year. The wolves share the mountains with several European wild brown bears. Both species attract wildlife-watchers from around the world but are often elusive so a guided tour is recommended.

Other wildlife to look for in the Picos include wild boar, otters, deer and more than 150 varieties of moths and butterflies. In the skies, the buitre leonado (griffon vulture) and the águila real (golden eagle) circle, and in 2020 the first chick of a quebrantahuesos (bearded vulture or lammergeier) couple named Deva and Casanova hatched, making it the first baby bearded vulture in the Picos de Europa in 70 years. At above 5250ft (1600m) you'll be in the terrain of the rebeco (or Pyrenean chamois), relatives of sheep and goats. Although you won't come close to emulating their agile leaps from rock to rock, it's still an inspiring thrill to share the high mountains with such wild and free creatures. .

Airports in Oviedo and Santander and also in Bilbao, two hours' drive east and also the main ferry port on the north coast. August is the driest month of the year and consequently the busiest. For watching wildlife and enjoying foods from the harvest, September is just as good. Most people stay in Cangas de Onís for the western Picos, which can be reached by bus from Oviedo, although your own transport will open up more of the park.

TIBET, CHINA

Mt Kailash

Save your soul by making a circuit of this spiritual mountain, as arduous as you dare.

Standing apart in the Kangdise range, Mt Kailash's distinctive pyramid-shaped bulk dominates the landscape of this remote corner of the western Tibet plateau, a hint of its huge spiritual significance. For more than a billion devotees it is, quite literally, the navel of the universe. It is not unusual for mountains to be revered in religions and perhaps none are more so than Mt Kailash, which is central to the theologies of Tibetan Buddhism, Hinduism, Jainism and Bon Po, which preceded Buddhism in this region.

In Buddhism, Kailash is the physical manifestation of Mt Meru, the central mountain of Buddhist (and Hindu) cosmography, and, like the sun is regarded in the West, it's the 'gravitational centre of the known universe,' as WY Evans-Wentz puts it in his introduction to *The Tibetan Book of the Dead* (see sidebar). Hindus, however, believe that it is the repository of all the knowledge of Shiva, one of Hinduism's great triumvirate of gods: Brahma is the creator of the universe, Vishnu preserves it, and Shiva is its destroyer so that the universe may be recreated.

As a result, Mt Kailash is perhaps the most important pilgrimage site in the world, where, even if you're not a believer, you can come to experience some of what draws people into this harsh place. You don't climb up Mt Kailash, which is forbidden, but you trek around it. This 32-mile (52km) circuit of the mountain is done

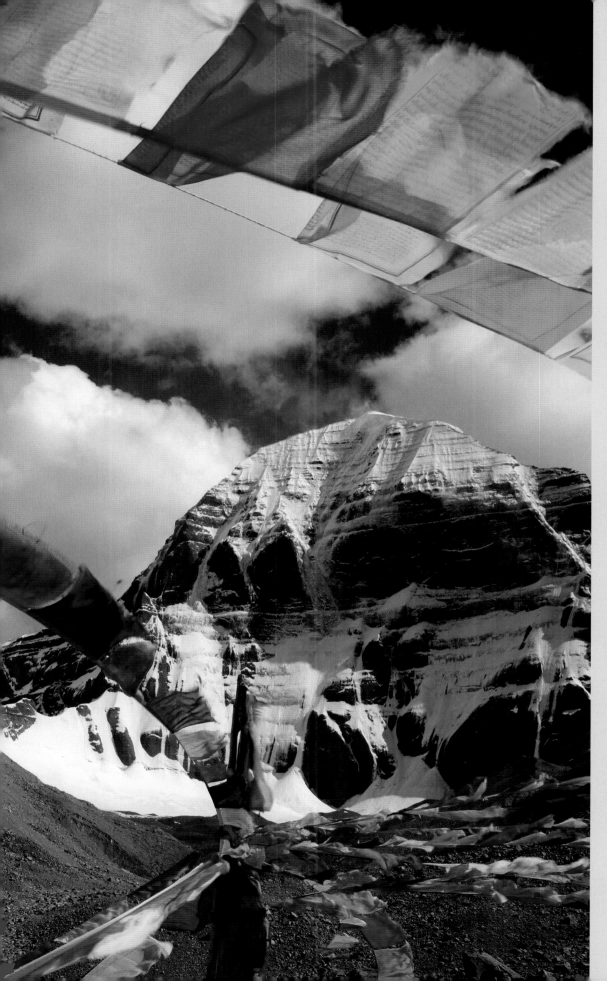

HOLY MT MERU

The heavens rest upon Mt Meru and within the mountain, in Buddhist texts, there are four realms, one above another. In the three lower levels dwell various orders of genii. In the top realm, just beneath the heavens, are the Titans or Asuras, ungodly spirits thrown out from heaven and now waging eternal war with the gods above. Surrounding Mt Meru is an ocean, then a ring of golden mountains, then another ocean and more mountains, repeated, like the layers of an onion, 15 times. The consecutive circles of oceans and mountains diminish until the continents in the 'outer ocean of space' are reached. There are four such continents, the southern of which is Earth, Jambuling, blue in colour, rich and bountiful, with forces of both good and evil present.

Left, the singular and sacred peak of Mt Kailash.

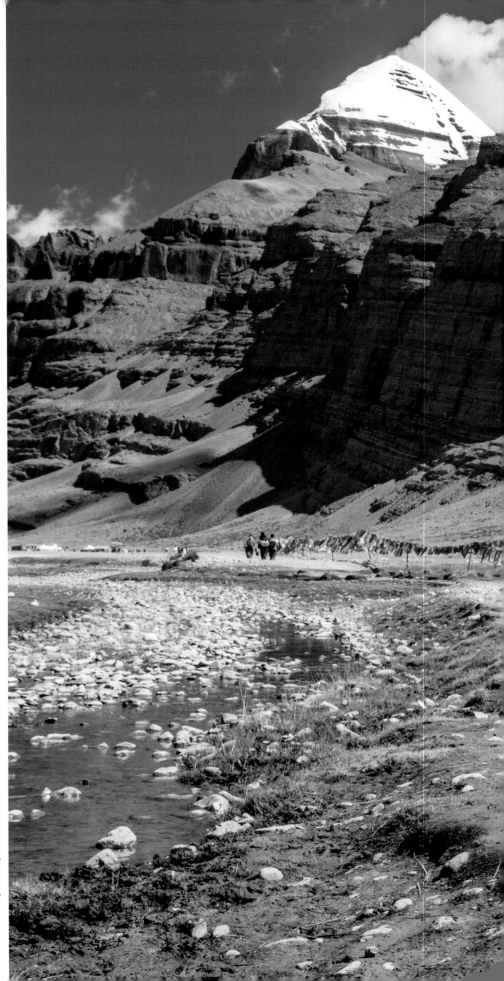

From right, the harder your pilgrimage, the more of your sins are absolved; traditional nomadic Tibetan attire.

at an average altitude of 16,400ft (5000m). Oxygen is thin. And there will be strong winds, snows and freezing temperatures. For believers this is a *kora*.

Performing *kora* is a type of pilgrimage for followers of Tibetan Buddhism and Bon religions and involves circling sacred sites (clockwise for Buddhists, anti-clockwise for Bon). This doesn't only apply to Mt Kailash. You may see Buddhists walking around the Potala Palace or a monastery, spinning their hand-held prayer wheel. *Koras* are also often performed in nature because Tibetans believe that deities dwell in places like Namtso Lake and the high mountains. The idea is that the *kora* is so tough that it earns you blessings and absolves you of your wrongdoings – one lap of Kailash can wash away a lifetime's worth of sin. Go around 108 times and you attain nirvana, spiritual freedom from desire, suffering and self and the goal of Buddhism. Ardent Buddhists will try to complete the pilgrimage in one long day. Or they will take up to three weeks if opting for frequent full-body prostrations. The trek typically takes three days, with trekkers often carrying tents and provisions.

But you don't have to do it the hard way. With the popularity of the trek, creature comforts have arrived for those that chose them. Teahouse tents along the route offer noodles, tea, water and even beer. And you can hire horses, yaks and porters in the gateway town of Darchen, with accommodation also available at the monasteries of Drira-puk and Zutul-puk en route.

In the summer of 2020 a new 80km (50-mile) link road between Dharchula

in Uttarakhand to the Lipulekh Pass on India's border with Tibet opened, speeding journey times to Mt Kailash and Mansarovar from India by 80%, although the trip by road will still take two days, including time to acclimatise to the altitude. Over previous centuries this journey would have been made on foot or horseback over weeks.

At the base of Mt Kailash lies the similarly sacred lake of Mansarovar, which has several monasteries along its shores. Many pilgrims will take an icy dip in the large, glacier-fed lake after their kora and some believe that a sip of its water absolves all your sins (spot the theme here?). From these mountains, waters flow into Asia's great rivers, the Indus, the Ganges and the Brahmaputra – even if you don't subscribe to the spiritual influence of this place, its physical importance to billions of people is undeniable.

The main pilgrim season is summer from June to September but it's possible to hike the circuit from May to mid-October so long as you're prepared for dangerous weather. The busiest time of the year is during the festival of Saga Dawa, which takes places on the full-moon day of the fourth Tibetan month, towards the end of May and early June. A prayer pole is raised and costumed monks process around it as Tibetan horns, *dungchens*, sound. And then pilgrims and trekkers alike set off for another circuit of the mountain at the centre of the universe.

Although it's possible to reach the Kailash region from India, due to the permits required and potential political stresses, most visitors will take a flight to Lhasa in Tibet from Kathmandu or China, acclimatise to the altitude for a couple of days, and then make the long drive west. The trip typically takes about four days but don't rush it: stops at the town of Shigatse and the ancient monastery of Sakya are recommended and you can even make a two-day detour to Everest Base Camp. The standard of roads and accommodation in western Tibet is ever improving. Tours direct from Kathmandu are also offered but beware the sudden altitude increase.

COLOMBIA

The Lost City

High in the Sierra Nevada de Santa Marta are the ruins of a remarkable Pre-Columbian civilisation.

Right, the landscaped terraces of the Ciudad Perdida; overleaf from left, Kogi village huts; prepare to cross many rivers.

Humankind has been quick to make its mark on the world but, from Angkor Wat to Chernobyl, it doesn't take long for nature to reclaim its territory. Around 1000 years ago the Tayrona people of the Sierra Nevada de Santa Marta, in the north of Colombia, constructed a city called Teyuna in the forested mountains. With engineering expertise they built bridges and drainage systems to deal with the heavy tropical rains, and they carved terraces for houses, warehouses and ceremonial plazas into the steep slopes, connected by paved paths and stairways. They were also skilled goldsmiths. With a population of up to 5000, this was the largest cities in the region until the 1570s.

The arrival of Spanish conquistadors to Colombia brought disease and death to the indigenous people. Eventually, the Spanish arrived in Teyuna in around 1578 and carted off the city's gold, leaving what was most likely smallpox. Teyuna, a city older than Machu Picchu, was gradually abandoned from 1580 to 1650 until it became the Ciudad Perdida, the Lost City. Of course it was never truly lost to the indigenous descendants of the Tayrona, such as the Kogi, Wiwa, Arhuaco and Kankuamo people who live in the region today. But the jungle swiftly swallowed Teyuna as if it had never existed. Then in the 1970s more gangs of treasure hunters rediscovered the site and looted it once more and the world remembered this

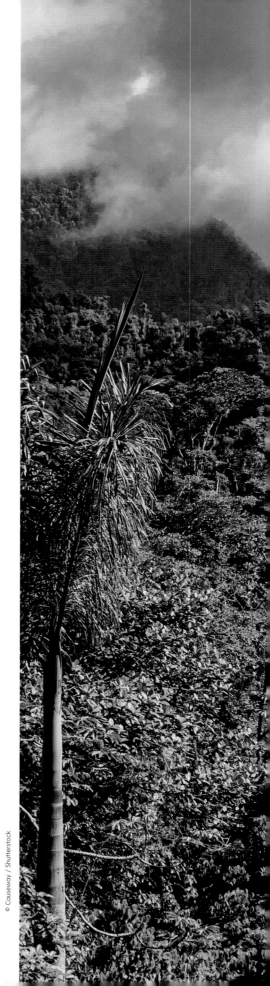

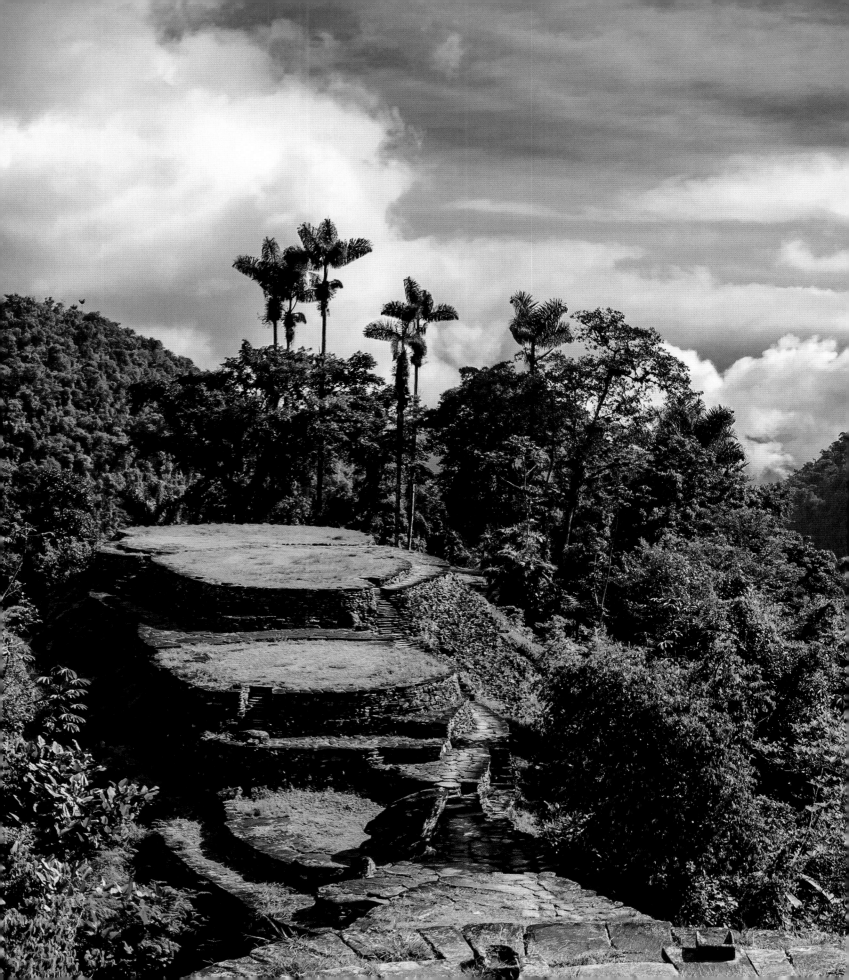

HUMMINGBIRD HAVEN
Whirring around you on the trek to the Lost City will be hummingbirds. Colombia is a paradise for birdwatchers, with more than 70 endemic species of bird and an amazing 162 types of hummingbird. In the Sierra Nevada de Santa Marta these include the blue-bearded helmetcrest, long thought extinct until one was spotting in 2015 in the highlands. More common is the large white-tailed starfrontlet, identified by its flash of white tail feathers. At the opposite end of the size spectrum, the diminutive woodstar family of hummingbirds measure about 6-7cm (2.5in) in length, smaller than many insects in this jungle. In the Sierra Nevada de Santa Marta keep your eyes open for the Santa Marta woodstar, with its iridescent blue-green back. They're found only in these mountains but, like the starfrontlet, they do like to flutter about at hummingbird feeders in the El Dorado Bird Reserve, an hour's drive from Santa Marta.

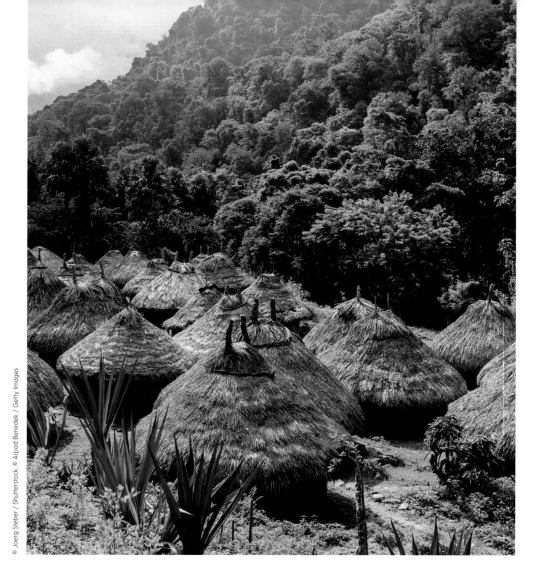

© Joerg Steber / Shutterstock. © Arpad Benedek / Getty Images

remarkable place. Fortunately, many of the items, including gold idols and intricate pottery, were recovered and can now be seen in the Museo del Oro (the Gold Museum) in Santa Marta, the coastal capital of Magdalena (incidentally, a city founded by the Spaniard Rodrigo de Bastidas in 1525).

Today, access to Teyuna is via the Lost City Trek, a 47km (30-mile) out-and-back hike from the town of El Mamey, through deep jungle punctuated by waterfalls, river crossings and indigenous settlements. Have no illusions: this is a tough and demanding trek, even during the dry season from December to March. The heat and humidity are energy-sapping, the mud and bugs morale-sapping. But a positive mental attitude conquers all. Tip: pack swimwear, there are plenty of pools in which to take a refreshing

dip. And if you tune your senses into this wild emerald forest you'll find natural wonders to be enthralled by: blue morpho butterflies, the giant yellow bills of toucans, fruits of the mango and cacao trees that abound, and the non-stop soundtrack. A book of Colombian birdlife might help identify what you're listening to – those raucous squawks could be the Santa Marta parakeet, found only in these forests. A survey in the journal *Science* named the Sierra Nevada de Santa Marta national park as the world's most irreplaceable nature reserve thanks to its unique, rare and threatened species.

You'll be staying in rudimentary campgrounds with your fellow hikers. Visitors have to join a tour group for access to the Ciudad Perdida but only about 8500 people hike to the Lost City every year (for comparison, the number

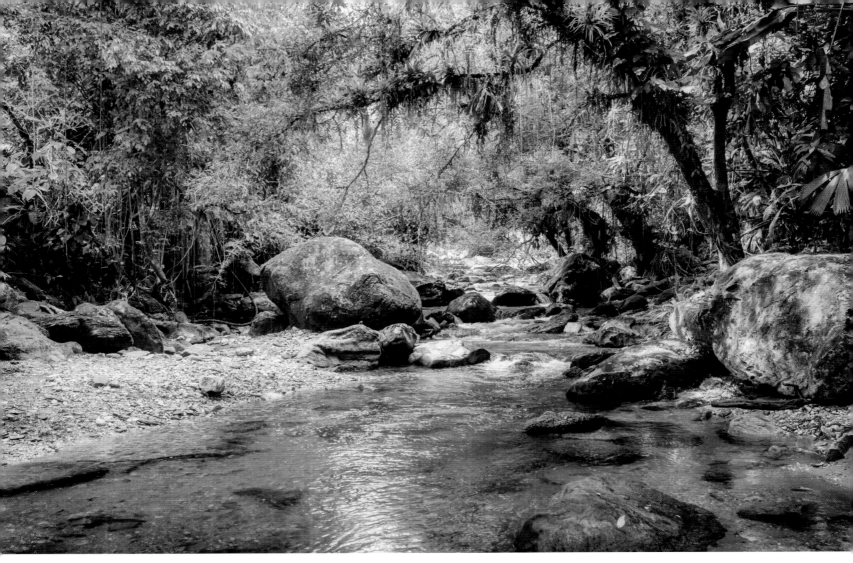

of visitors permitted each day at Machu Picchu is capped at 2500). Try to select a tour operator that employs guides from the indigenous Wiwa and Kogi communities, descendants of the Tayrona people who built Teyuna. Their language skills will help you communicate with the highly reserved local people you will encounter.

The peaks of the Sierra Nevada de Santa Marta reach 18,000ft (5500m), but the Lost City lies at 3-4000ft (900-1200m). Nevertheless, guides and local people usual chew coca leaves to ease the climb. Late on day two of the trek, or more likely on day three, you'll cross the Río Buritaca and begin the final ascent into the city up a staircase of 1200 slippery stone steps. What unfolds before you at the top will be unforgettable: a hilltop city with terraces and plazas, walls and paths still overgrown with moss. Only about 10% of the settlement has been uncovered but even so it's not hard to imagine the routines of the society that lived here, the men, women and children that walked these terraces and lanes. They would have lived in conical houses with wood walls erected on one or two circular stone tiers, like a cake, to withstand the heavy, flooding rains of the cloud forest. It is thought that the highest terraces were reserved for ceremonial functions, including human sacrifice.

After a day in the Ciudad Perdida it will be time to make the return journey back to modernity and mobile phone reception, perhaps reminded of the impermanence of empires.

The thriving tourist hub of Santa Marta on Colombia's Caribbean coast receives direct flights from Bogotá and other cities. The hike to the Ciudad Perdida begins from El Mamey, about a 90-minute drive southeast of Santa Marta and typically takes four to five days depending on the season. You will need to book with a local tour operator. Bring eco-friendly insect repellent at any time of year. Elsewhere in the Sierra Nevada de Santa Marta, explore the El Dorado nature reserve, which is run by the Proaves bird conservation non-profit organisation.

USA

Mauna Kea

This giant Hawaiian volcano is a sacred space and also a window to our universe.

Right, the volcanic landscape of Mauna Kea.

Welcome to the tallest mountain in the world, Mauna Kea in Hawaii! No, that's not the most obvious error in travel writing history. Mauna Kea, according to the US Geological Survey (USGS) rises for around 33,496ft (10,209m) from its base to its apex. Mt Everest, in the Himalaya, however, is most usually estimated at 29,029ft (8848m) tall, give or take a few feet. The difference, of course, is that the foot of Mauna Kea is on the Pacific sea floor, from where this giant volcano emerged almost a million years ago. Less than half of Mauna Kea, about 13,796ft (4205m), is above sea level. It was created relatively recently, first erupting less than a million years ago, but, compared to its volatile neighbour Kīlauea to the south, it's not especially active, last erupting about 5000 years ago.

Mauna Kea's altitude and generally mild disposition, combined with the clear, dark nights and dry atmosphere, make it the perfect place for star-gazing, which is why since the 1970s the summit has hosted the world's most powerful telescopes at the most important astronomical observatory on the planet. The largest telescopes here are 10 metres across and have been crucial in key discoveries at the edges of our galaxy and beyond, confirming, for example, the rate at which the universe is expanding and detecting methane on Mars (perhaps a sign of biological life). Mountain tops have traditionally been the site of religious revelations and Mauna Kea is perhaps

© CK / AWL Images

THE NĒNĒ

Like many isolated islands – see also New Zealand and New Guinea – a number of unique creatures call Hawaii home. One of them is the Hawaiian goose, or nēnē, which has been the state bird since 1957. It is found only on three islands, Hawaii, Kauai and Maui, and, rather unusually for a goose, it doesn't much travel between them, let alone migrate anywhere. They spend most of their time on the ground and don't even swim much. As a result, they suffered immensely when settlers introduced new predators and their population reduced to about 30 birds. They remain endangered but if you're lucky you may spot some on Mauna Loa, where they like to nest on volcanos.

From right, Kīlauea erupting; space telescopes and observatories on top of Mauna Kea.

© Douglas Peebles / Getty Images

© Lopolo / Shutterstock

the cosmic, scientific equivalent.

However, the scientific advances have not come without controversy. Proposals to add a 30-metre diameter telescope costing $1.4bn to the array at the Mauna Kea observatory, caused native Hawaiians to protest. For many, Mauna Kea is a deeply sacred place, a *piko* or centre of life. The summit, otherworldly with its grey cinder cones and baked red dirt, is regarded as the home of gods, Na Akua, and divine ancestors, Na'Aumakua. It's where the Earth Mother, Papahānaumoku, and the Sky Father, Wākea, met and gave birth to the Hawaiian islands; Mauna Kea was their first born. There are traditional burial grounds and shrines encircling the whole volcano. Protestors argued not only that the construction of another telescope atop Mauna

Kea was disrespectful to its cultural significance but also that the process would disrupt essential watersheds.

But the friction goes a lot further back, all the way to the founding of Hawaii. Captain James Cook was the first European to set foot on the islands in 1778 (after his visit to Australia) but they had been settled by Polynesian peoples many centuries previously. By 1853, the local population had declined from 300,000 at the time of Cook's arrival to about 70,000 due to diseases introduced by the outsiders. In 1893, American colonists already controlled the islands' economy and set about overthrowing the Hawaiian monarchy. The colonists established a republic and by 1898 the US government annexed the islands as an American territory. The last ruler of the Hawaiian royal family, Queen

Lili'uokalani, who remains a Hawaiian folk hero, was imprisoned then forced to abdicate. Finally, in 1959, Hawaii became the 50th American state. With a history like that, the protests at Mauna Kea against the University of Hawaii's development plans are perhaps more understandable.

Depending on the status of the protests, visitors may be able to reach the visitor information station on Mauna Kea, which is at 9,200ft (2800m) and accessible by road. Here, in the evenings, amateur astronomers often set up telescopes and allow visitors to scan the night skies for stars, which are spectacular due to the lack of light pollution. You can actually see more stars from the lower visitor station than from the summit because your vision suffers from the altitude at the very top (and beware altitude sickness and be prepared for snow in the winter).

However, if you wish to sidestep the issues around Mauna Kea, an alternative can be found to the south. Mauna Loa, the world's largest shield volcano, lies in the Volcanoes National Park, close to smouldering Kīlauea volcano. Hiking trails lead from tropical forests thick with ferns, fragrant foliage and bright-plumaged birds such as the 'apapane honeycreeper into volcanic craters carpeted with hardened lava in sulphuric shades. The Kīlauea Iki trail reopened in 2018 after an unexpected eruption – you may still see glowing lava and steaming vents, especially where the molten rock reaches the Pacific Ocean with a loud hiss. It's a reminder that these mountains are continuously changing.

Both Kona (west coast) and Hilo (east coast) have international airports, with Kona's being the more trafficked. From Kona or Waimea take Saddle Road (Hwy 200) or the new Daniel K Inouye reroute. From Hilo, drive mauka (inland) on Kaumana Dr (Hwy 200) or Puainako Extension (Hwy 2000), both of which become Saddle Road. Start with a full tank of gas – there are no service stations out here. The Visitor Information Station (MKVIS) and the summit beyond are on Mauna Kea Access Rd, near Mile 28 on Saddle Road. Driving to the summit is best done in a low-gear 4WD vehicle and check with your rental-car company if your contract even allows driving past the visitor centre. And take care, the road conditions are challenging.

Deserts & Plains

Since the dawn of history, deserts and plains have been a fundamental part of the human experience. Mighty empires have been raised in them. Bloody battles fought over them. Faiths have been tested in them, visions glimpsed, epic tales told. They're places of exploration and adventure, and of magic and mystery. They are the land of the djinn and the rainbow serpent, of mirages and sphinxes, of walkabouts and revelations. Since time immemorial, people have been drawn to these wide, open spaces in search of the freedom, solitude and spirituality they offer. They're tough places to survive, but they're certainly not devoid of life: there are ecosystems here that exist nowhere else on planet Earth.

'I have always loved the desert,' wrote the adventurer, author and poet-pilot, Antoine de Saint-Exupéry. 'One sits down on a desert sand dune, sees nothing, hears nothing. Yet through the silence something throbs, something gleams...'

Time to embrace the emptiness.

lose your eyes and picture a desert. What do you see?

A sea of shifting sands. Undulating dunes. A white-hot sun. A featureless horizon stretching out to all corners of the compass.

Well, you might be surprised to hear that the world's largest desert is actually freezing cold, not scorching hot. It's nowhere near the equator. And in none of its 5.5 million sq miles (14.25 million sq km) is there a single grain of sand to be seen. Because the greatest desert on earth is actually the Antarctic, the icy wilderness at the bottom of the world, which is large enough to swallow one-and-a-half Saharas with room to spare. The Sahara isn't even the second largest: that's the Arctic, which at 5.4 million sq miles (14 million sq km) is roughly 2 million sq miles (5.2 million sq km) larger than the Sahara.

All of which goes to show the distance between what we believe a desert should look like and what a desert is, in reality. To illustrate the point, here's a follow-up. How much of the Sahara is sand, do you think? Nine tenths? Three quarters? In fact, it's less than a third. The vast majority of the Sahara – 70% - is made of rock, rubble, stone or gravel.

There are plenty of reasons why our image of the desert isn't as accurate as it should be. Cinema has a lot to do with it. Films such as *Lawrence of Arabia*, *The English Patient*, *Indiana Jones and the Temple of Doom* and *Ice Cold in Alex* have helped define the desert in the popular imagination. Who can possibly think of a desert without picturing a dashing, sun-burnished young Peter O'Toole, *ghutra* flying, framed against a panorama of golden dunes? And since very few of us have actually spent much time in a desert, we rely on pop culture for our reference points. It's only when you actually visit a few that you realise how wildly diverse deserts can be.

Some, such as the Antarctic and the Arctic, are icy and bitterly cold. Others, such as Australia's Great Sandy Desert and Saudi Arabia's Rub' al Khali, are sandy and scorching hot. Some, such as the Atacama Desert in Chile, are high enough to give you altitude sickness; others, such as the Danakil Desert in Ethiopia, are sub sea-level.

The desert has a cousin, too. We call them plains. Like deserts, they come in many forms – as uplands, steppes, plateaus, savannahs, floodplains, tundra and prairies. Some were carved by lava flows, others gouged out by floods, or

eroded over millennia by the slow attrition of wind, weather and time.

At this point, it might be helpful to get our definitions straight. According to the *Oxford English Dictionary*, our word for desert comes from the Latin *desertus*, or 'left waste'. In scientific terms, a desert is defined as an arid landscape, specifically one which receives less than 25cm (10in) of precipitation per year. So when we imagine a desert, we should be thinking of dryness, not dunes; we should be picturing an absence of water, rather than an abundance of sand. Similarly, the English word for plain derives from the Latin *planus*, meaning 'flat'.

There are deserts and plains on every continent, at any longitude you care to choose. Collectively, they cover a third of all the land on earth. But it would be a mistake to think that because they are numerous, all deserts and plains are alike. They're as distinct as the world's forests, oceans or mountains, each one a world within a world, with its own ecosystem, weather, special population of plants, insects and animals. Equating one with another is as pointless as comparing a puddle with the Pacific Ocean.

If there's one characteristic plains share, it's flatness. Unlike deserts, however, plains are usually fertile rather than arid. Nutrient-rich, mineral-heavy soil washed down from mountains or deposited by rivers often ends up on plains. This makes many of them ideal for agriculture, especially cattle-farming and crop-growing. Thanks to the grasses and shrubs that grow on them, plains are also often blessed with an abundance of game animals, meaning that, for humans and predators alike, they usually offer good hunting. Plains then are the world's bread-baskets and butchers' counters.

So now we know what deserts and plains are, at least scientifically speaking. The next question is why you'd would want to go anywhere near one.

From left, Antarctica is a desert; the El-Agabat valley in the Sahara desert, Egypt; previous page, Rub' al Khali.

Because most right-minded people don't relish the prospect of spending any time in the desert, or in the middle of a plain for that matter. Even fewer would contemplate devoting much of their hard-earned holiday to them. There's an unsettling quality about them – something about their blankness, their wildness, their lack of civilisation.

Simply mention the word desert, and a frisson of dread shivers across the subconscious. Our brains conjure up a nightmarish slideshow: cracked lips, shimmering mirages, empty billy cans, carrion birds wheeling over piles of bleached bones. Deserts are, we feel, one of the corners of the world where Mother Nature still holds the cards. Far from manifesting herself as a benevolent maternal force, in truly wild places such as the desert she doesn't seem to be on our side after all. It feels more like she's actively plotting our demise – whether it be through dehydration, a scorpion's sting, or a slow roasting under the sun's relentless heat.

In fact, humans have spent much of their existence dreaming up ways to escape from environments like the desert. Ceiling fans, swimming pools, air-con, refrigerators – what are these if not symbols of mankind's ability to conjure comfort even in the most unforgiving of climes? Just look at Dubai, for heaven's sake: a city raised from the sands of the Arabian Desert, where you could live out your days in air-conditioned, dehumidified, refrigerated luxury, and never even clap eyes on a sand dune unless you so desired.

Yet throughout human history, many cultures have not avoided these places, but actively made them their home. From the Bedouins and Tuaregs of the Sahara to the San Bushmen of the Kalahari, and from the Blackfoot, Comanche and Cheyenne of the North American plains to the nomadic yak-herders of the Gobi Desert, the wide, open spaces of deserts and plains have been inhabited by people since mankind took its first faltering steps down from the trees.

It's surely no coincidence that the oldest human civilisation on the planet happens to be a desert people. For the last 65,000 years, Australia's indigenous inhabitants have lived in the harshest desert landscape imaginable, forming an intimate knowledge and deep connection with it. From the depths of the Simpson Desert to the crocodile-filled creeks of the Northern Territory, Aboriginal tribes have ranged over every inch of the Australian continent. They have woven legends around it and told stories about it, using oral history and rock art to pass on their knowledge across the generations: which animals to hunt, what plants and fruits to harvest in which season, and most importantly, how to find the *mikiri* (wells) that provided them with fresh water.

They survived because they understood a truth: in the desert, if you try to fight your environment, you will always lose. Instead you must study it. Learn from it. Embrace it. And, above all, respect it. And in return, if you're worthy of it, the desert might reveal some of its secrets: old truths about the world, the cosmos and our place in it. Tales from a time when the planet was young, and humanity wasn't even a twinkle in Mother Nature's eye.

Many of the world's cultures associate the desert with spiritual revelation. The aboriginal rite of passage known as walkabout, in which young men went out into the wilds in search of their inner selves, often took place in the desert. In Christianity, many key moments in scripture play out against a desert backdrop – from the burning of the bush to the devil's temptation of Christ in the wilderness. In Islam, the Prophet Muhammad was raised, for a time, in the desert by a Bedouin family, and its holiest city, Mecca, was founded in the fabled Desert of Paran. In Judaism, the holy book of the Torah was given to Moses in the desert after the Israelites' 40 years of exile. And in ancient Egypt, the desert was literally the realm of the divine – a

From left, zebras and meerkats in the Namib desert.

I met a traveller from an antique land,
Who said—'Two vast and trunkless legs of stone
Stand in the desert. . . . Near them, on the sand,
Half sunk a shattered visage lies, whose frown,
And wrinkled lip, and sneer of cold command,
Tell that its sculptor well those passions read
Which yet survive, stamped on these lifeless things,
The hand that mocked them, and the heart that fed;
And on the pedestal, these words appear:
My name is Ozymandias, King of Kings;
Look on my Works, ye Mighty, and despair!
Nothing beside remains. Round the decay
Of that colossal Wreck, boundless and bare
The lone and level sands stretch far away.'
Percy Bysshe Shelley, *Ozymandias* (1817)

Above and right, camel trekking in the Saharan dunes of Merzouga, Morocco; far right, an aerial view of the Burning Man festival, Nevada.

place where deities dwelt, and the dead departed on their journey into the afterlife.

What is it about these places that inspire such transcendent moments? For the desert explorer Wilfred Thesiger, who spent much of his life exploring the Arabian sands, it had to do with the desert's ability to strip away the distractions of life – the trivial routines, petty worries and material concerns.

'In the desert I had found a freedom unattainable in civilization,' he wrote in his great desert travelogue, *Arabian Sands*, published in 1959. 'A life unhampered by possessions, since everything that was not a necessity was an encumbrance. I had found, too, a comradeship inherent in the circumstances, and the belief that tranquillity was to be found there.'

For Thesiger, the austere environment and unforgiving climate allowed him the freedom to learn truths obscured by everyday life. In the desert's emptiness, he discovered the space to find himself.

Ironically, however, he also found a connection with other people. In another passage, he recounts his experience of desert hospitality with a group of nomadic shepherds.

'I remembered other encampments where I had slept, small tents on which I had happened in the Syrian desert and where I had spent the night. Gaunt men in rags and hungry-looking children had greeted me, and bade me welcome with the sonorous phrases of the desert. Later they had set a great dish before me, rice heaped round a sheep which they had slaughtered, over which my host poured liquid golden butter until it flowed down on to the sand; and when I protested, saying 'Enough! Enough!', had answered that I was a hundred times welcome. Their lavish hospitality had always made me uncomfortable, for I had known that as a result of it they would go hungry for days. Yet when I left them they had almost convinced me that I had done them a kindness by staying with them.'

Rather like his fellow desertophile T.E. Lawrence, Thesiger also found something rather surprising in the desert: a sense of his shared humanity. With the nomadic tribes of Bedouins and Berbers, Thesiger forged bonds which proved more lasting and meaningful than any he made in more hospitable climes.

Perhaps nothing symbolises that today more than Burning Man, the annual desert festival which attracts over 70,000 revellers to the middle of a dried-up lake bed in Nevada's Black Rock Desert. 'Burning Man is a life-changer for many people,' explains Will Roger, one of the festival's founders, himself a desert resident and passionate photographer. 'It's like a pilgrimage to get here. You go out into the flat expanse of the Black Rock Desert, which is kind of alien if you've never experienced it before, and you discover this state of awe. A state of awe that's shared by everyone who comes; 70,000 people experiencing awe at the power and beauty of Mother Nature. And that creates community. It changes you. You go away from Burning Man with a different view of humanity, and our place within it. In my opinion, the desert is the only place that something like that could happen.'

But for other explorers, it's the absence of people that makes the desert meaningful. The writer Edward Abbey is best-known for his counterculture classic *The Monkey Wrench Gang*, published in 1975, in which a group of conservationists wage a campaign of 'eco-tage' in an effort to save the planet. In the early 1960s, he spent two seasons as a National Park Ranger in the deserts of southeast Utah. There, he lived alone in a weather-beaten trailer, walking the trails, observing the wildlife, watching the sunrise and sunset, and sporadically attending to his ranger's duties. He recollected his experiences in a lyrical memoir, *Desert Solitaire: A Season in the Wilderness*, published in 1968.

'The desert says nothing,' he wrote. 'Completely passive, acted upon but never acting, the desert lies there like the bare skeleton of Being, spare, sparse, austere, utterly worthless, inviting not love but contemplation.'

'It seems to me,' he continued, 'that the strangeness and wonder of existence are emphasized here, in the desert, by the comparative sparsity of the flora and fauna; life not crowded upon life as in other places but scattered around in sparseness and simplicity... The extreme clarity of the desert light is equalled by the extreme individuation of desert life forms. Love flowers best in openness and freedom.'

For Abbey, the desert became the ultimate wilderness

HOW TO FIND WATER IN THE DESERT

First, look out for any birdlife, animals or foliage, which often indicate a hidden water source; clefts, canyons, gullies and depressions are good places to look. If you can find a tree, you can collect water by placing a plastic bag over a leafy branch; as the plant transpires, water collects inside the bag.

Alternatively, you can make a solar still by digging a hole and laying a sheet of plastic over it, anchored with rocks, and then placing a pebble in the centre to create a dip. Solar energy will evaporate moisture from the ground, which will condense on the underside of the plastic and can be collected in a receptacle beneath.

Whatever you do, don't drink water from a cactus; the fluids are high in alkalis which will induce stomach cramps and damage your kidneys. Squeezing water from animal dung is also possible in an absolute emergency; it will taste foul and may carry disease, so it should be a last resort.

Left, the calcium rock
formations of the
White Desert, Egypt.

© Ivoha / Shutterstock, © Cinoby / Getty Images

where he could reconnect with nature. In
the blankness, Abbey rediscovered the thrill
of experiencing something infinitely greater
than himself. The desert didn't care whether
he was there, or wasn't there. The desert
just was – and is.

As Abbey realised, the desert's
immutability explains much of our enduring
fascination with it. In a world where so
much of the planet has been tilled, farmed
and furrowed, deserts stand out as one
of the few places man has yet to tame. In
the emptiness, Abbey glimpsed a vision of
what a world without man might look like
– and it gave him solace. Or as the French
writer Honoré de Balzac succinctly phrased
it: 'In the desert there is everything, and
nothing. God is there, and man is not.'

This is surely why deserts are so often
the backdrop to post-apocalyptic stories.
Somehow, *Mad Max* just wouldn't have
the same hallucinatory, hyper-real quality
were it not set amongst the dust storms
and red dunes of the Australian outback.
In the nothingness, these tales remind
us, even the greatest of civilisations are
soon scrubbed out – like the gardens of
Babylon, or the pyramids of Egypt, or the
temples of Mesopotamia, or the statues of
Shelley's *Ozymandias*, the greatest works
of man can be swallowed up by the sands
soon enough.

But the desert has the power to inspire
too. Many artists have found their muse
in it, from the eccentric sculptors of South
Australia's Mutonia Sculpture Park to the
surreal canvases of Georgia O'Keefe and
Salvador Dalí. Driving across Australia's Red
Centre in 1992, the British artist Bruce Munro

experienced his own desert vision: 'an illuminated field of stems that, like the dormant seed in a dry desert, would burst into bloom at dusk with gentle rhythms of light under a blazing blanket of stars.' The result was his wildly successful *Field of Light* series: a forest of fibre-optic lights that seem to pulse and glow with the unseen power of the landscape. Munro has since created versions of the installation everywhere from Uluru to southwest England's Eden Project. Collectively, they are thought to have been seen by hundreds of thousands of people.

Munro's work recognised another fundamental quality common to all deserts: darkness. There's a reason so many of the world's observatories are located in them, way out in the middle of nowhere, as far from people as possible. Devoid of streets, towns, parking lots and shopping malls, deserts are fantastic for stargazing. Hidden stars, nebulae and constellations become visible in the gloom, allowing astronomers to peer into the deepest corners of the universe. For people accustomed to the perpetual sodium-yellow glow of city life, seeing the night sky in full clarity can come as nothing short of a revelation.

Deserts suggest another type of interstellar tourism, too. They're like stepping on to another world. The rugged terrain and crater-pocked surface of the deserts of Nevada, Texas and Arizona made the perfect terrain for replicating the lunar surface during practice runs for the Apollo moon landings. NASA put its Mars Rovers through their paces in California's

Mojave desert, and companies such as SpaceX and Blue Origin are currently testing the technologies which, one day, will allow the first human to set foot on Martian soil. Most of us won't get to visit another planet, but we can at least imagine a little of what it might feel like simply by setting foot in our nearest neighbourhood desert. It's as close to an extra-terrestrial experience as we can get without leaving planet Earth.

Some people claim to have experienced close encounters of a different kind. Sightings of UFOs and flying saucers are frequently reported, from crop circles in wheat fields to flashing lights in the desert sky. The most notorious incident is alleged to have taken place in the desert town of Roswell, New Mexico in 1947, where an alien craft supposedly crash-landed before being hushed up by a panicked government. Deserts, according to conspiracy theorists, are the perfect places to hide things you

From left, stars over Death Valley National Park; the Valley of Fire State Park, Nevada.

don't want people to see.

Alien visitors or not, the truth is that the desert already has enough weird and wonderful life-forms of its own. In Namibia, there is a lizard that does a disco dance to avoid burning its feet. In Mexico, there is a bird called the roadrunner that can run at more than 20mph (32km/h). In the Sahara, there is a viper with a horned head, a fox that uses its giant, saucer-like ears to dissipate heat, and a rodent called the jerboa, which looks like a cross between a mouse, a gerbil, a jackrabbit and a miniature kangaroo.

And that's just the fauna. Desert flora has evolved into many freakish forms to survive. There are plants that can survive on less than a teaspoon of rainfall a year, others that only bloom once every couple of decades before giving up the ghost. There are spiky plants, and sprawling plants, and bulbous plants; plants that can throw out their spines, plants that look like giant baseballs, plants that devour insects. The Namibian desert is home to what is said to be the world's toughest plant, *Welwitschia mirabilis*, which can survive up to five years of drought and still live for centuries (the oldest specimens are thought to be around 1500 years old). Equally tough is *Selaginella lepidophylla*, the Rose of Jericho, a native of the Chihuahuan Desert of North America, which can survive near-total desiccation before miraculously resurrecting itself at the first hint of rain.

Then there are the fossils. Many of the world's most important palaeontological sites are located in plains and deserts: places such as the Morrison Formation and Hell Creek Formation in the USA, Mongolia's Flaming

Many of the world's most important palaeontological sites are located in plains and deserts

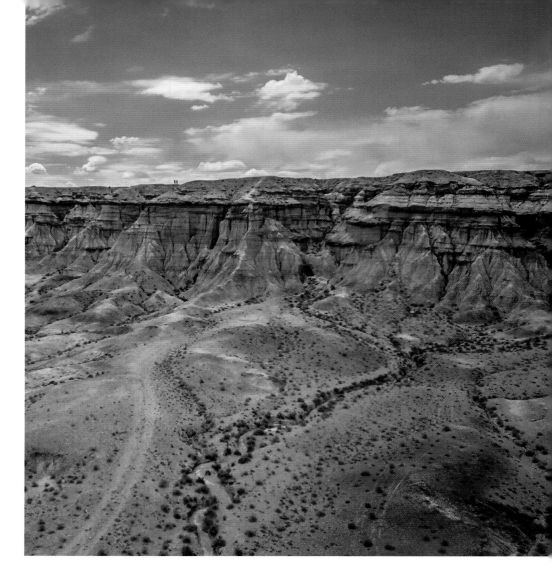

'The weird solitude, the great silence, the grim desolation, are the very things with which every desert wanderer eventually falls in love. You think that strange perhaps? Well, the beauty of the ugly was sometime a paradox, but today people admit its truth; and the grandeur of the desolate is just paradoxical, yet the desert gives it proof.'
John Charles van Dyke, *The Desert* (1918)

Cliffs and the Dashanpu Formation in south-central China. Places such as these have revealed the first diplodocus, unearthed in Morrison, Colorado in 1877; the 'Fighting Dinosaurs', a Protoceratops and Velociraptor locked in combat, discovered in the Gobi Desert in 1971; and Lucy, a 3.2 million-year-old hominid unearthed in the Afar Region of Ethiopia in 1974. They are portals into the past.

They invite us to contemplate time in other ways, too. The fact that so many of them are rich in oil, gas, coal and mineral deposits reminds us that once, long, long ago, these landscapes looked very different. Some were cloaked in tropical forest or fertile wetland. Others were submerged beneath deep lakes or temperate seas. Scooping up a handful of desert sand or plains soil is an exercise in time travel: as you watch the particles flow through your fingers, it's mind-boggling to think that they might once have formed part of a mighty mountain, flowed along a primeval river-bed, or sat at the bottom of a long-disappeared sea. Deserts and plains immerse us in deep time; by visiting them, we voyage into an ancient incarnation of the planet we call home.

They also intimate a vision of our future. In a warming world where the climate is spiralling out of control and species are struggling to adapt, deserts provide a warning of the consequences of our inaction, suggesting what an inexorably warming world might look like in the future. As forests burn, lakes dry up, and rivers disappear, the desert is what creeps in to take their place.

We've seen it within living memory. In the early 1930s, a combination of over-cultivation and drought ravaged the Southern Plains of the United States

From left, the stratified cliffs of the Gobi desert, Mongolia; Coral Pink Sand Dunes State Park, Utah; vast herds of bison once roamed the Great Plains, USA; overleaf, the dunes of Abu Dhabi.

from Texas to Nebraska, creating a vast region known as the Dust Bowl. Crops failed, livestock perished and millions of people were forced to abandon their farms, creating one of the largest migrations in human history (an event described in John Steinbeck's *Grapes of Wrath*). Rain returned by the late 1930s, but it was a warning of what can happen when we take nature for granted.

The fate of the bison, too, is a standing rebuke. When white settlers arrived in the New World, between 30 million and 60 million of these gentle giants roamed the Great Plains of North America. By the 1880s, mass slaughter had reduced their numbers to just a few hundred. Although conservation efforts have brought them back from extinction (current estimates are around 250,000, mostly in private herds), the vast bison herds of the past will never be seen again.

We've abused these places in even worse ways. On 16 July, 1945, in a remote part of the Jornada Del Muerto Desert, near Alamogordo, New Mexico, 230 miles (370km) south of Los Alamos, the first atomic bomb was detonated during the Trinity Test. It exploded with the force of approximately 21,000 tons of TNT (marginally more than the Little Boy bomb later dropped on Hiroshima), sending up a mushroom cloud 40,000ft (12,200m) into the atmosphere. It was the largest explosion mankind had ever seen, heralding the dawn of the Atomic Age.

Not every cataclysm is mankind's doing. East of Flagstaff, in Arizona's northern desert, lies Meteor Crater: a 0.75-mile (1.2km) wide, 560ft (170m) deep impact zone caused by a 160ft (50m) wide asteroid that slammed into the earth's surface about 50,000 years ago. It's one of the largest, and most visible, asteroid craters on earth: a sobering reminder of the threat from above which has snuffed out life many times in our planet's past, and could do so again at any moment.

Perhaps that's the most powerful lesson such places have to teach us. A-bombs, asteroids, apocalypses: deserts and plains have seen them all before, and endured. They have outlasted even the most destructive force. They are ancient, and permanent, in a way few landscapes truly are. They existed on planet Earth long before us – and they will be here long after the last of us is gone.

Humanity needs to be reminded of that sometimes. Maybe now more than ever.

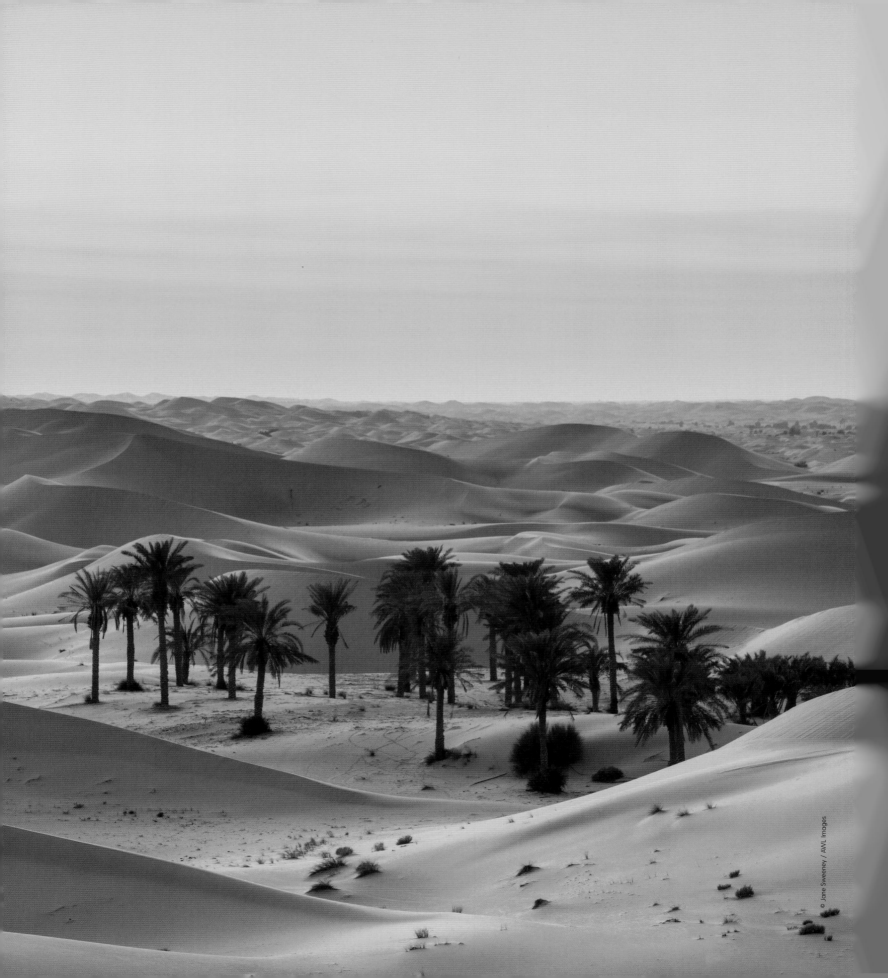

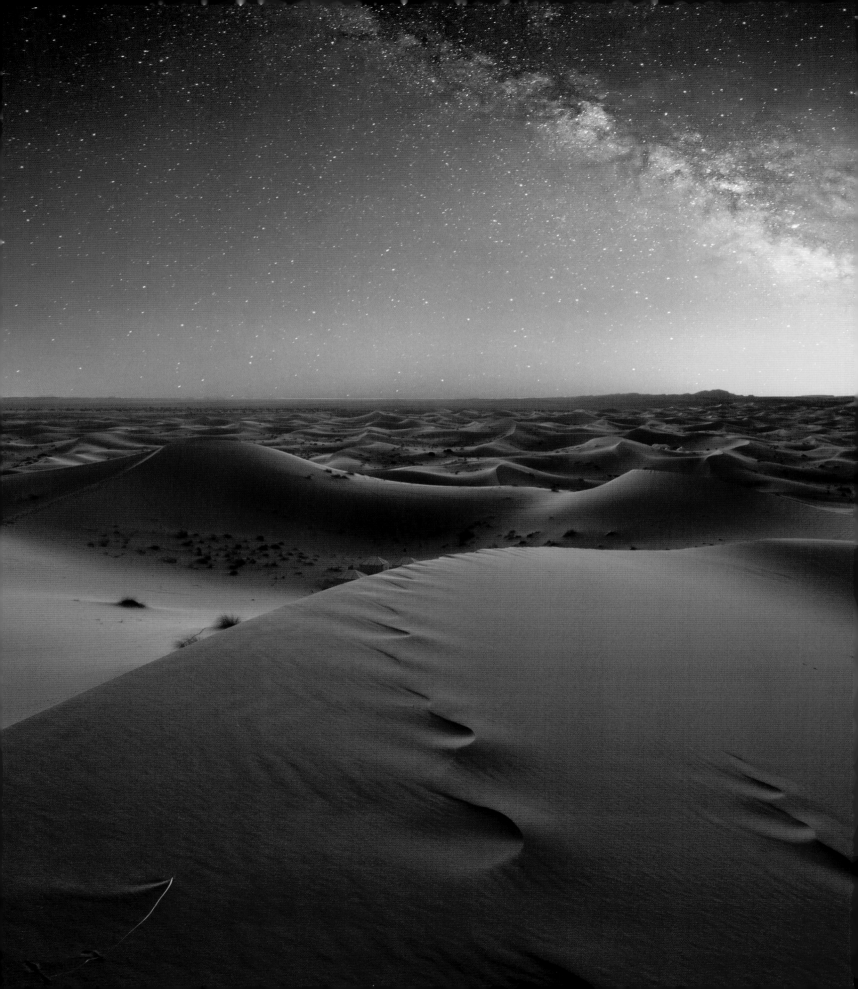

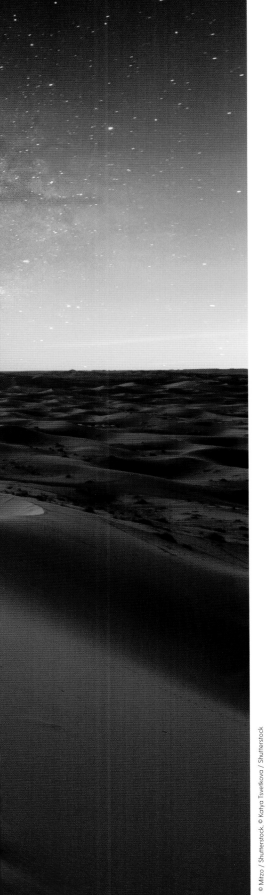

NORTH AFRICA

The Sahara

I f you're looking for the queen of deserts – for rolling dunes, flaming sunsets, camel trains and neverending blue skies – nowhere compares to the Sahara. Its name derives from *aṣ-ṣaḥrā' al-kubrá*, Arabic for 'the greatest desert', and couldn't be more apt. Roughly the same size as the continental United States, crossing at least 10 countries, it's the world's largest hot desert, encompassing a mind-boggling 3,600,000 sq miles (9,200,000 sq km) – enough to gobble up Australia with ample room to spare.

A curious fact about the Sahara is that it's relatively young. In its present form, it's probably only been around since the end of the last ice age. Then, much of the Sahara was green – closer to a tropical savannah, like the Kalahari, than the land of golden sands we see today. Scientists think that the Sahara alternates between desert and savannah every 20,000 years – a phenomenon caused by precession (the wobble in the position of the Earth's axis), which shifts the rain-bringing North African Monsoon. In roughly 15,000 years, the Sahara is expected to become green again, sometime around 17,000 AD.

Since none of us is likely to be around to see it, let's explore the Sahara as we know it. Contrary to the popular imagination, the vast majority of the Sahara isn't sand: 70% is composed of *reg* (gravel plains), *wadi* (dry valleys), *oued* (dried-up lakes), *hamada* (stone

In its sands, baked as hot as 80°C (176°F), remarkable wildlife and tough peoples have learned to thrive in the 'queen of deserts'

Left, the Milky Way far above the dunes of Erg Chebbi, Morocco.

Many explorers have attempted to cross the Sahara, but no journey is quite as impressive as the one made by Michael Asher and his wife Mariantonietta Peru, who in 1987 became the first people to successfully cross the Sahara west to east on foot. They left Chinguetti in Mauritania in August 1986 with three camels, and arrived on the banks of the Nile nine months later in May 1987, a journey lasting 271 days and covering 4500 miles (7250km). As yet, the journey has never been repeated. Asher's own desert adventures continued: he has also walked across Egypt's Western Desert, the Thar Desert in India and the Uruq ash-Shaiba, the highest dunes in the Empty Quarter of the Arabian Peninsula.

Right, a Berber camel train in Erg Chebbi, Morocco.

plateaus) and *chott* (salt flats). *Erg* (sand seas) make up around a third of its landmass, and none is mightier than the Great Sand Sea – a 27,800 sq mile (72,000 sq km) ocean of dunes extending from western Egypt into eastern Libya, 400 miles (650km) from north to south and 185 miles (300km) from east to west. The first European to document it was the German explorer Gerhard Rohlfs in 1865, but it was long known about by the people who called the Sahara home: the Berber, and especially the Tuareg, many of whom still live a semi-nomadic desert lifestyle.

One inescapable element of the Sahara is its heat. It is fiercely, violently, punishingly hot. The Algerian town of Bou Bernous is on record for experiencing the highest average temperature in the world: 47°C (116°F). The sand, of course, is much hotter, easily reaching temperatures of 80°C (176°F), hot enough to scorch skin.

Sunburn is far from the only danger. Photokeratis, or sand blindness, is another peril, caused by sunlight reflecting off the dunes. Deadly creatures lurk in the dunes, including the deathstalker scorpion, one of the world's most venomous; the sand viper, which hides just under the sand's surface; and the horned viper, identifiable by the spine-like scales above its eyes. And then there are the *simoom*, or sand storms: walls of dust whipped up by the wind that can tower one mile (1.5km) high. Surviving a *simoom* is an experience every Saharan traveller must endure. When you're in the middle of one, it feels like the apocalypse has arrived.

Despite the dangers, Africa's greatest desert has attracted adventurers since time immemorial. The ancient Greek historian Herodotus wrote about it; Mungo Park explored it in search of the Niger's source; Alexander Gordon Laing crossed it and discovered the city of Timbuktu; and the French pilot-poet Antoine de Saint-Exupéry flew across it, recalling his experiences in *Wind, Sand and Stars*.

Today, the Sahara continues to exert a magnetic hold over the people who visit it. The most accessible region is in Morocco. Overlooked by the High Atlas Mountains, two huge areas of sand dunes, Erg Chigaga and Erg Chebbi, can be reached by 4WD from the towns of M'Hamid and Merzouga, each roughly a day's bus ride from Marrakesh. This is the Sahara of the imagination, of palm-fringed oases, camping out on the dunes, checking your boots for scorpions and chatting to Tuareg guides by firelight over questionable goat stews.

Tunisia offers another route, especially for film fans. If you've dreamt of wandering across the dunes of Tatooine, scenes from *Star Wars* and *The English Patient* were filmed near the town of Tozeur and the great salt lake of Chott El Jerid; local guides offer tours to filming spots such as the Jawa valley, Obi-Wan Kenobi's house and Luke's homestead. Some locations, such as the Mos Espa set created for *The Phantom Menace*, are still intact, albeit obscured a little more each year by the march of the Saharan sands.

Travel in the Sahara is best between October and April or early May when daytime temperatures are generally bearable. In the depths of the Saharan winter (especially December and January), nighttime temperatures can fall below freezing. Sand storms are possible from January through May, while no sensible person ventures into the fierce firestorm of heat that blankets the Sahara from June to early September. Rain is rarely a problem. The two main gateway towns in Morocco are Tozeur, a seven-hour bus ride or one-hour flight from Tunis, and Douz, a nine-hour bus ride from Tunisia's capital. Guided tours by camel are slow but allow you to soak up the silence and surroundings; 4WDs, though not quite as authentic, allow you to explore a wider area.

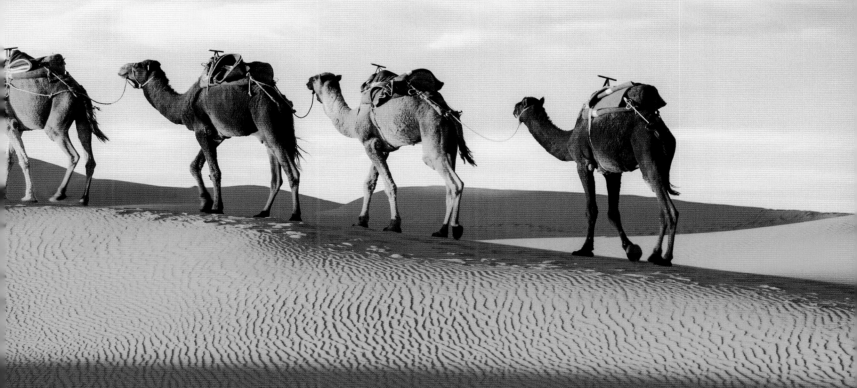

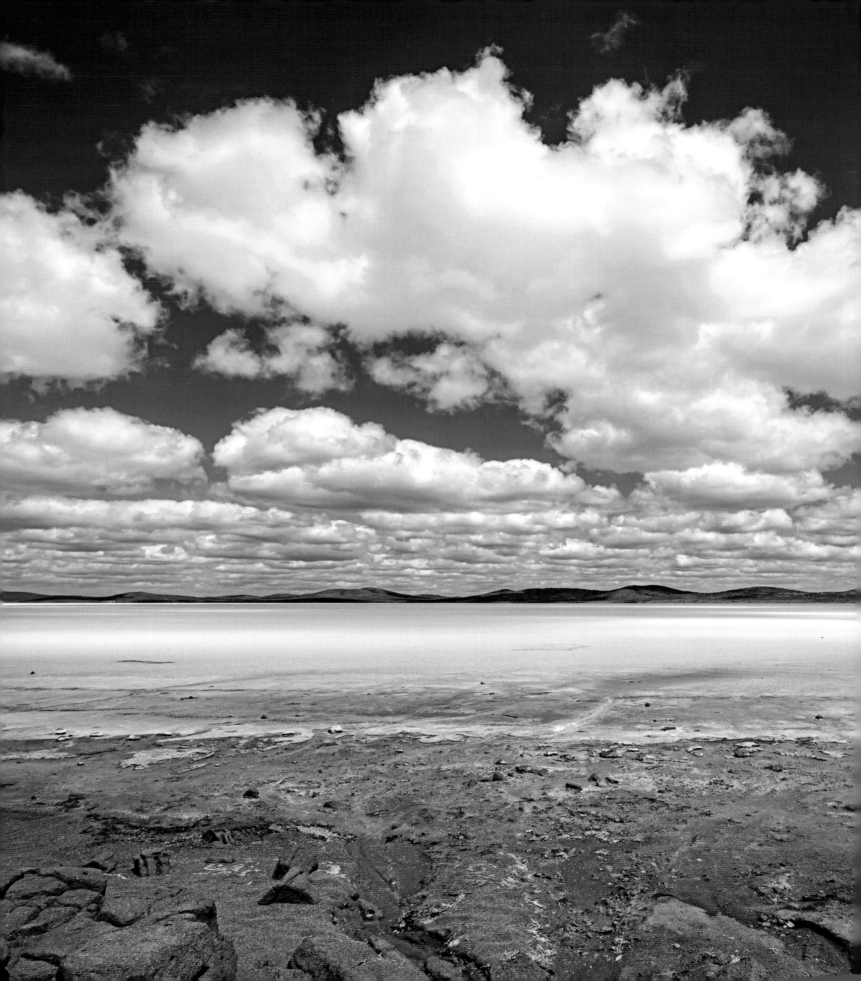

AUSTRALIA

The Simpson Desert

I n the middle of the Simpson Desert (108 miles/174km west of Birdsville, to be precise), there is a stone pillar called Poeppel Corner. It is named after Augustus Poeppel, the German-born surveyor who, in the late 1870s, was tasked with determining the borders of Queensland, South Australia and the Northern Territory. It took Poeppel and his team two months to complete the task, braving starvation, scurvy and extreme thirst, but the matter was settled in 1880, when the junction was marked at 26 degrees South and 138 degrees East with a post.

Standing there today, it's hard to see what the fuss was about. Because there's not much of anything at Poeppel Corner. No trees, no rivers, no lakes, no towns. It's surrounded by a great expanse of red, sandy nothingness that extends for 68,150 sq miles (176,500 sq km) in every direction. These days, the only people who visit are 4WD drivers who want to snap a selfie at the meeting point of three Australian states.

Poeppel's signpost isn't the top reason that off-roaders come to this remote part of the Australian Outback. They come for the dunes: 1100 of them. The Simpson Desert (named after Australian industrialist and geographer, Alfred Allen Simpson) is home to the world's longest parallel sand dunes, running from Birdsville to Alice Springs to the northwest. They vary in height from 10ft to 100ft (3m to 30m). The largest of all, Big Red (or Nappanerica) is 131ft (40m)

Beneath the bone-dry sands of the longest dunes in the world lies one of the planet's largest reserves of fresh water.

Left, rainwater that falls in Queensland arrives in Kati Thanda-Lake Eyre two months later.

The Simpson has been a magnet for explorers ever since the first European, Charles Sturt, clapped eyes on it in 1844. The first non-indigenous person to cross the desert was Ted Colson, a legendary bushman and pioneer born in South Australia. In May 1936, Colson set off from Mount Etingamba, accompanied by five camels and his Aboriginal guide, Eringa Peter. They reached Birdsville on 11 June, before setting out on their return journey three days later, and arriving at Bloods Creek on 29 June after almost 965km (600 miles) of travel.

Subsequent crossings include those of Dennis Bartel, who crossed the desert solo from west-east in 1984; Lucas Trihey, who crossed through the desert's geographical centre in 2006; Michael Giacometti, who completed the only unsupported east-west walk in 2008; and Louis-Philippe Loncke, who traversed the desert from north-south, also in 2008.

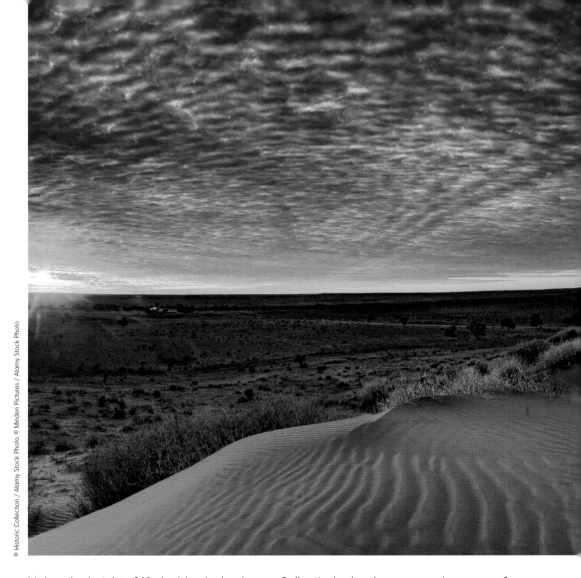

high – the height of 10 double-decker buses. Collectively, the dunes comprise some of the most exhilarating off-road driving in Australia: a seat-of-the-pants thrill-ride that involves gunning up the sheer side of one dune, leaping off the crest and careering down the opposite side. You can drive for days and still not reach the end of them.

A number of off-road tracks span the Simpson Desert, mostly forged by prospecting companies searching for oil and gas. But for millennia Australia's indigenous people had this wilderness all to themselves. Tribes such as the Wangkangurru Yarluyandi, Arrernte and Arabana learned how to survive here thanks to their knowledge of the bush, handed down from one generation to the next – particularly the location of *mikiri*, or hidden wells. Because while it might not look like there's any water at all in the Simpson Desert, in fact it sits on top of one of the largest freshwater reserves on earth, the Great Artesian Basin – a subterranean well underlying 22% of the continent, containing about 15,600 cubic miles (65,000 cubic km) of groundwater. This water bubbles up at several points, including the wildlife-rich Dalhousie Springs.

For much of the year, however, the Simpson Desert is bone dry, receiving less than 6in (150mm) of rainfall annually. Summer temperatures top 50°C (122°F). Only the hardiest forms of life exist out here – curious animals such as the water-holding frog and the hopping mouse, and hardy grasses such as spinifex and cane grass, that bind the dunes together. When the rains do come, however, areas of desert can transform themselves in the blink of an eye. Wildflowers bloom where nothing grew before, and lakes emerge like magic from the dust – such as Lake Eyre, the lowest point on the Australian continent at 50ft below sea-level. On the rare occasions it fills during heavy

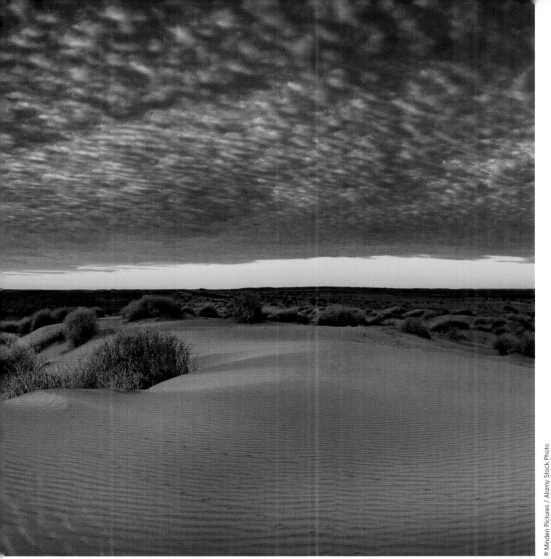

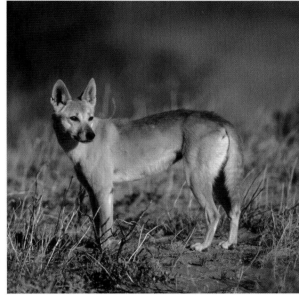

From left, sunrise over the Simpson; a resident dingo.

There are no maintained roads in the Simpson Desert, so a 4WD is essential if you're planning on exploring. The most accessible area is Munga-Thirri National Park (parks.des.qld.gov.au/parks/munga-thirri), Queensland's largest national park, which includes major sights such as the Big Red sand dune, the Approdinna Attora Knolls and Poeppel Corner. The park is best accessed from Birdsville via the main off-road track, the QAA Line. Camping is permitted within 500m of the QAA Line only, but there are no designated campgrounds or facilities. You will need to carry all your own supplies, spare petrol and emergency equipment including a satellite phone. The park is closed from December to mid-March due to extreme temperatures.

seasonal rains, it can swell to massive proportions – as much as 3668 sq miles (9,500 sq km), making it (at least for as long as it lasts) the largest lake in Australia. When it's full, it's as salty as the sea.

Make no mistake, though: the Simpson Desert can be a brutal and unforgiving place. Every year, cavalier drivers get lost, even in relatively well-monitored areas such as Munga-Thirri National Park. Some tracks are closed in summer to deter off-roading adventurers. Mobile phone signals are non-existent, and park rangers recommend that 4WD vehicles always travel in convoys of at least two, carry emergency supplies of food and water, along with a satellite phone and EPIRB (Emergency Position Indicating Radio Beacon) to send a distress signal.

It's only once you've been driving for a while that you understand why such precautions are necessary. Even on the best-known tracks, such as the French Line, the Rig Road and the Binns Track, it's not unusual to pass hours without passing another vehicle, and you'll be camping out with nothing more than the stars, the sand and maybe a skink or mulgara or two to keep you company. The Simpson is a place which really puts the desert in deserted.

But the isolation is worth it. Camping in the heart of the Outback with the crackle of a campfire and the Milky Way blazing overhead is an experience not soon forgotten. Who needs civilisation, anyway?

CHINA AND MONGOLIA

The Gobi Desert

Dinosaur boneyards and the Silk Road. Vast sand dunes and ice gorges. Welcome to the many faces of the Gobi.

Right, Bayan Zag, or the Flaming Cliffs of the Gobi, Mongolia; overleaf from left, bactrian camels on Khongoryn Els; sunset dunes.

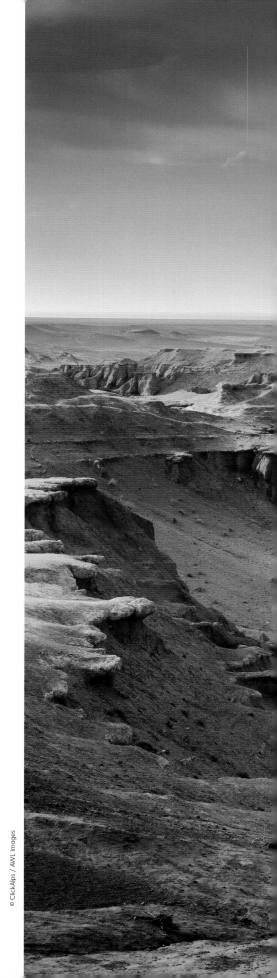

If you somehow had the chance to pop back to the 13th century to tell Marco Polo you were vacationing in the Gobi Desert, he probably would have had you clanged up in the nearest lunatic asylum. To Polo, and the explorers who followed him, the Gobi was a place of danger, death, strange spirits and murderous hardship. He crossed the desert several times during his journeys along the Silk Road, the network of ancient trading routes along which luxury goods such as silk, tea, ivory and furs were ferried from the Far East to Europe. 'This desert is reported to be so long that it would take a year to go from end to end,' he wrote. 'And at the narrowest point it takes a month to cross it. It consists entirely of mountains and sands and valleys. There is nothing at all to eat.'

Polo was right to be wary of the Gobi; 1000 miles (1600km) from west to east, between 300 miles (500km) and 600 miles (1000km) wide from north to south, it covers 502,000 sq miles (1.3 million sq km), making it Asia's second-biggest desert (only the Arabian Desert is larger). But wilderness extends far beyond the Gobi's official borders: to the north loom the Altai Mountains and the Mongolian steppes; to the west the great Taklamakan Desert; and to the south lie the plains and plateaus of Tibet and Northern China. All in all, they are a vast, blank space on the map.

It's not just the size of the Gobi that Marco Polo feared. It's dry, of course – on average,

© ClickAlps / AWL Images

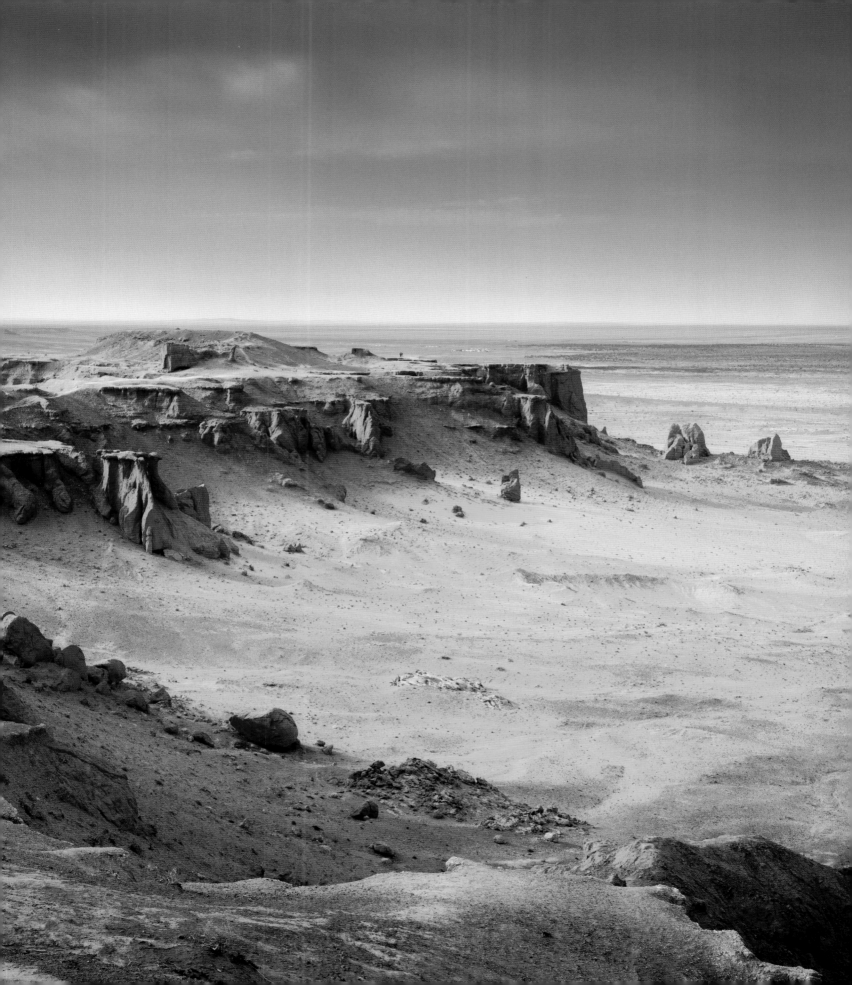

Many high-profile fossil finds have been made in the Gobi, including a clutch of dinosaur eggs, uncovered in 1923. The northwestern Gobi, particularly the area around the Nemegt Basin, is a rich hunting ground for palaeontologists and archaeologists. Finds here have included fossils of two types of titanosaur, lots of oviraptors, a pterosaur, crocodiles, turtles, and several early mammals. Most date from the late Cretaceous (145 million to 66 million years ago), when the region's climate appears to have been very different: fossilised tree trunks suggest the presence of forests. There have been more recent finds, too, including prehistoric stone tools fashioned by early humans, dated at around 100,000 years old. Over the decades, many of these finds have ended up in museums and private collections abroad, but in recent years Ulaanbaatar's Central Museum of Mongolian Dinosaurs has been working to stem the flow.

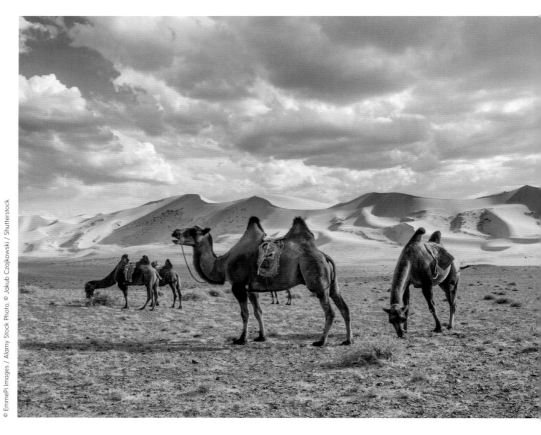

© EmmePi Images / Alamy Stock Photo. © Jakub Czajkowski / Shutterstock

© Alexander Izmaylov / Shutterstock, next page: © Ferry Tomasowa / Shutterstock

just under 8in (200mm) of rain falls here annually – but it's the extremes of temperature that are the killer in the Gobi. Its northerly latitude and high elevation (from 2300ft/700m to 4900ft/1500m), combined with fierce winds blowing in over the Siberian Steppes, mean that temperatures in the Gobi range wildly: from a frostbiting -40°C (-40°F) in winter to a fleshburning 45°C (113°F) in summer (there can be considerable fluctuations in a single day, too). Then consider the other dangers Polo faced: from Mongol raiders who plundered the Silk Road caravans, to the wolves, bears and snow leopards looking for their next meal.

These days it's possible to explore parts of it with an ease and comfort Polo would never have dreamed possible. One of the most accessible

areas is Gurvan Saikhan, Mongolia's largest and most popular national park, 10,400 sq miles (27,000 sq km) of the northern Gobi, making it one of the largest areas of protected desert in Asia.

The park is named after the Gurvan Saikhan Mountains, which run across its eastern edge (the name means 'Three Beauties', referring to the ranges that comprise the mountains). It's home to spectacular expanses of Mongolian steppe, and deep gorges such as Yolyn Am, whose narrow, shaded walls allow sheets of blue-veined ice to linger well into the summer. Elsewhere, there are dinosaur boneyards to explore, and ancient stone carvings to view: the famous Khavtsgait Petroglyphs date from between 8000BC and 3000BC. The park's highlight is the

Khongoryn Els sand dunes, the largest in Mongolia: 980ft (300m) high, 7.5 miles (12km) wide and about 62 miles (100km) long. They're also known as the Duut Mankhan, or Singing Dunes, a reference to the whistling sound they make when the sand is stirred up by the wind. It takes around an hour to trek to the top, and you may have to endure sand whipping about you near the crest, but the desert views are sublime. A less strenuous option is to catch a ride on a two-humped camel. Local herders are usually on hand to oblige.

Spectacular as the dunes are, the rate at which the Gobi is expanding is disturbing: 1300 sq miles (3400 sq km) of grassland a year are being gobbled up by the Gobi every year, and dust storms are becoming stronger and more frequent. The climate crisis is the major culprit, but deforestation, overgrazing and water use are major factors, too. The issue is so serious that the Chinese government has implemented projects to slow the desert's progress, including the Three-North Shelter Forest Program (or 'Green Great Wall'), a mass tree-planting project that began in 1978 and will continue until at least 2050. So far, it's had limited success, with critics pointing out that non-native poplar and pine are unlikely to take root. So it looks like the Gobi will go on growing.

Gurvan Saikhan is on the northern edge of the Gobi. The main gateway is the town of Dalanzadgad, which has direct flights to Ulaanbaatar. The most practical way to visit is on an organised tour, or chartering a private taxi, both of which can be arranged in Dalanzadgad. Yolyn Am gorge is in the Zuun Saikhan Nuruu (the easterly most of the Three Beauties), a 29-mile (46km) drive west of Dalanzadgad; the Khongoryn Els dunes are about 110 miles (180km) away. You can pay the national park entry fee at either site. Keep your ticket as you may need to show it more than once. Conservation Ink (conservationink. org) publishes the Gobi Gurvan Saikhan National Park Map and Guide, a satellite map with informative articles.

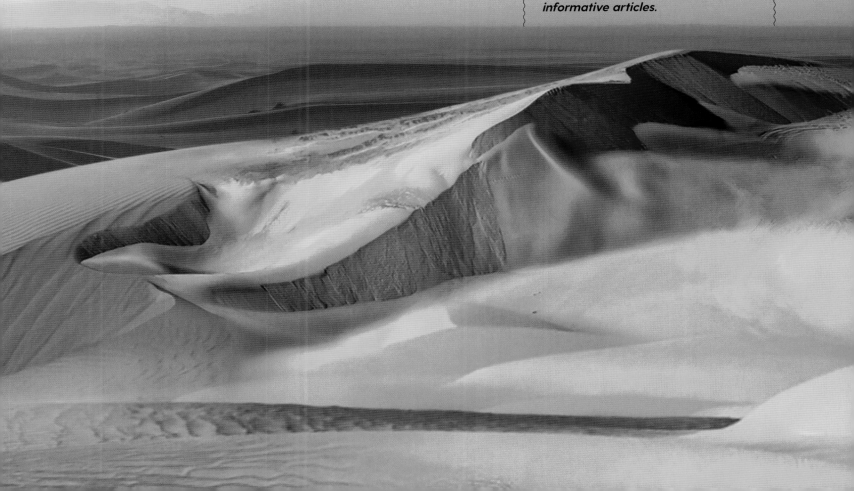

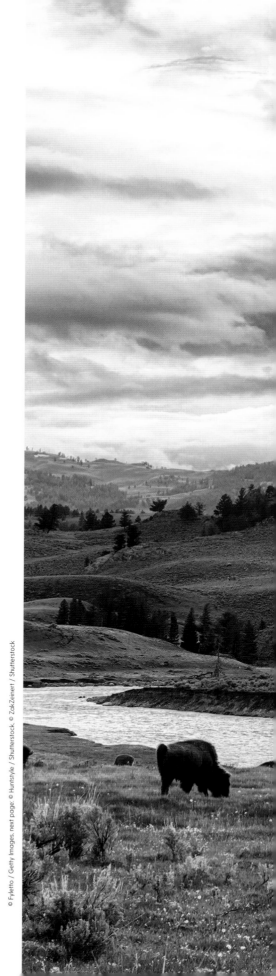

NORTH AMERICA

The Great Plains

Once it was pioneer country, the scene of some of the USA's most stirring and shameful history. Today, it remains a land of big skies and epic road trips.

I f you want to understand the history of America, then you need to get away from the coasts, and head for the nation's great, hinterland.

Extending west of the Mississippi clear through to the Rockies, the Great Plains are arguably America's most evocative – and important – landscape. This is pioneer country, where wagon-trains once rolled and cowboys ranged. It's the land of big skies and cattle ranches, of prairie grass and wheat fields. During the 1930s it saw some of the worst scenes of the Great Depression. To this day, the Plains are America's heartland, crossed by Route 66.

Where do they begin and end? There are no official bounds, but it's generally acknowledged that the Plains extend in a band across the American Midwest, about 2000 miles (3200km) north to south and 500 miles (800km) east to west. En route, they cover 10 US states (including the whole of Nebraska, North and South Dakota, and parts of Montana, Colorado, Oklahoma, Kansas, Texas, Wyoming and New Mexico) and three Canadian provinces (Saskatchewan, Manitoba and Alberta). In total they encompass about 502,000 square miles (1.3 million sq km).

Despite the name, there is more to the Plains than plains. There are escarpments, valleys, rivers, buttes, gulches and mesas. But when you're driving across them for days on end, they appear flat to the naked eye, a world of horizons without end.

Right, bison are now widely farmed in the Great Plains states. Previous spread, the Flaming Cliffs of the Gobi desert.

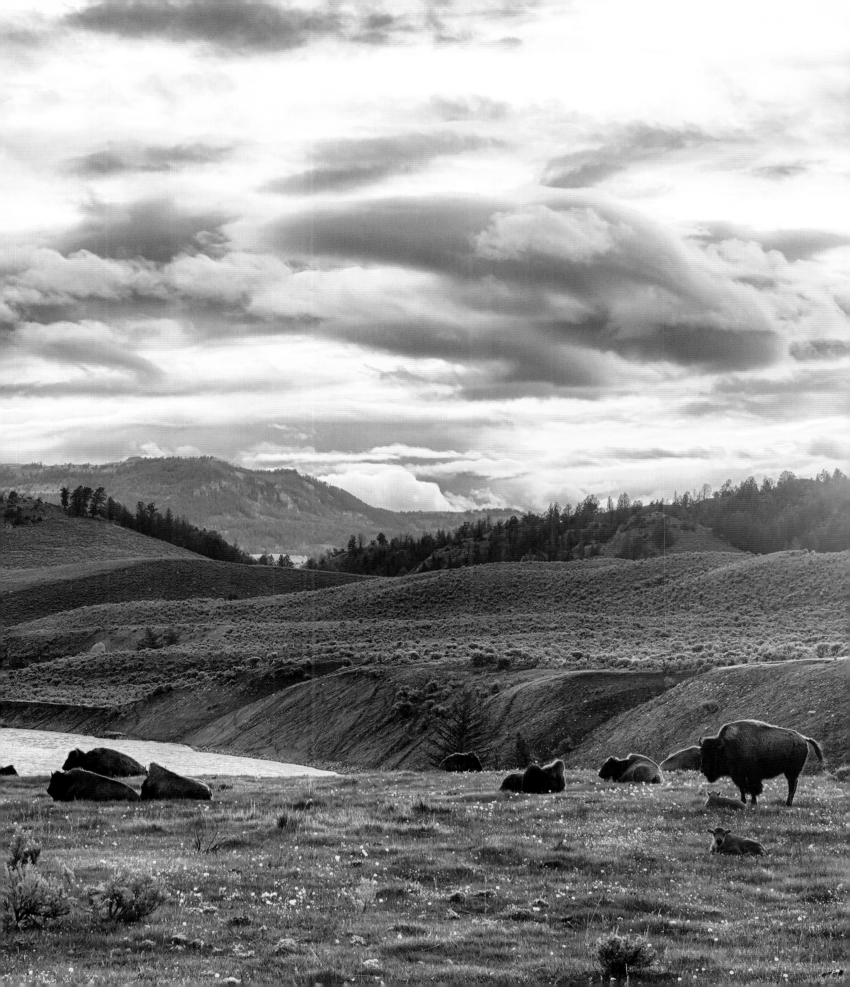

The southeastern Great Plains are home to Tornado Alley – the infamous corridor stretching from Texas to South Dakota that endures more tornadoes than anywhere on earth. As warm, humid air moves northwards from the Gulf of Mexico across the Great Plains, it hits cold, dry air moving south from Canada and east from the Rocky Mountains. Thunderstorms are created and, because there are few geographical features to impede tem, winds are whipped up to murderous speeds. About 1000 tornadoes rage across the US each year, the vast majority on the Great Plains (although in May 2003, 543 were recorded in a single month). The fastest tornado ever recorded on earth was clocked in Bridge Creek, Oklahoma, on 3 May, 1999: 302 mph (486km/h).

Right, sunrise over Theodore Roosevelt National Park, North Dakota.

The first people of the Plains were the Native Americans. For centuries, tribes including the Cherokee, Chickasaw, Choctaw, Creek and Seminole lived a semi-nomadic lifestyle on the Plains, following the great herds of buffalo, which grazed in their millions before being hunted to near-extinction over the course of the 19th century. As the buffalo were being all but wiped out, many tribes were forcibly relocated to reservations, most notoriously in mass movements of people, such as the Trail of Tears in 1838–9. A few tribes such as the Sioux fought on, but before long they too were overwhelmed and forced to relinquish the Plains to the settlers.

Next came the cowboy, that most storied of American archetypes. Employed to drive free-ranging cattle herds on the open plains to stockyards and railheads, the cowboy has become an icon of the American imagination. But like many popular myths, the truth is more prosaic: the era of large-scale cattle-herding by horseback lasted barely 15 years, from 1865 to about 1880. It was curtailed by the expansion of the railroad and the advent of barbed wire fences, which parcelled up the land and brought the Open Range to an end.

Settlers followed on the Plains, attracted by the 1862 Homestead Act, which offered 160 acres of land free to each settler, so long as the land was farmed for five years. Life on the Plains was no idyll. Farming was hard, lonely and isolated, and the frontier towns were dangerous places: legendary lawmen such as Wyatt Earp and Pat Garrett were required to keep the peace. As machinery improved, deep wells were sunk to extract

water, and agriculture slowly took hold. But farming remained a precarious business: poor soil, harsh winters, fierce winds and seasonal pests all took their toll, and in the 1930s a sudden, severe drought created a huge, parched area known as the 'Dust Bowl' that ruined many farms and forced millions to relocate. Even today, many once-busy corners of the Great Plains feel eerily empty.

Empty, yes, but not deserted. There are big cities on the plains, cosmopolitan college towns such as Kansas City and St Louis. And there are big views: rainbow-coloured rock formations in Theodore Roosevelt National Park, river vistas along the banks of the Mississippi, extra-terrestrial badlands in South Dakota, fossil beds in the Nebraska panhandle, rolling tumbleweeds and ghost towns in Western Oklahoma. And there's the bizarre monument to American democracy known as Mt Rushmore, sculpted into the side of the Black Hills of South Dakota by sculptor Gutzon Borglum between 1927 and 1941.

The Great Plains are made for road tripping. The Mother Road herself, Route 66, cuts right across the Plains, and there are few more American experiences than cruising through a forgotten town, stopping for lunch at a homely country diner, shopping for a kitsch souvenir at a mom-and-pop store before driving on till the sun goes down. As you cruise across the plains, you'll be travelling through the spiritual and geographical heart of America, just like the settlers of old – only with the added convenience of air-con and a stereo stocked with tunes.

Your own transport is essential for exploring the Great Plains. Thunderstorm season runs from May to August; April and September to October usually have the most settled weather. Blizzards shut down roads for days in the winter months, especially in the northern States and Canada. St Louis and Kansas City make useful bases, while regional cities such as Fargo, Tulsa and Omaha have a range of enticing historic hotels and classic motels.

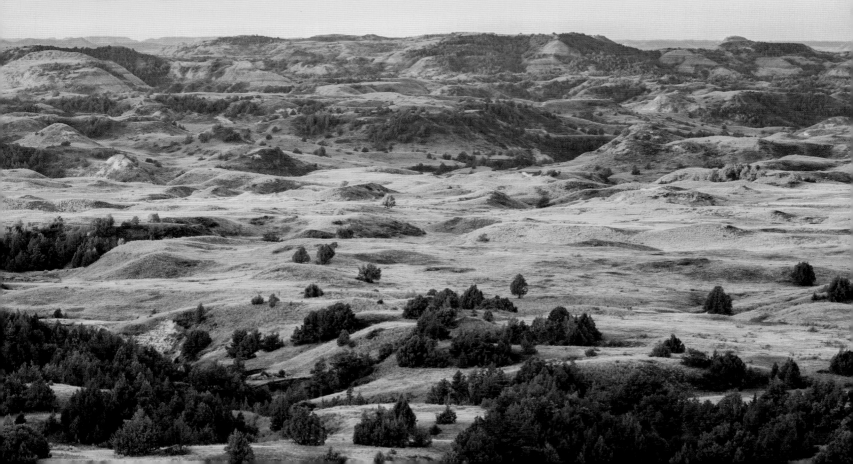

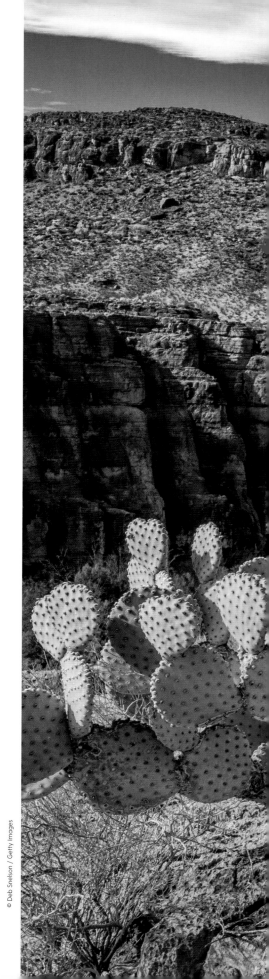

© Deb Snelson / Getty Images

USA AND MEXICO

The Chihuahuan Desert

North America's
biggest desert
exceeds expectations:
red-rock mesas,
endless cacti, 'sky
islands' – and
the original alien
conspiracy theory.

Right, viewing
the Rio Grande
from Hot
Springs Canyon,
Big Bend
National Park,
in the north of
the Chihuahuan
desert.

Driving around the Chihuahuan Desert feels weirdly familiar, even if you've never been here before. Nearly twice the size of Germany, this huge desert – North America's largest – extends across six Mexican states and parts of Texas and New Mexico. With its red-rock mesas, orange plains, and gullies filled with mesquite, cacti and prickly pears, it feels like driving through a freeze-frame from a Looney Tunes Roadrunner cartoon. All that's missing is Wile E. Coyote racing round the next corner armed with a fizzling Acme bomb.

Rather bizarrely, the roadrunner is a member of the cuckoo family. It's a common sight in the Chihuahuan Desert, easily spotted thanks to its long tail, punky crest, red-and-blue eye patches and gangly legs, capable of propelling it to speeds of 40mph (rather than 'meep meep', its voice is actually soft coo-coo).

The Chihuahuan Desert is home to many exotic creatures. According to the Worldwide Fund for Nature, this may be the most biologically diverse desert in the world: 3500 plant species (including a quarter of all cactus species), 170 amphibians and reptiles, and 130 mammals, including jaguars, javelins, grey foxes, pronghorns, golden eagles, mountain lions and prairie dogs. Many exist nowhere else on the planet.

Sadly, no desert is more threatened than the Chihuahuan. In the 1850s, Spanish

dercium onduct
suny labo ut er
volest uptatu e
sit, que adignat
rosim stin

According to conspiracy theorists, on 7 July, 1947, an alien craft crash-landed in the Chihuahuan Desert just outside the town of Roswell, New Mexico, allegedly containing one or more extra-terrestrial life-forms. The 'flying disk' and its occupants were later recovered and taken to Area 51, a secret military testing site, where autopsies were supposedly performed. Some 50 years later, the US military issued an explanation: the crashed craft was actually part of Project Mogul, a fleet of surveillance balloons designed to detect sound waves from Soviet atomic bomb tests. Regardless, the Roswell conspiracy rumbles on, and the town seems happy to cash in – it has a UFO museum, and hosts its own annual UFO Festival in July.

explorers described the lush grasses that cloaked it as 'belly high to a horse'. But a combination of overgrazing, water depletion, mining, invasive species and climate change have upset the desert's fragile ecosystems, endangering the survival of many of its unique habitats. Historically, the Chihuahuan Desert was one of the only places on the continent where wolves, jaguars and grizzly bears hunted alongside each other; the Mexican wolf, once widespread, was nearly hunted into extinction, and remains on the endangered species list.

Though little rain falls here – 9in (230mm) annually – underground springs, streams and the proximity of the Rio Grande provide a precious source of water. In fact, much of the Chihuahuan Desert is surprisingly green. It is what is known as a 'shrub desert': more than 20% of it is covered by grassland, supplemented by thick copses of yucca, rainbow cacti, agave, honey mesquite, creosote bushes, ocotillo, white-thorn acacia, allthorns and Mormon tea plants. At higher elevations, notably the nearby Sierra Madre, 'sky islands' exist that are cloaked in conifer and broadleaf trees. Amazingly, the desert even has oases that harbour aquatic life, such as pupfish and cichlids. There surely can't be many deserts where even the fish are special.

The desert's size is most easily visited in combination with a trip to Big Bend, Texas' most popular national park. Extending along the Mexican border and the banks of the Rio Grande (the park is named after a particularly distinctive swerve

From left, Davis Mountains State Park, Texas; a Chihuahuan desert native, the regal horned lizard.

in the river's course), the park contains one of the largest protected areas in the Chihuahuan Desert, including the Davis Mountains and the nearby Chihuahuan Desert Nature Center, where it's possible to hike through canyons, watch butterflies fluttering around wildflower gardens and visit a cacti-filled greenhouse. You can also pay a visit to the McDonald Observatory, which holds nightly star parties in the summer holiday season.

New Mexico is another popular access point thanks to the existence of the Carlsbad Caverns, one of 120 subterranean cave systems that burrow beneath the Chihuahuan Desert. Though it extends more than 30 miles (48km) (10% of which are open to visitors) and features the largest subterranean chamber in the US, amazingly, it's not even the desert's largest cave system: that's Lechuguilla, which extends for some 136 miles (219km) and descends to depths of 1600ft (490m, but is closed to the public). Even that might not be the most spectacular cave in the Chihuahuan Desert: on the Mexican side, the Cueva de los Cristales, or Cave of Crystals, contains gigantic gypsum crystals that can reach 39ft (12m) long, 13ft (4m) across and weigh 55 tons. Discovered and drained of water in 2000 as part of a mining operation, the cave has once again flooded.

Big Bend National Park is on the Texas/Mexico border, 292 miles (470km) southeast of El Paso, 373 miles (600km) west of San Antonio. Accommodation in the park includes campsites, motels and hotels. A car is required to get around. Spring and early summer are the driest times in the desert; there is often heavy rainfall during the North American monsoon from late June to early October. The average daytime temperature is 24°C (75°F), but ranges up to 40°C (104°F) in summer, down to 10°C (50°F) in winter. Nights are much cooler. Frost and snow can occur at higher elevations in winter.

SOUTH AFRICA

The Kalahari Desert

Spot lions, leopards and cheetahs across a rich array of habitats in this wild African wonderland – which also witnessed the dawn of early man.

Right, a male lion rests in the Kalahari desert.

To the local Tswana people, it's the Kgalagadi: the 'Waterless Place', or 'Land of Thirst'. And parts of it are every bit as arid as the Sahara: swathes of shifting sand dunes and rocky, desiccated valleys scorched by months of relentless, skin-searing heat.

But the Kalahari's immense size means it encompasses many topographies. Covering 360,000 sq miles (930,000 sq km) of Botswana, Namibia and South Africa, it's the fifth-largest among the non-polar deserts on earth, the second-largest in Africa. It's home to dry savannah, tropical forest, floodplains, waterfalls, marshes, and salt lakes, not to mention the great Okavango river, which runs for nearly 1000 miles (1600km) between Angola and Botswana. And with between 4in (100mm) and 20in (500mm) of rain a year, depending on which part of it you're in, the Kalahari also receives more rainfall than the average desert (annual precipitation of less than 250mm is the habitat's qualifying threshold, remember?).

As such, you might be surprised by how green much of the Kalahari is – 500 species of plants and shrubs thrive here in the rainy season, from semi-arid savannah coated in camelthorns, shepherd's trees and savannah grass, to forests filled with acacia and Rhodesian teak. On the South African side, there are even vineyards and fruit farms. In many places, the Kalahari doesn't look much like a desert at all.

© EcoPic / Getty Images

For the last 20,000 years, the Kalahari has been home to the San, an ancient tribe who still pursue a hunter-gatherer existence not that dissimilar to our ancient ancestors'. Traditionally, they hunt wild game using spears, bows and poison-tipped arrows, getting the rest of their nutrients from foraged berries, melons, nuts and seeds (much of their water apparently comes from desert melons). They are skilled trackers and bushmen, as well as masters of their desert environment, with an unparalleled knowledge of the medicinal and nutritional value of local plants. Studies have revealed that the development of the San's poison-tip hunting technique was not only a significant shift in cognitive evolution, but that their knowledge is highly localised: neighbouring communities' poisons are often quite distinct, and reflective of subtly differing habitats.

© Gary Cook / Alamy Stock Photo. © Catherina Unger / AWL Images

This diversity is reflected in its wildlife. The Kalahari is one of only a handful of places in Africa where it's possible to spy all three big cats – lions, leopards and cheetahs – along with spotted hyenas, wildebeest, springbok, ostriches, antelopes, caracals and secretary birds. Although an increasingly large chunk of the Kalahari is given over to grazing, and cattle fences have restricted the free movement of wildlife, on the Botswanan side at least, there are three huge game reserves where it's still possible to experience the Kalahari in something close to its wild state.

Foremost is the Central Kalahari Game Reserve (CKGR), covering an area of 20,390 sq miles (52,800 sq km) – approximately the size of Denmark. There is nowhere better in the Kalahari for wildlife spotting: all the charismatic predators can be seen here, including the black-maned Kalahari lion. For seven years between 1974 and 1981, two American zoologists, Mark and Delia Owens, based themselves in the remote area known as Deception Valley to undertake a study of lions, jackals and brown hyenas (an experience recounted in their 1984 cult-classic book, *Cry of the Kalahari*). Recent estimates drawn up by research scientists have suggested wildlife populations remain fairly healthy: around 500 lions, 300 leopards, 100 cheetahs, 100 spotted hyenas and 150 African wild dogs, at the last count. Deception Valley is one of four so-called 'fossil' valleys in the Central Kalahari, carved out by ancient rivers which dried up more than 16,000 years ago. They once drained into the long-gone Lake Makgadikgadi, on the shores of which paleontologists believe that homo

From left, the number of wildebeest in the Kalahari is declining; desert scrub.

© Dewald Kirsten / Shutterstock

> *The Kalahari's reserves are most accessible during the dry season (May to September), when tracks are passable in 4WD vehicles. Nights can be cold and daytime temperatures mild. In the rainy season (November to April), tracks can be difficult for inexperienced drivers. The main access town for the CKGR is Maun, where you can arrange guided safaris. Self-drive is possible, but a 4WD is essential, along with fuel, food and water and off-road driving experience. Campsites around the reserve must be booked in advance: ask at the park gates for GPS coordinates, or use an app such as Tracks4Africa.*

sapiens first evolved as a distinct species some 200,000 years ago.

Wildlife spotting requires patience and the terrain can be challenging, but the safari traffic here is lighter than in more accessible areas of Africa. In the more secluded spots, you may well feel like you have the place pretty much to yourself. Bordering the CKGR to the south is the smaller but no less spectacular 965 sq mile (2500 sq km) Khutse Game Reserve, another good area for lion and leopard sightings, along with gemsboks and giraffes. Away to the southwest, the 14,700 sq mile (38,000 sq km) Kgalagadi Transfrontier Park spans the border between Botswana and South Africa. This is among the largest and most pristine arid wilderness areas on the continent, and one of the few places that you can see the giant sand dunes that many people mistakenly think are typical of the Kalahari's landscape.

But like every desert, the Kalahari faces threats. The expansion of agriculture and cattle farming continues apace, and mining for coal, copper, nickel and more recently diamonds is a cause of much controversy and passionate local opposition – not least from the San people, whose ancestral lands are being plundered in the pursuit of profit.

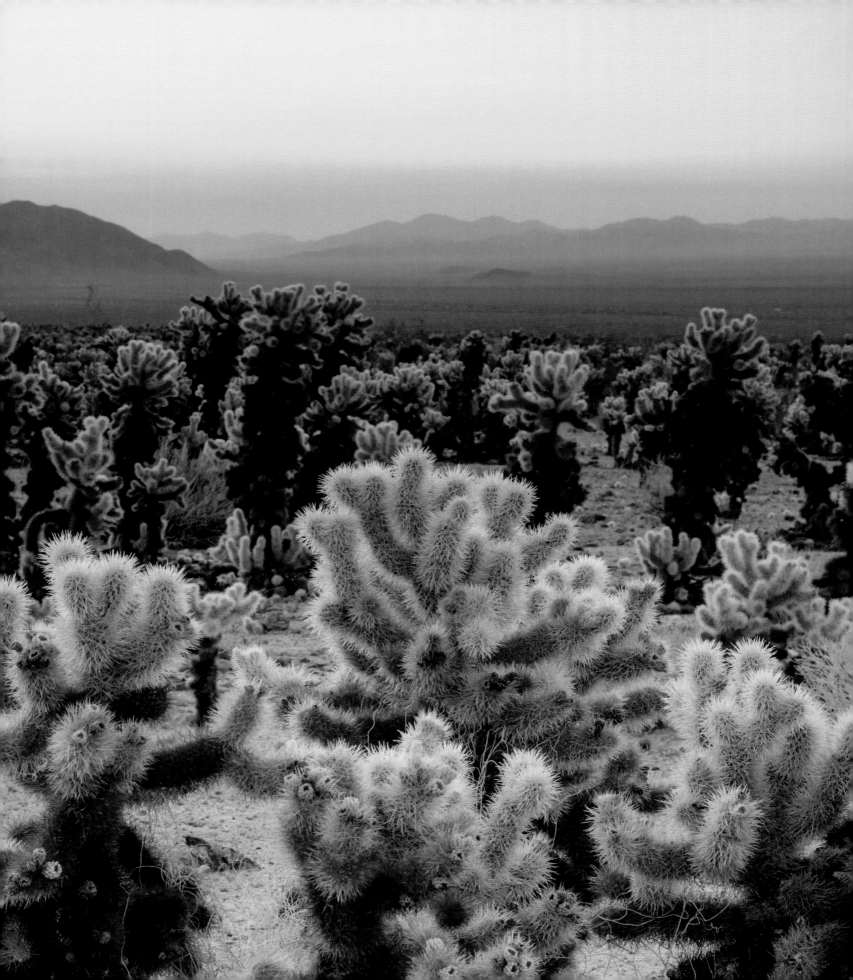

USA

The Mojave Desert

From the lights of Vegas, to ghost towns and mysterious military testing sites, from sand dunes and salt flats to snowy mountains, and from the majesty of the Hoover Dam to the epic, all-encompassing silence of Joshua Tree National Park, the Mojave is a desert of many guises. Within its boundaries you can experience wilderness or a wild night on the town. You can camp out under the stars with nothing but the coyotes for company, gamble away your life savings, and set foot in the hottest place in North America. It's weird. And the weirdness is what makes it memorable.

The Mojave sits largely in southern Nevada and southeastern California, but also creeps into Arizona and Utah. At 48,000 sq miles (124,000 sq km), it's about the same size as Greece and the fourth-largest desert in the US: the two largest, the Great Basin and Sonoran, border the Mojave to the north and south. It is a 'rain shadow' desert: its proximity to several large mountain ranges, including the Sierra Nevada to the west (see p148), means the prevailing rainclouds rarely make it this far. Mostly the Mojave just gets clouds and wind instead.

This absence of rain means the Mojave is North America's driest desert: on average there is about 3.5in (90mm) of precipitation annually (with about three times that in the mountains). It also means temperatures reach oven-like proportions. Nowhere gets hotter than Death

Death Valley and Las Vegas. Salt flats and Joshua trees. In the shadow of the Sierra Nevada stretches North America's hottest, driest, weirdest desert.

Left, the trees of Joshua Tree National Park, California, are native to the Mojave desert; overleaf, Zabriskie Point, Death Valley.

If you have limited time, the Mojave National Preserve (nps.gov/ moja) encapsulates many of the desert's most arresting sights. Highlights here include the 'singing' Kelso Dunes, which emit a low humming sound in the right conditions, and the Cima Dome & Volcanic Field National Natural Landmark, an ancient volcanic area that features 40 cinder cones: like an inverted pan, the strikingly symmetrical Cima itself rises over 1500ft (450m) from the desert plain; the field's other cones range from about 82ft (25m) to 509ft (155m) in height. Not far from the dome, you can also walk through one of the desert's largest growths of Joshua trees. The park's headquarters are at Kelso Depot, once a supply stop for workers on the Union Pacific Railroad. The last passenger train passed through in 1997, but the line is still used for freight transport.

Valley, the hottest and driest place in North America. At 279ft (85m) below sea level, the valley is a natural heat-trap: temperatures here routinely top 49°C (120°F) during summer. In 1913, the highest temperature on North American soil was recorded at the aptly-named Furnace Creek: a blistering 56.7°C. (The validity of this record has been challenged, though Death Valley also holds the record for the next-hottest temperature: 54.0°C.)

Once a place of dread for cross-country wagon trains headed for California, the valley is now a national park, visited by more than 1.5 million people a year. They come to see the salt-flats of Badwater Basin, hike into Golden Canyon or watch the sunset at Zabriskie Point. But long before the white settlers arrived, this land was home to indigenous tribes including the Mojave, Chemehuevi, Hopi, and Navajo, who mostly lived along the edge of the Colorado River, and the Cahuilla, who lived in the southwestern part of the desert towards the San Bernardino mountains. For these early Americans, the desert was woven into their everyday lives, informing everything from folklore and magic to food and medicine.

One of the desert plants used by indigenous people was the Joshua tree, which only grows in the Mojave at elevations between 1300ft (400m) and 5800ft (1770m). Its leaves were used to make baskets and sandals; its flowers and seeds were an important food source; its roots made a red dye used for clothing and war-paint. It's now given its name to a national park, covering 1236 sq miles (3200 sq km) of wilderness, and providing habitat for species such as the lynx, bobcat, bighorn sheep, golden eagle, desert tortoise and the roadrunner.

Death Valley and the Joshua Tree National Park is far from the Mojave's only attractions. There's the Devils Playground, a wide expanse

of sand dunes and salt flats. The Mojave National Preserve is home to the 200m-high Kelso Dunes, the Cima Dome lava fields and the Marl Mountains, where wagon trains once stopped to take on water. There's a much-photographed airplane graveyard (open to the public) near Mojave Airport, where nearly 5000 ex-military bombers and fighters are stored. There's mighty Lake Mead, hemmed in by the Hoover Dam. And there are ghost towns, lots of them, such as Oatman, Amboy, Kelso, Panamint City, Calico and Bodie, where gold and silver prospectors flocked in search of fortunes. And if all that's not enough, fans of very tall thermometers can visit the world's tallest along Interstate 15 near the town of Baker – it was erected in 1991 to commemorate the record temperature set at Furnace Creek and can indicate a maximum of 57°C (134.7°F).

And then there is Las Vegas. Rising from the desert dust, this surreal city is America's gambling mecca, complete with crazy light shows, orchestrated fountains and opulent hotels that stand out in dreamlike relief against the surrounding desert. A byword for American excess, Vegas is cleaning up its act: it's taking major steps to switch to renewable energy, using the abundant solar and wind energy on its doorstep to meet the Nevada-wide target of generating at least 50% of its power needs from renewable sources by 2030.

It can't come too soon. Las Vegas, along with the rest of southern Nevada, is officially the fastest-warming area in the United States. According to scientists, the prospect of the Mojave breaking the 60°C (140°F) barrier in the next century looks increasingly plausible. Looks like they might have to fix that big 'ole thermometer in Baker sometime in the not-too-faraway future.

The Mojave has distinct seasons. Summer runs from June to September, when temperatures above 40°C (104°F) are fairly routine. Winter runs from December to February, when the weather is much cooler: subzero temperatures are possible on the valley floors, and snow occasionally falls in areas such as the Spring Mountains. Autumn and spring are the most comfortable times to travel. The central Mojave is sparsely populated, but several sizeable towns can be found around the edges, including Barstow, Lancaster, Palmdale and Las Vegas. The only practical way to explore is with your own car. General information on the desert's three national parks – the Mojave National Preserve, Death Valley and Joshua Tree – is available on the National Park Service website (nps.gov).

CHILE

The Atacama

Hyper arid and encrusted in salt pans, the oldest desert on earth feels like another planet – which is appropriate, because there's nowhere better to scan the night skies.

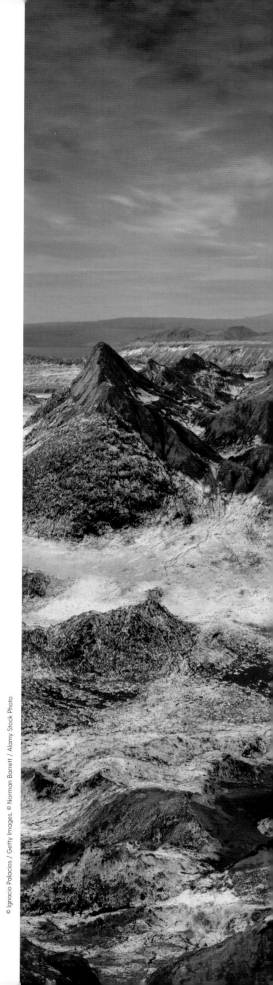

any deserts are old. The Atacama is ancient. Stretching across the north of Chile from the Andes to the Pacific Ocean, it has existed in one form or another for at least 20 million years. Some parts are thought to be 150 million years old.

It's also dry, drier even than the polar deserts. Framed by high mountains to the east, which block rainfall, and cool ocean currents to the west, which prevent prevailing winds collecting moisture, its atmospheric conditions almost entirely preclude the formation of clouds.

Or, to put it another way, it hardly ever rains in the Atacama. Parts of it are lucky to get 0.03in (1mm). Decades can pass here without a drop of rain falling.

Most of the Atacama is a high plateau, with an average altitude of around 7350ft (2240m). In a few areas, volcanic cones rise beyond 15,750ft (4800m), the product of the geological forces that continues to elevate the Andes. Salt deposits known as *playas* encrust much of the landscape – memories of lakes that dried up long ago. The Atacama is also rich in minerals, especially nitrates, copper, iodine and lithium; ironically, the recent boom in renewable battery technology, while positive for the wider environment, has been terrible for the Atacama, stripping already parched salt-pans of moisture and threatening delicate desert habitats.

Baked dry and barren, it's a realm that feels extra-terrestrial, the closest most of us will ever

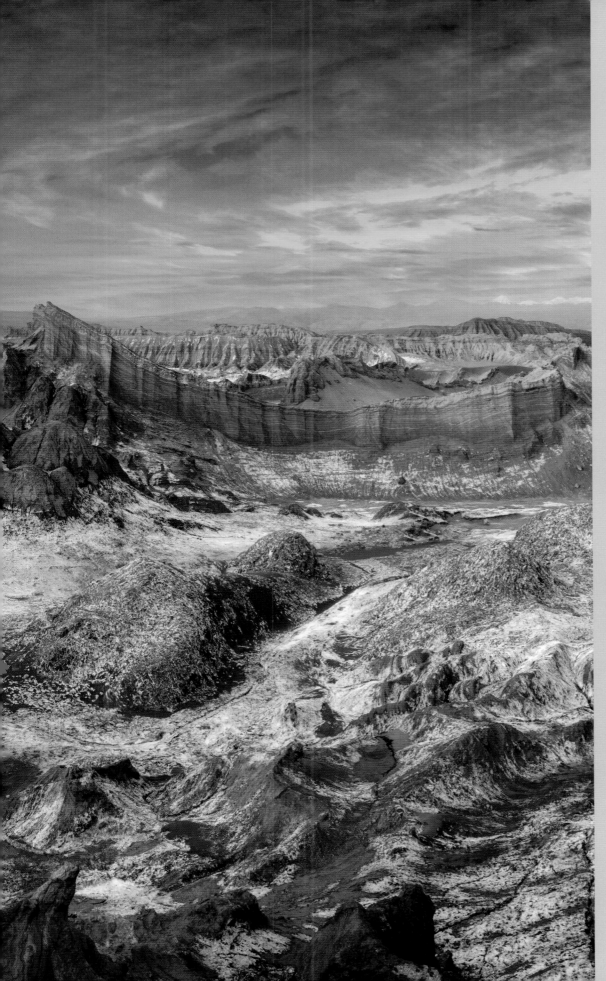

The Atacama may be inhospitable, but the Lickan Antay, or Atacameños, made the desert their home for thousands of years. They lived mostly along the course of the Loa River, which runs across the desert from the Andes to the coast, making a living from trading, llama-herding and agriculture. By 700AD, a number of villages existed along the riverbanks, protected by *pukara*, or strategic fortresses. The Spanish conquest had dire consequences for the Atacameños; after violent resistance, they were defeated and put to work in the desert's mineral mines, or moved elsewhere. Much of their culture, heritage and language was lost. They are now recognised as one of Chile's nine official ethnic minorities.

Left, the view over the Valle de la Luna from the Achaches lookout.

From right, the Cordillera de la Sal (Salt Mountains) near San Pedro; flamingos feed in the salt pans.

be able to get to a sense what it might be like to land on an alien planet. Unsurprisingly, life is hard for residents of the Atacama. A few tough animals live around the edges and in the more sheltered valleys – the South American grey fox, the lava lizard, the viscacha (a relative of the chinchilla) and Darwin's leaf-eared mouse, to name a hardy few. But in the desert's hyper-arid, cauldron-like core, almost nothing can survive.

Note that 'almost'. Because even in the extremes of the Atacama, as Dr Ian Malcolm in *Jurassic Park* put it, 'Life finds a way'. Over countless millennia, strains of bacteria have evolved to survive in the Atacama's moisture-starved soil, a discovery that has excited many cosmologists – because if life can exist here, then life may just have 'found a way' on many other, apparently lifeless planets, such as Mars.

The Atacama's parched, dusty landscape is believed to be quite similar to the Martian environment, and if, as is widely suspected, liquid water once flowed on Mars before it was stripped of its atmosphere, a few tenacious bacteria may just have been able to cling on to existence beneath the planet's crust. We won't know for sure until the first human sets foot on Mars, but in the meantime, the Atacama makes a convincing double for the Red Planet: it's featured in numerous films and scientific documentaries, including the BBC's landmark series *Wonders of the Solar System*.

As well its age and aridity, the Atacama's defining feature is its emptiness. Even more so than the average desert, the Atacama feels spectacularly empty. Apart from a

© HMS / AWL Images, © Lupus69 / Shutterstock

few cities on the Pacific coast and one ramshackle town in the interior, San Pedro de Atacama, the desert is mostly devoid of people – a fact that, along with its high altitude and clear skies, makes it perfect for star-gazing. One of the world's largest radio astronomy telescopes is the Atacama Large Millimeter Array; it comprises a network of 66 dish antennas that, when fully integrated, can equate to the resolving power of a single dish 10 miles (16km) across. It has been in operation since October 2011 and is an international collaboration between Chile, the USA, Canada, Japan and the EU. Several other big telescopes are sited in the Atacama, but even amateur astronomers can experience the wonders of the universe with nothing more powerful than the naked eye – or better still, a rented telescope, such as those offered during Atacama Lodge's nightly star tours (spaceobs.com).

Stars aren't the only reason to visit. San Pedro makes an ideal base for experiencing the desert's other attractions: dune-boarding down the slopes of Valle de la Muerte (Death Valley), walking though the geysers of El Tatio, steering a 4WD across the salt flats or bathing in the impossibly salty waters of Cejar Lagoon. But wherever you go, the Andes are everywhere: zig-zagging along the horizon like an incisor-studded jawbone, the mountains are best seen at dusk from a viewpoint such as the Valle de la Luna (Valley of the Moon), lit up in a spectrum of solar-tinted colours. There's just one drawback to an Atacaman sunset: the ones back home will never seem the same.

The convenient base for exploring is the small town of San Pedro de Atacama, where most activity providers are based, and there is a wide range of accommodation, from backpacker hostels to boutique hotels. The nearest airport is in the city of Calama, just over an hour's drive from San Pedro, from where there are regular buses. Alternatively, you can visit by guided tour, or hire a vehicle for maximum freedom (a 4WD is a good idea). Most people visit in summer (December to March), but the shoulder months (September to October and April to May) have fewer crowds. The winter runs from June to September; snowfall blocks the Andean mountain passes, and very occasionally falls on the desert too.

ARABIAN PENINSULA

The Empty Quarter

True solitude awaits in the world's largest sand sea, where the dunes constantly shift and no map can guide travellers.

Right, star-gazing in the Empty Quarter, Abu Dhabi.

Swallowing nearly a third of the Arabian Peninsula, the Empty Quarter – or Rub' Al Khali, as it's known in Arabic – comprises 250,000 square miles (650,000 sq km, about the same area as Afghanistan) and encroaches on four countries (Saudi Arabia, Oman, the United Arab Emirates and Yemen). It forms part of the much larger Arabian Desert, encompassing mountains, valleys, gypsum plains, gravel flats and even a few dried-up lake beds.

But it's for none of these that the Empty Quarter is most famous. It's sand.

The Rub' Al Khali is home to the biggest sand dunes in the world, some of which reach 980ft (300m) high. But they're not static; the dunes are more like a sea, constantly in motion, reforming in the swirling desert winds, and marching at a rate of about 33ft (10m) per year.

This protean quality is what makes navigating the Empty Quarter so difficult. There are no maps to guide travellers; what would be the point? In a few months, the topography can change beyond recognition. Satellite imagery can help, but is of limited use on the ground. The only reliable way to explore it is with a guide – ideally one who has grown up in the desert, and learned through experience to interpret its shape-shifting character.

There are no better guides than the Bedouin, the nomadic people who have lived in the Arabian desert since ancient times. Historically, Bedouin tribes such as the Al Murrah (the

© JA / AWL Images

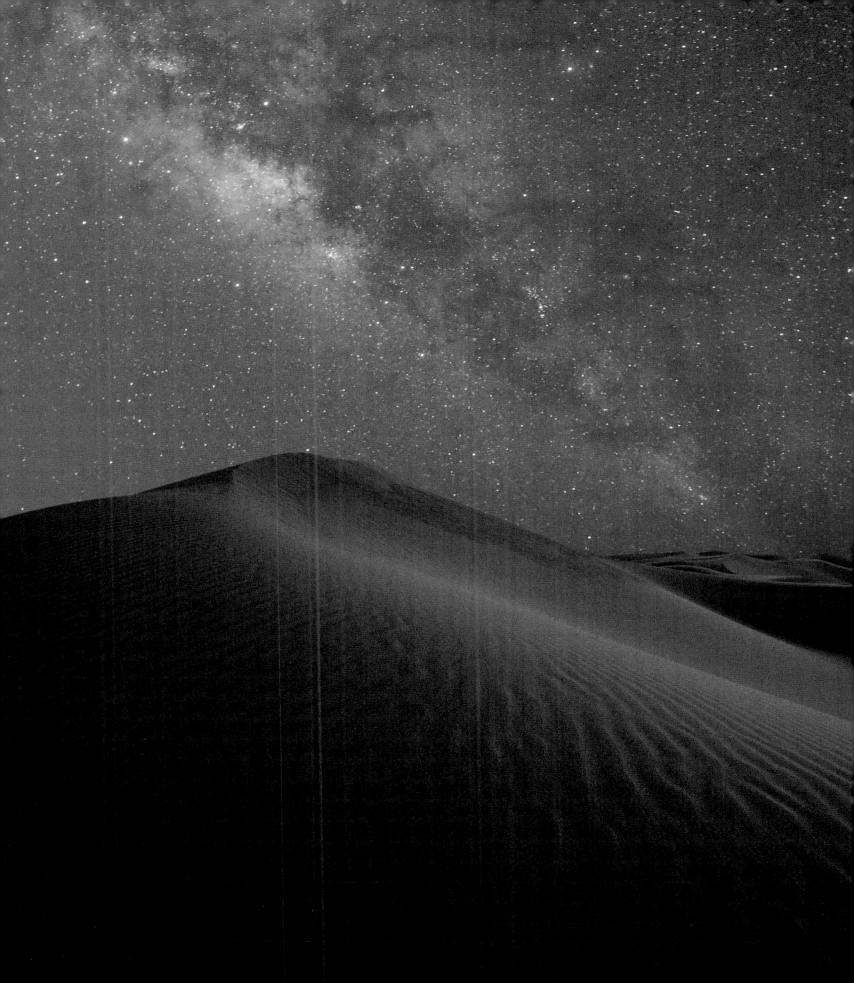

By the famed Bedouin hospitality code, *diyafa*, travellers in the Empty Quarter who bump into a Bedouin camp are bound to be invited to share 'bread and salt'. This will involve Arabic coffee, camel's milk and dried meat usually with a host of flies dancing in the bowl. If you are a particularly distinguished guest, a goat may be slaughtered in your honour. The practice of *diyafa* is a serious affair. TE Lawrence wrote of how, as Arab forces were en route to Medina where they were declare their revolt against the Turks, a pair of Turkish officers joined them. To have done away with them would have betrayed the spirit of *diyafa* – instead, the soon-to-be-enemies were escorted away. Honour and the revolution were kept intact.

Right, the dunes of Oman's Empty Quarter can reach 820ft (250m) in height.

largest), Banu Yam, Banu Hamdan and Bani Yas made their living trading goods such as camels, gems and the gum-resin products myrrh (used in perfumes) and frankincense (an important element in embalming and communicating with the Egyptian gods) across the desert. In the Biblical accounts of the birth of Christ's birth, it's not improbable that the frankincense and myrrh given to Jesus were supplied by a Bedouin trader, and as such were likely to have been transported across the Empty Quarter en route).

Traditionally, the Bedouins made temporary camps as they crossed the desert's expanse, using their knowledge of sheltered areas and hidden wells to make the journey possible. But the days of the great camel train are sadly long gone; the discovery of oil beneath the sands transformed the Arabian Peninsula, and the accelerating process of desertification in the Empty Quarter has made crossing it in the old-fashioned way impossible. These days most Bedouins live in towns. Those that do venture into the desert guide trips for tourists, rather than trade camels or precious stones. The Empty Quarter is emptier than ever.

One man who learned to love the Bedouin's desert culture was the explorer Wilfred Thesiger, who crossed the Empty Quarter several times in the late 1940s, and mapped several parts of it, including the mountains of Oman. He collected his experiences in one of the great desert travelogues, *Arabian Sands* (1959).

He wasn't the first Westerner to cross the Empty Quarter. That

honour belongs to the British explorer Bertram Thomas, who traversed it in 1931. Many others have followed in his footsteps. In 1999, the adventurer and climber Jamie Clarke became the first Westerner to cross the Empty Quarter of Arabia in more than 50 years. In March 2012, businesswoman Hajar Ali became the first woman to make a crossing. In 2013, a South African team was the first to traverse the desert from Oman to Dubai on foot and unsupported, pulling custom-designed carts on a journey that lasted 40 days. And over the winter of 2018/19, the first all-female expedition ventured into the Empty Quarter, led by British woman Janey McGill and her Omani companions Baida Al Zadjali and Atheer Al Sabri. They covered 470 miles (758km) in 28 days.

If you don't feel like mounting your own full-blown desert expedition, corners of the Empty Quarter are accessible to ordinary travellers. Liwa Oasis, for instance, the ancestral home of the Bani Yas tribe, which holds its own date festival in Jul, and Dhafeer Fort, one of several abandoned amongst the dunes. Also worth visiting are traditional mudbrick villages such as Misfat al Abriyeen, surrounded by gardens filled with date palms and mangoes. There's also Tel Moreeb (Arabic for 'scary hill'), the largest sand dune in the Empty Quarter, a mighty 300m high and 1.6km long. Locals enjoy careering down it in their 4WDs, but it's also possible to hike to the top for a truly breathtaking desert panorama. Just don't forget to pack your sunscreen. And water. And a hat.

Oman is the easiest and most practical country from which to access the Empty Quarter. A private tour is worth the expense, thanks to the paucity of public transport or tourist infrastructure. Most tour companies will pick you up directly from the international airports in Salalah or Muscat. Recommended agencies include Arabian Sand Tours (arabiansandtoursservices.com) and Oman Day Tours (omandaytours. com), who can arrange custom itineraries including overnight camps in the dunes. The desert is extremely hot in the day (up to 50°C/122°C is not unusual), but temperatures can fall to below freezing by night, so you'll need to pack both hot- and cold-weather clothing.

ARGENTINA, BRAZIL AND URUGUAY

The Pampas

The golden age of the gaucho may be long gone, but cowboys have not disappeared from the fertile plains and evocative *estancias* of Argentina.

Right, grasses and thistles thrive in the Pampas.

From the indigenous Quechua word for plain, the pampas is one of the defining landscapes of South America. Spanning 295,000 sq miles (760,000 sq km), these flat, fertile grasslands cover much of Argentina, as well as the southernmost part of Brazil and all of Uruguay. They are South America's breadbasket, producing a huge proportion of the nation's crops – especially wheat, maize, flax and alfalfa. And, of course, they are the spiritual home of the gaucho – the free-ranging, hard-living cowboys who have inspired so many of the nation's stories, art and songs.

Despite its name, the pampas isn't flat. It climbs from southeast to northwest, from the Atlantic coast to as high as 1640ft (500m) above sea-level near Mendoza in the eastern foothills of the Andes. The western pampas is semi-arid, characterised by sandy deserts, salt flats and brackish water courses; the eastern pampas is more temperate and humid, where rainfall and richer soils allow agriculture to flourish. The eastern pampas is the most prosperous and productive region of Argentina, and home to the capital city of Buenos Aires.

Spanish settlers were quick to recognise the potential of the pampas. Indigenous peoples were already exploiting the landscape for food cultivation, but the settlers ramped up agricultural production. Soon after colonisation, horses and cattle were introduced, and along with them came the gauchos, the livestock

One of the best ways to soak up traditional gaucho culture is at an *estancia* (ranch). Many of these grand mansions are now open to the public. *Día de campo* ('country days') typically include lunch and afternoon tea, plus horseback riding and other outdoor activities). The 300-hectare Estancia El Ombú de Areco (estanciaelombu.com) dates from 1880 and offers old-fashioned hospitality, and a chance to help round up the cattle. More affordable is Estancia La Cinacina (lacinacina.com.ar), which offers touristy gaucho shows, while La Porteña (laporteniadeareco. com) is where Ricardo Güiraldes, author of the gaucho epic *Don Segundo Sombra*, spent his childhood. All are within easy reach of San Antonio de Areco. Transfers from Buenos Aires to most *estancias* are available for an extra charge.

© Philip Lee Harvey / Lonely Planet. © Matt Munro / Lonely Planet

wranglers who kept control of the herds. Dressed in ponchos and *bombuchas* (loose-fitting trousers), and armed with the tools of their trade, the *lariat* (lasso), *rebenque* (whip) and *bolas* (leather straps weighted with rocks used to bring down cattle), along with the large knife known as the *facón* tucked into their belt, the gauchos came to epitomise the culture of life on the pampas. By the time of Argentinian independence in 1816, they had become symbols of freedom, nobility and fierce national pride, immortalised in literature and songs. The typical gaucho was said to be proud, independent, dignified and self-reliant, quiet in manner but quick to anger. They were known for their horsemanship, feats of bravery and lawlessness. Technological developments in agriculture heralded the decline of the gaucho towards the end of the 19th century. Nevertheless, their modern-day descendants still work on many of the large *estancias* (ranches) that carpet the pampas.

Agriculture continues to underpin the economy here. Cereal crops, beef and dairy, sugar cane, vegetables and fruit are all produced in abundance. Parts of the pampas, especially around Mendoza, offer ideal conditions for viticulture; more than half of South America's wine is produced in the pampas (Mendoza is rightly famous for its Malbecs). There are challenges too. Wildfires are frequent, ensuring that only shrubs and grasses can take hold. Intense thunderstorms known as *pamperos* are frequent in spring and summer, bringing flash-floods and fierce winds. Alongside the central and southern USA, the pampas is hit by more tornados annually than anywhere else in the world.

From left, gauchos working at El Roble ranch; a finch.

© Uwe Bergwitz / Shutterstock

The eastern pampas in particular is easy to explore. It's home to a third of Argentina's population and all major towns are linked by highway to Buenos Aires. Geographical features are few and far between. The pleasure, even the poetry, of the pampas is its epic uniformity: cattle grazing, clouds rolling overhead, grids of canals and irrigation ditches, endless plains of pampas grass stretching out to the horizon.

In remoter areas, you might spy some wildlife: maybe a *guanaco*, the wild cousin of the llama, or a *viscacha*, a fuzzy member of the chinchilla family. To see rarer inhabitants, you'll need to head for wilder parts, and likely employ the services of a guide: charismatic animals such the pampas fox, maned wolf, rhea and puma have dwindled as the *estancias* have expanded, and they're now becoming increasingly hard to spot – try nature reserves such as the desert-like, 125 sq miles (324 sq km) Parque Nacional Lihué Calel, and the Reserva Provincial Parque Luro, a 29 sq mile (76 sq km) reserve established by Pedro Luro, one of Argentina's more important landowners. Both lie within easy reach of the town of Santa Rosa, in southern Buenos Aires province.

The charming town of San Antonio de Areco, 70 miles (113km) northwest of Buenos Aires, is a convenient base. It welcomes daytrippers, who come for the peaceful atmosphere and picturesque colonial streets. (In early November, the town hosts the gaucho festival Fiesta de la Tradición.) Nearby estancias offer a glimpse of Argentina's cowboys in action, while the hills around Tandil are lovely for hiking and feasting on picadas (shared plates). Summer (January to February) brings warm, sunny weather. Spring (October– November) and autumn (March– April) are pleasant for exploring the Tandil area.

Coasts & Seas

Humans have hatched all manner of myths and legends in their desire to explain the origin of life on earth. On rare occasions these tales chime with what scientists have now documented as fact: that life began in the oceans. And as we evolved from sea dwellers to apes to homo sapiens, transitioned from hunter gatherers to farmers to consumers, and our language and stories morphed from cave art to moving pictures, our communication from drum beat to instant messaging, salt water creatures we have remained.

The ocean is about 3% salt. Which is similar to the salinity level of the amniotic fluid sloshing in a mother's placenta. Like the earth itself, we are mostly salt water. More than half the oxygen we breathe comes from marine photosynthesisers – our every second breath is provided by the world's oceans. A seemingly infinite resource we have relied upon for transportation, trade, food, sport, fun and a kind of emotional salve long since we crawled from the depths ages ago.

Perhaps that's why we are so often drawn to the coast. The ocean is wild and powerful. It provides. It forgives.

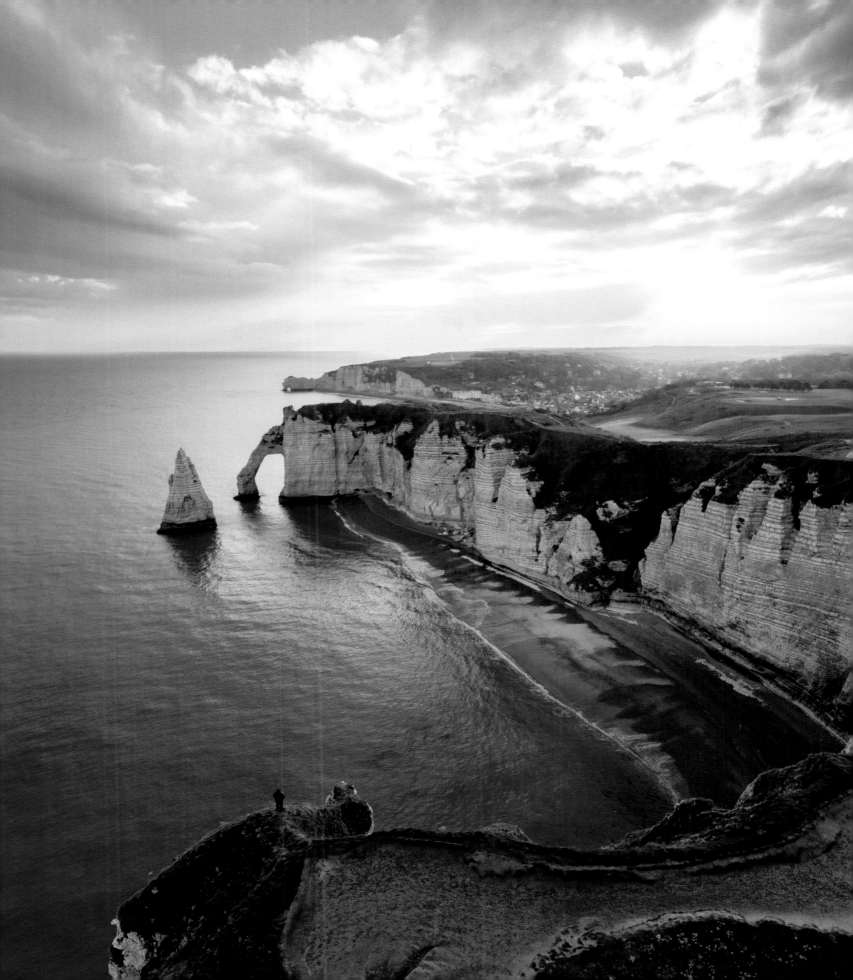

\mathcal{I} grew up in Santa Monica, Los Angeles's best loved beach town, and spent my summers on the sand when I wasn't throwing myself into the frothing waves. I didn't use a board. I was a body surfer, and no master of the form then or now. Like most kids I started by randomly splashing in knee-high ripples, but figured out how to let the waves carry me to the sand, and eventually learned to catch bigger and bigger ones. Sometimes I picked up tips from older kids, or adults who were children at heart, but really the ocean taught me.

Like most things in life, it was a matter of timing. I learned to angle to get a head start as the wave swelled. Then swim like hell as it peaked, hoping to generate enough power to be in position on time to catch the thrill of the drop. I would get thrashed, I would sometimes swallow water, and when the wave was big enough I'd get high on the rush, laugh and howl. It was addictive, until it wasn't.

My withdrawal from the sea was gradual. I never had a near-death experience or developed some phobia of murky water or unknown bacteria. I just grew up into a self-conscious teenager and had no gnawing urge to get wet and sandy. I still bodysurfed occasionally, but I lost the

bond with the ocean that held me when I was young.

Or maybe it just went dormant.

When I moved back to Los Angeles in my mid-20s, the city overwhelmed me. To me, it was a wide and shallow sea of lights. It was glamorous and sexy, sure, but it was also devious and exhausting, unjust and unequal, and I took comfort in the fact that on its western edge, it all ended, that there was a place where nature ruled again. The ocean could not be tamed, so that's where I returned, to the beach where I grew up.

One winter, seeking renewal after a tough year, I moved back to Santa Monica and walked 1.25 miles (2km) to the beach every day for 40 days just to jump into the swirling, cold water. Even in sunny Southern California the Pacific Ocean is chilly year round and especially in winter. I needed to feel its power, and hoped it could confer on me some of what made it so strong, flexible and forgiving.

I didn't wear a wetsuit or a mask and fins. I had no purpose in the water beyond some sort of low-level, daily baptism, and my swims – if you could even call them that – were seldom long. If I got lucky, I'd see a dolphin or two swim by, and there were ravenous seagulls about, and the

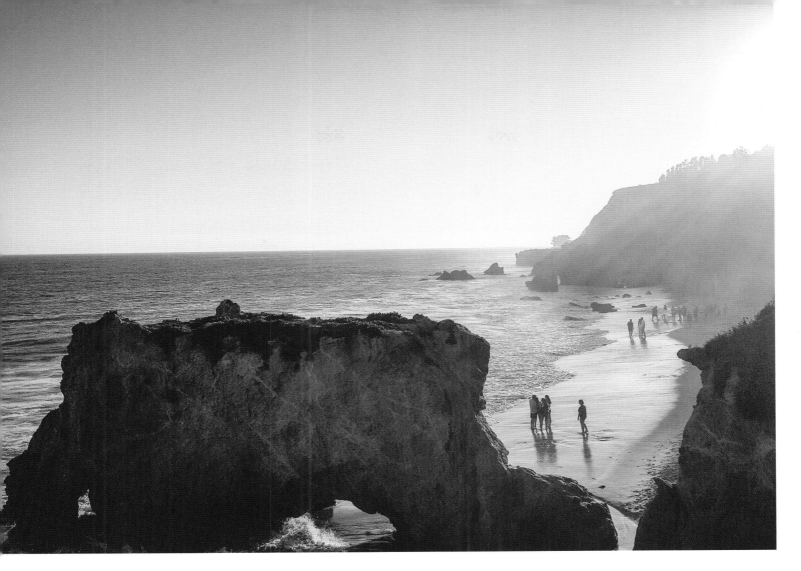

occasional band of snowy plovers scampering in the tides; but this was still an urban beach and wildlife was limited.

I was at a time in my life (which I now refer to as my 'eviction notice period') where I was striving to build habits. I needed to become stronger, so I did the same thing for 40 days, rain or shine. It wasn't always fun. On some days, my time was short or I felt like death and didn't want to go, but I always jumped in, battled through the surf, no matter the size, and stroked out beyond the waves. Whenever I swam back in to get dry, I felt a bit better and much calmer.

Yet for all the time I spent near the ocean, it wasn't until eight years later, when I was 40 years old, that I grew to need it, that I became a devotee. My marriage was on life support, my back had been injured for months. I was out of sorts emotionally and physically, and a well-meaning acquaintance suggested that swimming might be the salvation I was looking for. But in my first pool session I knew there was a better place to swim it all out.

By then I'd become an experienced scuba diver, but all that training was done in the tropics, where the water was warm and clear. Despite my dips in Santa Monica Bay, I had little experience swimming for distance in the open ocean, and willfully avoided cold water. Still, instead of hitting my old haunts, I made my way up the coast where the ocean was even colder and wilder, and, it turned out, filled with life.

The water was crystal clear that day, and cobalt blue. I counted 50 rays on the sandy bottom and by the time I was done with my 1.25-mile (2km) swim down the beach, I knew I was hooked again. This time for life. Over the past eight years, swimming and freediving in the open water has become a passion that I cannot and will not live without.

I have swum among playful harbour seals, curious sea lions, migrating whales and surfing

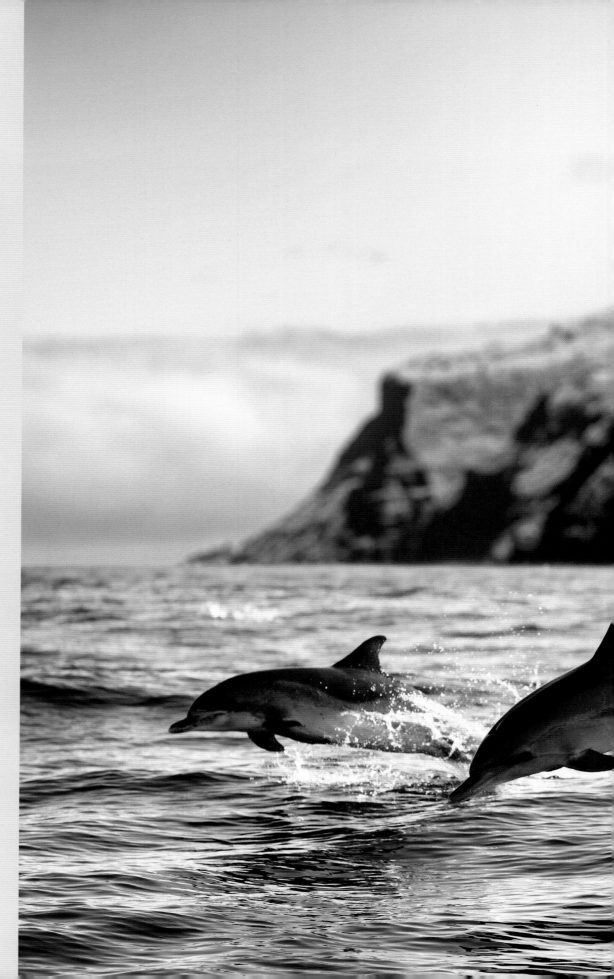

HEALTH BENEFITS OF SWIMMING IN SEAWATER

Thanks to its mineral content (sodium, sulphate, chloride, magnesium and calcium), seawater improves skin conditions such as psoriasis and eczema. Broader benefits of ocean swimming include a greater sense of relaxation; it's thought that the particular breathing patterns required of swimmers stimulates the parasympathetic nervous system, which controls organ function, leading to positive brain-wave and hormone production. The sensation of relative weightlessness has been shown to slow brain-wave activity and calm the mind. Swimming in cold water has specific benefits. The skin reacts to the low temperature by producing hormones such as adrenaline, endorphins and cortisol, which have therapeutic benefits. Habituating cold-water swims also benefits the parasympathetic nervous system, releasing dopamine and serotonin and promoting organ function. Generally, cold-water dips can improve the body's immune response. So, if you're not swimming in the sea, why not?

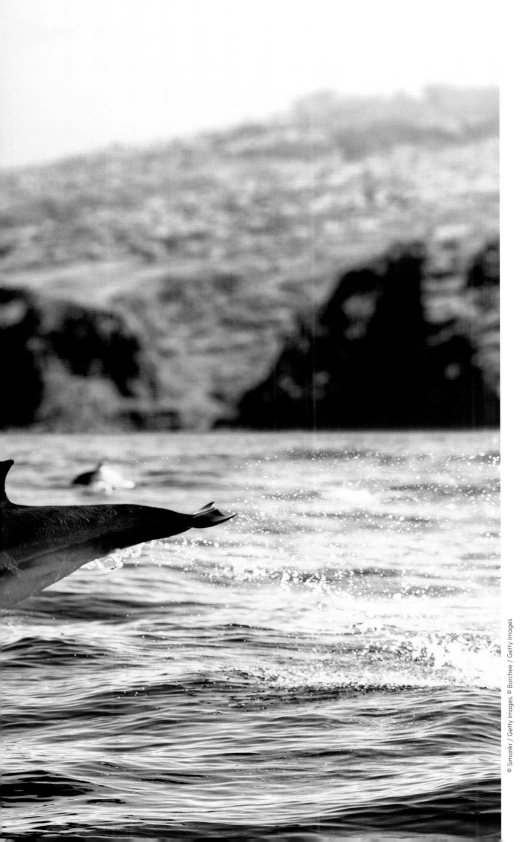

Left, bottlenose
dolphins, here off
Madeira, jump for a
number of reasons, not
least to save energy.

© Simonkr / Getty Images. © Borchee / Getty Images

dolphins. I've explored kelp forests thick
with fish and crawling with spiny lobsters.
It's often cold and murky – more green
than blue, and the currents can be
strong and unsettling, but no matter the
conditions, I swim out to disappear into
another world where I'm part of the food
chain and where even the smartest phones
can't function. I swim to test myself, to
learn important lessons about staying calm
when anxiety strikes and greater forces
have me in their grip. There is daring and
problem solving and self-reliance, but also
a profound love for the deep mystery that
is the ocean, all oceans.

Of course, the oceans didn't just
miraculously appear. They formed over
many millions of years. As the molten
land of early Earth cooled and took
shape, water vapour and other gases
escaped into the atmosphere. About 3.8
billion years ago, once the earth's surface
cooled below the boiling point of water,
rain began to fall in great sheets, and
continued to fall for ages. It drained into
all the continental gaps and depressions,
forming what we now call the five oceans
or the Seven Seas.

Today, the oceans cover 71% of the
earth's surface. They are home to millions
of marine species, and wherever salt water
meets land you can often find spectacular
scenery. Think: soaring sandstone, granite
and limestone cliffs drilled with caves
and caverns, lava fields, coral reefs, ice
shelves and ice bergs, rolling sand dunes,
black, white and even pink sand beaches,
mangroves and marshes – all distinct
ecosystems teeming with biodiversity.

From top right, clown fish in coral reefs; an albatross off South Georgia; Mauritius island.

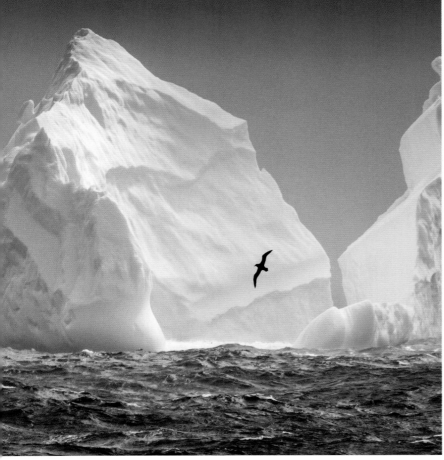

The Pacific Ocean, often divided into two and labeled as the Northern and Southern Pacific, is the largest of them all, and covers just under a third of the Earth's surface. It touches 67 countries and territories, and stretches from the Southern Sea around Antarctica to the Arctic Circle. It separates Asia and Australia from the Americas, nourishes coral reefs in the tropics and kelp forests in the temperate zones. Its waters are thick with sardines, anchovies and hammerhead sharks, and are patrolled by migrating schools of tuna and swordfish above and below the equator. In the upper reaches of North America's west coast, you can find giant octopus and squid. Elephant seals, capable of diving to depths of over 4920ft (1500m), are not an uncommon sight, nor are orcas and baleen whales including the largest animal on earth, the blue whale. Here are salmon runs and grizzly bears, humpbacks, beluga whales and great white sharks. The deepest of all the oceans by far, it is nearly 6.8 miles (11km) at its deepest point. Near the Equator its temperature ranges from 30°C (86°F) at the surface to 5°C (40°F) 3280ft (1000m) below. In the polar north, its surface temperature hovers around 1.4°C (34.5°F).

The Atlantic Ocean, also often divided into its Northern and Southern halves (hence the term 'Seven Seas'), is the next largest. It too stretches from the Southern Ocean to the Arctic and separates Africa, Europe and the Americas, covering a fifth of the Earth's surface with an average depth of just under 13,120ft (4000m). Around Greenland the Atlantic is covered in sea ice, with a surface temperature of 1.2°C (34°F); in the Caribbean it's tropical blue and can be as warm as 30°C (86°F). It's home to walrus and narwhal, manatee and sea turtles, penguins and sea horses, orcas, sperm whales and dozens of species of sharks and rays.

The Indian Ocean, the third largest, links East Africa with Southeast Asia and India, the Arabian Peninsula and Australia. It's warmer on average than the Pacific and the Atlantic, with surface temperatures ranging between

22-30°C (71.5-80°F), but it goes deep too. The Java trench in Indonesia is over 23,000ft (7000m) deep, and the Diamantina Trench southwest of Perth, reaches over 26,250ft (8000m). Ocean life includes manta and eagle rays, leopard and tiger sharks, frog fish and manta shrimp. There are dolphins and whale sharks, too. Even komodo dragons dip into the Indian Ocean to hunt and travel from one island to another.

The Southern Ocean is the second smallest of the five, and encompasses the waters around Antarctica. Its maximum depth of 23,736ft (7235m) has been documented, but where exactly it meets the Indian Ocean at its north end has been debated. Nevertheless, Australians consider the tumultuous seas at the southernmost border of their land to be the Southern Ocean. Though it's among the coldest stretches of ocean on earth, its temperatures ranging from -2°C to 10°C (28.5–50°F), it is packed with life. Around Antarctica alone, penguins hunt fish and dodge orcas and leopard seals. Weddell seals lounge on ice floes, and humpback whales, returning from warm winters in the South Pacific, arrive to lunge feed and binge on nutritious Antarctic krill all summer long. Further north, the Great Australian Bight is another wildlife wonderland, its clear waters home to orcas,

sperm whales, fin whales, endangered sea lions, dolphins, penguins, sharks, and even giant squid. The beaches of the Great Australian Bight are remote and hard to reach, and the surf often massive and spectacular.

The Arctic Ocean is the smallest of them all, and in this era of climatic shifts, arguably the most dynamic. With a maximum depth of 17,880ft (5450m), it swirls around the North Pole and kisses the upper reaches of North America to the west, and Scandinavia and Siberia to the east. It is partly covered in sea ice year round, but the acreage of ice shifts with the season and during the summer sea ice has been receding to record lows in recent years, which has been especially difficult for the polar bears and walrus that live there. The fearsome lion's mane jellyfish are abundant in Arctic waters, and narwhals – the unicorns of the sea – live here too. With an average surface temperature of between -1°C and -2°C (the freezing point of salt water), scientists believe that no ocean is warming faster than the Arctic Ocean. Its summer melt has opened up new shipping lanes and encouraged oil producers to increase exploration in the Arctic zone, placing its fragile ecosystem directly in the crosshairs of the forces of globalisation and the climate crisis.

Aside from nurturing marine life, these oceans shape the coast. Their waves erode the land and leave behind pieces of themselves in the form of shells and sand dollars, coral, seaweed and sea glass. Profound changes in the shape of our coasts can take millennia or mere years; much depends upon the material that makes up the shoreline. Granite cliffs can weather centuries almost unchanged. Sandstone bluffs or the calcium carbonate that makes up the White Cliffs in Dover erode more quickly. Sandy beaches can alter daily, and look completely different from season to season or even moon to moon.

You don't need to be an ocean addict like me to appreciate the coast or to love the sea. About 40% of the world's population lives within 62 miles (100km) of the shore, and 634 million people live in low-lying coastal zones. Some of that has to do with the way human communities developed around fishing and access to transportation. Now it's about airports and highways, but for centuries, you couldn't travel, explore or migrate very far unless you were willing to board a boat. Back then our bond with the ocean was more palpable. It was about survival.

Centuries before Europeans ever dreamed of travelling the seas in the search for spices, Polynesians built *wakas* (sailing canoes). They navigated by starlight and eventually fled the verdant islands of the Marquesas for Tahiti before moving on to uninhabited islands across the Pacific Ocean. Within a few centuries the Polynesian diaspora stretched from Easter Island off Chile, to the Hawaiian Islands to Tonga and Samoa and Aotearoa, the Māori name

These oceans' waves erode the coast and leave behind pieces of themselves in the form of shells, sand dollars, coral, seaweed and sea glass

From left, the Isle of Purbeck on England's Jurassic Coast; diving off Fernando de Noronha, Brazil; a lyretail coralfish in a Balinese reef.

for what most call the country of New Zealand. In each new island, the dialects and customs differed, but Polynesians continue to share a culture bonded to the sea.

As more cultures honed sailing and navigation techniques, seaside villages became coastal towns and then cities that brewed multicultural melting pots. In the 8th century, Bantu sailors set out from East Africa and engaged in the robust Indian Ocean trade, which was awash with Indian, Chinese, Persian and Arab culture. Islam rode the trade winds south and in the 10th century a number of Swahili city states flourished in present day Kenya, Tanzania and Mozambique. The same phenomenon brought both Chinese culture and Islam to present day Malaysia and Indonesia, where Hinduism had flourished for centuries.

As people mixed, mingled, struggled, fought, loved and thrived, Indian Ocean coastal cuisine, architecture, language and rituals evolved and spread. And not just in Africa and Asia. In the 8th century North Africans and Persians invaded Europe's Iberian Peninsula, leaving architectural, culinary and intellectual legacies.

Eventually European explorers set out to conquer the world too. In pursuit of spices, they sailed to Asia and the Americas, with guns and bibles in hand. Maps were remade, indigenous peoples wiped out. Africans were placed in chains and shipped across oceans to the Caribbean, South America and the United States (slaves were transported from the East

African coast to the Arab world, as well). And all of that problematic history can be explored on our coastlines, along with the art, food, music and people that survived it all and still influence global culture today.

You can see, feel, hear and taste this coastal stew on Spain's Andalusian coast or Sicily, in Habana, New Orleans, Cartagena, Zanzibar, Istanbul, Miami and even in Venice Beach, California.

The stretch of coast where I live, swim and explore, historically belonged to the Chumash people, one of the two most powerful cultures in pre-colonial Southern California. The Chumash believed that their connection to the ocean was a family bond as real as DNA. In their creation story, their ancestors cross a rainbow bridge to a promised land of plenty. On their way they are warned not to look down, but some can't resist the sparkling water. Their forbidden glance nearly blinds them. Dizzy,

they tumble from the rainbow toward the blue oblivion, but in that moment their relatives pray for their safety and the Creator responds. When they hit the water, the fallen don't die. They transform instead into blue dolphins. That story explains why the Chumash consider dolphins to be their ancestors, their brothers and sisters.

Unfortunately, when such cultures of humility and harmony encountered guns, germs and steel, the Industrial Revolution and technological innovation of so-called 'dominator cultures', they seldom survived. The result is a society out of balance because we don't see the land and sea as part of us, or we a part of it. Even if we do feel connected in that way as individuals, too often our institutions, corporations and decision makers don't act that way, and today the oceans are in peril, which means we are in peril.

The oceans are both the world's biggest carbon sink and our collective lungs. They absorb carbon dioxide which is used by phytoplankton, a microscopic marine plant, to create breathable oxygen. Half of the oxygen in our atmosphere is produced this way, but looking at the way we treat the sea, it's obvious we don't realise it. Instead, we continue to use and abuse the ocean in ways that threaten its delicate balance and threaten us.

One of the most significant problems we face is overfishing. According to a 2018 report published by the United Nations Food and Agriculture Organization (FAO), 90% of the world's fisheries are either overfished or fished to their absolute maximum capacity, and 33% of our fisheries are exploited to the point that regional species collapse is possible. There are 4.6 million fishing boats on the water worldwide, 3.5 million of them, or 75% of the global fleet, are in Asia, most looking for tuna, and those are the ones we know about. Illegal fishing in international waters is also a big problem, with very little enforcement. Shark finning is another grave threat because if we rid the sea of

its apex predators, such as sharks and tuna, the marine ecosystem will not function the way it's supposed to. That's how invasive species proliferate contaminating habitats far and wide.

Coastal pollution, including agricultural run-off, is another enormous concern. Untreated livestock waste, pesticides and fertilisers choke rivers which carry these toxic pollutants into the ocean. Agricultural run-off contributes to algae blooms that create dead zones in the sea.

Ocean acidification – a build up of carbon dioxide, which then dissolves into carbonic acid – also impacts marine life. Much of the carbon from the fossil fuels we burn winds up in the sea, but there's a danger that the build up will become too much. Carbonic acid has been found to inhibit crustaceans from making shells, depriving them of protection and disrupting their reproduction, which would have ramifications up and down the food chain.

The climate crisis, meanwhile, magnifies the effects of all of the above. If the ocean temperature rises just 1°C and stays there, that is enough to kill the algae that coral reefs rely on for their survival. It's enough to confuse generational oceanic migration patterns. Even fisheries that are well managed might see their stock disappear. Marine heat waves would be more prevalent, exacerbating coral bleaching, and of course sea ice would melt more rapidly than ever, causing sea levels to rise, which would increase coastal pollution.

Then there's the marine plastic pollution problem, one of our greatest environmental tragedies. Every day single-use consumer plastics and other plastic trash overload waste management systems and enter waterways around the world. That trash spins on oceanic currents where it breaks down into microplastics often mistaken for plankton and consumed by fish, marine mammals, turtles and birds. Plastic has been found in deep sea

Left, see tropical fish and stingrays snorkeling off Tahiti, Polynesia.

© DanitaDelimont / AWL Images

'The wind did not blow until the sun was overhead. Before that time I covered a good distance, pausing only when it was necessary to dip water from the canoe. With the wind I went more slowly and had to stop often because of the water spilling over the sides, but the leak did not grow worse.

This was my first good fortune. The next was when a swarm of dolphins appeared... as they saw the canoe they turned around in a great circle and began to follow me. They swam up slowly and so close that I could see their eyes, which are large and the color of the ocean. Then they swam on ahead of the canoe, crossing back and forth in front of it, diving in and out, as if they were weaving a piece of cloth with their broad snouts.'
Scott O'Dell, *Island of the Blue Dolphins* (1960).
The 1960 novel recounts the experience of a young girl stranded for years on an island off the coast of California.

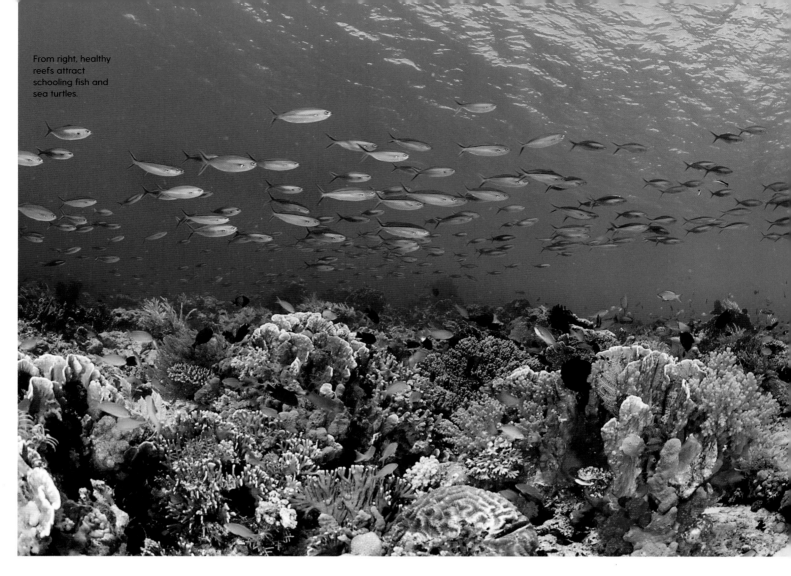

From right, healthy reefs attract schooling fish and sea turtles.

sediment and arctic ice cores, where it will take centuries to break down if it ever does. The only way to stop this vicious cycle is for companies to stop producing unnecessary plastic packaging and for us to stop consuming it. Momentum is building in that direction, but for all the plastic bag and straw bans that have passed around the world, single-use plastic packaging remains ubiquitous.

Although environmental issues have been important to me my entire adult life, and the ocean has been under these same pressures for over a decade, I wasn't aware of the extent to which our oceans suffered until open water swimming and freediving became a central part of my life. By bonding with the ocean, I became a more passionate advocate because love encourages a sense of personal responsibility. Which is precisely why, despite everything you just read, I'm optimistic about the future of the world's oceans.

Sure, the problems I've outlined are substantial and systemic – but they don't have to be overwhelming nor are they insurmountable. Because whether or not we surf, paddle, swim or dive, we all have the capacity to become ocean defenders. We do not have to see the ocean as

our playground to connect with the sea, or for it to offer something tangible to us. Whenever we are near it, we can feel it, which means we can grow to love it.

Wallace J. Nichols, a marine biologist and author of *Blue Mind*, has studied what he calls 'the effects of water on the human psyche', and what he has found is that nothing soothes us quite like being near water. He writes that the 'soothing familiarity' of the water's surface calms us, and when a bird dives for a fish or we see a dolphin or whale spout, that novelty provides a dopamine hit that relaxes us even further. As the mind unclenches into what he calls 'a dreamy state of involuntary attention', we become more creative, are disposed to insight and problem solving. We cultivate focus and a greater sense of awe and ease when we are near the ocean.

I'm not saying that's why so many people live on or near the coast, but it does explain why we have the urge to take long walks on the beach, spend summers lying in the sand and enjoying sunsets on the water, and feel drawn to the sea even when we may be thousands of miles away. Our primordial connection is still there, buried in our lizard brains, and that is a beautiful instinct.

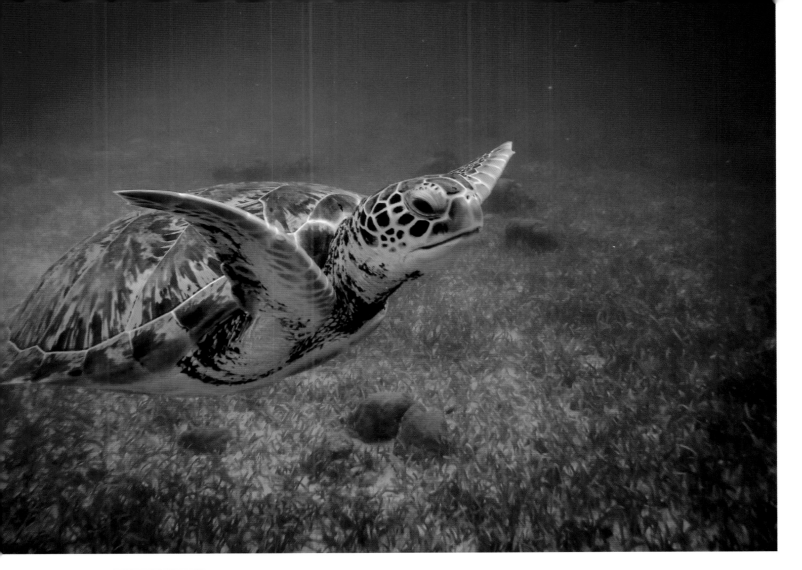

These days, many — though not all — whale populations have recovered to pre-whaling numbers

Because, as abused as the oceans may be, they have also proven to be resilient. From the 17th to the 20th century, whales were commercially hunted to the brink of extinction, when we relied on their blubber for fuel and soap. These days, many — though not all — whale populations have recovered to pre-whaling numbers. And whaling wasn't regulated at all until the 1940s and it wasn't banned in most countries until the 1980s.

More recently, the movement to create marine protected areas around the world has been shown to improve depleted fish stocks in a matter of years, while bleached coral reefs are being restored in Florida, Fiji, Tahiti, Mexico and Australia. It was once thought that when a coral reef died it was gone forever, but scientists and driven young activists are showing that it is possible to grow and transplant coral. Marine restoration and recovery is possible because the ocean is the most creative life force there has ever been. It was and remains the original evolutionary stew. When I say the ocean forgives, what I mean is that it will regenerate if we allow it.

There is much work to do, but the good news is that despite all its pressures, the oceans remain filled with life. Which is why my friends and I still suit up at least twice a week, year round, splash out beyond the waves in Chumash country, hold our breath and swim down to look for our favourite critters. Every day is fresh down there. No matter how many times we swim the same reef, starting and finishing in the same places almost every time, it inspires awe.

Our coasts and sea are ever changing.

'While posted in London in the 1750s, Benjamin Franklin swam daily in the Thames. The cold bath was a corrective much in vogue, and the scientist, inventor, and all-around Renaissance man was an avid skinny-dipper for much of his long life. Brits at the time suffered from what one writer called "a mass of maladies... fevers, digestive complaints, melancholia, nervous tics, tremors, and even stupidity were the epidemics of the day." The new wonder drug prescribed for the nasty health effects of urban living? Cold seawater. And thus the English seaside resort was born – not for sun worshipping or frolicking, but for dunking oneself in the cold miracle cure of the ocean. It was the collective baptism of a country.'

Bonnie Tsui, *Why We Swim* (©2020 by Bonnie Tsui. Reprinted by permission of Algonquin Books of Chapel Hill. All rights reserved.)

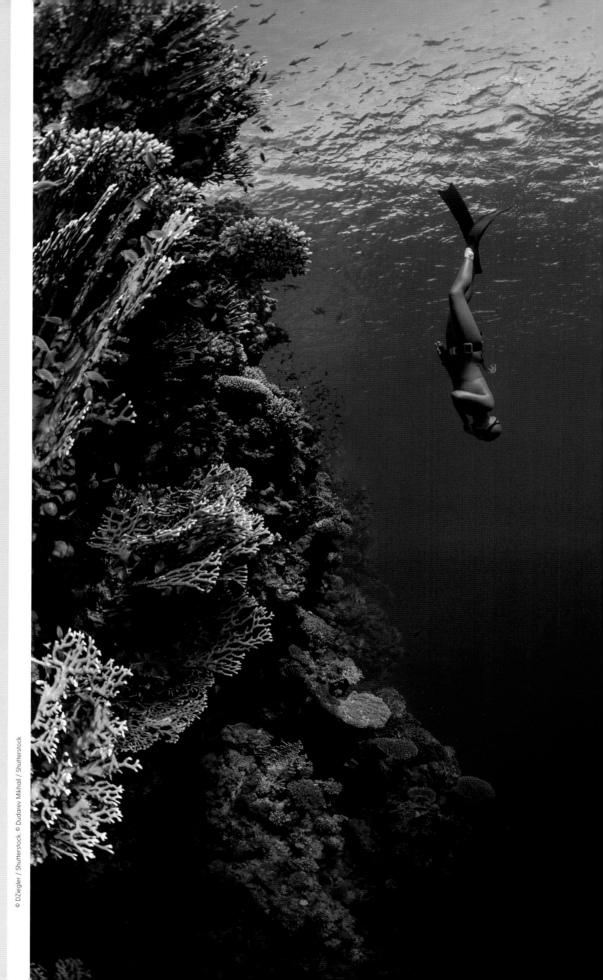

USA

Big Sur
& California's Central Coast

Here are empty beaches, whales, hippie retreats, waterfalls, towering redwoods, hot springs, inviting inns and wineries galore – take your pick.

Right, looking over Los Lobos State Reserve from Cypress Grove Trail.

o drive California's Highway 1 along the Big Sur coastline is to explore an enormous panorama, an IMAX film come to life. The winding road bends back and forth time and again, revealing sheer drops to a seething and swirling sea as it thrashes cliffs in one instance, and then laps calm crystalline coves the next. There are plenty of places to stop for photos and enjoy the views and you should because these vistas are mind-blowing.

The water colour varies from grey to green to cerulean blue, depending upon the surf and the sunlight. It is frequently foggy, thanks to Monterey Canyon, a submarine gorge that is over 13,100ft (4000m) deep and sits close to shore. As a result, the water is cold even in the summer, but because coastal development is limited, the beaches remain wild and untouched, and are spectacularly beautiful in sunshine, fog or rain. Plus, the marine habitat here is protected.

In fact, the giant kelp forests that thrive off the Big Sur coast, are the last refuge of California's most charismatic and endangered marine mammal: the sea otter. Further offshore, gray and humpback whales migrate twice a year between their feeding grounds in Alaska and Baja or Hawaii respectively, often with a stopover in the sardine-rich waters of Monterey Bay.

Whether in a car, on a bike or on foot, the views here abound. Big Sur's coastal range, the Santa Lucia Mountains, are laced with dozens of hiking trails. In Pfeiffer Big Sur State Park, the

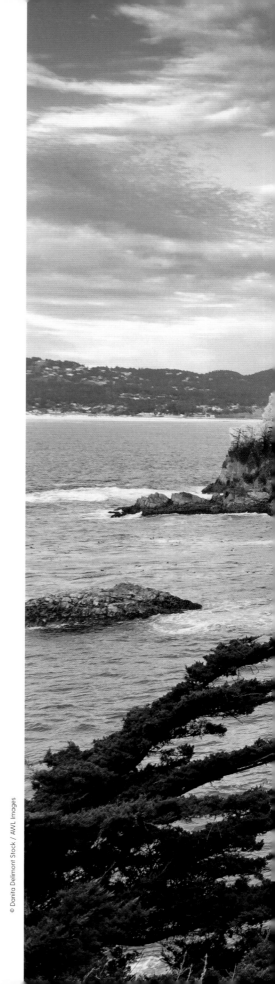

© Danita Delimont Stock / AWL Images

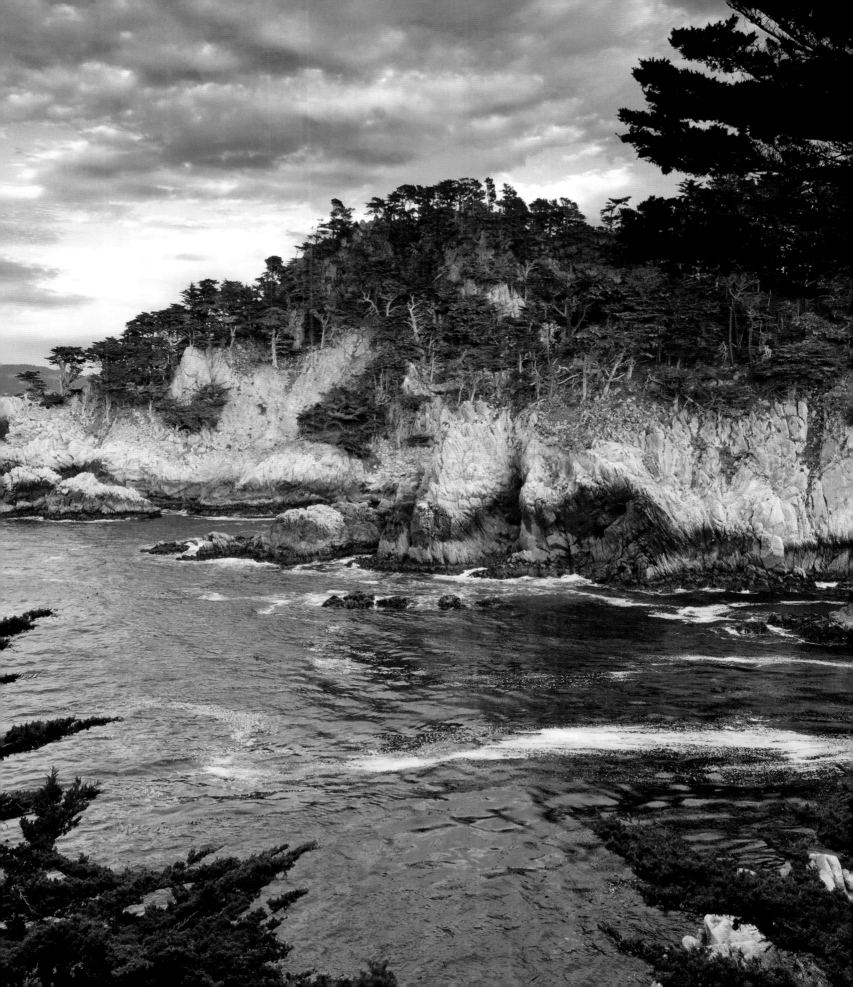

ELEPHANT SEAL MOSHPIT
Each winter thousands of northern elephant seals emerge from the Pacific, where they live solitary lives, to gather on the sand south of Big Sur. January is peak mating and pupping season, and it's a spectacle of love, sex, fear and violence. Dominant males, which top out at 5m (16ft) in length and weigh up to 2300kg, maintain a harem, and spend their waking hours defending their position. Some females, which weigh up to 800kg, arrive pregnant. Once their pups are born they don't stay long. Pups are nursed for about a month before their mothers return to the sea to feed. It's not uncommon to glimpse generous mothers nursing both their own young and adoptees.

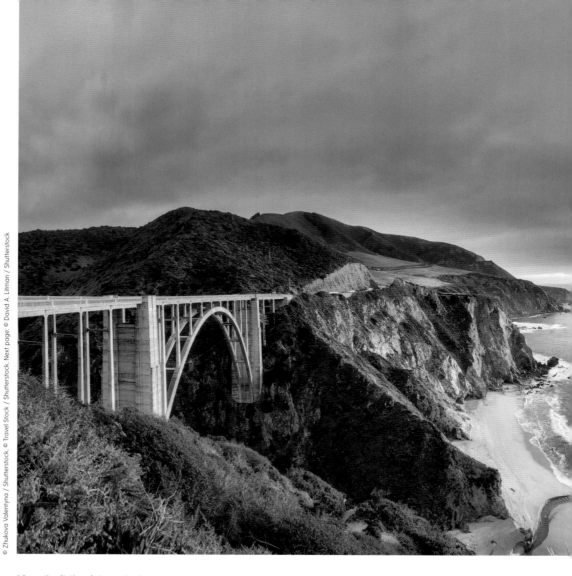

10-mile (16km) Pine Ridge Trail winds beneath coastal redwoods, some of the tallest trees on earth, and over sagebrush mountains before descending again into a river canyon, where hot springs bubble up for campers to soothe their aching muscles before the arduous trek back to the beach. The Bluffs Trail in Andrew Molera State Park offers some of the best views of empty beaches and sandstone cliffs in all of California.

When the Spanish settled Central California, establishing missions in Monterey and what became known as Carmel-by-the-Sea, they referred to the Big Sur wilderness as *el país grande del sur*, or 'big country to the south'. In 1915, English-speaking homesteaders who had ranched and fished the coastline for a generation formally adopted the name Big Sur for their post office. But it wasn't until the 1950s and 1960s that Big Sur emerged into the collective consciousness.

That's when artists and writers such as Henry Miller (*Tropic of Cancer*), Alan Ginsberg ('Howl') and Jack Kerouac came to town. Big Sur became the setting, and the title, to one of Kerouac's best-loved follow ups to his generational hit, *On The Road*. The New Age community arrived not long after, mostly gathering at the Esalen Institute, with its marvellous, clothing-optional hot springs and spa, spectacular private beach and range of self-realisation workshops. The community of Big Sur remains rooted in that hippie era. The town is still filled with writers, artists and mystics, which only adds to its rugged, throwback appeal. Sometimes it feels like this emerald-green corner of California is a portal to a perfect past where all things are peaceful and possible.

Of course, unless you buy property here, eventually you have to leave, which is fine because whether you drive north or south, the Central California coastline continues

From left, Bixby Creek Bridge, south of Carmel; Californian sea lions; overleaf, Big Sur's kelp forests are sea otter habitat.

 The closest regional airports are located in Monterey and San Luis Obispo, but most travelers fly into Los Angeles International (LAX) or San Francisco International (SFO), rent a car (you definitely need wheels) and embark on a coastal California road trip. Big Sur is packed with tasteful inns and fancy lodges, and sprinkled with attractive campsites in the trees. Lodging suits any budget, but restaurants can be pricey, so if you're camping, plan on self-catering too. In the summer and on weekends, it's vital to book your room or campsite in advance. We suggest making the trip off-season. May and October offer (usually) sunny weather and thin crowds, but no matter when you come you will leave amazed.

to dazzle. South of Big Sur at San Simeon, media magnate William Randolph Hearst's gilded dream home, Hearst Castle, a playground for the pre-war 1%, sits on the mountain top above vineyards and a pasture peppered with zebras (yes, those are actual zebras); offspring from Hearst's once-substantial private zoo. Further south, the beach retreat of Cambria offers more wide, empty beaches and rolling surf just a short drive from the world-famous wineries of Paso Robles. You could spend days roaming those golden hills and back roads, sampling Pinot in intimate tasting rooms.

North of Big Sur, you can explore the beaches and art galleries of Carmel-by-the-Sea (the setting for HBO's hit series *Big Little Lies*, starring Reese Witherspoon and Nicole Kidman), before arriving in the historic fishing port of Monterey which another legendary author, John Steinbeck, documented in *Cannery Row*. Once an industrial fishing town, the sardine canneries have been repurposed, but the fish are still out there, which is why humpback whales arrive in large numbers each summer to lunge feed in the frigid Pacific.

Be warned, thanks to the deep, cold ocean, Monterey can stay foggy and cold even in July and August, but if you book a room with a fireplace you can warm up after a day of whale watching. Or simply view marine life indoors at the Aquarium of the Pacific, one of the finest institutions of its kind in the world.

MEXICO

Cabo Pulmo National Park

After decades of abuse, the waters east of Baja California represent one of the great marine conservation triumphs.

Right, a Californian sea lion hunting in Baja California.

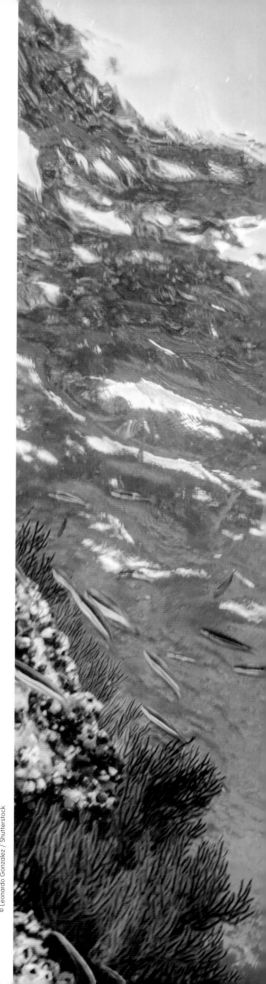
© Leonardo Gonzalez / Shutterstock

Set only about 62 miles (100km) north of the overhyped and overstuffed resort town of Cabo San Lucas, Cabo Pulmo feels like a different planet. It's accessible via a graded dirt road that cuts through rugged and open desert terrain and skirts a mostly undeveloped coastline. The big draw is that blue water just offshore, a national marine park home to sea lions, humpback and gray whales, octopus and guitarfish, vast congregations of mobula rays, five species of sea turtles, three dolphin species, hammerheads and whale sharks. Not to mention over 200 species of reef fish and 154 species of marine invertebrates, several of which look as if they were lifted straight from the pages of Dr. Seuss.

The marine park takes its name from the town, which was settled in the late 19th century. It's set on the east coast of Baja California's famous cape (*cabo* in Spanish). Technically, these waters are part of the Sea of Cortez, a gulf fed by the Pacific Ocean that runs up the eastern shore of Baja, for 620 miles (1000km) north from Cabo San Lucas to Sonora state.

Marine riches have always been Cabo Pulmo's tractor beam. The first settlers to be drawn here were after mother of pearl, which they harvested from oysters that lived on the reef. When that market saturated and the price fell, residents turned to commercial fishing, and Cabo Pulmo became a fishing village for the next 100 years.

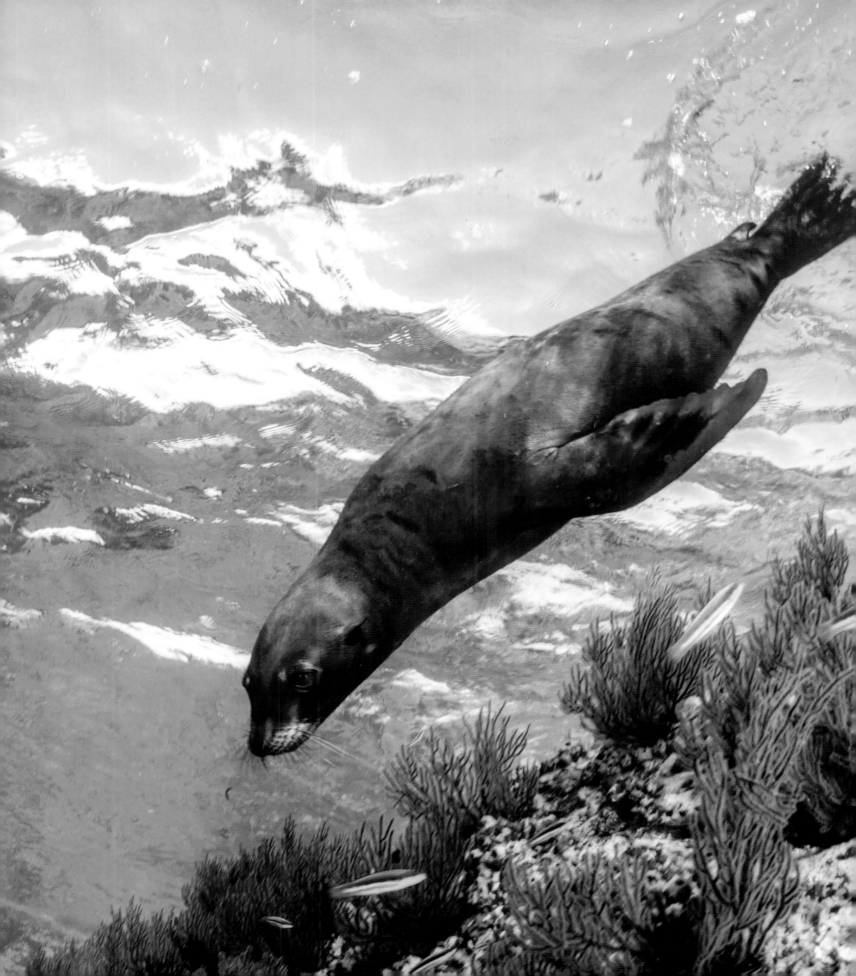

© Granger Historical Picture Archive / Alamy Stock Photo. © Leonardo Gonzalez / Shutterstock

STEINBECK'S SCIENTIFIC EXPEDITION

In 1940, a year after publishing *The Grapes of Wrath* and becoming a household name, American author John Steinbeck joined his biologist friend Ed Rickett's month-long expedition to the Sea of Cortez. Of all the sights they saw and specimens they collected, Steinbeck was most captivated by the expansive reef at Cabo Pulmo. In his classic 1951 travelogue, *The Log from the Sea of Cortez*, he writes: 'The complexity of the life pattern on Pulmo Reef was even greater than at Cabo San Lucas. Clinging to the coral, growing on it, burrowing into it, was a teeming fauna. One small piece of coral might conceal 30 or 40 species, and the colors on the reef were electric.'

From right, Cabo Pulmo shore; porkfish in Cabo Pulmo Marine National Park; healthy coral in the reef.

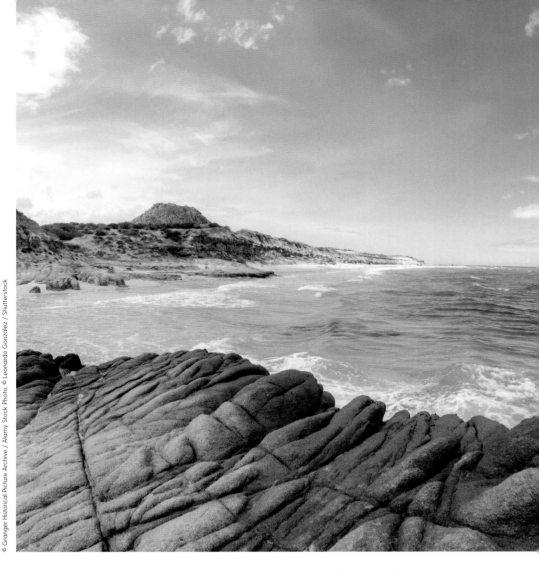

Tourists trickled in, but didn't arrive in substantial numbers until the 1980s, when windsurfers discovered Baja's east cape. They were rugged, shoestring travellers who rode the gales and the waves (which can swell double overhead on the offshore reef) and shared their stories over beers around bonfires they built on the beach. Sport fishermen weren't far behind. After just minutes of trolling along the outer reef they found they could hook dorado or wahoo. Spearfishing on the reef was popular then too. Word of mouth spread like a desert dust storm.

Soon enough, however, Cabo Pulmo almost became another ecological and economic catastrophe. Fish numbers plummeted overnight, commercial fishermen suffered losses and sport fishermen stopped showing up. A group of scientists from the Autonomous University of Baja California Sur in La Paz traced the problem to overfishing and coastal pollution, run off that damaged reef habitat. They documented trends for over a decade and, together with locals, pressured the federal government in Mexico City. Finally, in 1995, then President Ernesto Zedillo declared 27 square miles (71 sq km) of ocean in and around Cabo Pulmo to be a national park.

What happened next should buoy the hopes of ocean lovers and environmentalists everywhere. Mexico didn't just offer protected status. They patrolled the area, punished poachers and educated fishermen. The program worked better than anyone could have dreamed. According to a 2015 study, the collective biomass

(the weight of all life forms found) in the national park grew by nearly 500% in just 20 years, which makes it one of the biggest marine protected area success stories ever.

The tourists are back, but it's not overrun. This is still an off-the-beaten track destination geared toward adventure travellers who enjoy rugged hiking trails that offer 360-degree desert and ocean views, or kayaking out to a nearby sea lion colony, which locals like to think are the friendliest sea lions in the world. When the wind is up, kite surfers carve the reef break and the blue water beyond. Most visitors, however, come to don mask and fin, and drop into what amounts to a wild, open-water aquarium.

The reef is 20,000 years old, the oldest on the west coast of North America, and spreads out like so many hard coral fingers atop a rock shelf foundation. Depending upon the time of year, the water temperature can vary from as low as 18°C (64.5°F) to 29°C (85°F), with visibility from 66-98ft (20-30m). Scuba diving is sensational here, thanks to schooling jackfish that surround and dazzle divers, but the snorkeling and freediving are equally fantastic.

In fact, the park's biggest sensation is the biannual congregation of mobula rays (also called devil rays thanks to their horns) during which hundreds of 1m-wide stingrays swim in a vast school. The best show is in the springtime when currents shift and plankton and other nutrients rise to the surface. That's when the rays arrive, gathering to mate and give birth when they aren't thrilling onlookers with their acrobatics. They've been known to breach the surface, leap and somersault, one after another, for hours at a time. Unlike mantas, they don't like bubbles much, and move too fast for scuba divers anyway, but snorkelers and freedivers will have a front row view.

Fly into the international airport at Cabo San Lucas, rent a car and drive northeast along the rugged East Cape. You don't need a four-wheel-drive, but you might want a high-clearance vehicle. There are tasteful lodges in town, but beach house rentals are a better option for groups. Restaurants serve tasty, freshly caught seafood. Plant-based folks may want to self-cater at least some meals. If you love whale watching, the best time to visit is from December through March, when gray and humpback whales check in for the winter. Mobula rays are in the area December and January and April to July. Summers are hot in the desert, but that's when prices drop.

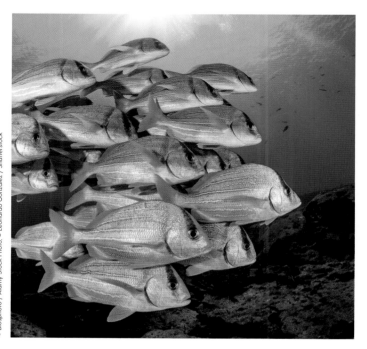

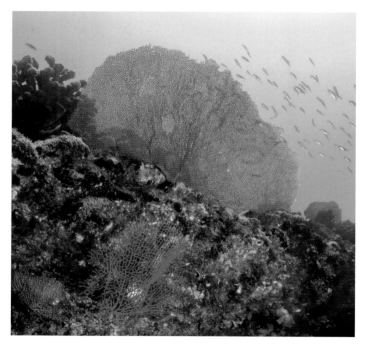

INDONESIA

Raja Ampat Archipelago

Between the limestone islands of Western Papua lie the planet's most biodiverse coral reefs – and a divers' paradise.

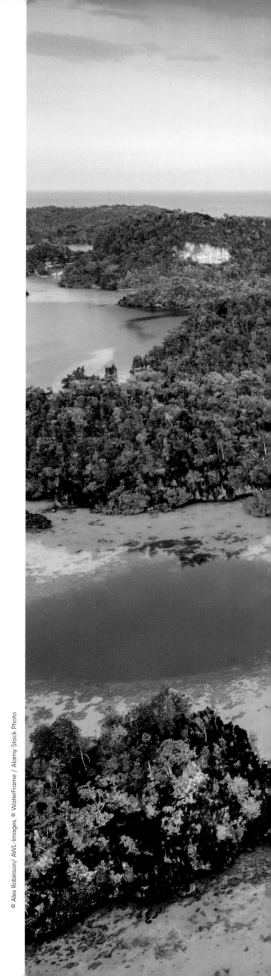

*I*s this tropical fantasyland real? It's almost unfathomable to believe that a place this sublime exists, let alone went unnoticed by so many for so long. But that's the way it was for generations in these remote, almost untouched islands, dotting the turquoise waters off Bird's Head peninsula of Indonesia's West Papua.

The Raja Ampat islands haven't been empty of humanity. There are fishing villages here, but they were left alone with few if any government services for decades. The only visitors who had any reason to fly into Sorong, the nearest airport on Papua, were Christian missionaries, government bureaucrats or employees of mining or oil and gas conglomerates, and most stayed in the city or headed inland, not out to sea. In the days before tourists discovered the islands, it was not uncommon for the airport to run out of jet fuel for days.

Then, a couple of decades ago, a scuba entrepreneur with a nose for mouldering WWII wrecks started poking around and discovered spectacular coral reefs, hidden lagoons, and a diversity of marine life he'd never seen before. He opened a dive resort. Live-aboard dive cruises had been in and out of the area for some years, but that first land-based resort changed everything. Before long, they multiplied, and once word got out about the beauty, adventure and hospitality on tap in the Raja Ampat, it wasn't just divers who were interested. Backpackers and Indonesian tourists were too. Villagers set

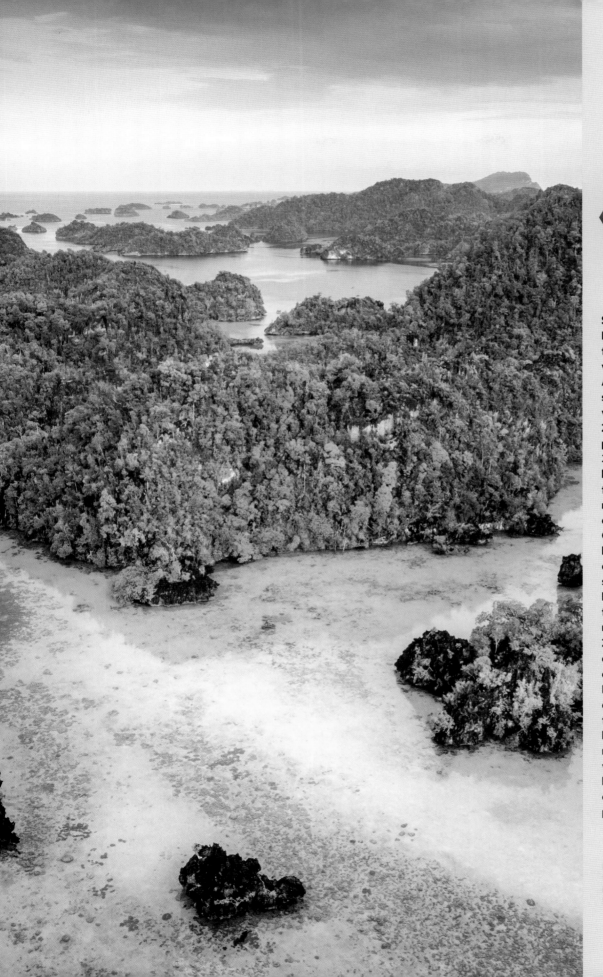

SHARK SANCTUARY

In 2002, five years before the first land-based resort was opened in the Raja Ampat, the number of sharks, rays and grouper were plummeting. In 2007, seven marine protected areas, covering 3475 sq miles (9000 sq km), were established to protect Raja Ampat reefs from large-scale commercial fishing. Of course, Indonesia has long been a well-documented source for shark fins, which fetch big money for subsistence fishermen too. More needed to be done. In 2010, the Raja Ampat archipelago was declared a shark sanctuary by the Indonesian government, and in 2013, with the tourist economy growing, both shark and manta ray fishing were banned, with former fishermen hired to patrol the waters and crack down on poachers.

Left, looking over the limestone islands from Harfat mountain.

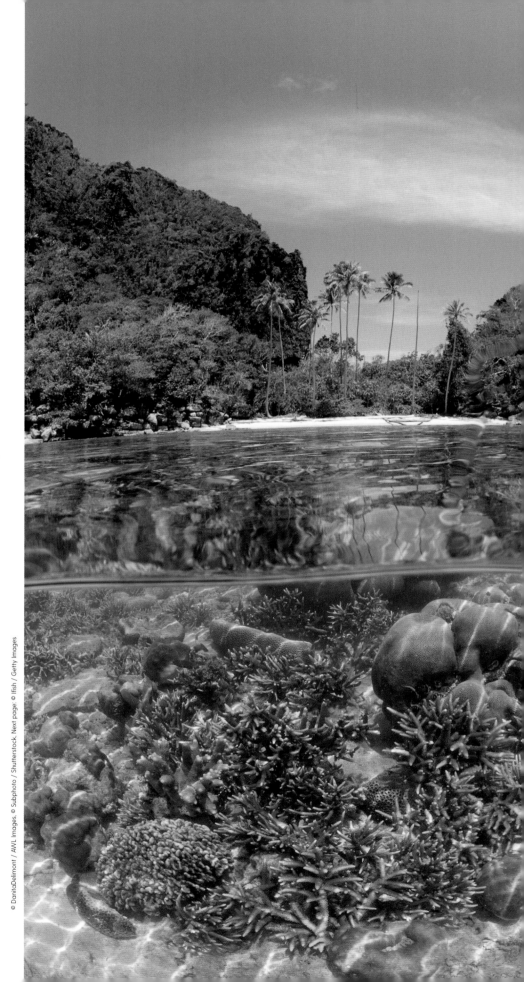

From right, the coral reef off Misool Island; golden damselfish in Raja Ampat's reef; overleaf, marine life thrives beneath the mangrove trees of Friwenbonda island.

up homestays, foreign investors set up more luxury lodges, and an eco-tour infrastructure took root.

Diving is still the main draw, and with good reason. These 1500 islands, islets and cays straddle the equator and are part of the so-called Coral Triangle. Even when the surface looks calm, it's not always placid beneath. The ripping currents here nourish 600 species of coral, which translates to over 75% of all coral varieties found on the planet. That diversity supports over 1400 varieties of reef fish and 700 types of molluscs.

It's been called a diving library and a biological hotspot because no other diving destination offers so much variety. According to the US environmental non-profit Conservation International, the underwater biodiversity in the Raja Ampat area is the highest ever recorded. It's also believed that the reef systems found here produce an armada of coral larvae, which ride oceanic currents to resupply reefs throughout the South Pacific and Indian Ocean (when you look at a map, the Raja Ampat archipelago appears to be where these two great oceans merge).

The beaches and island interiors are nearly as captivating. Follow a creek upstream through the jungle with your local guides and you just might glimpse rare species of birds of paradise or discover a waterfall. Boat tours are a must as well. Scores of uninhabited islands rise from the surface of a sapphire sea like so many green mushrooms. The photo ops, above and below the water, are legion here.

The name Raja Ampat (*raja* means 'king', *empat* means 'four' in Bahasa

Indonesia) comes from a local myth about a woman who happens upon seven eggs. Four hatch into kings who reign over the four major islands in the archipelago (Misool, Salawati, Batanta and Waigeo). The islands once belonged to a powerful sultanate in present day Indonesia's Maluku state, but when Dutch sailors invaded they deposed the sultan and claimed the islands for the Netherlands until Indonesia claimed independence for itself in 1945. Not that life changed much way out here.

Then as now, villagers tended to live in stilted homes on island beaches or the rocky coastline, and they are warm and welcoming to visitors as a general rule. Local residents belong to a network of tribes. Some are Muslim, others are Christian, yet traditional customs and family ties span that divide and remain strong. Until the tourist boom, almost all of them made their living by fishing. Now some operate homestays, act as guides or patrol the reef for poachers rather than catch fish for themselves.

Most visitors stay among the islands closest to Sorong, which include the three kings (Salawati, Batanta and Waigeo) north of the equator. Misool, the fourth, is south of the line which means it has a different monsoon season. It's also better known for big pelagic species such as manta rays and gray reef sharks. Thanks to a robust eco-tourism and local ranger network, there are nine Marine Protected Areas in the Raja Ampat, which have improved shark, ray and turtle numbers. Several whale and dolphin species, including orcas, are also said to transit the Raja Ampat on their annual migrations. This place is a wonderland.

Fly into Sorong, an industrial port in West Papua, where you can link up with your host for transport to a dive lodge or resort, or hop a ferry to one of the main islands where you can bunk in a homestay. Another choice is to book passage on a live-aboard dive expedition in the area. Dry season in the northern half of the archipelago is April through October, while in the Misool region it's November to March. Tourists must pay a mandatory 1,000,000RP conservation fee (about US$70) for a permit to visit the islands. That fee pays for conservation and community development programs in the archipelago.

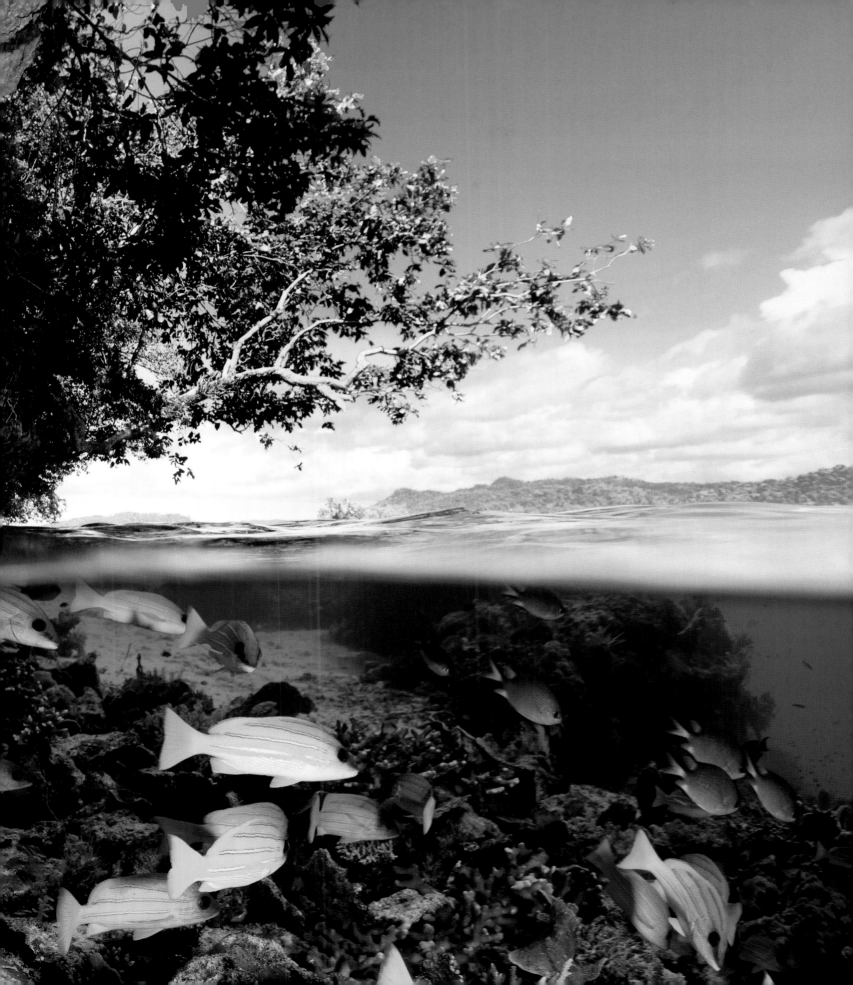

NORTHWEST PACIFIC

The Kerama Islands

These droplets of white sand and coral, set in the Pacific, halfway between Japan and Taiwan, are as laid back as they are inviting. The smallest and least developed is Aka-jima. With a circumference of just 7.5 miles (12km), tourists walk or pedal around the entire island year round. They come for the shoreline, of course, as it is edged in soft, white sand. Nishibama is the finest of beach of them all – 0.6 miles (1km) long, with a fringing coral reef offshore, the clear water is almost always calm and the swimming could not be safer. Zamami-jima, across the bay is only a bit more developed, has some delightful beaches too, as well as inviting off-shore islands that are accessible with local guides.

The draw here, once again, is diving and wildlife. The Kerama Island reef systems are fed by the North Pacific Ocean's Kuroshio Current (also referred to as the Black Current or the Black Stream), which is similar to the warm Gulf Stream in the Atlantic Ocean. The current begins in the Philippines and draws warm, tropical water north past Taiwan and into Japanese waters, which is why Japan is home to the northern-most coral reefs in the world.

These islands aren't quite that far north, but the reefs are among the healthiest worldwide, home to 360 types of fish, over 200 seaweed varieties and hundreds of coral species. There are reputable dive shops on all the islands

Between mainland Japan and Taiwan lies a paradise of white-sand beaches where coral reefs, sea turtles and humpbacks thrive.

Left, an aerial view of Zamami island and its beautiful beaches.

SHIRO & MARILYN

Once there was a dog named Shiro, whose family lived on Zamami-jima. Shiro had a girlfriend on the island, a doggie named Marilyn, but when his family up and moved to Aka-jima, bringing him with them, puppy love appeared doomed.

But after repeated disappearances Shiro's family discovered he'd been swimming across the 2-mile (3km) channel that separate the islands to visit Marilyn. He'd stay for a while then swim home to his family. Islanders were touched by his devotion and athleticism. Even during rough weather, Shiro could be spotted swimming between islands.

Shiro and Marilyn had three litters of puppies together, and after he died, Aka-jima locals built Shiro a statue at the port. Across the channel on Zamami-jima there is a statue of Marilyn, staring out to sea, awaiting her lover.

Right, Aharen beach on Tokashiki island.

and the snorkeling is terrific here, too. During the summer dozens of hawksbill, loggerhead and green turtles come ashore to bury their eggs in the sand, with babies hatching within 60 days. They can be seen in and out of the water.

Each winter humpback whales swim 3730 miles (6000km) southeast from Alaska to give birth and nurse their young in the warm waters around Okinawa and the Kerama Islands. While humpback whales have staged an incredible comeback from the brink of extinction worldwide, these particular whales are part of the endangered Western North Pacific population, which is around a thousand strong and susceptible to grave threats including energy exploration and development, fishing-gear entanglement and whaling. Japan is one of the last remaining countries to allow commercial whaling, but given the growing winter demand for eco-friendly whale watching tours in Zamami-jima and Aka-jima, it's becoming clear that most Japanese people would much rather watch whales and take pictures than eat whale meat. In other words, there is hope.

There's also captivating wildlife on land, including abundant bird life, a range of butterflies, orb-weaver spiders, and an endemic subspecies of the Japanese deer, called the Kerama deer, which evolved after Japanese deer were brought here in 1609. They are smaller and darker than the mainlanders, and have been documented swimming between islands; they are best glimpsed grazing around sunset. Given its abundant natural riches, in 2014 the Japanese government designated the Kerama Islands a national park.

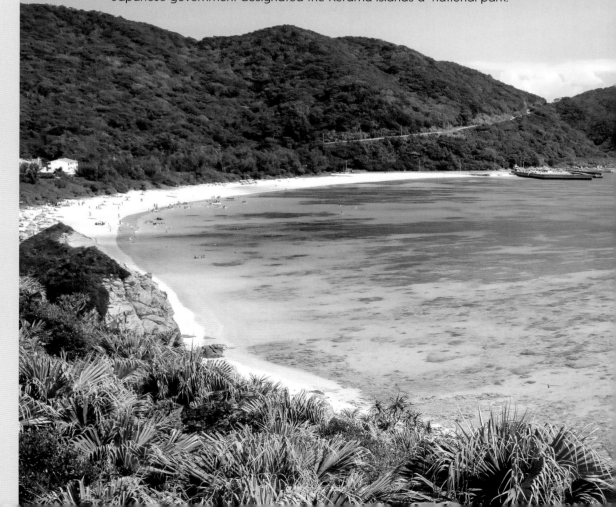

The Kerama Islands didn't always belong to central Japan. For six centuries they were part of the Okinawa-based Ryūkyū Kingdom, and Kerama islanders were their navigators on trade missions between Okinawa and China. The United States, which maintains a Naval base on nearby Okinawa, first landed on Aka-jima on 26 March, 1945 to prepare for the Battle of Okinawa, an 82-day bloodbath that began on 1 April, 1945 and included the largest amphibious assault in the Pacific during WWII.

In Japan the battle has been referred to as *tetsu no ame* (rain of steel) or *tetsu no bōfū* (violent wind of steel) thanks to the scale of the kamikaze attacks coming from the Japanese and number of Allied ships, tanks and other armoured vehicles that assaulted Okinawa. Before the war the estimated population on Okinawa was 300,000; some 149,000 went missing or were killed during the fight. Over 77,000 Japanese soldiers and 14,000 American soldiers lost their lives there too.

When you're on Aka-jima or Zamami-jima or any of the Kerama Islands today it's hard to feel anything but at peace. The only invasion you're likely to experience is the summertime or weekend day-trippers from Okinawa who arrive to enjoy a slice of paradise. But there are no grand resorts here and most tourists leave by late afternoon, which means, if you are willing to forego 4-star comforts, it's easy to burn many happy days here, relaxing into the rhythms of nature.

Ferries depart daily from Naha in Okinawa for Aka-jima and Zamami-jima, year round. The weather is dependable and thanks to that Kuroshio Current, the water is relatively warm all year. January, July and October are the driest months. Don't expect fancy accommodation, but guesthouses and minshuku (Japanese B&Bs), are clean, and you can book both western- and Japanese-style rooms. On Aka-jima arrange meals with your guesthouse. On Zamami-jima restaurants keep limited hours, but bento boxes are available for take-away early in the day, and most accommodation offers breakfast and dinner.

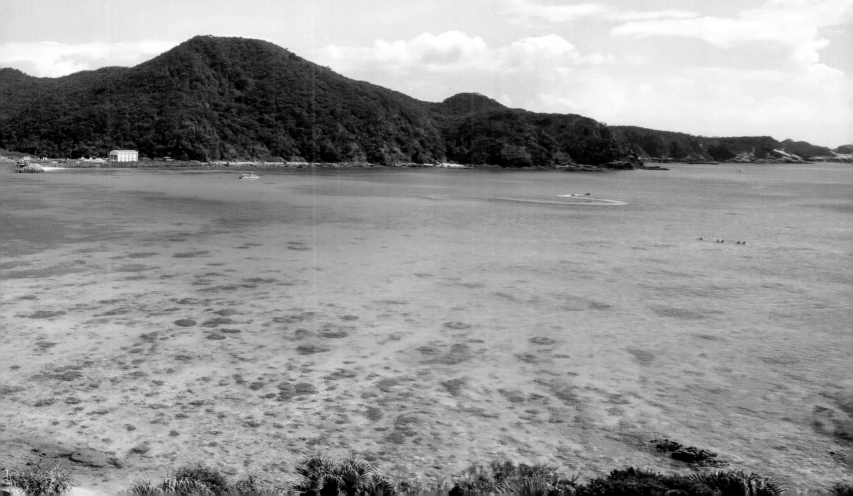

NORTHEAST ATLANTIC

Cabo Verde

Rearing up from the deep Atlantic are ten volcanic islands alive with beauty, history and music.

Cabo Verde is a remote archipelago gathered in the Atlantic Ocean 560km (348 miles) west of Senegal's Cape Verde Peninsula. It attracts magnificent marine wildlife, and offers surreal and spectacular scenery. The hiking in Santa Antão is some of the best in West Africa. Here are spiked, craggy peaks and vertical volcanic walls guarding deep gorges and sheltered valleys blooming with flowers, rooted with mango trees and wafting with sugar cane. The sand dunes on Sal and Maio seem plucked from a Saharan dream sequence, except they tumble toward white sand beaches and sapphire seas that are no mirage. Fogo delivers more volcanic moonscapes, terraced fields, an active volcano, placid bays and rugged coastline. Boa Vista feels like a desert island, albeit one with an increasing number of splendid beach resorts and terrific kite surfing. Rustic, cobblestoned Brava is a 19th-century time capsule. And Santiago's waterfront Cidade Velha (Old City), set 9 miles (15km) from the capital city of Praia, dates all the way back to 1462, when it was founded as Ribeira Grande and became the first European settlement anywhere in the tropics. Before then all of these islands were uninhabited.

Today, Cabo Verde is a natural and cultural wonderland, its living history a testament to human endurance, resourcefulness and tremendous cruelty. It's also the perfect place to trace the way cultures clashed, merged and developed on and around coasts and seas

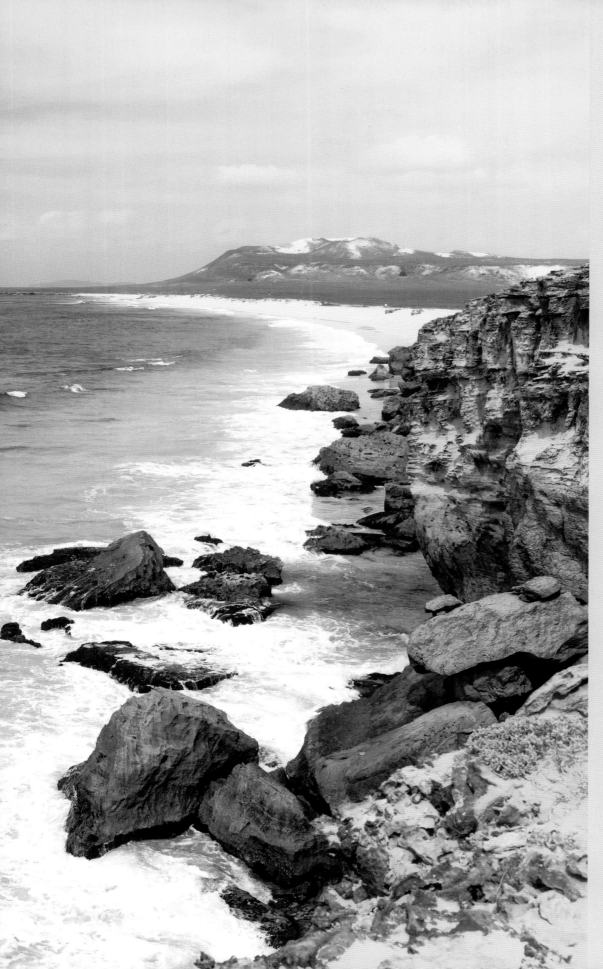

CABO VERDEAN MUSIC IS WORLD MUSIC

African and Latin rhythms, European instruments — such as violins and guitars — and origins rooted in protest music and work song have long been a potent musical blend. All over the world similar ingredients have yielded fertile music traditions including American blues and Cuban *son*. Cabo Verde cultivated its rich musical tradition from that same soil, including *mornas* and *coladeiras*. *Mornas* are melodic ballads filled with longing. *Coladeiras* are upbeat and poppy. The late Cesária Évora is Cabo Verde's most famous musical ambassador. Her *mornas* and *coladeiras* are infectious, and she performed tirelessly for decades, sharing the beautiful music from a little-known yet important island chain, all over the world.

Left, the coast of
Boa Vista island,
Cabo Verde.

From right,
humpback calves
stay close to their
mothers for two
years or more; a
yellowtail clownfish.

during the European expansionist era. Its geology, meanwhile, is a symphony of fire and water performed in relative isolation. There's a reason that National Geographic runs photography safaris to Cabo Verde.

The first of the islands breached the surface an estimated 20 million years ago, when the sea level was at least 164ft (50m) higher than it is today. Lizards, insects and plants eventually found a home on these remote rocks while a series of volcanic eruptions continued to shape the land. Humans didn't plant their first flag until 1456, when a series of Portuguese captains discovered and then returned to the islands in service of Henry the Navigator. When the Spanish Inquisition spread to Portugal at the end of the 15th century, King João II exiled thousands of Jews to Cabo Verde. Slaves joined descendants of those exiles during the 16th century, when the islands proved a handy stop over and market centre during the horrific transatlantic slave trade.

As if cursed by the gods or nature for its crimes against humanity, Cabo Verde experienced three centuries of erupting volcanoes and cyclical droughts that destroyed crops and spread famine. Several pirates, including Sir Francis Drake, sacked its most prosperous cities. When the slave trade mercifully collapsed, tanking the Cabo Verdean economy, whaling loomed as the next big business model.

The shores of the Cabo Verdean islands are 1.2 miles (2km) above the seafloor, in the mid-Atlantic Ocean. It's a law of nature that wherever there is structure in an otherwise arid expanse of deep blue water, life clings, blooms and swirls. It's no surprise

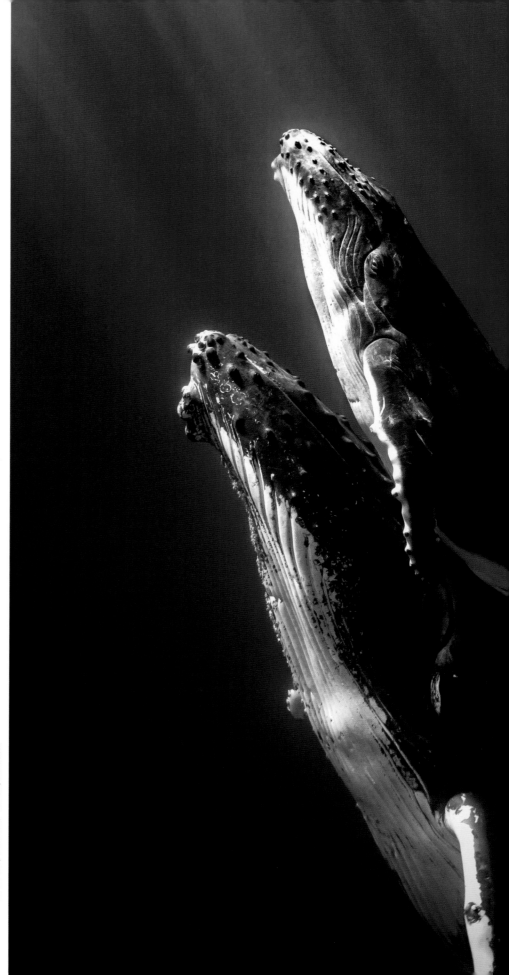

then that migrating humpback, sperm and pilot whales have long been attracted to the region. In the 19th century whaling ships out of Massachusetts began docking there, taking Cape Verdeans as crew, some of whom would eventually emigrate to the United States to escape the drought cycle and the hunger that came with it.

This tidal convergence of nationalities and traditions has created a rich and diverse cultural life in today's Cabo Verde, which did not win independence from Portugal until 1975. Theirs is a predominantly Crioulo (Creole) culture, with a singular music tradition and cuisine rooted in African rhythms and spices. The kitchen is bubbling with shrimp and pork stews, which can be plated alongside squid and conch salads, roast goat, corn, beans and all manner of fresh fish.

The centre of Cabo Verde's culture scene is the city of Mindelo, a web of cobblestone streets and colonial buildings built around a deep port on São Vicente island. That's where the whaling ships docked and cruise ships too, which made it something of a cultural gateway. Most of the country's best loved musicians and poets, including the legendary singer, Cesária Évora, were born in Mindelo.

Speaking of singers, humpback whales still come through, the males filling the ocean with their love songs. They arrive seasonally, in March and April, resting between the islands of Sal and Boa Vista, the only known breeding ground of humpbacks in the northeast Atlantic. This is a small population that winters in their feeding grounds around the Azores, Iceland and Norway, but during March and April they can be seen lingering in Cabo Verde, sheltering with their young.

Most international flights land on Sal or Santiago, though there are also international flights to Boa Vista and São Vicente. It's easy to fly between islands, and there are reliable ferry services too, though in the middle of the Atlantic, the water can be rough at any time of year. It's worth renting a car in Boa Vista, Fogo and Santiago. August to October is technically the rainy season, though it can be hot and still quite dry. Surfing is best between December and April, and whale watching peaks February to May. Turtles come ashore to nest from June to October.

EAST AFRICA

Mozambique's Coast

On Africa's longest stretch of Indian Ocean coastline pristine beaches and coral reefs await.

Right, the Quirimbas archipelago on Mozambique's northeast coast.

Like a frayed ribbon, the Mozambique coast runs from the Tanzanian border in the north, 2300km (1430 miles) south all the way to South Africa, and much of it remains unsettled and under-explored. In other words, it is a playground-in-waiting for eco-tourists, dive addicts and surf junkies, and its lack of development means the flora and fauna (marine and terrestrial) that live here have enjoyed something of a sanctuary.

There are two national parks, one in the remote north and the other in the more accessible south. Both offer world-class diving and snorkeling, sailing and paddling. The best surf is found in southern Mozambique. Whales seasonally migrate up and down the entire coast and on land you can see four of the 'big five' animals (elephants, cape buffalo, lions and leopards) among other bucket-list wildlife.

Broken off the jagged northern coast and sprinkled in the sea like so much shattered glass, are the 31 islands that make up the Quirimbas Archipelago, where the waters are influenced by the southern equatorial current and deep submarine canyons off shore. Those two factors help create an upwelling effect that nourishes the healthiest and most diverse coral reefs in East Africa. As a result, they are now protected as a World Heritage marine site and are the fulcrum of the continent's largest Marine Protected Area.

There are over 300 species of coral

© Clinton Friedman / Getty Images, © Julian Love / AWL Images

A SWAHILI COAST

Thousands of years ago, the Bantu people of West Africa moved through the Congo, across the continent, and settled East Africa. During the 8th century, Bantu sailors met up with Arabian traders who in turn arrived on the beaches of present-day Kenya, Tanzania and Mozambique. This intermingling of customs and language, and a fair bit of intermarrying, resulted in the Swahili culture that continues to thrive on Africa's east coast. Beira, Mozambique Island and Ibo Island were all early Swahili ports ruled by local sultans. In 1498 the Portuguese explorer Vasco da Gama arrived and for the next 200 years Portugal began setting up shop in Mozambique, trafficking in ivory, gold and slaves. Mozambique suffered under Portuguese rule until 1975, but the Swahili culture, language and people continue to thrive.

From right, Bazaruto; school of snappers.

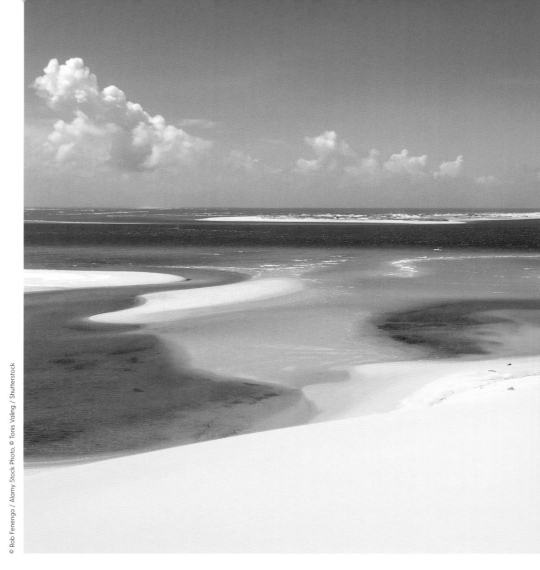

documented here, the most diverse array of any Indian Ocean reefs west of the Andaman Islands, and they are believed to feed coral larvae into the equatorial current to help replenish reefs further north off Tanzania and Kenya. Those reefs and the intact mangrove forests in the southern Quirimbas form an essential nursery for dozens of reef fish varieties as well as five of the seven sea turtle species.

Medjumbe, a narrow sliver of sand and coral, has the best diving in the Quirimbas, thanks to sloping coral reefs, and a sheer wall, drilled with caves and fringed with fan corals, that drops 2625ft (800m) vertically into the blue. Not to mention the large schools of dogtooth tuna, abundant sea turtles, leopard sharks, crocodile fish and blue spotted stingrays. But as

beautiful as these islands are, there's nothing quite like loading up a truck and exploring a wild continental coastline, dotted with fishing villages, empty beaches and a growing tourist infrastructure.

Southern Mozambique's coastal riches are unparalleled in East Africa. Tofo and Barra are set on opposite sides of a magnificent point that separates the Indian Ocean from the Inhambane Bay. There's a long arc of white sand at Tofo, clear blue water and great diving too. Further south, the lagoon coast encompasses 311 miles (500km) of coastal lakes and lagoons backed by tall forested sand dunes. The lakes are cut off from the sea entirely, but the lagoons get an influx of sea water and are prime salt-water fishing and bird-watching grounds.

There are still more dunes, wide beaches, fun surf and stellar diving along the coast both north and south of Ponta do Ouro, a popular resort town thanks to its proximity to the South African border. A string of point breaks and empty beaches run north from Ponta do Ouro, all the way to the Maputo River delta. The snorkeling all along the coast here is special and so is the scuba diving thanks to plankton-rich waters that attract dolphins and whale sharks year round.

Then there's the Bazaruto Archipelago, another off-shore island chain doubling as a national park. Here are still more white sand beaches and dunes with aquamarine bays, a Technicolor array of tropical fish, tremendous bird life – including fish eagles and flamingos – Nile crocodiles, dolphins and dugongs. Leatherback, loggerhead and green turtles nest on its beaches too. No wonder it's been protected since 1971.

The Bazaruto islands are also one of the best places to see humpback whales in Africa. These humpbacks swim north from Antarctica, where they feed all summer, to winter in the Bazaruto islands, where females calve and nurse their babies, and males angle to get a date.

The whales arrive around July and generally stay through September, and while whale watching is confined to boats in Mozambique, snorkelers or scuba divers should listen for the male humpback's haunting, mournful, meditative song which can carry underwater for several kilometres.

To hit the south coast, fly into Maputo Airport from Johannesburg. From there you can access the Bazaruto Islands; then hire a car, and make the slow drive south toward Ponta do Ouro, stopping in empty beaches and small fishing villages along the way. Pack your own boards, mask and fins. Beach-side grilled fish and beer is easy to find for lunch and lodging is getting more comfortable here too. To reach the Quirimbas Archipelago in the north, fly to Pemba from Maputo, where you can charter a flight or a speedboat to Ibo. Avoid the Christmas holiday crush and the monsoons between December and April. From May to November, Mozambique is dry and comfortable.

ITALY

Sardinia

The Italian island's stark cliffs and silky dunes overlook emerald waters and postcard-pretty bays.

On the Sardinian coastline, the white sand is blinding, the sea a shade of blue you only hoped might exist. In the north, Costa Smeralda, has become an aquatic playground for the rich and famous who are attracted to steep mountains that tumble haphazardly toward sea level then spread out like little rocky toes. Those secluded bays between slender peninsulas look almost tailor-made. To swim in them in solitude feels almost unfair. Almost. The best part, you don't need the yacht to do it. Anyone with a nose for adventure can find their way here and feel it for themselves.

And that's what makes Sardinia great. Its beauty is accessible to all yet for more inquisitive wanderers, the ones better suited to life out of bounds, it unfolds even further, and offers more. South of Costa Smeralda, also on the eastern shore, there are more hidden coves near the crescent beach of Golfo di Orosei, where cliff-top hiking trails bring panoramic views, and kayakers can weave their way around limestone walls, crawling with rock climbers, into tucked-away emerald grottos.

The interior is a different sort of jewel box. Weathered mountain villages built upon terraced slopes are transporting any time of day. The best of them feel like their own country, like their own place in time. Italian is not the first language for those who live here. They speak the Sardinian mother tongue, Sardo, and enjoy their own Sardinian cuisine, best paired

I'LL HAVE WHAT HE'S HAVING

Might Sardinian shepherds hold the secret to longevity? The answer is a resounding yes, according to *The Blue Zones* author Dan Buettner. In 2004, Buettner discovered a cluster of sheep-herding villages in the Sardinian highlands where the number of centenarian men was 10 times higher than the per-capita average in the United States. He investigated their lifestyle and found that the shepherds walk a minimum of five miles a day, harvest much of their own food, and eat very little meat. They also drink a local red wine from Grenache grapes known as Cannonau di Sardegna, which, he writes, 'has two to three times the artery scrubbing flavonoids as other wines'.

Left, Li Cossi beach on Sardinia's Costa Paradiso.

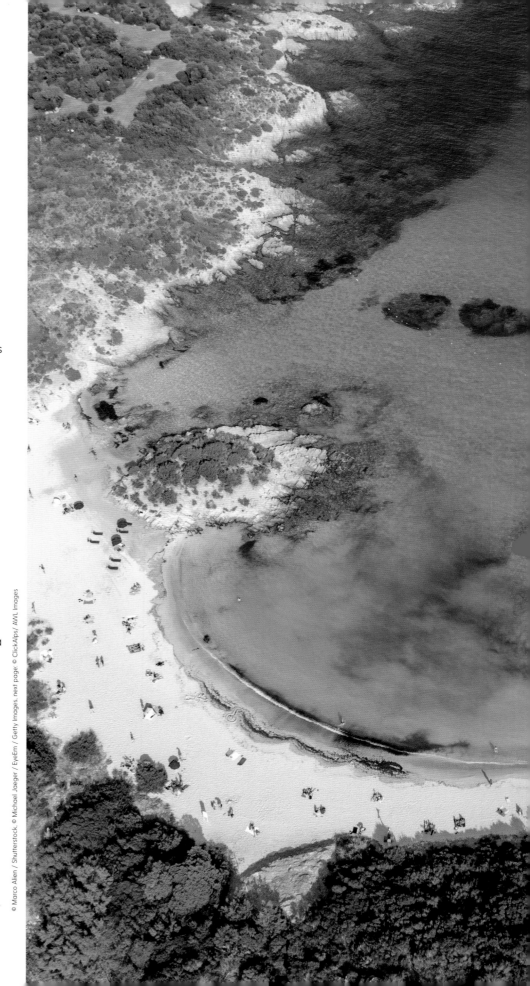

From right, Principe beach on the Costa Smerelda (Emerald Coast); sunset at Santa Teresa Gallura; overleaf, Sardinia's north coast.

with local wine. The combination must work, because there are more centenarians born and raised on Sardinia than almost anywhere else on earth.

Of course, there's old, and then there's *old*. The complex at Nuraghe Su Nuraxi is a Bronze Age throwback and Unesco World Heritage Site best visited at sunset. There are 7000 of these beehive-like structures on Sardinia and their purpose remains a beautiful mystery.

But the coast is where Sardinia is to be seen at its best. The Gallura coast to the north is a jigsaw of turquoise water and granite islands fringed with white sand. That's the Arcipelago di La Maddalena, seven islands that appear discrete but are actually joined underwater, like flowers on a tree branch. These islands are mountain peaks looming over a now underwater valley that once united Sardinia and Corsica. Water, wind and time has transformed the granite into pink sand beaches and carved out and fjord-like bays. The unimaginably inviting waters between them look almost tropical, with bright turquoise shallows fading into the deepest hues of blue.

Back on the north coast of Sardinia proper, and west of the town of Palau, the coast resembles a wind-sculpted moonscape, interspersed with the elegant beaches of Vignola and Santa Teresa di Gallura, which has a fashionable summer scene. The wind howls here, and some of the finest kite surfers on earth fly in to take advantage. The most adventurous of the bunch have been known to surf all the way

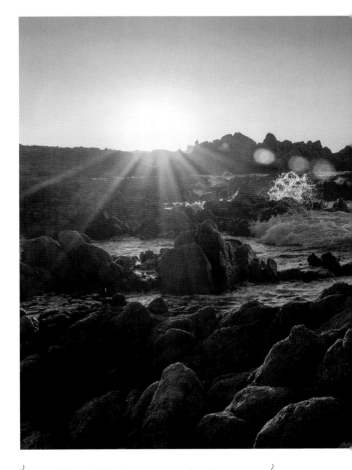

to Corsica 8 miles (13km) to the north.

The west coast, meanwhile, offers Roman ruins at Tempio di Antas, photo ops of wild horses around Table Mountain, a spectacular cave complex at Capo Caccia's Grotte di Nettuno, and, of course, yet another array of stunning beaches and blue waters, this time with sunset views. Spiaggia della Pelosa is a favourite for sunbathers and families each summer, thanks to powdery white sand and shallow turquoise seas. Surf thrashes the arced ribbon of golden sand at Spiaggia di Piscinas, which is accessed via a dirt track 5.6 miles (9km) long, and backed by towering 197ft (60m) sand dunes.

Cagliari, Sardinia's biggest city, is nestled on the south coast. It's neighbourhood trattorias serve tasty seafood dishes of rock lobsters and shellfish, and affordable and delicious wine, such as briny white wines from local vermentino grapes. There are baroque churches, charming art galleries, and colourful laneways dating back to Medieval times, much like the city's hilltop citadel, Il Castello. Still, the city can only deliver so much, and when the breeze blows in from the Mediterranean on a warm, late-summer morning, the sea can be impossible to resist. Fortunately, the coastal road from Cagliari runs southeast along a procession of superlative, rustic beaches, sheltered by granite headlands, all the way to Capo Carbonara, the island's most southeasterly point, where the fishing is off limits, and pink flamingos gather in the lagoon at springtime.

Whether you arrive by ferry from Corsica, Spain, France or mainland Italy, or fly into one of the island's three airports served by European cities (Cagliari in the south and Costa Smeralda in the north are the two best options), you'll need wheels to fully explore and appreciate Sardinia. There is no other way to reach the small villages, deserted beaches, and hiking trails. The good news is that there are no shortage of hotels and inns ready to welcome you, or wineries and trattorias to feed and water you. Pro tip: skip the July-August high season in favour of the shoulder seasons (April-June, September-October) when room rates drop.

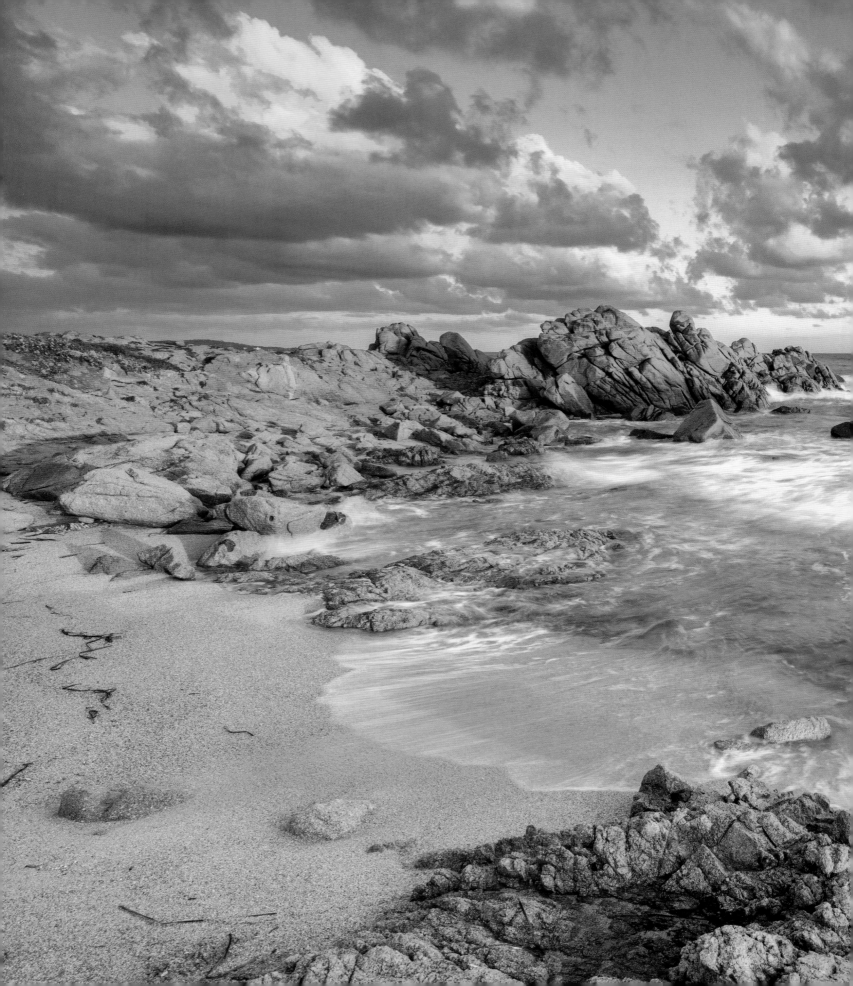

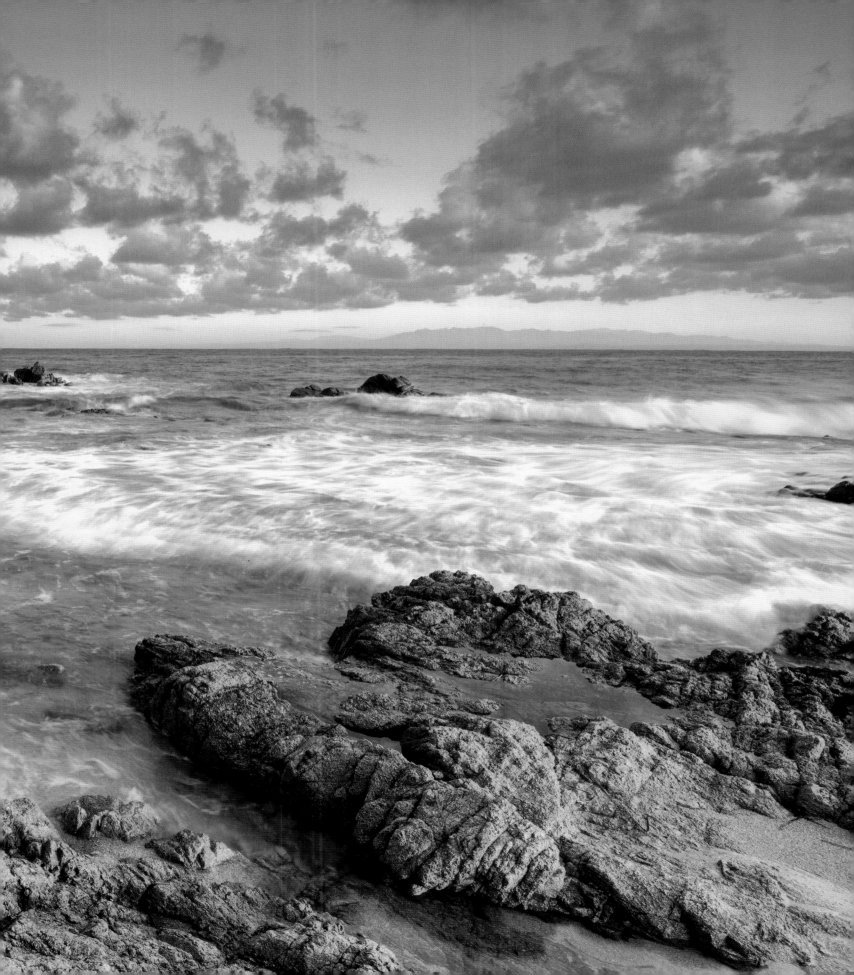

NORWAY

Norway's Fjord Coast

An almost endless mosaic of magical inlets and dizzying cliffs.

Right, the liquid landscape around Eidfjord near Bergen.

The coast of Norway spans over 1647 miles (2650km) as the crow flies, but this coastline doesn't come in one piece. Zoom in on the map and it looks like some bored Nordic god – that devious immortal artist – had his way with an ice pick, leaving the edge of an entire country looking fragmented. Scientists insist the job was done by glaciers, water and time.

While we generally refer to a single 'ice age' as formative in the development of life on Earth, present day Norway is thought to have had 40 ice ages(!), and during each thaw, glaciers further eroded land along the seashore as they receded. Those glaciers carved out deep ravines and sloped valleys that were inevitably flooded by the ocean. The result is countless ragged and shattered peninsulas separated by relatively narrow channels or fjords. It's believed that glaciers receded from Sognefjord, Norway's deepest (and the world's second-longest) fjord, for the final time some 12,000 years ago.

There are over 1000 fjords – long and narrow inlets – in Norway, so if you consider every metre of land fronting water to constitute part of the Norwegian coast, it stretches a lot further than 1647 miles. In 2011 a group of researchers did just that and calculated over 62,000 miles (100,000km). That's enough coastline to encircle the Earth two and a half times.

As you might imagine, the sheer extent of dramatic coastal scenery in Norway is almost as hard to fathom as the otherworldly scenery

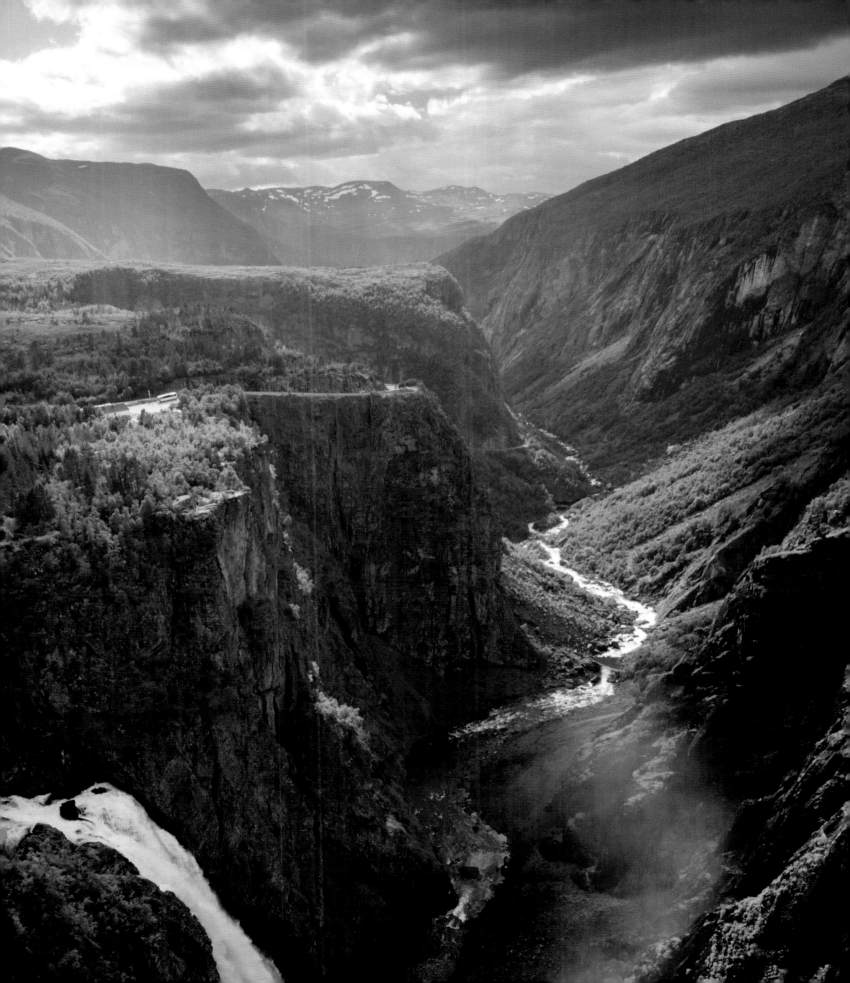

INTO THE ARCTIC

Fjords are wonderful and all, but in Norway's Arctic, nature and adventure get even bigger. The Svalbard Archipelago is not about creature comforts, but it does deliver spectacular snow-capped peaks, hulking icebergs, glaciers and ice fields, northern lights, and terrain better suited to polar bears than people. There's dog sledding and snowmobiling, kayaking trips and hiking expeditions, and it's true that bears outnumber humans, but you must join a boat tour and circumnavigate the island to spot them. During the summer visitors can join safaris in search of walrus, too. They can be glimpsed swimming in the sea or lounging on beaches with their family and friends.

itself, which rears up like set piece after set piece from some Game of Thrones-like fantasy world. So ubiquitous is this jaw-dropping beauty that even utilitarian public ferries offer five-star views. Consider the 12-mile (20km) trip from Geiranger to Hellesylt, which plies Geirangerfjord, a Unesco-listed fjord on almost every visitor's list. This generic ferry boat serves up soaring mountains and plunging cliffs laced with waterfalls that twist and spill into an aquamarine fjord over 820ft (250m) deep.

For a more comprehensive view, there's the Hurtigruten coastal ferry which links Bergen, one of Norway's most beautiful cities, with Kirkenes in the far north. A six-day journey (private berths are available), it weaves among too many fjords and headlands to count as it crosses the Arctic Circle. Also best viewed by boat, the 10.5-mile (17km) rivulet that is Nærøyfjord branches south from Sognefjord. Its name translates as the Narrow Fjord, an accurate description for a waterway that is just 820ft (250m) across in parts, framed by 3937ft (1200m) cliffs on either side. After heavy rains or during the snow melt, those cliffs are stitched in a tapestry of waterfalls.

In Southern Norway, Lysefjord (Light Fjord) is a hit with visitors because the granite rock appears to glow in the soft light, and the famous wooden staircase, some 4444 steps, leads to Pulpit Rock, a cliff top that juts over the water 1982ft (604m) below.

Hardangerfjord, not far from Bergen, is another classic. It meanders by fruit orchards, a handful of stunning hamlets and villages, and the Folgefonna National Park, where you can sign up for glacier walks or hit the mountain trails on your own.

The Lofoten Islands, further north, were sheared from the mainland eons ago and remain separated by the deep blue water of Vestfjorden. The slopes here are bathed

From left,
Hardangerfjord in
southwest Norway;
the coastal town of
Bergen, adventure
hub for the region;
overleaf a fjord near
Voss in summer.

International flights land in Bergen and Tromsø, in the heart of fjord country. Ferries are the best way to see the fjords. There are well-connected public ferry services along most of the coastline, and many carry cars, so it's possible to access the entire coast with a ferry schedule and a rental car. The Oslo-Bergen railway is another terrific option to get to Bergen and to rack up fjord vistas. Bergen is a great base for coastal exploration. Plush hotels, cosy B&Bs, and clean, basic guesthouse and pensions are all options along the Fjord Coast. During the summer the days are long, prime time for hiking and cycling. Winter gets extremely cold, but thanks to the northern lights, the scenery is arguably even more magical!

in greens and yellows during the spring and summer, and shrouded in their snow coats in winter. Dotted with sheep pastures and picturesque fishing villages, every view is a photograph, each snap postcard-worthy. The island peaks are so steep and jagged they seem to stab the sky.

Despite the harsh weather and isolation, people have lived on Norway's coastline for thousands of years. Petroglyphs have been discovered in Bremanger and Flora. Millstones dating back to the Viking days are on display in Kvernsteinsparken. In Solund, on Norway's westernmost point, you can see where Viking warriors once sharpened their swords before they shoved off on westbound expeditions.

Given the deep water, cold, sheltered bays and remote territory, it should not surprise you that humans are not the only animals that enjoy the fjords. Off Andenes, Stø or Tromsø, in the Vesterålen islands, sperm whales visit every summer, and in October humpback whales arrive to lunge feed on krill before heading south to the Caribbean for the winter, where they mate, give birth and nurse their young. Orcas turn up in November to hunt shoals of herring. They often chase the fish into the fjords where they can feast undisturbed. The water is icy, the visibility seldom great and the days short (the sun goes down at 2pm). Not ideal conditions for humans, but perfect for killer whales.

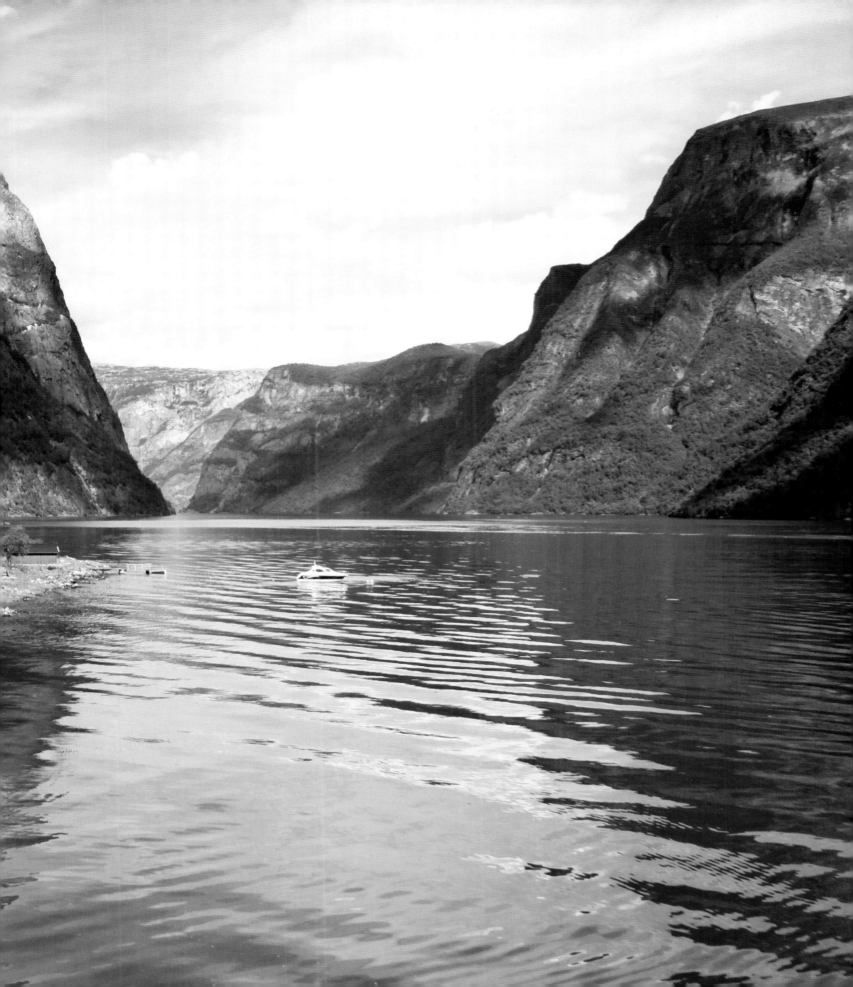

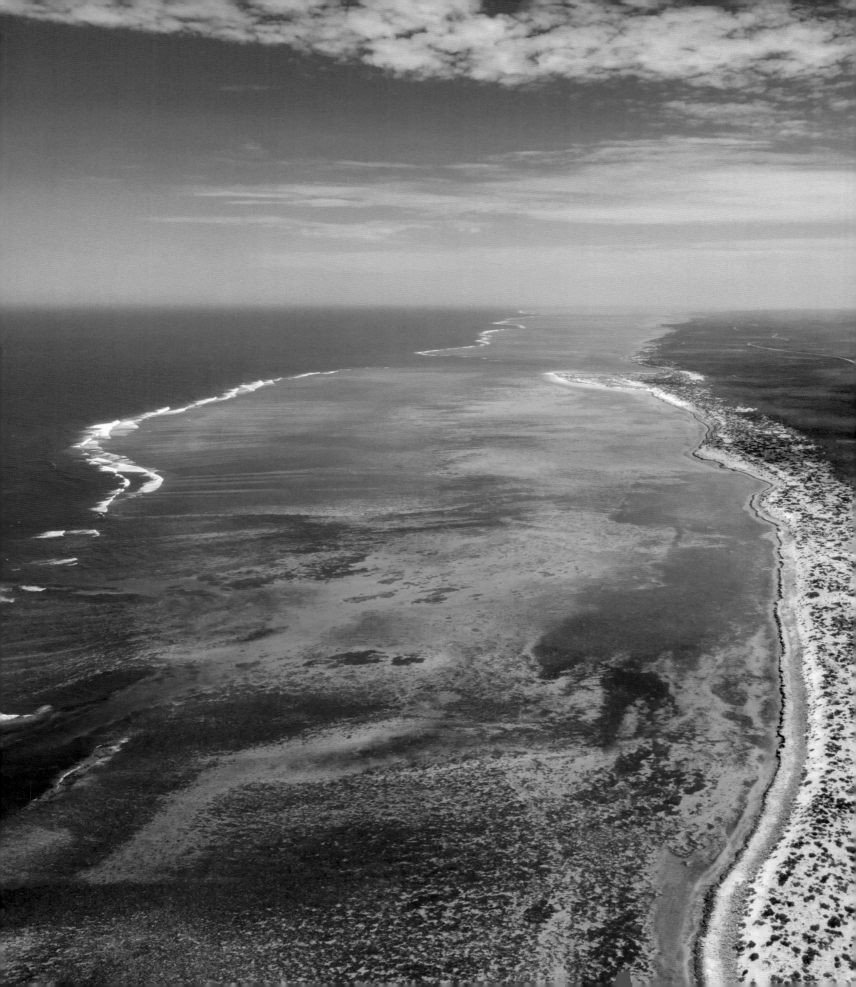

WESTERN AUSTRALIA

The Ningaloo Coast

Western Australia's Ningaloo Coast, set 746 miles (1200km) north of Perth, looks inhospitable to human life: near endless kilometres of unbroken desert and a marine ecosystem that doubles as a playground and nursery for sharks. Fun fact: it's forbidden to drive your rental car on the highway after the sun drops to prevent visitors from ploughing headlong into kangaroos hopping across the road. Yet, there is something incredibly inviting about this coastline – there may not be a better place on earth to snorkel. The bays are shallow and calm, sheltered by Australia's largest fringing reef system, which stretches 162 miles (260km) from end to end. In some places it sits a mere 328ft (100m) from shore.

But just because the Ningaloo reef is accessible, and the bays it protects are calm and always shallow (often not deeper than 26ft (8m), generally much shallower), doesn't mean it's tame. The reef is a wild convergence of temperate and tropical reef systems. Marine biologists have documented over 200 species of hard coral in the Ningaloo Marine Park. Although less colourful than vibrant soft corals, the architecture is otherworldly. Think: spherical brain corals, racks of staghorn corals, and others that look like mushrooms, cabbage and honeycomb.

More than 500 species of tropical fish live in the park, including gray, white-tip and black-tip

Visitors come for the giant, gentle whale sharks and teeming coral reefs, then stay for the expanses of cracked red earth and sugar-white beaches.

Left, the Exmouth coast, gateway to the marine park.

WILDLIFE TOURISM IN WESTERN AUSTRALIA

If you visit Ningaloo, you'll notice that wildlife encounters are widely facilitated by tour operators. In 2016 a four-year trial of swimming with humpback whales was started by Western Australia's Parks and Wildlife Service. Among the stipulations was that swimmers were to get no closer than 100m to humpback whales (not to mention the manta rays and whale sharks that also frequent the bay). The trial was deemed a success for both the human visitors and the sealife, despite reservations about animal welfare. As of 2021, up to 15 operators can hold licenses for swimming with (near) humpbacks, which pass through from August to October.

From right, Osprey Bay in Cape Range National Park; a whale shark cruises past.

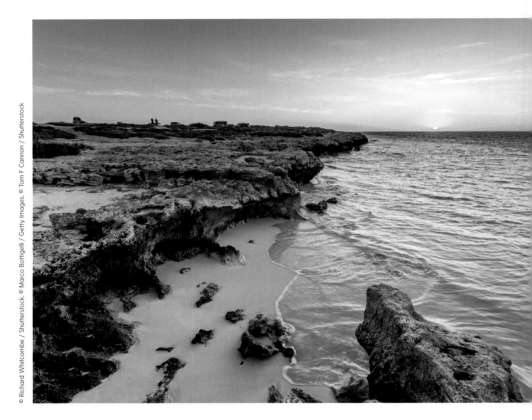

© Richard Whitcombe / Shutterstock, © Marco Bottigelli / Getty Images, © Tom F Cannon / Shutterstock

reef sharks, manta rays and tiger sharks. Humpback whales migrate up and down the coast each year too. Then there are the whale sharks, the largest fish in the world, and arguably Ningaloo's biggest draw. When coral spawns it ejects eggs and sperm into the water which attract hungry whale sharks. Peak spawning usually happens 10 days after the March and April full moons, the timing of which must be in whale shark DNA, because that's when up to 500 of them arrive annually.

These regal giants can grow up to 59ft (18m) long, and live 100 years. Even a 39ft/12m-long whale shark – the largest you'd be likely to see in Ningaloo – can weigh 18 tonnes. Their mouths open up to 3.5ft (1m) wide, but they are filter feeders, have no teeth and are as gentle as can be. Ningaloo is one of the best places on earth to swim with them, and they are a sight to behold. Like mantas they are thrilling and magnificent, yet calming, both silencing the mind and quickening the heart as if you are witnessing a genuine miracle, or a force of nature.

The Ningaloo Coast extends from Exmouth, at the north end of Australia's North West Cape to Quobba Station, 186 miles (300km) south. The 93 miles (150km) between Coral Bay and Exmouth, the two main population centres, are the most accessible and have all the highlights: the remote beaches and bays, and the 195-sq-mile (506-sq-km) Cape Range National Park. Cape Range encompasses the peninsula's mountainous limestone spine, which is riddled with gorges, and home to the rare black-

flanked wallaby and over 160 bird species. From January to March, green and loggerhead turtles come ashore and nest on its wild and pristine beaches and dunes. When the babies hatch they make a beeline for the relative shelter of any number of turquoise bays.

Ningaloo is an Aboriginal Wajarri word meaning 'high land jutting into the sea'. Though the land and weather can be harsh (temperatures soar to 40°C (104°F) during the summer months), the Yamaji people have lived in the area for over 30,000 years. Much more recently, in 1618, the first Europeans landed in the area, and in 1818 he peninsula was dubbed the North West Cape by explorer Phillip Parker King. In 2011 it was listed as a Unesco World Heritage site.

Sheep ranches were laid out and pearl divers used to frequent the area too, but there was no real development until WWII when Americans built a submarine station near the town of Exmouth, which continued to be a military town for decades. Many of its streets are named for Australian and English war heroes. Coral Bay, meanwhile, has been a holiday destination for many decades. Word first got out about its long, wide beaches and easy to access coral gardens in the 1950s and 1960s. The road was finally sealed in the 1980s and it remains a rustic getaway for families and retirees. Kangaroos hop around the dunes, there's a black-tip shark nursery a short walk from town, and the sunsets are almost as magical as those pristine coral gardens just waiting to be explored.

The longer you stay, the more Ningaloo's blend of red earth, white sand and blue water works on the brain like colour therapy, unraveling the mind, relaxing the body and eliciting awe.

Fly into Exmouth from Perth. From there plot out your trip to include stops in Coral Bay, the beaches of Cape Range National Park and the town of Exmouth. A popular way of exploring this coastline is with a rented campervan, though in Coral Bay there are clean and basic hotel rooms with kitchens, which are a better option than the cramped grassy campsites with no privacy. The beach camping is better in Cape Range National Park. Exmouth and Coral Bay have restaurants and grocery stores. Coral Bay also has a fabulous bakery. Tour operators all offer similar trips, and wherever you are on the coast, the snorkeling is splendid. Mask and fins are essential.

SOUTH PACIFIC

The Tuamotu Islands

Deep in the South Pacific, on the rim of ancient volcanoes, lies an archipelago that's a haven for windblown sailors and marine wildlife.

echnically, this isn't a group of islands, but atolls, ancient echoes of sunken volcanoes that once soared toward the clouds. As those giant mountains receded beneath the sea they left sunken rims of lava around spent craters. Those rims became foundations for nature to build on as seawater flooded the craters and created interior lagoons. Along with that water came free-swimming coral larvae which attached to lava rock and formed nascent coral reefs, which kept growing.

Over the years, each atoll gathered enough rock, coral and sand (which in the Tuamotus is emulsified coral and shells) to breach the surface, and for palm trees and other scrub brush to grow. Land didn't connect around the lagoons in unbroken rings. There were gaps and each piece of land became known as a *motu*. Some motus were big enough for villages and future airports, others were tiny, just enough for a family house. Between them were channels, mostly small rivulets of seawater, but at each atoll there was always at least one great pass; a rip in the seam used by wildlife and early Polynesian explorers to venture into the lagoons from the open ocean, and settle what became known as the Tuamotu Islands.

In many ways the Tuamotu Islands are French Polynesia. Of the 118 islands and atolls in the country, 80 of them are in the Tuamotus. Fakarava and Rangiroa are the big hits, but Tikehau is another gem, and the lesser-known atolls are

Right, pink sands on Tikehau lagoon.

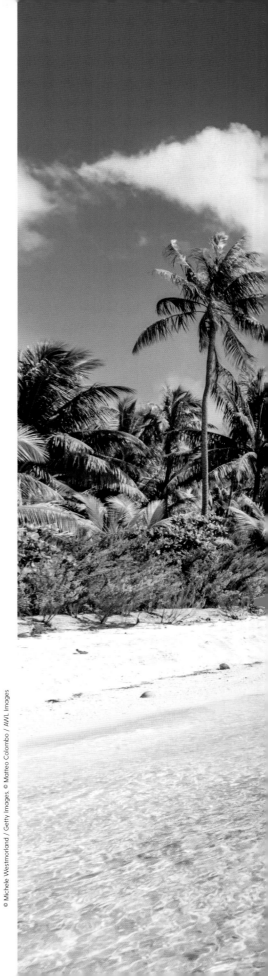

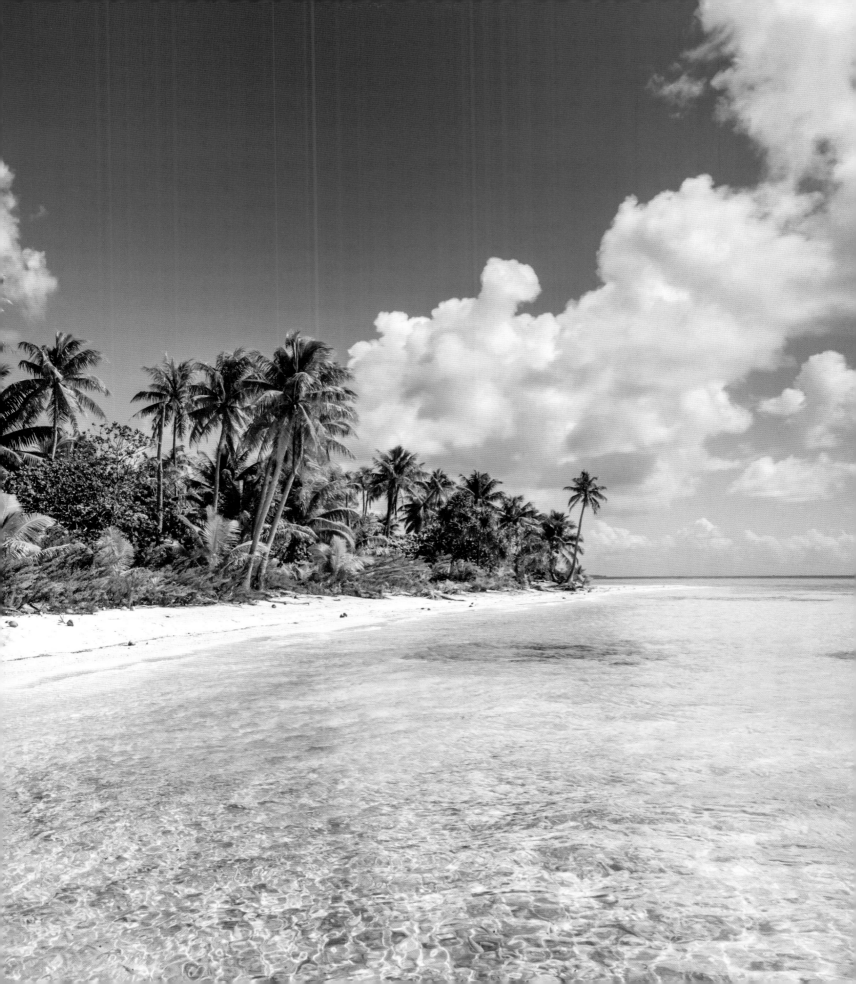

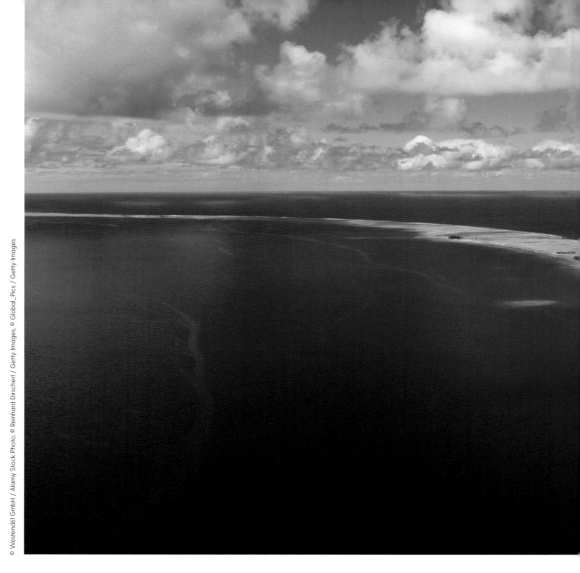

PEARL LAGOONS
In the 1980s and 1990s, the Tuamotus were the domain of pearl farmers, some of whom became millionaires almost overnight. These aren't your grandma's pearls. Tahitian (or black) pearls are multi-hued and much larger. They are made when a graft, or pearl seed, is embedded into living oysters which are strung up on lines that dangle in the lagoons for three years.

Although pearl farms first popped up in the Tuamotus in the 1960s, the market benefited from airstrips built in the 1970s. By the 1980s, the gold rush was on and atoll populations boomed. The best connected farmers made millions as demand stayed high for over a decade, but soon the market flooded, and the price began to drop like a lava rock in 2003. Pearl farms were soon abandoned throughout the Tuamotus. The price, and the local economy, has not recovered since.

all almost equally beautiful, and all share the same unique quirk. None of them have mountains, and the elevations and area of even the largest motus are so low and small that to experience its weather is not unlike being adrift on a sailboat in the open sea.

With no mountains for clouds to congregate around, and no landmass to generate heat or wind, weather blows through in fits and spurts. Sunny and calm mornings can be spoiled by surprise gale force winds and downpours, which can evaporate just as quickly. The rainbows are magic, the sunsets unequaled. And when you put it all together, the Tuamotus still get more sunny days than any other archipelago in French Polynesia.

There is no definitive account of when the Paumotu (people of the Tuamotus) came to live on the atolls. Some think after fleeing the Leeward and Marquesas islands in the 14th, 15th and 16th centuries they landed here. Others believe the eastern Tuamotus were populated along with the other islands in the South Pacific during the major Polynesia exodus from the Marquesas around the 10th century.

French explorers were less than enthusiastic about the atolls. Many European sailors considered the islands and the people who lived there dangerous. Yet when France annexed Tahiti, the Tuamotus came with them. Life there was harsh, the soils sandy. Hardly anything grew aside from coconuts. Fruit and veggies were hard to come by and so was drinking water, which was harvested from the rain. Those same limitations still exist, but islanders find a way. And that remote, exposed feel, the tumultuous weather, the lack of development and ease, are the reasons the skies are so dark at night, the stars so brilliant, the natural beauty all pervasive.

From left, the arc of Kauehi Atoll, remnant of an undersea volcano; the double-saddle butterflyfish is a common species.

Rangiroa, Fakarava and Tikehau are the most visited thanks to frequent flights and excellent resorts. Diving is a major draw, but so are fishing, lagoon tours, kayaking and snorkeling. Each atoll has a main village near the airstrip, but you will almost certainly need a boat to reach your resort or guest house. That's easily arranged. Hotels serve meals too. Diving is great year round, but December to March is the wet season, which means it's both very hot and very humid. Great for mosquitoes, less good for tourists. The trade winds are up between June and September, and choppy lagoons make for adventurous boat excursions. April, May, October and November are perfection.

That's why the Tuamotus have become a haven for sailors, who anchor in their lagoons, and tourists from both within and outside French Polynesia. It's a place to get in touch with the raw elements and away from everything else. And the best time and place to do that is in any atoll's pass – that tidal river that funnels in and out of the lagoon.

When the tide is rolling in from the blue ocean just before sunset, the pass is often crystal clear and bustling with immense shoals of tropical fish, including jack fish, unicorn fish, barracuda and dogtooth tuna. It's dream terrain for spear fishermen, as well as hungry sharks. Black tip, white tip, gray reef sharks, immense silver tips and tiger sharks patrol the passes. Hammerheads, too.

That's what makes the Tuamotus a scuba and freediving hotspot. The Tiputa Pass on Rangiroa is one of the best-loved drift dives in the world thanks to frequent sightings of hammerheads, mantas, eagle rays and dolphins. Fakarava, another popular atoll, offers the second-largest lagoon in the Tuamotus and has two passes. Though Rangiroa typically gets bigger sharks, Fakarava has a healthier reef. The diving in Tikehau is also spectacular, both in the pass, and in the Shark Hole, an aperture in a coral-encrusted wall on the outer reef. Nobody except maybe the resident sharks know how deep that hole goes.

Index

Contributors

ADAM WEYMOUTH wrote the chapter on rivers and waterways. He is a writer and journalist, whose work has appeared in publications including Granta, The Guardian, the BBC and The Atlantic. His first book, Kings of the Yukon, tells the story of his 2000-mile canoe trip down the Yukon river, investigating the crash in king salmon numbers, and the impact on the people and ecosystems that depend on them. The book won The Sunday Times Young Writer of the Year and the Lonely Planet Adventure Travel Book of the Year awards. He lives on a 100-year-old Dutch barge on the River Lea.

ADAM SKOLNICK wrote the chapter on coasts and seas. He is an award-winning journalist and author covering adventure sports, environmental issues, travel and human rights for The New York Times, Outside, Playboy and Lonely Planet. He's travelled to over 50 countries, worked on six continents, and contributed to over 35 Lonely Planet guides. He is also the author of One Breath: Freediving, Death and the Quest to Shatter Human Limits, and was the ghost writer and narrator of David Goggins' hit memoir and audiobook Can't Hurt Me: Master Your Mind and Defy the Odds, which has sold two million copies worldwide.

OLIVER BERRY wrote the chapter on deserts and plains. He is a writer and photographer specialising in travel, wildlife and the natural world. He has contributed to more than 30 Lonely Planet books, and his writing has been published by some of the world's leading magazines, websites and newspapers. During his travels, he has visited several of the world's great deserts, from interviewing cowboys in the Chihuahuan Desert to camping out with camels and Bedouins in the Sahara. His favourite desert memory is stargazing in the Atacama Desert. See his latest work at www.oliverberry.com

LONELY PLANET'S Natural World

Published in October 2020 by Lonely Planet
Global Limited CRN 554153
www.lonelyplanet.com
ISBN 9781788689397
© Lonely Planet 2020
10 9 8 7 6 5 4 3 2 1
Printed in China

Managing Director, Publishing: Piers Pickard
Associate Publisher and Commissioning Editor: Robin Barton
Writers: Adam Skolnick (Coasts & Seas), Adam Weymouth
(Rivers & Waterways), Oliver Berry (Deserts & Plains)
Editor: Mike Higgins
Art Direction: Daniel Di Paolo
Design: Tina García
Illustrations: Holly Exley
Print Production: Nigel Longuet

Picture credits: Page 2: © Justin Foulkes / Lonely Planet. Page 4: © Diego Grandi / Shutterstock, © Géza Egyed / egyedg / 500px / Getty Images, © Katt Talsma / 500px / Getty Images, © Olga Kashubin / Shutterstock, © Totajla / Shutterstock, © SkyImages / Shutterstock, © Nora Carol Photography / Getty Images, © NatalieJean / Shutterstock, © Chris Holman / Shutterstock. Page 25: © Danita Delimont Stock / AWL Images, © Juan Carlos Vindas / Getty Images, © Torsten Pursche / Shutterstock, © PJ photography / Shutterstock, © Rodcoffee / Shutterstock, © Robert Harding / Alamy Stock Photo, © Ryoko.os / Shutterstock, © Scott Canning / Getty Images, © ImageBROKER / Peter Giovannini / Getty Images, © Juan Montero / Getty Images. Page 85: © Justin Foulkes / Lonely Planet, © Stefano Salvetti / Getty Images, © Image Broker / Alamy Stock Photo, © Danita Delimont / AWL Images, © UniquePhotoArts / Shutterstock, © Pascal Boegli / Getty Images, © Steve Lovegrove / Shutterstock, © HMS / AWL Images, © RBY / AWL Images, © Lautaro Federico / Shutterstock. Page 147: © JMK / AWL Images, © Matt Munro / Lonely Planet, © Michal Balada / Shutterstock, © Yanwen Zheng / 500px / Getty Images, © Jonne Seijdel / Getty Images, © Nando Machado / Shutterstock, © Minden Pictures / Alamy Stock Photo, © Almazoff / Shutterstock, © Jess Kraft / 500px / Getty Images, © Creative Endeavors / Shutterstock. Page 203: © Nigel Pavitt / John Warburton-Lee Photography Ltd, © Tim Graham / Getty Images, © ClickAlps/ AWL Images Ltd, © Christian Heeb/ AWL Images Ltd, © Vaclav Sebek / Shutterstock, © Nigel Pavitt/ AWL Images Ltd, © IMB / AWL Images, © Hemis / AWL Images, © Justin Foulkes / Lonely Planet, © Celli07 / Shutterstock. Page 263: © Lynn Yeh / Shutterstock, © Leonardo Gonzalez / Shutterstock, © HMS / AWL Images, © JCB / AWL Images, © Sabino Parente / Shutterstock, © BlueOrange Studio / Shutterstock, © CLK / AWL Images, © IMB / AWL Images, © Nature Picture Library / Alamy Stock Photo, © Global Pics / Getty Images

Lonely Planet offices
AUSTRALIA
The Malt Store, Level 3, 551 Swanston Street,
Carlton VIC, 3053 Australia
Phone 03 8379 8000

UNITED KINGDOM
240 Blackfriars Road, London SE1 8NW
Phone 020 3771 5100

USA
Suite 208, 155 Filbert Street, Oakland, CA 94607
Phone 510 250 6400

IRELAND
Digital Depot, Roe Lane (off Thomas St),
Digital Hub, Dublin 8, D08 TCV4

Stay In Touch
lonelyplanet.com/contact

Although the authors and Lonely Planet have taken all reasonable care in preparing this book, we make no warranty about the accuracy or completeness of its content and, to the maximum extent permitted, disclaim all liability from its use.